Drawing
1400–1600
Invention and Innovation

Edited by Stuart Currie

ASHGATE

Published by

Ashgate Publishing Limited Ashgate Publishing Company
Gower House Old Post Road
Croft Road Brookfield
Aldershot Vermont 05036–9704
Hants GU11 3HR USA
England

British Library Cataloguing-in-Publication data.

Drawing, 1400–1600 : invention and innovation
 1. Drawing – 15th century 2. Drawing – 16th century
 I. Currie, Stuart
 741.9'23

Library of Congress Cataloging-in-Publication data.

Drawing, 1400–1600 : invention and innovation / edited by Stuart Currie.
 Collection of essays presented at a conference of the Association of Art
Historians in 1994 at the University of Birmingham.
 Includes index.
 ISBN 1-85928-364-0 (hc)
 1. Drawing, Gothic. 2. Drawing Renaissance. 3. Drawing, Baroque. I. Currie,
Stuart
NC70.D7 1998
741'.09'024—dc21 97-33668
 CIP

ISBN 1 85928 364 0

Printed on acid-free paper

Typeset in Palatino by Photoprint, Torquay, Devon
Printed in Great Britain by Hobbs the Printers, Totton, Hampshire SO40 3WX

Contents

List of figures

4 Maso Finiguerra and early Florentine printmaking

5 Mantegna and Pollaiuolo: artistic personality and the marketing of invention

List of contributors

JULIA WATSON studied History of Art at Birkbeck College, University of London. She is currently completing her Ph.D on fourteenth-century French sculpture at the University of Leicester, She has written on late medieval French sculpted mantelpieces and figure cycles.

SUSIE NASH is a lecturer in Northern Renaissance Art at the Courtauld Institute of Art, University of London. She studied History of Art at Reading University at both undergraduate and postgraduate level, completing her doctoral thesis on manuscript illumination in Amiens during the fifteenth century in 1994. She is the author of *Between France and Flanders: Manuscript Illumination in Amiens in the Fifteenth Century* (London, 1997) and co-editor of *Robert Campin: New Directions in Scholarship* (London and Brepols, 1996).

FRANCIS AMES-LEWIS is a Reader in History of Art at Birkbeck College, University of London, where he has taught since 1969. He was educated at the University of St Andrews and at the Courtauld Institute of Art, gaining his doctorate in 1977 with a thesis entitled *The Library and Manuscripts of Piero di Cosimo de' Medici* (New York, 1984). He has written books on Italian Renaissance drawing: *Drawing in early Renaissance Italy* (London and New Haven, 1981), and *The Draftsman Raphael* (London and New Haven, 1986), and on Italian Medieval sculpture: *Tuscan Marble Carving 1250–1350* (Aldershot 1997), and many periodical articles including several on aspects of the art and patronage of the early Medici.

LUCY WHITAKER studied History of Art at the Courtauld Institute of Art and in 1986 completed her M.Phil dissertation on *The Florentine Picture Chronicle*, a book of drawings attributed to Maso Finiguerra. She was the Research Assistant at the National Gallery, London, prior to joining Christ Church

Picture Gallery, Oxford, in 1989 as Assistant Curator of Pictures, specializing in fifteenth- and sixteenth-century drawings, with a particular interest in those produced in Florence. She became Assistant to the Surveyor of The Queen's Pictures in 1997.

ALISON WRIGHT studied at the Courtauld Institute of Art as an undergraduate and postgraduate, completing her Ph.D on the paintings of Antonio and Piero Pollaiuolo in 1991. Following fellowships at the Metropolitan Museum of Art in New York and the Courtauld Institute, she was appointed lecturer in Italian art of the late middle ages and early Renaissance at University College London in 1994.

CLAIRE VAN CLEAVE completed her Masters degree at the Courtauld Institute, University of London. She then developed her interest in Italian Renaissance drawings with her doctoral thesis on *Luca Signorelli as a Draughtsman* at Christ Church, University of Oxford. Apart from her writings on Signorelli, Dr Van Cleave has published on drawing techniques in the Italian quattrocento workshop.

ANDREW MORRALL read Modern History at Oxford University and received his doctorate in the History of Art at the Courtauld Institute of Art, University of London, in 1996. He is a lecturer in the History of Art at Christie's Education, London, and has written articles on German and Venetian art.

SHARON GREGORY studied History of Art at the University of Calgary as an undergraduate. She received her Masters degree at Queen's University, Kingston, Canada, where she has been a lecturer in the History of Art since 1995. She is currently completing her doctoral thesis entitled 'Vasari, Prints and Printmaking' at the Courtauld Institute of Art, University of London. Her specialist interests are Renaissance prints, Italian Mannerism and artistic exchanges between Italy and northern Europe. She has written various periodical articles on these subjects.

STUART CURRIE studied History of Art at Birkbeck College, University of London, where he is currently completing his doctoral thesis on the Florentine painted altarpiece c.1560–1580. He is a freelance lecturer in the History of Art, specialising in Italian Renaissance art. He has taught at Birkbeck College, The University of Reading and Kingston University. He is co-editor (with Peta Motture) of *The Sculpted Object 1400–1700* (Aldershot 1997) and has written on Bronzino.

MONIQUE KORNELL's main area of research is History of Art and Anatomy. In 1993 she received her Ph.D in combined Historical Studies from the Warburg

Institute, University of London. She was co-curator of *The Ingenious Machine of Nature: Four Centuries of Art and Anatomy*, an exhibition of prints and drawings held at the National Gallery of Canada, Ottawa, 1996.

MICHAEL BURY was educated at the Universities of Cambridge and London. His initial employment was as Assistant Keeper of Foreign Art at the Walker Art Gallery, Liverpool. Since 1972 he has taught History of Art at Edinburgh University. He has written on various aspects of Italian Renaissance art.

TARNYA COOPER completed her first degree at Camberwell School of Art. She undertook postgraduate study at the Courtauld Institute of Art, University of London, and is currently completing her Ph.D at Sussex University on *vanitas* representations in early modern England. She is Assistant Curator of the College Art Collections, University College London, in which role she has curated the exhibitions, *Origin and Originality: Copied Drawings from the Grote Collection* (1994) and *Refashioning Death: Vanitas and Memento Mori prints from Northern Europe 1514–c.1640* (1997).

Preface

This book has evolved from the papers given at the session of the same name held at the 1994 Association of Art Historians conference at the University of Birmingham. The conference's theme, *Forward: Art and Industry,* provided an exciting challenge to scholars involved in research on subjects from the late fourteenth century and through the Renaissance period into the early seventeenth century. The book, *Drawing 1400–1600: Invention and Innovation,* probes further into the subjects presented at the conference to outline some of the imaginative ways in which drawing was utilized by artists stimulated by the new technical processes and broader cultural developments that arose during this highly fertile period for artistic inventiveness. The main thrust of many of the essays falls on the development of drawing procedures employed by artists seeking to respond in an individually innovative manner to projects associated with the diverse political, religious and intellectual preoccupations that characterized the centuries in question.

The twelve essays embrace the various expansions in drawing practice which accompanied the proliferation of specialized fields of artistic activity that occurred particularly during Renaissance times. Amongst these, the interrelationship between drawing and printmaking is a recurring theme, often receiving specific attention in terms of artists devising imaginative new image-types for sophisticated individual or corporate reproduction projects, or in relation to inventive graphic creations by artists from other European countries. Drawings are also investigated in relation to wider concepts of invention and innovation, whether being viewed in terms of differing types of workshop practice, or of less elevated and essentially practical notions of copying for purposes of study through the reuse of a master's prototypes or revered exemplary images. Still other approaches consider drawings from the period in connection with legal and business procedures, and with attitudes to their collection and classification by later conoisseurs.

Julia Watson's subject is the practice of drawing by sculptors in France during the late fourteenth century. Her paper covers two interlinked topics: the rights of the sculptor with regard to drawing and design, and the surviving evidence that sculptors actually did make and use drawings. The first part deals with the legislation and regulations on the working practice of sculptors and how these compare with those relating to painters. It examines and considers the implications of the disputes between painters over the right to execute the design of sculptural works. The second part of the paper presents evidence for the use and execution of drawings by sculptors. The term 'drawing' in this context is not restricted to works on paper or parchment, but includes any evidence of a drawing having been carried out, whether on paper, on a wall, on a floor, or on any other surface, temporary or permanent.

Susie Nash examines the reuse of compositions and the dependence on drawing models by artists undertaking the illumination of Books of Hours, which to an extent had a standardized programme of illustrations. Focusing upon a group of closely related manuscripts made in Amiens in the first half of the fifteenth century, the essay underlines how the desire to make a profit and the need to produce well-illuminated books speedily often led to a heavy reliance on pattern-book drawings. These Amiens manuscripts are almost the only surviving examples of art produced in the region during this period, and, as Amiens was a cosmopolitan centre and a melting-pot for influences from France and Flanders, they consequently have considerable importance. The examination of how drawings were used by illuminators working in Amiens raises questions concerning the diffusion of ideas, style and iconography. The essay also considers the extent to which drawings were aids to systematized production and increased productivity in the book-making industry.

Francis Ames-Lewis concentrates on the sketchbook sheets probably used around 1460 in Benozzo Gozzoli's workshop, and now mostly in the Boijmans Van Beuningen Museum, Rotterdam. These drawings provide evidence of workshop procedures and of the materials available to apprentices learning their craft in Gozzoli's *bottega*. Dr Ames-Lewis examines the so-called *Rotterdam Sketchbook* and related sheets with a view to deducing more than has hitherto been understood about early-Renaissance workshop practice. Consideration is also given to whether or not the draughtsmen using these sheets drew from the live model or from sculptural models, to the use in Gozzoli's *bottega* of both near-contemporary but non-Florentine two-dimensional prototypes for copying, and to objects of classical derivation employed as 'visual aids' for workshop instruction. The author proposes that such possibilities may suggest parallels with the range of activity, and

perhaps even with the pretensions, of Francesco Squarcione's Paduan *studium*.

Lucy Whitaker assesses the drawings of Maso Finiguerra, the artist identified by Vasari as the inventor of engraving. Vasari's statement is considered in conjunction with the fact that no prints can be securely attributed to Finiguerra, but that strong stylistic and technical evidence suggests that he held an important position in the development of Italian printmaking. Referred to by a contemporary source as *maestro di disegno*, Finiguerra ran a successful *bottega*, producing works in various media: nielli, sulphur casts from nielli, prints taken from both nielli and sulphur casts, designs for intarsia figures and goldsmith work. His follower Baccio Baldini produced the history book known as *The Florentine Picture Chronicle* which is very dependent on Finiguerra sources. Finiguerra is also associated with a large group of pen-and-ink drawings, the style and purpose of which are considered here in relation to the prints, nielli and sulphur casts also linked to his name. The author considers the continuation of Finiguerra's workshop practices by associates and successors, and speculates on the place of his workshop and subsequent printmaking in Florence within that city's artistic tradition.

Alison Wright makes a comparative examination of the approach to the new medium of the print in the careers of Antonio Pollaiuolo and Andrea Mantegna. Their engravings are discussed as objects which involved considerable technical skill, displayed exceptional ability in *disegno*, and allowed a greater degree of iconographical invention than images in conventional media. The paper considers the factors influencing the two artists' attraction to the print and their markedly different engagement with the medium, addressing how far their prints fulfilled similar functions and what their intended market may have been. The production of engravings is discussed as a potential field of artistic competition, a field which underlines the professional sensitivity of Mantegna and Pollaiuolo to their market and their contribution to a developing perception of the artist as creative inventor.

Claire Van Cleave determines that Vasari's significant placement of Signorelli at the end of the second part of his *Lives of the Artists* was inspired by the artist's innovative approach to the depiction of the human body. She examines Signorelli's understanding of the body as seen through his drawings and discusses his emphasis on the form and lighting of the body's musculature, viewing these aspects of the artist's drawing technique as defining characteristics of his figure studies. The author considers the different kinds of model that enabled Signorelli to achieve strikingly realistic effects, and she elaborates upon the various figure-types he created from these models. Dr Van Cleave also highlights the fundamental significance of Signorelli's choice of black chalk for the drawings to contrast his work in this

medium with quattrocento traditional practice. Her paper concludes with the way Signorelli utilized his drawings of the human figure in his paintings.

Andrew Morrall defines the differences in character between Jörg Breu's preparatory sketch and his finished painting of the *Story of Lucretia*, executed for the Duke of Bavaria in 1528. From this starting point the essay develops into an examination of the apparently self-conscious distinction in style employed by Breu and other sixteenth-century German artists, that contemporaries termed the *'welsch'* and the *'deutsch'* – the italianate and the germanic. While the figures in the sketch are dressed in contemporary costumes and their forms are conceived in the fluent linear style of an indigenous 'germanic' tradition, the painting is self-consciously 'classical' in its treatment of costume, figure-style and architectural background. Through discussion of the development and character of Breu's classicism and its visual and literary sources, in the light of the painting's intended setting and function, and set against the diverse meanings with which northern contemporaries invested the italianate, the author sheds light on the categorization of style as well as on the uses of classicism in Germany during the early sixteenth century.

Sharon Gregory examines drawings by Giorgio Vasari in the light of mid-sixteenth-century attitudes towards Imitation. As it pertains to Renaissance art, the term 'Imitation' covers a broad range of practices. Its simplest form is the use by an artist of inventions created by another to enable him to find visual means of expressing an idea. A more sophisticated Imitation involves emulation of a model or models with the intention that an informed observer can recognize the source. Such an approach may have been employed to deepen iconographical meaning or to proclaim a lineage for the resulting work of art. Visual quotations abound in Vasari's paintings, but since Imitation is the product of an artistic process further evidence for overt and hidden references can be found in the preparatory drawings. The essay considers several examples to reveal how Vasari used his sources and what his intentions may have been. The author also discusses the manner in which Vasari's varying responses to Albrecht Dürer's prints, and prints designed by Rosso Fiorentino, were conditioned by contemporary definitions of *invenzione, buon disegno* and *bella maniera*.

My own essay focuses upon two drawings in the British Museum by Giovambattista Naldini. Both drawings feature the *Way to Calvary* or *Christ carrying the Cross,* and are universally accepted as compositional studies for the altarpiece of the same subject still *in situ* in the Badia Fiorentina. The striking qualities of the drawings have often been recognized, but there has been minimal elaboration in the literature. This paper pinpoints the innovative elements in Naldini's graphic meditations on the gospel incident by

exploring the meaning of the changes that occurred between the two drawings and the infinitely more decorous condensation of expression in the altarpiece. The essay reviews all three visualizations in relation to the evolution of *Way to Calvary* imagery since late-medieval times, and considers the artist's apparent consciousness of the subject's unique significance with respect to Counter-Reformation attitudes to religious art. Finally, the paper attempts to deduce why the solutions towards which Naldini appeared to be working in the drawings were so drastically refined in the painting, and whether the inventive *disegno* effects which he sought to fuse with his imaginative interpretations of the biblical text were in fact constrained by the recommendations of advisors.

Monique Kornell discusses Bartolomeo Passarotti's project for a book of anatomy against the background of sixteenth-century Italy when both ana-tomists and artists were involved in a renewed study of the body. The study of anatomy was promoted as one of the central elements in an artistic education and was included in the instruction offered at the early art academies of the sixteenth century. The Bolognese painter Bartolomeo Pas-sarotti (1529–1592) was one among several notable artists of the period who attempted to compose a treatise on anatomy. In 1584 Raffaello Borghini reported that Passarotti was at work on a book of anatomy for artists. The book was never published and the author examines the artist's surviving anatomical studies for an indication of the themes that he would have addressed in his treatise. In her essay, Dr Kornell publishes drawings which demonstrate Passarotti's use of the bilateral figure-type to compare the different layers of the body and which reveal his interest in the measurement and proportions of the body based on its anatomy.

Michael Bury considers Antonio Tempesta's etchings, which, with their long-bitten, strong lines suitable for printing large editions, were criticised by Baglione for their lack of refinement. Baldinucci defended their value by characterizing Tempesta's approach as *pittoresco*, noting that he was not concerned with appealing to connoisseurs interested in beautiful effects. Tempesta, using a firm line and bold tonal contrasts, created clear and striking original compositions, whatever their subject-matter. He was responsible for the 'invention' in a large proportion of the prints he pro-duced. The fertility of his visual imagination is evident not only in the scale of his output, but also in the variety of challenges he met. These vary from hunting scenes, where his own fantasy had free range, to illustrations for texts both religious and profane. The author explores the relationship between Tempesta's prints and surviving drawings to throw light on the artist's processes of invention and his preference for etching over other printmaking techniques.

Tarnya Cooper focuses upon a group of seventeenth-century drawings from the Grote Collection at University College London. These drawings are mainly copies after sixteenth-century prints, and it is likely that the collection was established in Holland during the seventeenth century and subsequently owned by a German provincial collector who settled in England. As with most collections of this period, the drawings have been removed from their original album, and thus the author compares the Grote Collection with other partially intact drawings albums in British collections. Through discussion of the form and content of the various albums, collectors' intentions are considered, with particular attention being paid to the variety of taxonomies employed. The paper establishes a range of motivations for producing and collecting copied drawings and considers the didactic role of sixteenth-century prints in the development of drawing in Northern Europe. The status of copied drawings is linked to connoisseurial concerns of authorship, authenticity and quality, and these concerns are shown to be areas appropriate to the study of the modest or provincial drawing collection.

STUART CURRIE

Acknowledgements

Special thanks are due to Francis Ames-Lewis, Diane Bilbey, Judith Bullent, Elizabeth Cowling, Eckart Marchand, Peta Motture, Julia Watson and Alan Windsor.

.

Drawing and design in late fourteenth-century France: the case for the sculptor

Julia Watson

The second half of the fourteenth century was an extremely rich period for the production of sculpture in France. Although the great Gothic cathedral enterprises had provided a prominent forum for sculptural cycles, by the fourteenth century an arena of differing character was offered by the secular world. Its great patrons, the kings, dukes and nobility of France, created new employment for sculptors, and a demand for monumental figure sculpture and decorative work. At the turn of the century, such a situation was exemplified by the cycle of statues of the kings of France commissioned for the Palais de la Cité by Philippe le Bel (1285–1314). In the second half of the century, the reigns of Jean le Bon (1350–1364), Charles V (1364–1380) and Charles VI (1380–1422) brought new building campaigns for the construction of châteaux, palaces, gateways, and chapels, and a new interest in the potential of imagery to convey power and prestige. Charles V had statues of himself and his queen, Jeanne de Bourbon, erected over the gateways to his palaces at the Louvre, the Bastille, and Vincennes, as well as at the entrance to his foundation of the Célestins in Paris. The famous ten-statue display on the Louvre staircase also featured figures of the king and queen and their two male heirs, the dukes of Anjou, Berry, Burgundy and Orléans, the Virgin and St John, and two sergeants of arms.[1]

Outside Paris, Jean de Berry's constructions included the Palais de Poitiers and the Tour Maubergeon, complete with nineteen large-scale figures; the Sainte-Chapelle at Bourges, the internal decoration of which included life-size statues of apostles, with a further five statues on the portal; and the monumental chimney-pieces of the Palais de Bourges and the Palais de Poitiers, the latter ornamented with a sculptural programme of portrait figures and angels bearing coats of arms. Similar cycles of apostles, nine worthies, and portrait figures were commissioned by the dukes of Burgundy and Orléans for chapels, château exteriors, and monumental chimney-pieces.

These portrait statues of the rulers of France linked with angels supporting the arms of France formed part of the repackaging and reaffirmation of the public image of the new Valois dynasty.

The increased demand for sculptural works was met by numerous able sculptors, many of whose names are known to us, including Guy de Dammartin, Jean de Saint-Romain, Jean de Thoiry, Jean de Liège, André Beauneveu, Jean de Cambrai, Jean de Marville, Claus Sluter, Claus de Werve, and Jacques de Baerze, to name only the most renowned today.[2] Until recently, their practice and working environment have received little attention.[3] In seeking to address such issues, this paper will present evidence from contemporary documents for the use of drawing by fourteenth-century French sculptors.

Two issues will be dealt with: the rights of the sculptor with regard to drawing and design, and the surviving evidence for the execution and employment of drawings by sculptors of the period. The first part of the paper will look at the legislation and regulations on the working practice of sculptors. The second part will present evidence for the execution and use of drawings by sculptors. It will be seen that drawing was not restricted to paper or parchment but frequently extended to execution on other surfaces, particularly plaster.

In 1391, Parisian painters and sculptors received a renewal and revision of the guild statutes controlling their métier, which had remained more or less unchanged since those of 1263 recorded by Etienne Boileau.[4] Thirty-one painters and sculptors were present at the granting of these statutes by Jean de Folleville, counsellor of Charles VI and Provost of Paris. Their names are recorded in the introduction to the statutes, where they are listed as 25 painters and six sculptors or *tailleurs d'images*, although it should be noted that some of those listed among the painters are known to have worked also as sculptors.[5] Until this time, the statutes had not referred to design, but were concerned mainly with the quality of the work and materials, and with the control of personnel. But Item 17 of the amended 1391 *Statuts des tailleurs d'images, sculpteurs, peintres et enlumineurs de la ville de Paris*, reads as follows:

That no one of the said métier should sell a piece of work to the community, such as the colleges, convents and parishes, or other works, of which the merchandise is above 100 sols or six livres, but only with a good *cirographe* or *lettres*, made of the work and of the contents, as much for carving as for painting: such a *cirographe* should be double, the *ouvrier* will have one to better make his work, and those to whom the work will belong will have the other, so that if there is dispute between the latter parties, one should pay regard to the aforesaid *cirographe* and the piece of work in order to judge and advise whether the *ouvrier* will have done his work or not, and in case that he will not have, that he should be held to do it and improve it according to the terms of the said *cirographe*.[6]

Here we have a definite indication that a contract was employed, and indeed required. Whether this included a drawing or design is unclear – it may have consisted only of a detailed description. However, the contract had to include sufficent information on both carving and polychromy for it to be compared with the completed sculpture. Whether the *cirographe* and *lettres* were alternative types of contract is unclear, but both had to be in duplicate.[7]

Further evidence is supplied in the *Statuts des tailleurs de pierre de Strasbourg* of 1459, where the only reference to design occurs in article 10:

> If a master has accepted the construction of a work and has established the design (*dessin*) according to which the work should be executed, he should not modify this earlier drawing (*tracé*). But he must execute the work according to the plan which he will have presented to the seigneurs, town or country so that the work should not be diminished or depreciated.[8]

Here the reference is to a drawing which fills the role of a contract drawing committing the stone-cutters and sculptors to an agreed design. As methods did not change greatly it is possible that, although not included in earlier statutes, the practice of executing a design with a contract was usual.

As yet I have not come across any statutory evidence to confirm the control of the design of sculptural works, and would conclude that the commissioned sculptor carried out the design as well as the work, unless asked to do otherwise, as was the case with the tomb for Louis d'Orléans. The questioning of this rather obvious working practice arises from evidence of disputes between fifteenth-century Netherlandish painters' and sculptors' guilds in which the painters frequently claimed the right to execute the design for a sculptural work as well as its polychromy.[9] It should be said that the guilds in France were weak and relatively inactive in comparison to those of Flanders, which perhaps reflects the lack of autonomous status of French towns during the period. However, in one of the documents relating to retables sculpted by Jacques de Baerze for Philippe le Hardi's foundation of the Chartreuse de Champmol at Dijon, the *certifficacion* for payment was given by Melchior Broederlam, the duke's painter, who had also been responsible for the polychromy of the sculpted retable and the painting of its wings,[10] and who, therefore, would have been in an ideal position to judge the quality of the carving. But can this be the only reason?

Although few drawings have survived from the fourteenth and early fifteenth centuries, and hardly any that are attributed to sculptors, there is a considerable amount of documentary evidence for the execution of drawings by sculptors. It should be noted that the division between masons, stone-cutters and sculptors, or *imagiers*, was not clearly defined. Guy de Dammartin, who worked as architect and *Maître général des oeuvres* for Jean, duc

de Berry, had worked previously as a sculptor, carving some of the portrait statues for the Louvre staircase, and may have continued to work as a sculptor. Secondly, it has become clear that much of the architectural sculpture (capitals, friezes, etc.) was often carved by *tailleurs de pierre*, or stonecutters, rather than by *imagiers*. However, there was a definite division between sculptors working in stone or marble and those who worked in wood. The latter were classified either as carpenters, or as *maîtres des menues oeuvres* or *menuisiers*, craftsmen who made small-scale works in wood as opposed to the carpentry of roofs and other large wooden structures.

Amongst the construction accounts for the Palais de Poitiers and the Tour Maubergeon which cover the years 1384–1395, and which survive in part, is the reference, dated 21 November 1384, to a large skin of parchment being ordered from Colas *le parchemineur* for Jehan Guerart (Guy de Dammartin's lieutenant at Poitiers) 'to portray the design of the works which Monseigneur had ordered to be made at the Tour Maubergeon'.[11] The design referred to could have been for the masonry work, details of construction or sculptural decoration.[12] The figure sculpture would have been subject to a separate study.

The largely surviving construction accounts for Philippe le Hardi's undertaking of the Chartreuse de Champmol supply several indications of the use of drawing. They document Drouet de Dammartin, who was engaged by the duke in 1383 as '*maître général des oeuvres de maçonnerie pour tous ses pays*', as working in the large room of the Hôtel de la Motte at Champmol '*a faire les traiz des ediffices et les traciés de pierres*'.[13] They also state that the masons, Perrin Gairey and Girart de Fleurey, set out a layer of very flat plaster on the floor of this upper room on which Drouet could trace his plans and working drawings for the cutting of stone.[14]

From August 1391, Jehan Baudet, the master carpenter, was installed in another large room situated in the Accounts building (*bâtiment de la Dépense*), where he made the tracing or sketch (*tracé*) of the woodcarving for the oratory. Robert de Cambrai, the master glassmaker, who supplied 'seven pieces of white glass for a panel to put in the window of the *grand salle* where Jehan Baudet was working', on 6 August 1391 paid 15 gros to 'Huguenin Lamoinier, resident of Dijon, for the making of a partial plastering in the *salle* which is above that of the Accounts of the Chartreuse . . . to make the drawings of the oratory of Monseigneur at the aforesaid Champmol'. In February 1398, sand was supplied for making a plaster for the designs (*traiz*) of the masonry and construction of the fountain for the large cloister.[15] The fountain was adorned with six over-life-size sculptures of prophets and six weeping angels, and supported a sculpted tableau of Christ on the cross flanked by figures of the Virgin, St John and the Magdalene. Claus Sluter made a *tracé* on the plaster of the ornamention of the huge hexagonal

pedestal base for this sculpted Calvary.[16] However, I have not found any indication of how these drawings were made, and it remains uncertain whether they were executed in charcoal or chalk, or whether they were incised into the plaster with a sharp tool. It is possible that the initial drawing was executed in chalk or metalpoint prior to the final design being inscribed in the plaster. The definitive design, which was fixed to the plaster, could then be transferred as needed by the sculptors. At Poitiers, a *chambre aux traiz* is referred to in an account for the supply of sand,[17] and, from the documents of Champmol, we know that sand was used in the making of plaster. In England a contemporary *trasyng hous*, or room for executing drawings, is recorded at Exeter in the fabric rolls of 1374–5.[18]

Plaster was not the only base for drawings, paper was also in use. Many of the accounts of the works conducted by Guy de Dammartin for Jean, duc de Berry refer to a *papier* on which his instructions were recorded.[19] It is unclear whether these instructions were simply written on the *papier* or whether drawings and designs were included as well. One would imagine that drawings would convey Guy's plans more precisely than a description. In the 1395–96 accounts, there is a further record of payment to Jehan Baudet, the master carpenter, for work on the *Chapelle des Anges* and the ducal Oratory: for 'which works he has made and satisfied according to his métier, exactly (*de point en point*) by the form and manner contained on a certain design and project made on paper, which, Claus Sluter, sculptor of *mondit seigneur*, has in his possession'.[20] It seems that Sluter had made a design or *croquis* on paper for the carpenter to follow. Sluter evidently supervised the execution of the work, since he was called to give the certificate of satisfactory completion. Here, for the ducal chapel at least, he was fulfilling the role, not simply of master sculptor, but of master of works of art, as he had been responsible also for the glasswork following the disappearance of the master glazier. Furthermore, Jacques de Neuilly, the master mason, was recorded as directing works according to the outline by Sluter; the latter had provided the plans of the ensemble and details of the monument, and had given the measurements to the quarrymen.[21] Thus, Sluter, sculptor and *valet de chambre* to Philippe, duke of Burgundy, seems to have been appointed as administrator of the project at Champmol, a move perhaps prompted by Drouet de Dammartin's return to Bourges, or perhaps by Sluter's own temperament and ability.

In August 1388, the carpenter *maistre* Philippe was requested by Jean de Marville to make a pair of trestles for *tresier dessus* the work for Champmol.[22] It is probable that this trestle table would have been employed for smaller drawings. It seems that a similar *table à tracer* was used for the works at Poitiers, since wood for its construction is documented as being supplied by Micheau Jadres.[23]

At Champmol, the master painter was also required to provide designs, and the duke's painter, Jean de Beaumez, is recorded as doing so for the carpenter to make moulds or models (*moles*) for the *Chapelle des Anges*. A further reference relates to the use of *patrons découpés* (cut patterns or templates) for the decorative borders and the numerous different colours, which indicates that the carpenter was making wooden templates for the painters to use in the repeated-design decoration of the chapel.[24]

An extremely valuable surviving document is the inventory of the belongings of Jean de Liège, the royal sculptor responsible for the beautifully fine tomb of Philippa of Hainaut in Westminster Abbey. Unfortunately, the inventory, taken in 1382–83 after the sculptor's death, is not detailed enough to supply us with a list of his tools. However, sculptures still in the workshop are recorded, as are unworked blocks of alabaster, Dinant marble, black marble, black *marbre d'Antony*, and stone from several quarries – *pierre de liais, pierre de Vernon, pierre de franc de Vitry*. But evidence of humbler items, the actual tools of the sculptor's trade, is limited to: 'Item, for the tools belonging to the above said métier, have been left to Robert Loisel because they are of little value',[25] and 'Item, he left his *tables à pourtraire*, [and] his tools to the assistants of his house [Robert and Regnault Loisel]'.[26] From the context these *tables à pourtraire* would seem to be drawing tables, or drawing boards.

Returning to the accounts of the Chartreuse de Champmol, one finds evidence of a contract drawing. The wood sculptor, Jean de Liège, who produced several works for the Chartreuse, was granted the contract for the 72 stalls for the church. When this work was finished, it was judged to be of such high quality, and so far superior to the design submitted with the contract, that the administrative committee of Champmol, assisted by the master sculptor and painter, Jean de Marville and Jean de Beaumez, requested that the Accounts make a supplementary payment to Jean de Liège for his outstanding work.[27] This is an unusual example of a contract working in favour of the artist in terms of guaranteed quality of work. And we know from the accounts that this contract drawing was on paper: *'desquelz ouvraiges les patrons sont toisiez en 2 cédules de papier ataichées audit marchié'*.

Evidence of a further contract drawing is revealed in the commission for the tomb of Louis d'Orléans and Valentina Visconti. The circumstances surrounding the commission and the use of the drawing are somewhat unusual. Louis was particularly attached to the order of the Célestins and went to hear mass every day at their Parisian church, which was close to the royal palace of Saint Pol. In his will he requested that he be buried in the chapel he had built there. He further requested that his tomb should be very simple, in black marble and white alabaster; that he should be depicted in death and wearing the Célestin habit; and that instead of a pillow, a stone

should serve to support his head, and another, bearing his coat of arms should be at his feet.[28] However, after Louis's assassination in 1407, Valentina, his widow, decided to order a more elaborate double tomb for her husband and herself. She selected the sculptor *Maître* Bernard Vincent, who executed the design to her supposed approval, and who may or may not have begun the work before Valentina herself died in December 1408. Responsibility for the tomb then passed to her son and heir, Charles d'Orléans.

Charles attended to the execution of the tomb according to the design agreed with Valentina, but, unusually, he refused to allow the sculptor she had selected to execute the work. He cancelled the commission to Bernard Vincent and transferred it to the royal sculptor Jean de Thoiry, whose previous works included the figure of Pierre Célestin, commissioned by Charles V for the Church of the Célestins in Paris; the tomb of Guillaume de Lestrange, archbishop of Rouen, for the Chartreuse de la Rose-Notre-Dame in Rouen; and works for the Cathedral of Arras.[29] The most obvious reason for this change of sculptor would have been the desire for a more prestigious tomb as a fitting memorial to the king's only brother, Louis d'Orléans, who, until his untimely death, had been the most powerful figure in France. Louis had been murdered by agents of the duke of Burgundy, Jean Sans Peur, an event which sparked the civil war and power struggle in France between the Armagnacs (Orléans partisans), and the Burgundians. At the time of Valentina's death, Charles was still demanding justice for the murder of his father. Consequently, the tomb had become a political object. What is extremely surprising, however, is not so much the change of commission to Jean de Thoiry, but the fact that he was obliged to execute the tomb according to the original design drawn up by Master Vincent and approved by Valentina. All that Jean de Thoiry could have offered in addition was greater skill and a renowned name, rather than a more elaborate, politically potent design. However, what is of specific interest here is that Jean de Thoiry left a description of the work, dated 26 February 1409, in which he constantly refers to the original design he had been constrained to follow:

> [He] confesses to have made an agreement with the noble and excellent prince Monseigneur Duc d'Orléans, to make well . . . the tomb of the deceased very noble and of excellent memory monseigneur the duc and madame the duchesse d'Orléans, lately departed, . . . by the form and manner hereafter declared, and which is furthermore clearly traced on certain parchment.[30]

Jean de Thoiry described the design, which comprised the tomb chest of black Dinant marble, the pillars, bases, responds and tabernacles of fine Pisan (Italian) alabaster, the alabaster figures of apostles or prophets to be placed in the tabernacles, the two alabaster effigies of the duke and duchess

enriched with gilded metalwork and precious stones, with their feet resting on an alabaster lion and a dog, and the alabaster image of Abraham holding the two souls. The tomb was decorated further with the coats of arms of the duke and duchess, and gilding of the leaves, finials, borders and hems. Each of the ten items of the contract was described and qualified with the phrase *'par la manière tracée sur le dit parchemin'* or *'ainsi qu'il est tracée sur le parchemin'*. Thus the phrase is repeated on a total of ten occasions.[31]

This contract drawing was clearly very detailed, but lacked certain items of information, so Jean de Thoiry had to consult the Duchess's metalworker for information on her coat of arms. The tomb was placed in the Orléans chapel at the church of the Célestins, but for some reason it did not survive long, nor was Valentina ever buried in it, since, in 1502, Louis XII ordered a new tomb for four of his ancestors, and had the body of Valentina brought from Blois, where she had been interred in the church of the Cordeliers.

A final puzzle concerns the first sculptor, Bernard Vincent. He has been considered a little-known, local sculptor whom Valentina had encountered while resident at her palace at Blois. But Vincent turns out to have been much more important. From 1407, he succeeded Arnoult de Luilly as Louis d'Orléans's *maître des oeuvres* at Blois, Dunois, and Orléans. In a *certificat de travaux* of November 1407, he was referred to as *Bernard Vincent, maistre des oeuvres de maçonnerie de Monseigneur le duc oudit duchié*.[32]

The documentary evidence presented in this paper reveals a variety of references to the use of drawing by sculptors working in fourteenth-century France. However, although I have been able to trace a certain amount of evidence for the execution of drawings by sculptors for the period, information on small-scale drawing has so far eluded me. An exception is the small sketch of a head which accompanies the signature of Claus de Werve, master sculptor of Jean Sans Peur and Philippe le Bon of Burgundy, and nephew of Claus Sluter, on a request for a reduction in taxes of 1422.[33] We have evidence for the creation of models, but not for the drawing of single figures, details of foliage or animal decoration. It could be argued that this function was served by models, which had the advantage of being three-dimensional, and that two-dimensional drawings were employed solely to convey the design of ensembles, although this seems unlikely. However, such possibilities will remain unresolved until further evidence comes to light. It is not impossible that surviving sketches by sculptors of the period have been attributed to painters, but only further research will tell.

Frequently cited literature

Monget, C., (1898–1905), *La Chartreuse de Champmol*, 3 vols, Montreuil-sur-Mer; Magne, L., (1904), *Le Palais de Justice de Poitiers*, Poitiers.

Notes

1. Sauval, H., (1724), *Histoire et recherches des antiquités de la ville de Paris*, 3 vols, Paris: **2**, p. 23. The statues of the staircase were sculpted between 1364 and 1368 by Jean de Saint-Romain, Jean de Liège, Guy de Dammartin, Jacques de Chartres and Jean de Launay. Sauval's claim that Charles V's sons were included has generally been ignored. While it is true that they were not born until after the main work had been executed (in 1368 and 1372), it is not impossible that their statues were added later.

2. For biographies of these sculptors, see Beaulieu, M., (1992), *Dictionnaire des sculpteurs français du moyen âge*, Paris.

3. I address this question in my Ph.D thesis, *Patrons and Sculptors in Fourteenth-Century France, c.1350–1420*, University of Leicester (in progress).

4. The statutes are published in de Lespinasse, R. and Bonnardot, F., (1879), *Histoire Générale de Paris: Les mètiers et corporations de la ville de Paris*, Paris.

5. The artists present at the granting of the statutes were: '*maistres* Jean Dorleans, Estienne Lenglier, Colart de Laon, Jean de Thory, Jean de Saint-Romain, Thomas Privé, Jean Normandie, Robert Loizel, Adam Petit, Imbert le Lorain, Jean Girelay, Roger Darnult, Jean Viterne, Gilles Mennessé, Perrin Moitteur, Jean Parisot, Jean Bervage, Guillaume Loyseau, Nicaise le Privé, Jean de Saint-Lucien, Georges Baudoin, Estienne Naquet, Simon du Molin, Robert Bourion, Girard de Beaumeteau, *peintres*, and Philippe Cochon, Jean Petit le jeune, Gilbert du Perrier, Hulet le Rantier, Guillaume de Saint-Lucien, *tailleurs d'images'*. See Leber, C., (1838), *Statuts des tailleurs d'images, sculpteurs, peintres et enlumineurs de la ville de Paris; Collection des meilleurs dissertations, notices et traités particuliers relatifs à l'histoire de France*, 20 vols, Paris: **19**, pp. 450–8.

6. '17. *Item*. Que nul dudit mestier ne marchande de besogne touchant communauté, comme colleges, couvent et paroisses, ou autres besognes, dont la marchandise monte au dessus de cent sols ou de six livres, ce ainsi n'est que bon cirographe ou lettres ne soient faites du marché et du contenu tant de taille comme de peinture: lequel cirographe soit double, l'ouvrier aura l'un pour mieux faire son devoir, et ceux à qui la besogne sera auront l'autre, afin que si débat y avoit entre les dernieres parties, que l'on eust égard audit cirographe, et la besogne pour juger et aviser si l'ouvrier aura fait son devoir ou non, et au cas qu'il ne l'auroit fait, qu'il fust tenu de le faire et amander selon la teneur dudit cirographe'. See Leber 1838, *op. cit.* at n. 5, pp. 450–8.

7. Later a *cirographe* came to mean a contract in duplicate or a piece bearing a signature, as in English.

8. 'Si un maître a accepté la construction d'un ouvrage et qu'il en a établi le dessin tel que l'oeuvre doit être exécutée, il ne doit pas modifier ce tracé primitif. Mais il doit exécuter l'ouvrage selon le plan qu'il aura présenté aux seigneurs, villes ou pays afin que l'oeuvre ne soit pas diminuée ou dépréciée'. Schimpf, A., trans., (1989), 'Statuts des tailleurs de pierre de Strasbourg, 1459', in Recht, R., ed., *Les bâtisseurs des cathédrales gothiques*, Strasbourg: pp. 103–9.

9. See Campbell, L., (1976), 'The Art Market in the Southern Netherlands in the Fifteenth Century', *Burlington Magazine*, **118**, pp. 188–98.

10. 'A Maistre Jaques du Bars, entailleur d'ymaiges demourant à Theuremonde, pour don à luy fait par Mons[gr], pour récompense de plusieurs mises et despens qu'il a eues et soustenues pour avoir fait par l'ordenance de mondit seigneur, mener deux tables d'autel qu'il avoit faites pour l'esglise des Chartreux de delez Dijon, dudit Theuremonde audit Dijon – Mand. donné à Corbeil 12 d'ottobre 1392 et quittance de luy, et sur ce certifficacion de Melchior Broederlam, paintre de mondit seigneur 140 frans'. Dijon, Archives départementales de la Côte d'Or, B. 1495, fol. 51r. See Monget 1898–1905, **1**, p. 202.

11. 'A Colas le parchemineur pour une grant peau de parchemin baillée à Jehan Guerart pour pourtraire la devise des euvres que Mons[gr] a ordenné fere en la tour de Maubergeon po ce . . . xx d.' Paris, Archives nationales, KK 256, fol. 28r. See Magne 1904, p. 52.

12. From coats of arms on two of the consoles, two of the missing figures represented Jean de Berry and Jeanne de Boulogne. A document of 1443 identified the other figures as the seven *vicontes* and other lords of Poitou: '*à l'entour fist eriger les statuez en pierre desd. sept vicontés et d'autres grans seigneuries tenues de lad. tour en foy et homage'*. Archives nationales, X[1a] 4798. fol. 279v, published by Favreau, R., (1966), 'Les maîtres des oeuvres du roi en Poitou au XVe siècle', in Gallais, P. and Riou, Y.-J., eds, *Mélanges offerts à René Crozet*, Paris: **2**, pp. 1359–66 (esp. p.1362).

13. Monget 1898–1905, **1**, p. 25.

14. *Ibid.*, p. 30.

15. 'A Thevenin Blonde, voiturier, demorant à Dijon, pour 16 journées de ses char et tumbereau à 4 chevaulx, faites au charroier sablon pour faire un plastre, pour faire et getier sur ycellui, les traiz pour la maçonnerie et façon de la fontaine estant ou milieu du grant cloistre desdiz Chartreux . . . 25 fevrier 1398'. See Monget 1898–1905, **1**, p. 314.

16. Huguenin Lavoignier, the plasterer, spent three days 'à niveler la place pour faire les traiz par Claux, pour la fontaine que l'on fait au grant cloistre – 13 octobre 1398'. See Monget 1898–1905, **1**, p. 298.

17. 'A Jehan Demone et a Jehan Sidonnie qui pour les dictes oeuvres ont la dicte sepmaine livre cest assavoir le dit demons xij tumbelles de sablon de riviere a ij s. vi d. la tumbellee pour la chambre aus traiz. Et le dit Sidonnie xvij tumbellees de sable roge aupris de xv d. la tumbelleree pour ses deux parties lj s. iiij d.t. Pour ce . . . lj s.iiij d.t. En la sepmaine . . . lundi'. (9 February 1399). Paris, Bibliothèque nationale, MS fr. 20686, fol. 45v.

18. 'Custos nove domus in Calendarhay vocate "trasyng hous", 9 l. 19 s. 7 d.'. See Andrews, F.B., (1992), *The Medieval Builder and his Methods*, New York: p. 81.

19. 'Pour les iournées de plusr* tailheurs de pierre qui ont ouvré . . . pour le fait de la tailhe de la cheminée du pavillon dudit chastel de Poitiers les parties contenues ou papier dudit maistre Guy, maistre des dictes euvres signées de sa main en la fin de chune sepmaine pour ce . . . xv l. xviii s. iiii d.'. Paris, Archives nationales, KK 257, fol. 49r; see Magne 1904, p. 87; and an entry dated the week of 12 January 1386 (n.s.) 'Pour les jornées de plusieurs tailleurs de pierre et macons qui ont ouvré en la dicte sepmaine pour le fait de la tour de Maubergeon, les parties contenues ou papier de maistre Guy, maistre des dictes oeuvres signées de sa main ou la fin de chune sepmaine'. Paris, Archives nationales, KK. 257b, fol. 3r; see Magne 1904, p. 72.

20. 'A Jehan Baudet . . . pour le demourant de certaine grosse somme d'argent, à quoy plusieurs des gens de Mons*r avoient marchandé audit Jehan de faire l'ouvraige de charpentere de l'oratoire de la chapelle haulte, avec le housseys de bois d'Illande de la Chapelle basse de mondit seigneur appelée la Chapelle aux Angelles, audit Champmol, lesquels ouvraiges il a faiz et assouvis de son mestier, de point en point, par la forme et manière contenue en un certaine pourtrait et giet fait en papier, lequel, Claux Slustre ouvrier d'ymagerie de mondit seigneur a devers soy. Paié a luy par sa quittance en la fin de laquelle la certifficacion dudit Claux donnée le 8ᵉ jour de mars 1396 est contenue . . . 20 frans'. See Monget 1898–1905, **1**, p. 223.

21. *Ibid.*, p. 274.

22. 'une paire de tretteaux pour tresier dessus les ouvraiges qui fait pour lesdiz chartreux – 10 aôut 1388'. See Monget 1898–1905, **1**, p. 149.

23. 'A Micheau de Jadres pour vij ais de nouher neccesaires pour fere une table à tracer les dictes besoignes et ont chune ais x piez de long et deux de large pour chune ais xij s.' Paris, Archives nationales, KK 256, fol. 39r; see Magne 1904, p. 56.

24. '. . . découper des moles pour la chapelle des Angeles à la devise de Beaumez'. See Monget 1898–1905, **1**, p. 248.

25. 'Item, pour les outiex appartenant au mestier dessusdit, ont este laissé à Robert Loisel pour ce qu'il estoient de petite valeur'. Vidier, A., (1903), 'Un tombier liégeois à Paris au XIVᵉ siècle', *Mémoires de la Société de l'Histoire de Paris et de l'Ile de France*, **30**, pp. 281–308 (esp. p. 299).

26. 'Item, il laissa ses tables à pourtraire, ses outiex aux compaignons vallés de son hostel'. *Ibid.*, p. 303.

27. 'A luy (Jehan de Liège) lesquelz les gens du Conseil de Mons*r estans en sa Chambre des Comptes à Dijon luy ont ordenez avoir par l'avis dudit Conseil présents Maistre Dreuhe Felise, Amiot Arnault, Dom Raoul Caille, procureur desdiz Chartreux – pour l'ouvraige qu'il a fait ès dit chaières, de l'ordenance de Mons*r duquel ouvrage Jehan de Fenain charpentier, avait marchandé par avant de les faire et assouvir, comme plus à plain peut apparoir par une cédule de pappier faitte 3 de juillet 1387, desquelz ouvraiges les patrons sont toisiez en 2 cédules de papier ataichées audit marchié. Pour ce, paié à luy oultre le pris dont il avoit marchandé par vertu des diz patrons, et par l'avis des dessus diz, escript en la fin dudit marchié, donné en ladite Chambre des Comptes le 16ᵉ jour de novembre 1388 ainsi que la relation des ouvriers en ce cognoisseurs, c'est assavoir de Jehan de Marville, de Beaumetz et d'autres, et quittance faitte de décembre audit an . . . 100 frans'. See Monget 1898–1905, **1**, p. 145. For the contract, see Dijon, Archives départementales de la Côte d'Or, B. 11671, fol. 189v.

28. 'Je veux et ordonne que la remembrance de mon visage et de mes mains soit faite sur ma tombe en guise de morte, et soit madite remembrance vestue de l'habit desdits religieux celestins, ayant dessous la teste au lieu d'oreiller une rude pierre en guise et manière d'une roche, et aux pieds au lieu de lyons ou d'autres bestes une autre rude roche, semée ou couverte de mes armes: et veux et ordonne que madite tombe ou sepulture ne soit que de trois doigts de haut sur terre, et soit faite icelle tombe de marbre noir eslevée, et d'albastre blanc es lieux qu'il appartient, et que je tienne en mes mains un livre, auquel soit escrit le Psaume: *quicumque vult* . . . et autour de madite tombe soit escrit le *Pater noster* et l'*Ave Maria*, et le *Credo* grand et petit, en lettres d'or: et dessous ladite roche de mes armes, soit escrit mon nom et tiltres, et le jour de mon trespas, comme il est accoustumé en tel cas'. See Godefroy, D., (1653), *Histoire de Charles VI, roy de France*, Paris: p. 633 and Erlande-Brandenburg, A., (1972), 'Jean de Thoiry, sculpteur de Charles V, *Journal des Savantes*, pp. 210–27, n. 29.

29. See Erlande-Brandenburg 1972, *op. cit.* at n. 28, pp. 212–3.

30. Paris, Bibliothèque nationale, MS nouv. acq. fr. 3640, n. 520, published by Graves, F.-M., (1913), *Pièces relatives à la vie de Louis 1ᵉʳ, duc d'Orléans et de Valentine Visconti sa femme*, Paris: pp. 253–5.

31. *Ibid.*

32. The connection between Bernard Vincent, *maitre des oeuvres* of Louis d'Orléans and *Maistre* Vincent of the tomb commission has not previously been made. For his work for Louis d'Orléans, see Mesqui, J. and Ribéra-Pervillé, C., (1980), 'Les Châteaux de Louis d'Orléans et leurs architects (1391–1407)', *Bulletin Monumental*, **138**, pp. 293–345 (esp. p. 300, n. 43).

33. Archives de la ville de Dijon, L.639. A reproduction is included in Quarré, P., ed., (1976), *Claux de Werve, imagier des ducs de Bourgogne*, exh. cat., Dijon (Musée des Beaux-arts): p. 20; and Morand, K., (1991), *Claus Sluter, Artist at the Court of Burgundy*, London: p. 159.

Imitation, invention or good business sense? The use of drawings in a group of fifteenth-century French Books of Hours

Susie Nash

In the world of the fifteenth-century artist, patterns and drawings were important and valuable commodities. They were jealously guarded and coveted. When they were stolen, it was a serious matter, and recompense for the loss, even if temporary, and punishment for the thief, were sought. When in 1398 Jean de Hollande accused Jacquemart de Hesdin, an illuminator in the service of Jean de Berry, of stealing his drawings, the dispute ended in murder.[1] The famous quarrel between the painters Ambrosius Benson and Gerard David which resulted in a lengthy law-suit in Bruges in 1519–20 was in part over David refusing to hand back drawings specified as for paintings and miniatures, 'a sketchbook full of heads and nudes', and several pattern drawings which belonged to him but which had originally come from Adrien Isenbrant, all of which Benson had left in David's workshop.[2]

For the manuscript illuminator the relationship between model and finished work was particularly close. Since compositions and figures could easily be planned and drawn on the same scale as the final painted versions there was no need for the intermediate stage of enlargement usually required for panel or wall paintings. Moreover, since parchment was a regularly used support for drawing, the finished product and the drawn model would frequently have been produced on the same material. Parchment was also used as tracing paper: Cennino Cennini describes how this material, scraped very thin, could be used as a medium for copying since it was 'transparent of itself'.[3] The inherent translucency of the surface on which illuminators worked meant that direct tracing from drawings offered itself as a labour-saving device. The support's transparency was certainly exploited in the production of illuminated manuscript borders, with designs often traced from recto to verso.[4] This technique also provided an aesthetically pleasing result since it avoided the unsightly effects of the decoration on the recto bleeding through and spoiling that on the verso. In addition, the growing

demand in the fifteenth century for illuminated books, especially the Book of Hours, aptly described by Delaissé as the 'medieval bestseller',[5] encouraged the extensive use of drawn models to speed up production. Some idea of the size of this growing demand can be gained from statistics regarding the number of printed *Horae* for sale in the sixteenth century. In 1545, for example, the Parisian *libraire* Guillaume Godard had 263 696 books of which 148 717 – well over half – were Books of Hours.[6] Although the cheapness of printing had naturally expanded the market, the tendency in the fifteenth century towards the mass production of manuscripts meant that many illuminators were working in a systematized industry, where the necessity for the speedy production of well-illustrated books increased reliance on a set of patterns.

The aim of this brief study is to examine some of the ways in which pattern drawings were used by a group of these commercially-oriented illuminators, and to consider the artistic consequences of the methods the painters employed. However, few illuminators' drawings or model-books from Northern Europe survive.[7] Drawings were working materials, so many may simply have disintegrated with use, while others probably became useless when styles changed, and were finally discarded as old-fashioned.[8] Many of the fragments of model-books which have come down to us were produced on hardy materials like boxwood.[9] From their layout and form these can tell us something about how the drawings in them were used, although their very survival marks them as exceptional – either in their degree of finish or in their artistic merit. Moreover, since painters also worked as illuminators, it is sometimes difficult and not always desirable to distinguish between drawings for miniatures and those for paintings.[10]

However, information regarding the use of drawings by manuscript illuminators can be gleaned from the finished product. Some groups of manuscripts have very closely related decoration. This is particularly so with Books of Hours, in which the iconographic programme was fairly standard and points to production from a common set of drawn or painted models. Also, the appearance and reappearance of compositions, figures and motifs, permits hypotheses on the form and function of these models.

The manuscripts considered here are a group of closely interrelated Books of Hours produced in Amiens during the second quarter of the fifteenth century.[11] Amiens was a cosmopolitan centre at that period. Due to its geographical, political and economic importance, it played a central role in the Hundred Years War, during which noblemen and dignitaries from all over Europe met within its walls. From around 1420, artists began to migrate there from Paris, to escape the turmoil caused by the Burgundian-Armagnac feud and the capture of Paris by the English. Between 1435 and 1461, the city was part of the Burgundian Netherlands and artists also came in some

numbers from that region.[12] During this relatively peaceful period, manu-
script illumination flourished, with considerable demand from both the local
bourgeois and the Picard nobility, most of whom were partisans of the
Burgundian dukes.[13]

One of the first things that is apparent from this group of Amiénois
miniatures is the dependence on models, which were often reproduced in a
very exact manner, possibly on occasion with some mechanical means of
transfer. This can be seen from a comparison of two miniatures of the *Mass of
St Gregory*, one in a manuscript now in the British Library, London (BL Add.
MS. 31835; Figure 2.1), and the other in a manuscript at Waddesdon Manor
(MS. 6; Figure 2.2). While the settings of the images are different, with one
painter opting for a more realistic interior, the figures match each other
virtually line for line.[14] Significantly, the measurements of the figures in the
two manuscripts are identical, which is unlikely to have been achieved by
free-hand rendering. However, although the use of tracing by illuminators
has been suggested in the literature, it has been neither proven nor generally
accepted.[15] Here, nonetheless, the case for the use of such a technique seems
strong. Moreover, unfinished miniatures often show that the initial drawing
concentrated on outlines rather than on the subtleties of modelling or
shading.[16] Where the drawing is visible in the Amiens group of manuscripts,
either where it can be seen through the paint layer, or where it overlaps the
miniature's frame, it appears to be of a similar type, revealing a very
carefully described outline, especially for the figures, which is in keeping
with the reproduction or tracing of a model rather than with the spontaneity
associated with a freehand sketch.

A comparison of the two *Mass of St Gregory* miniatures indicates that
although the underdrawing may have been minimal and essentially linear,
the model from which the illuminators were working was probably more
fully fleshed out. It must have been fairly detailed, since the exact patterning
on the saint's vestments and on the altar frontal is repeated in both images.
It also seems probable that the model was either coloured or had colour
notations, since there are exact correspondences between the colours used in
both miniatures. A coloured model would have been time-consuming and
more costly to produce than a notated drawing, but notations could interfere
with the legibility and detail of the model.[17] There is some evidence to
suggest that the Amiénois illuminators were working from a fully painted
exemplar: the style of the Waddesdon *Mass of St Gregory* is slightly different
from that found in the rest of the manuscript, with the figures' faces being
more fully modelled. This may suggest a different hand, but might also
imply that the miniaturist was responding to a painted model.[18] It is unlikely
that the painted model was the London miniature itself which, from the style
of its borders, probably pre-dates by some years the majority of the images in

the Waddesdon Hours. In a commercial industry it is unlikely that the manuscript would have been available several years later for the Waddesdon painter to copy. Books could of course enter or return to the book-producer's stock, if only briefly, to be revamped or embellished, and this would often have been the point at which drawings were made and disseminated.[19] Whatever the case, it is clear that more than just the outlines of a drawing were being followed.

Since the *Mass of St Gregory* miniatures correspond closely in the central figure group, but vary in their background detail, it might be supposed that the illuminator's patterns were primarily figurative. The figures, after all, were the most difficult parts, and the parts for which drawn models would have been most needed. However, it is apparent that the patterns employed by illuminators included far more than simply the major figurative elements. This can be seen from a comparison of sets of almost identical calendar miniatures which appear in two of the manuscripts from the Amiens group dating perhaps as much as fifteen years apart.[20] These examples indicate that models for the complete illumination existed, that they were planned for specific miniature formats and shapes, and that they included landscape and architectural details. That the illuminators were often working very closely from sets of patterns for complete cycles of miniatures, and not just from drawings for particular figures or types, is further shown in the miniatures accompanying the Hours of the Virgin in three different *Horae*, now in Cambridge (Fitzwilliam Museum, MS. 66), Paris (Bibliothèque Nationale, MS. lat. 13308), and Brussels (Bibliothèque Royale, MS. 10774).[21] Seven of the eight miniatures illustrating this office in the Paris manuscript, and five of the eight in the Brussels Hours, are direct copies of prototypes found in the more accomplished, presumably earlier, exemplar at Cambridge. Although patterned backdrops sometimes replace landscape settings, and more taxing details are occasionally omitted, in most respects the models have been repeated with exactitude. This precise emulation includes the architectural settings, which are designed to fit the round-topped miniature format. The measurements of the figures also match closely, which might again suggest that some form of mechanical transfer had been employed. However, there are occasional variations in the drawings, which would seem to suggest a very careful manual reproduction. It seems probable that the set of models being used were again in colour, as all the surviving versions follow an almost identical colour scheme.

The use of complete maquettes for cycles of miniatures may have been taken one step further by the Amiens group of illuminators. Two folios, one from the Waddesdon Hours and the other a single leaf sold at Sotheby's in London (25 April 1983, lot 112), are virtually identical, not only in the miniatures, but also in the borders.[22] This points to the existence of a design

for the whole page but is also an isolated example among the group of manuscripts, since border designs were usually invented from a combination of stock motifs which were sometimes traced, but which were often variations on a standard format. Such flexibility in the borders would have been important since the density of the painted elements in a border might have depended upon cost and available time. In addition, division of labour meant that the borders were not always painted by the miniaturist, but more often by an illuminator who specialized in such work and who may have been working from different models consisting solely of border motifs.[23]

Of course, the exact reproduction of an entire drawn model within an allotted miniature slot was not always possible. A given miniature may have been larger or smaller than the standard size; or perhaps the price the patron was willing to pay, or at which a book was to be sold, may not have allowed for as much detail or as large a cast of characters as the model might have contained. Such problems could be solved without serious inconvenience, but not always without sacrificing artistic effect. For example, the model employed for the *Presentation in the Temple* in a Book of Hours previously at Upholland College and sold most recently at Sotheby's, London (5 December 1994, lot 94; Figure 2.3), was reused in an *Horae* made before 1439 for Hughes de Cayeu, Bishop of Arras, (Cambridge, Fitzwilliam Museum, McClean MS 77; Figure 2.4). The Cayeu manuscript was a more splendid production than the Upholland book, having larger miniatures, more extensive decoration and a more expensive type of script. Nevertheless, rather than design a new composition on a larger scale in order to fill the enlarged format, the setting was simply expanded and the figures set further away from each other. Such a decision reduced the effectiveness of the image, making it less focused and less compelling than the Upholland version. Due to the horizontal expansion of the Cayeu composition (which is 6.5 cm wide as opposed to 5.8 cm for the Upholland miniature), the figures are now more awkwardly spaced and fail to come into dramatic contact: gazes no longer meet, and gestures are less intimate. Moreover, in trying to expand the space vertically, the painter of the Cayeu miniature has made nonsense of the structure of the vaulted room. Similarly unhappy effects were also sometimes the result of cutting the cast of characters. The model behind a *Crucifixion* in a manuscript in Arras (Bibliothèque Municipale, MS. 540, fol. 107) was at least partly reused by a less skilful imitator in a book now in Paris (Bibliothèque Nationale, MS. lat 13308, fol. 124). In the Arras book, St John supports the Virgin while she swoons, but in the Paris version, the Virgin stands alone, the reduced composition rendering her pose and gesture inexplicable and somewhat perplexing.

This precisely imitative use of drawings could clearly be detrimental to creative, meaningful composition. And, although the speed at which it was

possible to produce such illuminations made good business sense, mechanical reproduction, while a handy and effective tool, was not always desirable. The more talented and ambitious artists and a more discerning clientele would not accept the aesthetically compromised artistic results produced by constant repetition. Good business sense also demanded that illuminated books be attractive, saleable and, on occasion, varied according to the wishes of a particular patron. The more resourceful artists of the Amiens group still relied on model drawings, but adapted them in ways which often produced lively, effective and occasionally surprising compositions, more quickly and with less effort than would have been the case had they been concerned with more outright invention. The imaginative illuminator could adapt parts of one drawing for use in a miniature of a totally different subject. This happened, for example, with the architectural setting featuring an open loggia, a vaulted roof and traceried windows in the *Pentecost* miniature of a Book of Hours made in Amiens around 1420, now in Baltimore (Walters Art Gallery, MS. 281, fol. 155), which was redeployed some twenty years later as a suitable setting for the *Presentation in the Temple* in a luxurious book now in Philadelphia, (Philip S. Collins Collection, Philadelphia Museum of Art, MS. 45–65-4, fol. 83v) made by an Amiénois artist, probably in Bruges or Tournai.[24]

Similarly, figures designed for one context could be adapted for service in another. Changing the identity of saints by adding different attributes, and varying the compositions by reversing the models, were common practices.[25] The kneeling Virgin of the *Annunciation* in the Book of Hours at Cambridge (MS. 66; fol. 22)[26] was reversed, either by tracing or by copying the back of the drawing, for a composition of the *Pietà* (Figure 2.5) in the Hours of Raoul d'Ailly, with only minor alterations needed to show her sitting rather than kneeling. This adaptation created a type of *Pietà* which departs distinctly from the standard iconography wherein the Virgin holds Christ on her lap. The new image is a successful invention which stresses the isolation of the Virgin and allows the praying observer to imitate her attitude before the body of Christ while saying the *Salve Mater Dolorosa* which this image heads.

Just as this *Pietà* was created by a resourceful adaptation of a model, drawings from it or for it were in turn used in a dramatically different context to create another powerful, if somewhat unorthodox image. In the Waddesdon Hours, the d'Ailly *Pietà* figure of Christ reappears as a corpse in a scene of a *Burial in a Churchyard* which heads the text of the Office of the Dead (Figure 2.6).[27] The figure was clearly mechanically transferred, since not only do the lines of the body and the shroud correspond directly, but the measurements of the two figures also match exactly. In using this model for the new miniature, and in tracing it rather than rendering it freehand from

the source, the illuminator created considerable problems for himself, since the Waddesdon Hours miniatures are narrower than those of the d'Ailly Hours. Therefore, to fit the model to the miniature, the artist had to turn it at an angle, but even then it remains disproportionately large and out of scale with both the setting and the additional figures of the priest and attendant. Almost by accident, it seems, these incongruities have resulted in a dramatic and memorable image, if one with slightly dubious iconographical associations, since, although lacking the wounds, the corpse is instantly recognizable as Christ, from the long stringy hair.

Consideration of this miniature without knowledge of the pragmatic methods used to produce it might have tempted speculation as to its meaning. A less effective image with far more dubious iconographical connotations was created in a similar way in another contemporary *Pietà*, probably from the Brittany region (Rennes, Bibliothèque Municipale, MS. 1277),[28] in which the type of corpse used for Christ would perhaps have been more appropriate for the Waddesdon burial miniature. Aside from the added wounds, there is nothing about the facial features to indicate that the figure is Christ, while the body's rather shrunken form suggests that decomposition has begun.

The adaptation of drawings from one context to another in a manner that displays invention and resourcefulness is seen again in a miniature of *St Margaret* (Figure 2.7) from an Amiens manuscript of around 1440, now in Baltimore (Walters Art Gallery, MS. 262). The action of the saint as she emerges from the dragon is unusual. She is shown blessing and simultaneously stabbing the beast, whereas normal iconographic practice depicted her praying, often looking heavenwards.[29] The more active pose of the virgin saint in the Walters manuscript has considerable similarities to that of the resurrected Christ stepping from the tomb, and her face has a rather ambivalent and not overly feminine quality, while she also lacks the long flowing locks found in all other depictions of virgin saints by this artist and his associates. But why adapt a drawing from such a wildly different context? The reason cannot have been solely to save time and labour but may perhaps have been for the sake of variety, or for artistic effect. St Margaret was often depicted in Books of Hours as a protectress against the hazards of childbirth, so it was likely that a pattern drawing of her in a more conventional attitude would have existed. But through use of a model created for a different context, the figure of the saint is given a more dynamic appearance, and the resultant image may be seen as an iconographic invention.[30]

By mixing and matching figures and settings, the more talented illuminators from the Amiens group were able to create inventive and original solutions to artistic problems, while still meeting the demands for speed in commercial book production. The hypothetical collection of patterns posited

in this paper, which would have contained drawings of figures and their settings with strong outlines to facilitate tracing, painted or at least colour-notated models with carefully reproduced decorative details, and possibly designs for the whole miniature page, would have catered for the needs of the Amiens group of illuminators as they responded to such demands.

Frequently cited literature

Nash, S., (1997), *Between France and Flanders: Manuscript Illumination in Amiens in the Fifteenth Century*, British Library Studies in Medieval Culture, London and Toronto.

Notes

1. Meiss, M., (1967), *French Painting at the time of Jean de Berry: The Late Fourteenth Century and the Patronage of the Duke*, London: p. 226.

2. For this dispute, see Marlier, G., (1957), *Ambrosius Benson et la peinture. Bruges au temps de Charles–Quint*, Damme: pp. 15–9, 41–2; and Ainsworth, M., (1993), 'Gérard David's Workshop Practices, an Overview', in van Schoute, H. and Verougstraete-Marcq, H., eds., *Le dessin sous-jacent dans la peinture, Colloque IX, 12–14 septembre 1991. Dessin sous–jacent et pratiques d'atelier*, Louvain-la-Neuve: pp. 11–12.

3. Cennini, C., ed. and trans., Thompson, D.V., (1960), *Il Libro dell'Arte (The Craftsman's Handbook)* New York: p. 13, chap. XXIV, 'The First Way to Learn How to Make a Clear Tracing Paper'.

4. Ross, D.J.A., (1962), 'An Illuminator's Labour-saving Device', *Scriptorium*, **16**, pp. 94–5.

5. Delaissé, L.M.J., (1974), 'The Importance of Books of Hours for the History of the Medieval Book', in McCraken, U., Randall, L.M.C. and Randall jr, H., eds, *Gatherings in Honor of Dorothy Miner*, Baltimore: pp. 203–25.

6. Labarre, A., (1971), *Le livre dans la vie amiénoise du seizième siècle. L'enseignement des inventaires aprés décès 1503–1576*, Paris: pp. 166–7.

7. For surviving examples see Scheller, R.W., (1963), *A Survey of Medieval Model Books*, Haarlem; and *ibid.* (1995), *Exemplum. Model-book Drawings and the Practice of Artistic Transmission in the Middle Ages (ca. 900–ca. 1470)*, Amsterdam.

8. A rare example of the desire to preserve drawings at an early date may be seen in a manuscript in Wiesbaden (Hauptstaatsarchiv, MS. 3004 B 10), which is a collection of texts with drawings pasted in. These drawings were clearly collected from various sources and date from c.1380–1410 when the miscellany was finished; see Renger, M.O., (1987), 'The Wiesbaden Drawings', *Master Drawings*, **25**, pp. 390–410.

9. For example, the model-book of c.1380–1400 attributed to Jacquemart de Hesdin in the Pierpont Morgan Library, New York, and the 'Jacques Daliwe' model-book of c.1400–1420 in the Staatsbibliothek, Berlin; the Bohemian model-book of c.1400 in Vienna, Kunsthistorisches Museum, is on maplewood. For these, see Scheller 1995, *op. cit.* at n. 7, pp. 218–40.

10. Some individual drawings can be identified as specifically for illumination through their subject matter or layout, for example the design for a page attributed to the Master of Mary of Burgundy; see Pächt, O., (1948), *The Master of Mary of Burgundy*, London: p. 70 ff.

11. These manuscripts and others associated with the town are studied in Nash 1997. For further details and references concerning the manuscripts discussed in this paper, the reader is referred to that publication.

12. Nash, S., (1995), 'Some Relationships between Flemish Painting and Illumination in Amiens c. 1400–1460', in Smeyers M. and Cardon, B., eds, *Flanders in a European Perspective. Manuscript Illumination around 1400 in Flanders and Abroad* (Proceedings of the International Colloquium, Leuven, 7–10 September 1993), Leuven: pp. 541–57.

13. For an assessment of the demand for manuscripts in Amiens at this period, see Nash 1997, chap. 1.

14. A relationship between these two compositions was noted by J. Backhouse, in a communication cited by Sterling, C., (1981), 'Un nouveau tableau de Simon Marmion', *Revue d'art canadien/ Canadian Art Review*, 8, p. 16, n. 42.

15. Farquhar, J.D., (1976), *Creation and Imitation: The Work of a Fifteenth-century Manuscript Illuminator*, Fort Lauderdale: pp. 61–72. See also Alexander, J.J.G., (1992), *Medieval Illuminators and Their Methods of Work*, New Haven and London.

16. For a selection of unfinished manuscripts and manuscripts with preparatory drawings left visible, see Alexander 1992, *op. cit.* at n. 15, pp. 38–41, 184–6, and esp. figs 57 and 60–4.

17. Notated drawings would have had even less artistic value to collectors and their almost total demise is unsurprising. A rare surviving example of such an illuminator's notated model is to be seen in a mid-fourteenth-century drawing in Paris (Bibliothèque Sainte Geneviève, MS. 1624), which is illustrated and discussed in Alexander 1992, *op. cit.* at n. 15, pp. 45–7.

18. The extent to which models could influence the technique and the style of the copyist is referred to by Farquhar 1976, *op. cit.* at n. 15, pp. 49–50, and further explored with regard to a manuscript associated with the Gold Scrolls group by Gifford, E.M., (1987), 'Pattern and Style in a Flemish Book of Hours: Walters MS. 239', *Journal of the Walters Art Gallery*, **45**, pp. 89–102.

19. The Waddesdon Book was certainly revamped in an extensive way; see Delaissé, L.M.J., Marrow, J. and de Wit, J., (1977), *The James A. de Rothschild Collection at Waddesdon Manor: Illuminated Manuscripts*, London and Fribourg: pp. 119–26. The *Mass of St Gregory* in the London Hours is, in fact, on an added bifolio with a variant ruling pattern, but the style of the miniature and border are in keeping with the rest of the manuscript and would appear to be contemporary.

20. London, British Library, Add. MS. 31835 (c.1435) and Brussels, Bibliothèque Royale, MS. 9785 (c.1445); for illustrations of these calendars, see Nash 1997, figs 60, 61.

21. For illustrations of these manuscripts, see Nash 1997, figs 46, 47, 48.

22. *Ibid.*, 1997, figs 93, 94.

23. For a surviving example see Backhouse, J., (1975) 'An Illuminator's Sketchbook', *British Library Journal*, **1**, pp. 3–14.

24. See Nash 1997, figs 129, 131.

25. Brinkmann, B., (1988), 'The Hastings Hours and the Master of 1499', *British Library Journal*, **14**, pp. 93–5, lists various examples from a group of Ghent–Bruges manuscripts.

26. See Nash 1997, fig. 26.

27. In Delaissé, Marrow and de Wit 1977, *op. cit.* at n. 19, p. 128, just such a possible model is proposed for this figure, and the relationship was identified when the d'Ailly Hours was sold in 1978; see London, Sotheby Parke Bernet and Co., (1978), *Catalogue of Western Manuscripts and Miniatures*, London, 11 July 1978, pp. 43–4, lot 48.

28. König, E., (1992), *Manuscrits à peintures XIIIe–XVe siècles*, exh. cat., Rennes, (Espace Ouest-France), pp. 43–5, no. 9.

29. The more active depiction of Margaret seems, however, to have been a feature of Amiens iconography, since she is also shown stabbing the dragon in two other Amiénois Books of Hours (London, British Library MS. 31835, and the Châtillon Hours, location unknown).

30. A similar if less effective mixing of patterns for a miniature of *St Margaret* is noted in the *Hastings Hours*, where the saint is clearly based on a figure of the Virgin from an Annunciation, and the illuminator had transposed not only the figure but also the dove hovering above her head. See Kren, T., ed., (1983), *Renaissance Painting in Manuscripts. Treasures from the British Library*, exh. cat., London (British Museum), New York (Pierpont Morgan Library) and Malibu (J. Paul Getty Museum): p. 27.

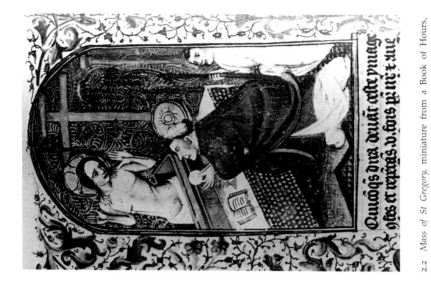

2.2 *Mass of St Gregory*, miniature from a Book of Hours, parchment.

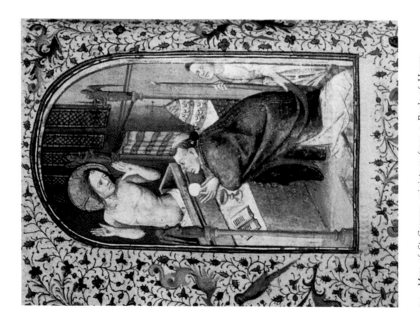

2.1 *Mass of St Gregory*, miniature from a Book of Hours, parchment.

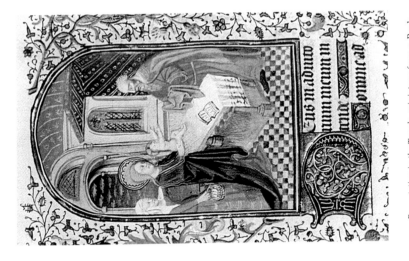

2.4 *Presentation in the Temple*, miniature from a Book of Hours, parchment.

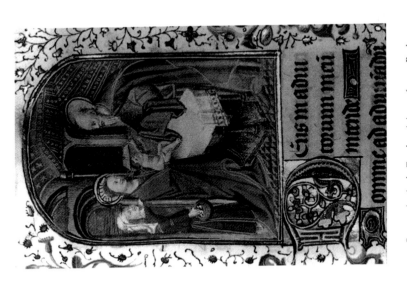

2.3 *Presentation in the Temple*, miniature from a Book of Hours, parchment.

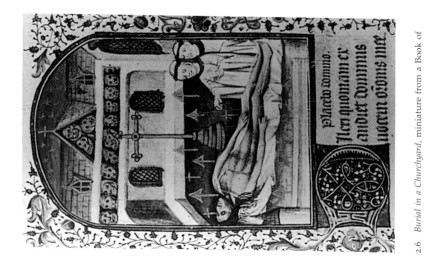

2.6 *Burial in a Churchyard*, miniature from a Book of Hours, parchment.

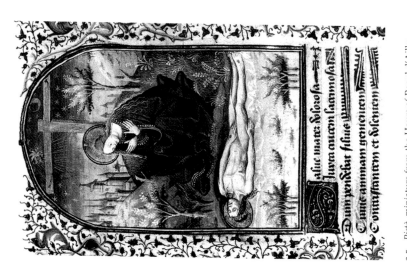

2.5 *Pietà*, miniature from the Hours of Raoul d'Ailly, parchment.

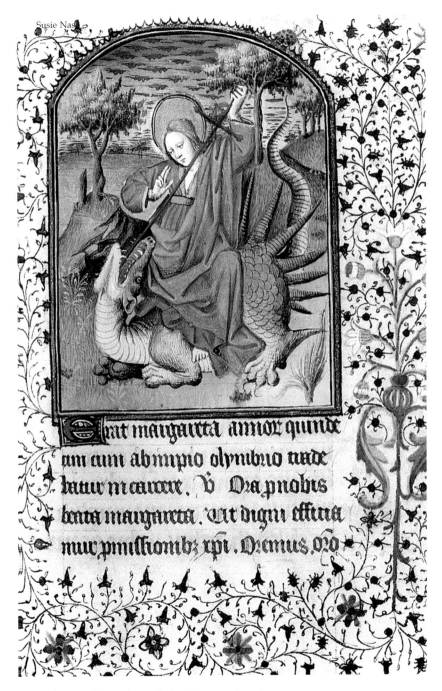

2.7 *St Margaret*, miniature from a Book of Hours, parchment.

Training and practice in the early Renaissance workshop: observations on Benozzo Gozzoli's Rotterdam Sketchbook

Francis Ames-Lewis

Benozzo Gozzoli is often characterized as a decorative painter working in an essentially late Gothic stylistic mode. Such a characterization depends mainly on a conventional but I think questionable reading of the pictorial style of Benozzo's most celebrated work, the frescoes in the chapel of the Palazzo Medici in Florence. In various respects these frescoes in fact demonstrate remarkable imagination and artistic innovation; but, nevertheless, there is some truth in the view that they reflect an interest in the late Gothic art of the North Italian courts. It is reasonable to suggest that Piero di Cosimo de' Medici – who, if not the patron, was at least responsible for seeing the decoration of the family chapel carried through to completion – developed this artistic taste through his contact with courts such as that of the Este at Ferrara. It is less safe, however, to assume that Benozzo Gozzoli's stylistic preferences were limited to those shown in the Cappella Medici frescoes. Evidence that his interests and artistic skills ranged far beyond those that might be classified as 'courtly late Gothic' is to be found in other works, notably the frescoes formerly in the Camposanto in Pisa which he painted towards the end of his career in the 1480s. This evidence can be mirrored by consideration of a group of drawings which originally formed part of the property of his workshop. The sketchbook has been discussed by a number of scholars, recently in particular by Robert Scheller and Albert Elen, and by Bernhard Degenhart and Annegrit Schmitt in their great Corpus of early Italian drawings.[1] The quality of draughtsmanship in the drawings in this sketchbook is not high, and clearly shows that a number of assistants in Gozzoli's workshop contributed their efforts to it, in some cases when they were apparently still at a fairly early stage of their training as painters. But the contents of the surviving drawings, as well as the workshop practices that may be inferred from them, are of considerable interest and

invite an attempt to evaluate the character and training methods of the Gozzoli workshop.

They belong to what is often called a sketchbook – for want of a better term – which was in use in the Gozzoli *bottega* probably during the 1460s. The recent research has meant that there is no cause for debate about the sketchbook's original structure or about the sheets that originally belonged together between its covers. The major group of drawings from it are the 20 double-sided sheets housed at the Boijmans Van Beuningen Museum in Rotterdam; nine others survive in various printrooms, and one or two additional fragments may also originally have belonged to the book. But this total accounts for less than half the original sketchbook, since the sixteenth-century page numbering reached at least 60, the number inscribed on one of the Rotterdam sheets; while a further inscription suggests that before the sketchbook was broken up in the mid-sixteenth century there were 85 pages.[2] Several other extant drawings by Gozzoli or his assistants can be associated with the 29 surviving sheets, and even if we have only a fragment of the original book, these sheets, taken as a group, represent an impressive corpus for a mid-fifteenth-century workshop. It is certainly large enough to provide the materials with which to attempt to reconstruct some of Gozzoli's workshop practices.

It is very clear from his Palazzo Medici chapel frescoes that Benozzo Gozzoli was no stranger to late Gothic model-book drawings. Two of the group of birds shown on the banks of the pool in the chapel's *Paradise* fresco were copied from a sheet onto which a page in the celebrated Bergamo model-book of Giovannino de' Grassi had in turn been copied.[3] Other motifs in Gozzoli's work also derive from model-book drawings, not least a number recorded in the sketchbook. The foremost example is a page in pen and ink showing the head of an eagle and a two-humped camel (fol. 44; Figure 3.1). The eagle head is closely similar to that in a drawing by Antonio Pisanello (Paris, Louvre, Vallardi 2503), and parallels can also be found in other Florentine drawings such as a sheet, now divided between Dijon (Musée des Beaux-Arts, 1745) and Vienna (Albertina, 27), of studies attributed to Paolo Uccello – an artist who was, of course, celebrated for his love of birds.[4] The two-humped Bactrian camel, labelled 'dromedario' in a sixteenth-century hand, could have come directly from a Lombard source similar to that in the Giovannino de' Grassi model-book, but another drawing attributed by Degenhart and Schmitt to Uccello includes a camel ridden by a child just as does Domenico Veneziano's *Adoration of the Magi* tondo (Berlin, Gemälde-galerie).[5] This painting, probably made for Piero di Cosimo de' Medici, may have served as a quarry for motifs used by Gozzoli in the Medici chapel frescoes: where, not surprisingly, two black boys riding Bactrian camels also appear.

Other model-book motifs in the Gozzoli sketchbook derive more closely from surviving prototypes by Pisanello. It is now usually thought that Pisanello cast his celebrated medal of Emperor John VIII Palaeologus in Florence at the time of the Council of the Churches in 1439. If so, copies of Pisanello drawings could have been made in Florence by Uccello, for example, or by Domenico Veneziano, although Gozzoli himself was probably too young to have copied Pisanello drawings first-hand at this date.[6] Two Gozzoli drawings after Pisanello are the paired oxen on one of the sheets in Rotterdam (fol. 47v) which closely resemble Paris, Louvre, Codex Vallardi 2409, and the wild boar on a sheet in Berlin (Kupferstichkabinett, 5578v), also originally from the Gozzoli workshop sketchbook, which stems from a Pisanello drawing now in Cambridge (Fitzwilliam Museum, PD. 124–1961).[7] Predictably, the Pisanello drawing is of significantly higher quality than the copy, especially in terms of the characterization of surface textures. In this context, however, what is important is that animal and bird studies such as these were regarded in the Gozzoli *bottega* as an important part of a painter's training. Gozzoli's assistants were encouraged to continue the tradition of copying model-book drawings, a procedure which had been embedded in workshop practice by Lombard painters many decades earlier, and it was clearly necessary to do so when faced with projects like the Medici chapel frescoes and the expectations of patrons like Piero di Cosimo de' Medici. Further examples of animal studies in the Gozzoli sketchbook reinforce these deductions. A stag on a sheet from the sketchbook now in Paris (Louvre, 0054) is closely comparable with models both from the Lombard group and in Pisanello's corpus,[8] and a goat on fol. 15 of the Rotterdam sketchbook can again be related to a Pisanello drawing. It reappears in the so-called 'Rothschild model-book', a Florentine model-book of perhaps a decade or two earlier,[9] again suggesting the popularity of Pisanellesque motifs in Florentine workshops.[10] From the range of handling and quality of their execution, these model drawings demonstrate that Gozzoli workshop assistants used model-book drawings as prototypes for their training exercises. Given the number of birds in the Cappella Medici frescoes that are evidently derived from North Italian model-book prototypes, it is surprising that the sample of model drawings in the Gozzoli workshop sketchbook is almost exclusively of animals. It might be hypothesized that studies of birds were assembled in a separate section of the sketchbook, which became detached and is now lost; but it should be noted that there is no evidence from either the surviving sheets or from their presumed original arrangement that studies were grouped in terms of subject. Indeed, the reverse appears likelier, with the pages of the sketchbook being used in a completely random manner by any members of the *bottega* at any time and for any purposes.

It appears that as well as animal and bird studies, figure-types in Gozzoli workshop drawings also stem from Lombard traditions. On one of a pair of sheets in Florence is an image of the comic actor, Philemon, known from the quaint story that he died laughing at a joke he had made on seeing a donkey eating figs (Uffizi, 70E; Figure 3.2). This figure was probably copied from an earlier rendering in a Milanese 'World Chronicle' such as that signed by Leonardo da Besozzo (Milan, Crespi Collection) and datable around 1440.[11] Drawings from this group show that Gozzoli also had contact with artistic ideas from further north than Lombardy. The same Uffizi sheet includes a figure, evidently the youngest of the three Magi, clearly deriving from Netherlandish art. The closest parallel to this figure is in a German drawing apparently made for – or more probably after – a painting or a carved relief of the *Adoration of the Magi*.[12] It is likely that this motif itself stemmed from a work made in the circle of Rogier van der Weyden – a parallel may, for example, be drawn with the pose of the young king in Rogier's *St Columba Altarpiece* (Munich, Alte Pinakothek). Netherlandish paintings had been reaching Florence in almost certainly increasing numbers since around 1450, but the intermediary here may have been a drawing, or perhaps a German engraving – for these were also arriving in Florence in growing numbers from about 1460.[13] This figure was presumably admired as a novel type, since it was also copied into the Palazzo Medici chapel frescoes, although there he is no longer Moorish.[14] The fresco figure in fact relates better to the result of a conversion process that was carried out, probably by Gozzoli himself, on a sheet in London (British Museum, 1895–9–15–444).[15] This shows the same motif that was copied more literally onto the Uffizi sheet, but Gozzoli has transmuted the Weydenesque young king into an Italianate one. A two-stage process is involved: the figure on the right of Gozzoli's sheet reduces the Netherlandish angularity, replaces the Moorish facial type of the workshop copy with a relatively bland contemporary Italianate one, and discards the frankincense container while retaining the young king's pointed slippers and his turban with its long flowing veil. When Gozzoli drew the figure on the left, only the slippers survived; and although something of the figure's movement has been retained, the Netherlandish pose is now hidden beneath an enveloping robe which falls in the thick, angular-pleated folds characteristic of Gozzoli's drapery style. The assistant's copy on the Uffizi sheet acknowledges the interest that this alien motif aroused in the workshop: an interest that led Gozzoli himself to interpolate an 'italianized' version of the figure into the processional cortège of the Magi in his fresco.

A process analogous to Gozzoli's transformation of a Netherlandish figure into an essentially Florentine one can be seen on another sheet from the Rotterdam sketchbook (fol. 58), which may suggest that it was an established

bottega procedure for figure design. Here a workshop draughtsman has made a partial version of the exemplar provided by a more refined drawing, well finished in pen and wash, with white heightening, on red-tinted paper.[16] Standing in a pose not unlike Donatello's bronze *David* (Florence, Bargello), the male nude of this exemplar is set against a partially washed-in background reminiscent of the technique used by Pollaiuolo in drawings like the *Battling Figures* (Cambridge, Mass., Fogg Art Museum, 1940.9; see Figure 5.5). The much-modified Gozzoli sketchbook variation of this figure-type is a rapid pen-and-ink sketch with coarse hatching to emphasize the nude's rudimentary muscular structure. To judge by the simplified rendering of the head, facial features, hands and feet, the draughtsman was concerned primarily to examine the articulation of his prototype's pose. Nevertheless, the copy was reused as the model for the study to its left on the same sheet in which the nude form is lost beneath swathes of heavy drapery and, with the addition of a long beard, has been converted into a prophet, or perhaps an Old Testament patriarch, such as appeared later in Gozzoli's Camposanto frescoes.

This is just one example of the figure-design processes that Gozzoli's assistants followed in their training and study in the *bottega*. The workshop sketchbook and related drawings indicate that Gozzoli's assistants and apprentices drew on a range of materials and sources for their study of the human form and its features. A series of studies of the nude in the Rotterdam sheets shows a process of copying drawings within the workshop. It is hard to judge which of the two drawings (Stockholm, Nationalmuseum, 57; and Vienna, Albertina, 12) of a nude youth standing in a pose closely related to that of the exemplar just discussed, and in the characteristic Florentine technique of silverpoint with white heightening, served as the model for the other, or what sort of model was used in drawing the earlier one, whichever this may have been.[17] More can perhaps be deduced about Gozzoli workshop practice from a group of three versions of a study of a recumbent figure apparently in sleep. The source of this motif may well have been a life-drawing, perhaps of one of the assistants in the *bottega* at a relaxed moment, but there is little sign in these derivative studies that a three-dimensional model had originally been used. A sketchbook sheet, now in Rome (Gabinetto Nazionale delle Stampe, 128284v),[18] includes a very brief sketch of the pose shown in more detail on a sheet in the Rotterdam group (fol. 45v), and both were perhaps copied from the more finished exemplar on the next page of the Rotterdam sketchbook (fol. 46v; Figure 3.3). These studies were presumably made for exercise in silverpoint drawing: the sort of studies that in slightly earlier times would usually have been made on the prepared boxwood panel that Cennino Cennini wrote about.[19] Another drawing of a recumbent nude (fol. 51; Figure 3.4) shares Andrea Mantegna's interest in

studying the problem of how to show a steeply foreshortened pose.[20] The Gozzoli assistant may in this case have been copying an original drawn from a sculptural model rather than a live one, made probably of wax or clay and conforming with a type of workshop aid for which there is growing evidence after the middle of the century, notably in the Antonio Pollaiuolo workshop.[21]

A celebrated antique bronze sculpture, the *Spinario*, certainly served, albeit at a considerable remove, as the generic model for the two series of studies of seated nudes. A drawing in the Rotterdam group (fol. 46v) and a more roughly handled copy (fol. 5), which shows even less comprehension of anatomical form and structure, look as though they were derived from a study of a live model who was posed in a vague reflection of the *Spinario*. The seated nude on a sheet of the sketchbook now in London (British Museum, Pp. 1–7), and the copy-drawing in Rotterdam (fol. 51; Figure 3.4), which is cruder in the application of white heightening and more simplified in setting, use a pose more closely based on the *Spinario* but in reverse.[22] That Gozzoli was interested in motifs to be found in classical sculpture is shown by a sheet in Dresden (Kupferstichkabinett, C.6v) which includes a copy of a detail from a sarcophagus of the *Indian Triumph of Bacchus*.[23] This may indicate that Gozzoli had had access either to the original, or perhaps more probably to a cast after it. The appearance of the *Spinario*-type drawings may also suggest that they originated not from a life study but from a sculptural model in clay or plaster which imitated the celebrated classical exemplar.

These examples suggest that sculptural models after the Antique may have been included amongst the Gozzoli workshop artists' materials. At this point, it may be worth recalling the practice in Francesco Squarcione's studio at much the same date. In 1455, part of the cost of Marco Zoppo's tuition under Squarcione was paid in plaster 'for shaping into figures and images', very probably after the Antique; and in the same year an inventory of Squarcione's house records that it included a large *studium* 'with reliefs, drawings and other things in it' from which his apprentices could learn.[24] Other figure-studies in Gozzoli workshop drawings are also based on classical types, although again distantly and therefore perhaps through the intermediary of generically classicizing clay models made in the *bottega*. Alternatively, of course, they may have been drawn from live models holding poses generically based on classical types. The two figures on a second sheet in Florence (Uffizi, 1112E; Figure 3.5), which is related to but is not part of the Rotterdam sketchbook, are also studies from classical figure-types.[25] On the right is a derivative of the figure of *Desire* or *Pothos* by Scopas.[26] This is best known from the figure, likewise seen from behind, in Piero della Francesca's *Death of Adam* in the fresco-cycle at San Francesco, Arezzo, which was painted at much the same time as Gozzoli's

assistants were active, and from Pollaiuolo's drawing of *Adam* (Florence, Uffizi, 95F) in which the figure is seen from the front. But the type had been in use earlier, as is shown by the figure in profile, again of Adam, in the terracotta relief of *Adam and Eve* on an early fifteenth-century cassone panel (London, Victoria and Albert Museum).[27] The different viewpoints in these three examples once again suggest that a sculptural model in clay, terracotta or even possibly in bronze, was available in the fifteenth century, to which Gozzoli too had access.

Similar models were perhaps used in an intriguing group study (Stockholm, Nationalmuseum, 11) which has been associated with the Uccello *bottega* rather than with that of Gozzoli, but which reinforces the impression that in the third quarter of the fifteenth century an almost academic interest in the process of figure study developed in Florentine painters' workshops.[28] On this single sheet eleven studies of the nude are rather self-consciously arranged to display the draughtsman's skill in figure drawing, and also perhaps to serve as a yardstick of workshop activity and an exemplar for apprentice copying. The figures are artificially posed on a polygonal platform which equally can be understood as a display of skill in perspectival construction. The *Pothos* figure, seen from the front as in Pollaiuolo's *Adam* drawing, reappears in this exhibition piece. So also does a close mirror image of the second figure on Gozzoli's Uffizi sheet; this latter seems to be running sideways, perhaps in fear, and was also used by Andrea del Castagno in his *Young David* shield (Washington, National Gallery of Art). The classical source for this type, the Paedagogue from the Niobid group, was known in the mid-quattrocento from a truncated marble showing the figure only from torso down,[29] so Castagno and the model-makers must have invented the upper part of the body to suit the movement implied in the legs. A sculptural model for a closely similar pose, based on another classical type, the *Marsyas Piping*, survives in several bronzes often attributed to Antonio Pollaiuolo, and provides evidence of the circulation of sculptural models.[30] Other studies in the Stockholm academic showpiece may well have been drawn from such models, and a hypothesis can perhaps be put forward that one also served for the Gozzoli assistant's figure-drawing on the Uffizi 1112E sheet.

This discussion has demonstrated that Benozzo Gozzoli and his workshop showed an interest in classical figure-types, an interest shared with his Florentine contemporary, Pollaiuolo, and with Mantegna, who had probably already gained similar experience as an apprentice in Squarcione's *studium* during the 1440s. Gozzoli's interest in further echoes of the classical past, again clearly shared with painters of greater stature, can be seen in other Rotterdam sketchbook drawings. The workshop evidently possessed a number of plaster casts after classical fragments: one sheet (fol. 53; Figure 3.6)

shows a series of seven studies of feet which appear to have been drawn from at least two different casts. Similar, though cruder, drawings on other sheets from the sketchbook (fols 55v and 58v) indicate the interest with which these casts, or drawings after them, were copied and recopied. Materials such as these are listed in some quantity in the inventory of the contents of Fra Bartolommeo's workshop, drawn up after the artist's death in 1517, which includes, besides two lay-figures (one of which, made of wood, was life-size), '22 wax models of babies and other things' and '63 plaster fragments of heads, feet and torsos'.[31] A noteworthy contemporary parallel to the Gozzoli workshop use of similar casts after the Antique is the classical foot shown in the lower left corner of Mantegna's Vienna *St Sebastian*.[32] Through representations of fragments of classical statuary Mantegna paid tribute to the inspiration behind his figure style at about the same date as Gozzoli's workshop sketchbook was in use. Mantegna's rather studied display of classical fragments in the Vienna *St Sebastian* may suggest that such pieces had already been available in Squarcione's workshop during his apprenticeship. By the 1460s, casts after antiquities were similarly utilized as study materials in Benozzo Gozzoli's workshop; a further example is the female torso seen from the rear in a Gozzoli workshop drawing in New York (Cooper Union Museum, 1901.39.2971), for which Mantegna's Vienna *St Sebastian*, with its imposing torso fragment, again provides a compelling parallel.

A final type of classicizing study is a group of sheets in the Rotterdam sketchbook on which details of classical architecture were recorded. The studies, inscribed as being of the doorframe of the Pantheon (fol. 4; Figure 3.7), of a capital from Tivoli and a column base from San Bartolommeo in Isola in Rome (fol. 1v), suggest that Gozzoli's assistants had access to a collection of drawings after the Antique, similar perhaps to that recorded in an inventory of Piero di Cosimo de' Medici's library as a 'libro di disegni di roma'. A third drawing (Vienna, Albertina, 2545v) may be a copy of the entablatures studied on Rotterdam fol. 4;[33] one of these records a fragment of a Flavian entablature immured in the Arch of Constantine, and the Pantheon doorframe reappears later in a drawing in Giuliano da Sangallo's *Siena Sketchbook*.[34] Drawings of the San Bartolommeo in Isola column-base also appear in Jacopo Bellini's Louvre Book of Drawings, and later on in the Domenico Ghirlandaio workshop *Codex Escurialensis*, amongst other collections of drawings after the Antique.[35] This suggests that in the field of architectural drawings, too, Benozzo Gozzoli's *bottega* had an antiquarian interest in common with leading workshops of later fifteenth-century Florence.

I have attempted in this paper to identify some of the materials available to assistants in Benozzo Gozzoli's *bottega* as prototypes for copying during

their training or in their design practice. These appear to have ranged from North European drawings, and perhaps engravings, to North Italian model-books of birds and animals; from drawings, and probably sculptural models, of the nude figure, to casts after classical sculptural fragments, and to drawings of classical architectural details. Given this catholic range of visual source material, and the bias shown in the Rotterdam sketchbook towards the study of the human form on the basis of classicizing prototypes, it is perhaps justifiable that the humanistic sentiment 'PICTORIBUS ATQUE POETIS SEMPER FUIT ET ERIT EQUA POTESTAS': to painters and poets always has been and will be equal power' could be inscribed in Latin on the Rotterdam sketchbook's title-page (fol. 1). The pictorial character and quality of Gozzoli's finished works, on the other hand, might or might not have justified a claim for such high cultural status for his paintings. Be that as it may, the inscription suggests that through the training and practice of his workshop Gozzoli consciously aspired towards the intellectual level of Antonio Pollaiuolo's probably slightly later classicizing inscription on the *Battle of Nude Men* engraving (see Figure 5.2),[36] or to the antiquarian atmosphere of Francesco Squarcione's workshop. Squarcione appears to have striven deliberately to convert his workshop from the *bottega* of the craftsman-painter into the *studium* of the humanistic artist. The evidence of the Rotterdam sketchbook and its related drawings may suggest that Benozzo Gozzoli's workshop deserves to be considered as an early and embryonic prototype of the sixteenth-century *accademia del disegno*.

Frequently cited literature

Fossi Todorow, M., (1966), *I Disegni del Pisanello e della sua Cerchia*, Florence; Degenhart, B. and Schmitt, A., (1968), *Corpus der Italienischen Zeichnungen 1300–1450, I: Sud- und Mittelitalien*, 4 vols, Berlin.

Notes

1. Scheller, R., (1995), *Exemplum. Model-Book Drawings and the Practice of Artistic Transmission in the Middle Ages (ca.900–ca.1450)*, Amsterdam: pp. 371–80; Elen, A.J., (1995), *Italian Late–Medieval and Renaissance Drawing Books from Giovannino de' Grassi to Palma Vecchio. A codicological approach*, Leiden: pp. 222–6; Degenhart and Schmitt 1968, **2**, pp. 478–90, cats 434–69; and **4**, pls 327–38.

2. On fol. 1r is inscribed in a sixteenth-century hand, 'carte 85'; see Elen 1995, *op. cit.* at n. 1, pp. 223 and 225.

3. See Ames-Lewis, F., (1987), 'Modelbook drawings and the Florentine quattrocento artist', *Art History* **10**, pp. 1–11. For the Bergamo model-book drawing, see de' Grassi, G., (1961), *Giovannino de' Grassi. Taccuino di disegni: codice della Biblioteca Civica di Bergamo*, Monumenta Bergomensia, **5**, Milan: fol. 13v.

4. The comparable sheet is Paris, Louvre, Codex Vallardi, 2503; see Fossi Todorow 1966, p. 194, cat. 436. For the Dijon/Vienna sheet, see Degenhart and Schmitt 1968, **2**, pp. 395–402, cats 310–1; and **4**, pls 282 a–b. For Uccello's love of birds, from which of course his name derives, see Vasari, G., eds, Bettarini R. and Barocchi, P., (1966–1987), *Le vite de' più eccellenti pittori, scultori e architettori*, 6 vols, Florence: **3**, testo, p. 65.

5. The drawing of a Bactrian camel in the Bergamo model–book (for which see de' Grassi 1961, *op. cit.* at n. 3, fol. 15v) is too weak itself to have served as a usable model, either for Gozzoli or for Uccello (whose Bactrian camel is on Stockholm, Nationalmuseum, 45a recto; see Degenhart and Schmitt 1968, **2**, p. 388, cat. 304; and **4**, pl. 279b). However, given the relationship between the detail in the Cappella Medici frescoes (see Acidini Luchinat, C., (1993), *La Cappella de'Magi*, Milan: p. 243 and detail, pp. 252–3) and the Berlin *Adoration* tondo (see Wohl, H., (1980), *The Paintings of Domenico Veneziano*, Oxford: pl. 38), it may be that both Uccello and Gozzoli derived the motif from a drawing in a model-book in Domenico Veneziano's workshop.

6. First documented as a painter in 1444, Gozzoli was born probably around 1421. In 1439 he was perhaps still an apprentice with Fra Angelico who seems never to have used a prototype derived from a North Italian model-book drawing. For the Palaeologus medal, see recently Lavin, I., (1993), 'Pisanello and the Invention of the Renaissance Medal', in Poeschke, J., ed., *Italienische Frührenaissance und nordeuropäisches Spätmittelalter*, Munich: pp. 67–84.

7. For Paris, Louvre, Codex Vallardi, 2409, see Fossi Todorow 1966, p. 78, cat. 52, pl. LXII. They also reappear, with a cow and its calf (see n. 10 below) and a boar on a double-sided sheet (whereabouts unknown), considered by Degenhart and Schmitt to be Florentine of the last third of the fifteenth century; see Degenhart and Schmitt 1968, **2**, p. 626, cat. 635; and **4**, pl. 443e. For the study of a wild boar (Berlin, Kupferstichkabinett 5578v), see Degenhart and Schmitt 1968, **2**, p. 488, cat. 464; and **4**, pl. 336d; and for the Pisanello prototype (Cambridge, Fitzwilliam Museum, PD. 124–1961), see Fossi Todorow 1966, p. 79, cat. 55, pl. LXVI.

8. See Degenhart and Schmitt 1968, **2**, pp. 488–9, cat. 466; and **4**, pl. 337d. I have not located an exact precedent for Gozzoli's stag, but comparable studies are to be found in the Bergamo model-book (see *Giovannino de' Grassi* 1961, fol. 22v) and on, for example, Paris, Louvre, Codex Vallardi, 2494 (Fossi Todorow 1966, pp. 192–3, no. 429).

9. For the Rothschild model-book, see Degenhart and Schmitt 1968, **1**, pp. 256–62, cat. 154; and **3**, pls. 185c–190b; and Scheller 1995, *op. cit.* at n. 1, pp. 331–40.

10. The goat compares closely with Paris, Louvre, Codex Vallardi, 2412 (Fossi Todorow 1966, p. 64, cat. 14, pl. XXV; and see also Degenhart, B., (1942), *Antonio Pisanello*, Vienna: pl. 87). Other animal studies with parallels in model-book drawings are an elephant (Rotterdam sketchbook, fol. 42v), a cow suckling its calf (Venice, Accademia 10; Degenhart and Schmitt 1968, **2**, pp. 489–90, cat. 468; and **4**, pl. 338c), and a recumbent ox, apparently being fed and stroked by a naked putto (Rotterdam sketchbook, fol. 45).

11. See Degenhart and Schmitt 1968, **2**, pp. 490–1, cat. 470 (see fig. 665 for the comparison with Leonardo da Besozzo); and **4**, pl. 339a.

12. This parallel was demonstrated by Degenhart and Schmitt 1968, **2**, p. 491, fig. 667, who attribute the sheet to a late fifteenth-century Rhenish draughtsman.

13. On these questions in general, see Holmes, M., (1983), *The Influence of Northern engravings on Florentine art during the second half of the Fifteenth Century*, unpublished M.Phil thesis, University of London (Courtauld Institute of Art); and Nuttall, P., (1990), *Early Netherlandish Painting in Florence. Acquisition, ownership and influence, c.1435–1500*, unpublished Ph.D thesis, University of London (Courtauld Institute of Art).

14. Visible in Acidini Luchinat 1993, *op. cit.* at n. 5, pl. 243 and detail, pl. 249. I suspect that the source for the pair of shepherds, one playing a bagpipe and the other carrying a sheep, who appear in a rather coarse sketch on a Gozzoli workshop sheet (London, Victoria and Albert Museum, Dyce 173; Degenhart and Schmitt 1968, **2**, p. 477 cat. 433; and **4**, pl. 326b), may have been German. The motif could have reached Gozzoli in the form of a drawing, or perhaps an engraving; a parallel can be drawn with Mantegna's early *Adoration of the Shepherds* (New York, Metropolitan Museum of Art) in which the shepherds are evidently of German extraction, see Ames-Lewis, F., (1992), 'A Northern Source for Mantegna's *Adoration of the Shepherds*', *Print Quarterly*, **9**, pp. 268–71.

15. See Degenhart and Schmitt 1968, **2**, pp. 471–2, cat. 418; and **4**, pl. 322a; Popham, A.E., and Pouncey, P., (1950), *Italian Drawings in the Department of Prints and Drawings of the British Museum: The Fourteenth and Fifteenth Centuries*, 2 vols, London: **1**, p. 53, cat. 89.

16. Rotterdam, Boijmans Van Beuningen Museum, Gozzoli–2 (Degenhart and Schmitt 1968, **2**, p. 472, cat. 420; and **4**, pl. 322c): this sheet is not part of the sketchbook, but with its companion, Rotterdam, Boijmans Van Beuningen Museum, Gozzoli–1 (Degenhart and Schmitt 1968, **2**, p. 472, cat. 419; and **4**, pl. 322b), may have served as a figure-pose paradigm for workshop copying and reuse. For the Pollaiuolo drawing, see Ettlinger, L., (1978), *Antonio and Piero Pollaiuolo*, Oxford: p. 161, cat. 36 and pl. 74.

17. For the Stockholm and Vienna drawings, respectively, see Degenhart and Schmitt 1968, **2**, p. 483, cat. 444; and **4**, pl. 329e; and **2**, pp. 487–8, cat. 462; and **4**, pl. 335c.

18. See Degenhart and Schmitt 1968, **2**, pp. 466–7, cat. 410; and **4**, pl. 318d.

19. Cennini, C., ed. and trans., Thompson, D.V., (1933), *Il Libro dell'Arte* (The Craftsman's Handbook), New Haven: p. 4, chap. V.

20. Compare Mantegna's rather later *Dead Christ* (Milan, Brera), or his studies for a recumbent Christ on a sheet in London, British Museum, 1909–4–6–3 (Popham and Pouncey 1950, *op. cit.* at n. 15, p. 8, cat. 12r).

21. See Fusco, L., (1982), 'The Use of Sculptural Models by Painters in Fifteenth-Century Italy', *Art Bulletin*, 64, pp. 174–94.

22. See Popham and Pouncey 1950, *op. cit.* at n. 15, p. 54, cat. 91; and Degenhart and Schmitt 1968, **2**, p. 482, cat. 440; and **4**, pl. 328c.

23. For the drawing, see Degenhart and Schmitt 1968, **2**, p. 459, cat. 399; and **4**, pl. 314b; and, for the sarcophagus relief, see Bober, P.P. and Rubinstein, R., (1986), *Renaissance Artists and Antique Sculpture: A Handbook of Sources*, London: pp. 111–2, cat. 76.

24. See, most recently, Lightbown, R., (1986), *Mantegna*, London: p. 18. Reference is also made to these issues in Martineau, J., ed., (1993), *Andrea Mantegna*, exh. cat., London (Royal Academy of Arts), and New York (Metropolitan Museum of Art): pp. 94–98.

25. See Degenhart and Schmitt 1968, **2**, pp. 491, 471; and **4**, pl. 339c; and more recently in Petrioli Tofani, A.M., ed., (1992), *Il Disegno Fiorentino al Tempo di Lorenzo il Magnifico*, exh. cat., Florence (Uffizi, Gabinetto Disegni e Stampe): p. 43, cat. 2.2. This sheet evidently came from the same group of sheets as Uffizi 70E, considered earlier (see n. 11 above).

26. The use of this figure-type is considered by Cocke, R., (1980),'Masaccio and the Spinario, Piero and the Pothos: Observations on the Reception of the Antique in Renaissance Painting', *Zeitschrift für Kunstgeschichte*, **43** pp. 21–32, especially p. 30.

27. Pope-Hennessy, J., (1964), *Catalogue of Italian Sculpture in the Victoria and Albert Museum*, 3 vols, London: **1**, pp. 57–59, no. 51, and **3**, pl. 74. See also Bellosi, L., (1986), 'I problemi dell'attività giovanile', in Darr A.P. and Bonsanti, G., eds, *Donatello e i Suoi*, exh. cat., Florence (Fortezza di Belvedere): pp. 47–54. For the Pollaiuolo drawing, see Petrioli Tofani 1992, *op. cit.* at n. 25, p. 50, cat. 2.8.

28. See Degenhart and Schmitt 1968, **2**, p. 527, cat. 515; and **4**, pl. 360c; and Petrioli Tofani 1992, *op. cit.* at n. 25, pp. 154–5, cat. 7.9.

29. Bober and Rubinstein 1986, *op. cit.* at n. 23, p. 35.

30. For this, see Fusco 1982, *op. cit.* at n. 21.

31. For this, see Knapp, F., (1903), *Fra Bartolommeo della Porta und die Schule von San Marco*, Halle A.S.: pp. 275–6.

32. Vienna, Kunsthistorisches Museum; see Lightbown 1986, *op. cit.* at n. 24, pl. 43. See also his pl. XI for Mantegna's later *St Sebastian* (Paris, Louvre), a detail of which is reproduced in Martindale, A. and Garavaglia, N., (1971), *The Complete Paintings of Mantegna*, London: pl. XXVIII, which offers an even better example.

33. See Degenhart and Schmitt 1968, **2**, p. 488, cat. 463; and **4**, pl. 336b.

34. Giuliano da Sangallo's drawing is in Siena, Biblioteca Communale, MS. S. IV. 8, fol. 1; see Borsi, S., (1985), *Giuliano da Sangallo. I disegni di architettura e dell'antico*, Rome: pp. 250–314.

35. Degenhart and Schmitt 1968, **2**, p. 480; the Bellini drawing is on fol. 39v of the Louvre book (see Degenhart, B. and Schmitt, A., (1984), *Jacopo Bellini: The Louvre Album of Drawings*, New York, pl. 46), and the Ghirlandaio workshop version is Escorial MS. 28. II.12, fol. 23 (for which see Egger, H., (1906), *Codex Escurialensis: ein Skizzenbuch aus der Werkstatt Domenico Ghirlandaios*, Vienna: p. 86.

36. See Ettlinger 1978, *op. cit.* at n. 16, pp. 146–7, and pl. 72.

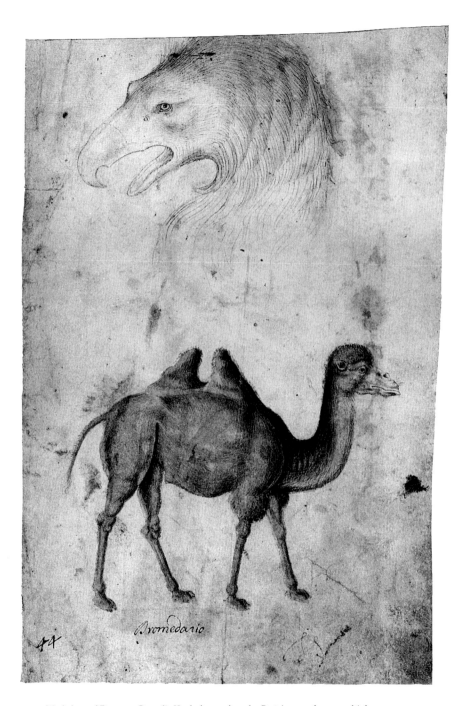

3.1 Workshop of Benozzo Gozzoli, *Head of an eagle and a Bactrian camel*, pen and ink on paper.

3.2 Workshop of Benozzo Gozzoli, *Studies of two figures*, pen and ink with white heightening on redenned paper.

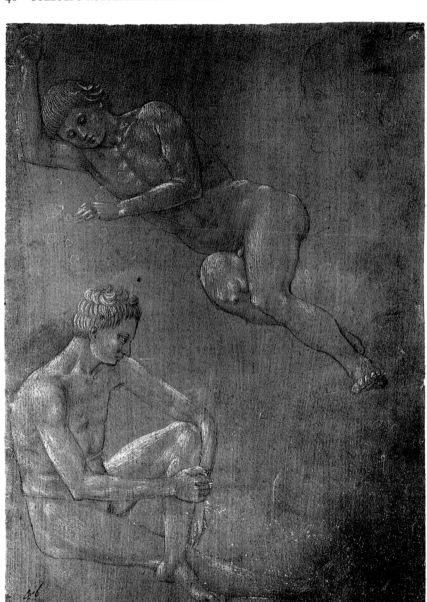

3.3 Workshop of Benozzo Gozzoli, *Studies of two nude youths*, silverpoint and white heightening on violet prepared paper.

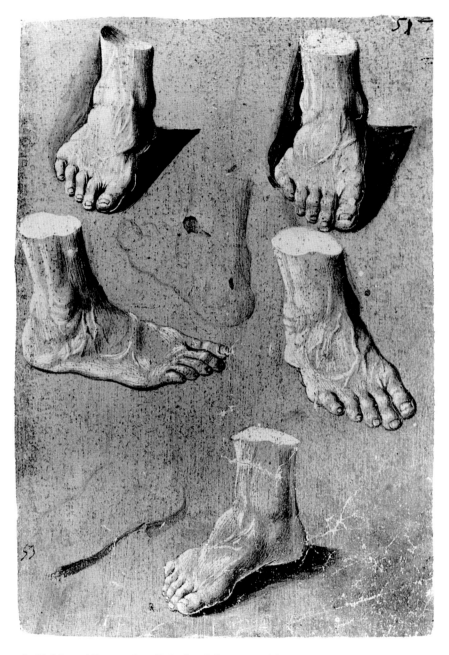

3.6 Workshop of Benozzo Gozzoli, *Studies of plaster casts of feet*, silverpoint with wash and white heightening on green prepared paper.

PORTA SCTA
MARIA·RITODA

3.7 Workshop of Benozzo Gozzoli, *Studies of details of classical architecture*, pen and ink on paper.

3.4 Workshop of Benozzo Gozzoli, *Studies of two nude youths*, silverpoint and white heightening on violet prepared paper.

3.5 Workshop of Benozzo Gozzoli, *Studies of two figures after the antique*, pen and ink with white heightening on redenned paper.

Maso Finiguerra and early Florentine printmaking

Lucy Whitaker

Recent research has helped to clarify the career of Maso Finiguerra (1426–1464), who was heralded by Vasari as the inventor of engraving, but who, nevertheless, remains a much discussed, mysterious figure.[1] Despite his brief life (he died in 1464 at the relatively young age of 38), Finiguerra's influence was enormous in many media. No one can convincingly attribute any print to him, yet most early Florentine printmakers were associated with him and his shop, and early Italian prints in both the so-called Fine and Broad Manners were influenced by his style, technique and designs.[2] The purpose of this paper is to study Finiguerra's large corpus of drawings, which was the fundamental part of his output, and to relate them to his work in other media. Although the organization of his workshop resembled that of other contemporary artists' *botteghe*, and his shop's drawings have much in common with those associated with the workshops of Benozzo Gozzoli, Domenico Veneziano, and Antonio Pollaiuolo,[3] I hope to show that it was the clarity of Finiguerra's designs which led to his exceptionally wide-ranging influence beyond the short span of his career. Assistants and artists with similar interests could collaborate efficiently with him and transfer his ideas into those other media which also depended on the effective use of contour lines. Finiguerra's drawing style was inseparable from his work as a goldsmith and niellist; his skills encouraged his followers to embark on printmaking, the process with which his name will always be associated.

The son of a goldsmith, Finiguerra was reputedly an assistant to Lorenzo Ghiberti, and, like his slightly younger colleague and rival, Antonio Pollaiuolo (c.1432?–1498), he worked in a variety of media and on different scales. By 1457, Finiguerra was himself employed as a goldsmith in collaboration with Piero di Bartolomeo Salì (with whom Pollaiuolo also collaborated) and in that year two candlesticks were ordered from him and Salì for the church of San Jacopo in Pistoia.[4] Between 1461 and 1464, both Finiguerra

and Pollaiuolo produced luxury items of silver and gold for Cino di Filippo Rinuccini (as we know from his domestic chronicle), and in 1461 Finiguerra was paid by Bernardo di Stoldo Rinieri for a silver buckle.[5]

Finiguerra was much praised by fifteenth- and sixteenth-century writers for his skill as a niellist.[6] Most art historians agree that he probably executed two of the four niello paxes now in the Bargello in Florence: the *Crucifixion with two thieves and soldiers drawing lots*, placed by scholars in the 1440s or c.1450, and the *Coronation of the Virgin*, commissioned by the Merchants' Guild for the Florence Baptistry and thought to date from c.1452.[7] Niello work had been practised by goldsmiths and armourers for several centuries, but, perhaps stimulated by Finiguerra's skill, it suddenly became more widespread in the middle of the fifteenth century, before gradually falling into decline again after his death.[8] Plates, usually made of silver, were engraved and the resultant furrowed lines were filled with a black powdery substance called niello (from the Latin '*nigellum*'). Made of a mixture of metals – copper, silver and lead, together with, possibly, sulphur and borax – the powder was laid on the surface of the plate, then heat was applied. This melted the substance so that it filled the lines and hardened as it cooled. The superfluous niello was then scraped away and the plate burnished, leaving black, enamel-filled lines which contrasted with the bright surface of the silver. The *niello* plates, small, precious items, executed with minute modelling, were made to decorate religious or household objects. A series of nielli, sulphur casts of nielli, and prints taken either from metal plates or from the sulphur casts, relate to the Bargello paxes. Some of the series seem close to the *Crucifixion* pax, while others correspond to the *Coronation of the Virgin*.[9]

When Richard Kubiak traced Finiguerra's development, he demonstrated how the artist's early style looked to Ghiberti's relief sculpture but later became more dependent on paintings by Fra Filippo Lippi and Domenico Veneziano. The composition and many of the details of the *Crucifixion* pax are related to the work of Ghiberti, while particular figures are derived from Filippo Lippi's *Miracle of St Ambrose* and Domenico Veneziano's *Adoration of the Magi* tondo (both Berlin, Gemäldegalerie). In terms of composition and figures, the *Coronation of the Virgin* pax is particularly close to Fra Filippo's 1447 *Coronation of the Virgin* (Florence, Uffizi), while certain saints show the influence of Domenico Veneziano's *St Lucy altarpiece* (Florence, Uffizi); for example, Maso's St John the Baptist and St Agnes resemble Domenico's St John and St Lucy.[10]

There are definite connections between Finiguerra and Pollaiuolo. These are apparent from the fact that Finiguerra's name is listed immediately after that of Antonio Pollaiuolo as 'maestro di disegno' in Giovanni Rucellai's *Zibaldone Quaresimale*, begun in 1459.[11] Connections with Pollaiuolo are also evident in Vasari's *Life* of Antonio and Piero Pollaiuolo, where Finiguerra's

skill as a draughtsman is praised and the fact is related that he possessed in his *Libro*: 'molte carte di vestiti, ignudi, e di storie disegnate di acquerello'.[12] Vasari also relates how Antonio Pollaiuolo made certain drawings in competition with Finiguerra which led to the former receiving the commission from the Merchants' Guild for parts of the Florence Baptistry silver altar.[13] Despite the documented associations between the artists, Kubiak has emphasised how different Finiguerra's aesthetic point of view was from that of Pollaiuolo. However, the more emphatic outlines defining some nielli images such as *Justice* (Paris, Louvre, Rothschild Collection, 143 Ni),[14] which like the intarsia designs can be dated to the end of Finiguerra's career, show both an increased sense of naturalism and the influence of Pollaiuolo.

Other factors make it clear that Finiguerra and Pollaiuolo were closely associated: both were goldsmiths and had partners, patrons and output in common. As Alison Wright has outlined, Giovanni Rucellai's description of both artists as 'maestri di disegno', may have a particular meaning,[15] that is as providers of finished designs which could be reproduced or used by artists working in different media. Finiguerra is also mentioned by Alesso Baldovinetti, who, on 21 February 1464, noted in his *Libro di Ricordi* that Giuliano da Maiano owed him 3 lire for colouring the heads of the five figures drawn by Maso Finiguerra – a Virgin Mary, an angel, a St Zenobius and two deacons – and that these figures were in the sacristy in Florence Cathedral,[16] a project completed in 1468.[17] Pollaiuolo, like Finiguerra, supplied designs for different contexts – ecclesiastical vestments, jewellery, small bronzes and prints – and it seems likely that he also provided designs for the figures of *Amos* and *Isaiah* for the Cathedral's intarsia sacristy.[18] It is possible that the two artists' names are listed immediately after the intarsist Giuliano da Maiano in Rucellai's book because both may have supplied the latter with designs for benches or *spalliere* for the Rucellai palace.[19]

Both artists shared a similar interest in depicting the human figure with a single fluid line, and, like Ghiberti, were skilled at presenting a complete design with a high degree of grace and finish. This flair for design grew out of the strong Florentine goldsmiths' tradition, which encompassed Ghiberti's large and important workshop, spurring on the development of intaglio printing in the Tuscan capital during the 1460s.[20] The Fine Manner print of the *Planet Mercury* (Figure 4.1), in which an intaglio engraver is shown at work in a goldsmith's shop, illustrates the point nicely. Pollaiuolo and Finiguerra were able to experiment with new techniques like making prints from copper or sulphur plates because of their experience in this discipline. In their prints they investigated the possibilities of systematic drawing at the precise time in the fifteenth century when it was discovered that the searching line of the draughtsman could be translated into mechanical processes. In their drawings the goldsmith's precise use of the pen emulated

the burin, and, as *maestri di disegno*, both Finiguerra and Pollaiuolo would have intended that the virtuosity of their lines be appreciated. Their designs, which crossed barriers of media and scale, reveal the way in which they searched for certain formulae to convey movement, as, for example, in Pollaiuolo's use of repeated figures or parts of figures in the Arcetri *Dancing Nudes* fresco and the engraved *Battle of Nude Men* (see Figure 5.2).[21] Laurie Fusco has shown that certain poses recur throughout the fifteenth century, and that in order to achieve specific effects artists frequently repeated a particular pose even in the same image. Pollaiuolo used this pattern-book approach imaginatively, pivoting and reversing figures deliberately in individual works to suggest rhythmic movement and dramatic tension.[22] The reuse of certain figure types in the Finiguerra and Pollaiuolo workshops enabled assistants or partners to participate to a greater degree in the design process. The use of such formulae opened up possibilities of collaboration between different artists who had similar interests and meant that other artists could take up inventive workshop ideas and incorporate them into their own work.

Doris Carl's discovery that Finiguerra's family inherited as many as 14 books of drawings by the artist, as well as loose sheets, sulphur casts, prints from sulphurs and a drawing or model for a cross, confirms that Maso was a prolific draughtsman. Carl also reveals that Finiguerra's drawings were highly respected in that the terms of their possession were set out in three legal contracts drawn up at different times between Maso's brother, Francesco and the artist's son, Pierantonio.[23] There is a large group of drawings which are linked stylistically to the nielli. The majority of these drawings are grouped under Finiguerra's name in the Uffizi collection. Most of them are of single figures or pairs of figures. Elsewhere, however, three major compositional drawings survive: the *Life of Adam and Eve* (Frankfurt, Städel, 415); *Moses on Mount Sinai* (London, British Museum, 1898–11–23–4); and the *Deluge* (Hamburg, Kunsthalle, 14867),[24] which fit Vasari's description of 'storie'.[25] The 14 books of drawings included in Finiguerra's bequest to his heirs reinforce his reputation as a designer as well as a niellist. The group of more than 80 drawings in the Uffizi, the 23 in the Louvre (pasted into an eighteenth-century album known as the Bonnat Album), as well as others scattered in different collections, must have formed part of this legacy.[26]

Carl has put forward the hypothesis that at the beginning of the sixteenth century Maso Finiguerra's bequest was passed from Vincenzo Finiguerra to Vasari, and then to Cardinal Leopoldo de' Medici's collection, before subsequently forming part of the Uffizi collection.[27] Lorenza Melli has discovered that Filippo Baldinucci listed both a volume of drawings by Finiguerra and three inscribed sheets in his 1673 register of the drawings in Cardinal

Leopoldo de' Medici's collection. In 1687 the number of drawings in the Finiguerra volume is listed as totalling 56.[28] Both Melli and Albert Elen agree with Carl that the majority of drawings in the Uffizi, as well as those in the Louvre, can be traced back to Finiguerra's workshop. However, Melli disagrees with Elen's theory that the two groups of drawings were once part of a single octavo drawing book.[29] It is apparent that at one stage the Uffizi sheets were bound together in a book because some of them are numbered and in certain cases the right edge shows signs of frequent handling. An asterisk, which appears on many of them, may be the mark of an unidentified sixteenth-century owner who wished to indicate that the leaves belonged together.[30] The drawings, mainly studies of figures, either clothed or nude, and of animals, may therefore have been preserved because they were bound together rather than simply because they were always regarded as being of the highest quality or because they were by Finiguerra himself. The 14 books would have been a working collection containing a wide range of ideas of varying quality. They were workshop resources, which, despite appearances, were not considered finished works of art. However, the need to preserve ideas meant that at some stage certain drawings were silhouetted and mounted on another sheet. Examples of this are: the *Seated man writing or drawing* and the *Seated man wearing a turban writing or drawing* (Uffizi, 47F and 48F).[31]

The collection in the Uffizi forms a definite corpus of work. The studies combine simple pen-and-ink outlines with modelling in washes. Most recently, authors have attributed almost all the drawings to Finiguerra himself, but their finished style of single contours is deceptive and in fact the quality within the Uffizi group is very varied.[32] The hallmarks of Finiguerra's style are obvious: the frequent choice of a complicated view of the model, the stocky figures, the flat strands of curly hair, the interest in the pattern formed by drapery falling in flat folds, the long, tapering fingers and the wide feet with the smaller toes hardly individualized. A handful of the images have barely any chalk underdrawing or chalk pentimenti. The figures are well-proportioned and self-contained, and one can admire the accuracy of the single outlines, which define both volume and foreshortening, as well as the sensitivity of the modelling, which, often through three shades of wash, suggests the fall of light and enhances the sense of volume.

The clarity of Finiguerra's drawing technique meant that figures could easily be transferred into different contexts. A well-known example of this is the *Standing male figure* (Uffizi, 117E),[33] who also appears in the sulphur print of the *Circumcision* (Paris, Louvre, Rothschild Collection, 132 Ni.).[34] The studies from the nude could be used in other media for religious figures such as David and for mythological subjects such as the *Judgement of Paris*, as well as for secular figures without an obvious mythological context. The

numerous studies of workshop assistants sitting on stools, drawing, incising nielli or carving wood, are often mentioned as interesting insights into fifteenth-century workshop practice. In fact, Finiguerra, in common with his contemporaries, was making use of models available in the studio to examine poses which could then be employed elsewhere. These figures always look posed rather than as if they are working naturally. A striking example of this is the *Three workshop assistants raising an ass* (Louvre, Rothschild Collection, DR 653),[35] who reappear in reverse in the Rothschild niello print of the same subject.[36]

The participation of assistants in the execution of some of the Uffizi drawings is illustrated by the weaker pen-and-ink version of the nielli print of *Cupid asleep* (Uffizi, 50S).[37] It is similarly evident in the hesitant chalk lines of some drawings which contrast strongly in terms of quality with other drawings consisting of a few confidently applied lines. The two putti in Uffizi 81F,[38] drawn over uncertain chalk lines, are weaker anatomically than their counterparts in Uffizi 89F,[39] who are defined over very few traces of chalk. The competently-rendered hands in Uffizi 84F were drawn first and an assistant added the more tentative head and body which are too small in scale.[40] Compared with the Rotterdam Benozzo Gozzoli drawing-book (see Francis Ames-Lewis's essay in the present volume), there seems, in this collection, to be less evidence of workshop assistants copying the master's drawings, although these wide variations in quality suggest that some drawings were training exercises.[41] There must have been repetitions within the drawing books and there is evidence that images were transferred either to another sheet of paper or to another context such as embroidery. The drawing of a *Saint in Dominican habit, holding a palm (or feather) and a book* (Uffizi, 85F) was pricked, possibly for embroidery.[42] The close pricking of just the head of a *Nude with a trumpet* (Uffizi, 80F),[43] implies that the head was the only part of the body to be transferred. In fact there are several drawings of parts of bodies – legs, feet or hands. As in Benozzo Gozzoli's workshop, plaster casts must have been used to study parts of the body.[44] The study of the foot on Uffizi 744 Orn verso is presented as if from life, but the underdrawing in stylus shows the leg cut off in the shape of a plaster cast.[45]

Finiguerra clearly worked on the basis of very few poses which could be altered subtly to give variation. The *Male nude with one foot resting on a plinth* (Uffizi, 79F; Figure 4.2),[46] whose stance recalls that of *David* in Uffizi drawings 42F and 41F,[47] was initially drawn in chalk with his right leg on the ground in the pose of the *Male nude with raised arms and a putto holding a staff* (Uffizi, 76F; Figure 4.3).[48] The raised right hand is the same in both. The Uffizi 76F nude was originally striding out with his left leg, described in chalk, as Adam does in the drawing of *Adam and Eve* (Uffizi 44F; Figure

4.4),[49] who also repeats the right hand gesture. This specific positioning of the legs is also found in a *Study of legs and a right arm* (New York, Pierpont Morgan Library, Scholz Collection, 1986.70: 7v; Figure 4.5).[50] The idea of reusing a small number of poses was current in Florence, and, as we have seen, seems also to have been a key concept in Pollaiuolo's workshop. In Pollaiuolo's *Martyrdom of St Sebastian* altarpiece (1475, London, National Gallery), the archer on the left of Sebastian in the middle distance takes up the pose described above which, as Fusco has pointed out, can be traced to a version of the antique statue of *Marsyas* (Figure 4.6), known in Florence during the fifteenth century. Finiguerra, like several contemporaries, found this particular pose an essential formula for conveying the idea of the human figure in action.[51] He did not only study the human form, as recommended by Ghiberti in his *Commentarii*, but, like Ghiberti, also copied single figures from antique reliefs.[52] An example is his drawing of *Hercules and Cacus* (Turin, Biblioteca Reale, 15591)[53] which can be traced to the marble relief of the *Death of Pentheus* (Pisa, Camposanto).[54] Finiguerra's clear definition of forms and his system of reusing certain poses meant that workshop assistants could easily participate in the design process at every stage, which explains the variations of quality in this group of drawings.

Vasari referred to Finiguerra's ability to place a great number of figures in both large and very small spaces,[55] and the artist's compositional method must have involved transferring and combining single figures from workshop books. In the British Museum *Moses on Mount Sinai* drawing, single figures from various sources – Ghiberti, Filippo Lippi and Baldovinetti – are combined to form a gesticulating crowd. The composition and rocky landscape are based on Ghiberti's *Moses* panel for the Florence Baptistry 'Gates of Paradise', and certain figures appear in both works. For example, the man in the centre of the drawing with both hands raised is based on the woman and child in the centre of the Ghiberti panel, while the man in the short tunic on the right, reeling back, is derived from the man in armour, also reacting dramatically, in Ghiberti's image. As Kubiak has pointed out, the composition of the crowd arranged in a semi-circle, and the way in which the figures often gaze upwards, hands projecting at right angles to their wrists to express wonder, has much in common with Filippo Lippi's *Adoration of the Magi* (completed mid-1450s, Washington, National Gallery of Art). In both works there is a similar interest in the graceful fall of thin drapery and the decorative curves of hemlines. The back view of the man with three pigtails, left of centre, is based on the figure standing to the left in Baldovinetti's *Transfiguration* for the Santissima Annunziata silver chest (Florence, San Marco Museum).[56] For his scene, Finiguerra started with the foreground figures and worked back, filling the gaps between them. In the Hamburg *Deluge*, with its compositional and figural debts to Paolo Uccello, there is a

disturbing conjunction of the atmospheric effects of wind on water and trees with self-contained figures arranged in groups.[57] Figures half-submerged in the water recall workshop drawings of limbs and parts of bodies, while the two men kneeling on the raft in the centre look too large for their position beyond the ark. Finiguerra was clearly able to design foreshortened architectural structures in space, the throne in the *Coronation of the Virgin* pax being a case in point, but he preferred to distort size in the traditional manner to emphasize the most important protagonists, presenting Christ, the Virgin, and the two kneeling saints on a much larger scale than the accompanying figures.[58]

It is debatable whether the architectural settings for the Cathedral sacristy intarsia figures were designed by Finiguerra or whether they were by Giuliano da Maiano. The figures complement their surroundings, particularly the Angel and the Virgin Mary, who are foreshortened in space to take into account the height of their position on the wall. As Margaret Haines has suggested, da Maiano may have created a rational Renaissance space for which Finiguerra supplied the actors – an Albertian idea.[59] It seems to have been the case that the participants in this project, Baldovinetti, Pollaiuolo, and Finiguerra, collaborated closely with each other, and with Giuliano da Maiano, who had overall supervision of it.

Finiguerra, in fact, had much in common with intarsists. His family included two other established woodworkers for whom he probably often provided cartoons as he undoubtedly did for Giuliano da Maiano, who also happened to be his brother-in-law.[60] In the sacristy, the clear contours and tonal modelling of forms through different types of wood recall Finiguerra's pen-and-wash drawing technique, while the precision of line required in intarsia work is akin to that used for printmaking, goldsmithery, and the production of nielli. Similarly, the preoccupation with complex geometric patterns is related to the ornate linear decoration of the sheet of paper in Fine Manner prints.

It is likely that Baldovinetti was employed to 'colour' the heads of Finiguerra's designs because their translation into wood required painterly gradations of tones and Finiguerra did not work with colour. The effectiveness of the sacristy wall designed by Finiguerra also results from the high standards achieved by the intarsist in translating the designs into wood, for Baldovinetti is known to have coloured the heads for his own design of the *Nativity* on the sacristy's west wall, but the final intarsia work is of a lower quality.[61] That Baldovinetti and Finiguerra were close associates seems to be confirmed by the former, who, as early as 1449, mentioned a transaction between them involving a sulphur cast that Finiguerra had made of a dagger.[62] Like Pollaiuolo, Baldovinetti shared Finiguerra's interests; his pictorial technique with its emphasis on line and modelling through

definite patches of hatching recalls that of Finiguerra and his workshop.[63]

While being derivative regarding pictorial sources, Finiguerra must also have been technically innovative and experimental. This is implied by Vasari's controversial statement in the *Life* of Marcantonio Raimondi, which describes how, in 1460, Finiguerra discovered intaglio engraving from the technique of nielli. He made a mould in clay of the silver plate before the application of the niello. The clay mould was in turn filled with amorphous sulphur which hardened in time. The lines of the sulphur cast were filled with a type of black ink, giving the artist a reproduction of his niello in the same direction as the original. Vasari suggests that Maso discovered the idea of printing engravings by rubbing damp paper with a roller on the inked sulphur cast. These prints would obviously be the reverse of the original niello.[64]

To judge from the tell-tale cracks in a print such as the Louvre *Baptism*, it seems that most of the prints on paper that have survived were taken from sulphur casts rather than from the actual nielli.[65] One can only speculate about the reasons for engaging in the laborious process of making sulphur casts and then taking prints from them rather than from the original nielli plates. Finiguerra may have inked and taken a paper impression from a silver plate to check its progress because before the application of the black niello it would have been difficult to distinguish the incised lines from the plate. Alternatively, he may have wanted to keep the print from the silver plate in the workshop as a pattern once the original plate had been sold. However, very few prints from nielli have survived. As mentioned above, the sulphur cast has the advantage over a print of reproducing the plate in the same direction as the original. The sulphur cast itself could also have been kept as a record of the niello plate. Surviving sulphurs are often damaged but it is likely that they were originally of a high enough aesthetic quality to be sold as decorative plaques, and they may have embellished religious ornaments such as paxes. According to Luigi Lanzi,[66] sulphurs like the small *Genesis* and *Passion of Christ* scenes (British Museum)[67] came from the monastery of the Carmelites in Florence where they decorated a small altarpiece.

However, neither silver nor sulphur could withstand the pressure of presses devised at a later date for copper engravings. Vasari describes 'un rullo tondo' which was probably a type of roller used at this period to make the impressions on paper.[68] There must have been something in this printing process that made it preferable to take impressions from the sulphur casts rather than from the silver plates. It is possible that silver was too soft for even a primitive press, whereas sulphur, when hardened, was much tougher and therefore a more feasible option for printing. Presumably, prints would

have to be taken from the silver plaques before the engraved lines were filled with the enamel-like substance of the niello, whereas prints could be taken from the sulphur casts at any time, which would have been more convenient for the workshop.

Sulphurs and prints from sulphurs are specifically mentioned in Finiguerra's will.[69] He was familiar with some German engravings circulating in Florence and may have taken up certain motifs from the Master E.S., as in the Bargello niello *Crucifixion* pax in which the horse and rider entering on the left may derive from the Master E.S. *St George and the Dragon* print.[70] It seems likely that early Northern prints inspired Finiguerra to experiment with the process of taking paper impressions from nielli and sulphur casts. Some of his later nielli and sulphurs are more deeply cut, as for example the Louvre *Baptism* print.[71] This may have been due to his development away from the elegant figures and the fine detail of Ghiberti towards more bulky drapery and more dynamic figures, but it is perhaps also because the nielli were part of a wider printmaking process and needed more deeply engraved modelling, just as the Broad Manner of intaglio engraving replaced the Fine Manner technique. Such developments meant that the prospective buyer in fifteenth-century Florence could choose between a precious and expensive silver niello, a sulphur of exactly the same image for a much lower price, and, an even cheaper print taken from a sulphur. Although Finiguerra did adopt certain motifs from Northern prints, as in the *Crucifixion*, there are few indications that this practice was extensive, and the main influence from this field appears to have been technical. In his nielli and drawings he is much more indebted to Florentine artists, and in particular to Ghiberti, Lippi and Pollaiuolo.

Vasari admired Finiguerra's burin technique ('che per lavorare di bulino e fare di niello non si era veduto mai'),[72] which suggests that Maso was a printmaker as well as a niellist. In the documents published by Carl, the 14 books of drawings are mentioned as 'volumina librorum pictorum et seu disegnatorum'.[73] The phrase could refer to prints, or coloured prints, as well as drawings. However, while we know that Finiguerra's designs were executed as prints, and that goldsmiths associated with Finiguerra pioneered copperplate engraving in Florence, we cannot attribute the actual execution of any print to him. The fact that the three large Finiguerra drawings with many figures: the Hamburg *Deluge*, the British Museum *Moses on Mount Sinai*, and the Frankfurt *Life of Adam and Eve*, are in pen and ink and on the expensive support of parchment, suggests that these drawings were particularly important to Finiguerra and that he wished to preserve them. This point is underlined by the restoration of areas of the *Moses* drawing by a later hand. Both the *Deluge* and the *Moses* were executed as prints in the Broad Manner by Francesco Rosselli,[74] and the plates for these prints are

listed in the 1525 inventory of items from Rosselli's workshop.[75] The plates of similarly large compositional prints in the Fine Manner, the *Conversion of St Paul* and the *Judgement Hall of Pilate*,[76] together with three in the Broad Manner, the *Adoration of the Magi, Solomon and Sheba* and *David and Goliath*,[77] are also listed in Rosselli's inventory and may have been designed by Finiguerra as well.[78] As David Landau proposes, it is possible that designs were transferred mechanically from drawing to copper by *carta lucida* (transparent transfer paper) because there are no indentation marks on the vellum and the prints do not reverse the drawings. Landau superimposed enlarged transparencies of the Hamburg *Deluge* drawing and Rosselli's first engraved version, and the outlines correspond exactly.[79]

Since Rosselli was only 15 or 16 years old when Finiguerra died, it is unlikely that the experienced master would have entrusted the execution of such large prints to someone so young. It is more feasible that Rosselli used the three drawings after Maso's death, particularly as they appear to date from different periods in Finiguerra's career. However, the question remains: why did Finiguerra not print the designs himself? The drawings seem to be more like highly finished works in their own right than preparatory drawings. This possibility is reinforced in the case of the *Moses* drawing by the fact that the artist drew a frame around it. Such characteristics link these drawings to those in the *Florentine Picture Chronicle* (London, British Museum), a book of drawings produced during the 1470s by Baccio Baldini (d.1487) and his workshop, and which ambitiously undertook to portray the history of the world.[80] Baldini was a Florentine goldsmith and follower of Finiguerra. The *Chronicle* drawings are also highly finished with modelling in wash as well as hatching, and, like Finiguerra's *Moses* drawing, those in the first section are framed in pen and ink. The book itself was a luxury item, not necessarily a preparatory work for prints, and together with the large Finiguerra sheets, shows the demand at the time for finished drawings, to which it seems that Finiguerra and his shop were responding.

The technique and style of the *Picture Chronicle* connect it closely to prints in the so-called Fine Manner which are also linked to Finiguerra. Early print cataloguers and subsequent art historians have attributed most of the Fine Manner engravings to Baldini.[81] The clearly-engraved outlines and modelling in the very fine, irregular cross-hatching of the Fine Manner technique resemble the highly detailed approach of the goldsmith and Finiguerra's niello technique. Both the Fine Manner engravings and nielli also reflect the precise outlines of Finiguerra's drawings, the fuzzy cross-hatching imitating the washes. In general, the format of the niello plate is taken up in Fine Manner prints, in which a single figure or a few figures are frequently set in decorative surroundings with a restricted sense of space. Like Finiguerra, Baldini collaborated closely with other artists – the most famous being

Botticelli[82] – and reused a variety of pictorial sources. Amongst the earliest of this group of prints are the c.1460–65 *Planets*,[83] in which figures and architecture are clearly indebted to Finiguerra. One of many examples is the *Mars* print,[84] from which the running girl at the far right and the hooded man in the centre are both also found, on the right in the British Museum *Moses* drawing, reeling at the sight of the serpents.[85] As Arthur Hind has suggested, subsequent prints, like the early 1470s *Prophets and Sibyls* series, drew upon several different sources: early German prints, particularly by the Master E.S. and Martin Schongauer; local sources, the Pollaiuolo Mercanzia *Virtues* (Florence, Uffizi); and French or Burgundian prototypes. These images provided entire figures or details such as a veil or headdress, which could be combined with other sources.[86] However, in spite of the derivations, the series is unified by consistent features such as the graphic technique, the decorative detail, the format of figure to sheet, and the morphology of the faces, for example those of the older prophets.

The artists composing the *Florentine Picture Chronicle* used the same design processes. As had been the case with the intarsia sacristy, this book involved the close collaboration of several artists.[87] Like the early printmakers, the *Chronicle* artists borrowed from and successfully reinterpreted a wide range of works of art, including Finiguerra's imagery. An example of Finiguerra drawings being among such sources is the *Remus* (fol. 53r) from the *Picture Chronicle*,[88] derived from the artist's study of a *Young man standing in a turban and cloak* (Uffizi, 117E).[89] As mentioned earlier, the same figure appears in reverse in the niello print of the Louvre *Circumcision*.[90] The *Chronicle*'s large, slightly bowed figure of *Hermes Trismegistus* (fol. 32r)[91] is based on Masaccio's Brancacci Chapel fresco, *St Peter Baptising the Neophytes*, and is repeated for the more upright *Eurystheus* (fol. 39v).[92] In the book there are at least 12 other instances of a figure being exactly repeated, but in each case the figure is subtly changed so that the final effect is very different, rich variety being achieved from a few ideas, just as Finiguerra created variations on a single standing pose. The same pattern was used for two different images of men abducting women. The first, *Paris and Helen* (fol. 35r),[93] features Paris as an expensively-dressed courtier, with the profile view of his face contributing to the restraint and elegance of the scene. In the second, *Proserpine and Pluto* (fol. 39r),[94] Pluto is nude, which intensifies the unruliness and violence of the abduction, while his face expresses obstinacy rather than detachment, because, in contrast to Helen, Proserpine is unwilling to be taken. The *Chronicle* artists returned to a formula for each category of subject – for example, king or magician – although their use was not restricted to male or female subjects or to whole figures, so cloaks with the same folds, the position of limbs and particular gestures are repeated regardless of a figure's age or sex.[95]

Pictorial evidence suggests a close relationship between Finiguerra, Baldini and Rosselli and that a key part of their working practice was their ability to collaborate on a single project and make inventive use of pattern-book sources. Existing documents, however, neither confirm nor clarify these relationships. Instead, it is known that Finiguerra's father, Antonio, his two brothers, Francesco and Stefano, and their sons were all goldsmiths, and that the artist's family carried on the workshop after his death.[96] In 1466, Cino di Filippo Rinuccini noted payments to Maso's brother Francesco.[97] In 1470, Benedetto Dei recorded that Antonio and Francesco Finiguerra had a shop in Via Vaccereccia, which is confirmed by Francesco's *catasti* of 1469 and 1480.[98] In 1469 the brothers took Betto di Francesco di Duccio Betti as a partner.[99] Carl has observed that Francesco continued to work unsuccessfully in Via Vaccereccia until 1498.[100] However, in these documents relating to Finiguerra's family, no mention is made of either Baldini or Rosselli.[101]

Since they were very carefully guarded by his family, it is not surprising that so many of Finiguerra's figure drawings, which are highly finished and restrained in style, survive today. This, however, was not the case with Pollaiuolo and other contemporary artists, whose workshops must, nevertheless, have had books of drawings which have subsequently been lost. It is of course possible that Finiguerra produced more drawings than his contemporaries, while the type and multiple applications of such books undoubtedly enhanced their chances of being preserved – chances which were considerably increased by the interests of Finiguerra's family. Yet, in spite of their many connections, it can be misleading to bracket Finiguerra and Pollaiuolo together as skilled designers. Finiguerra was the elder by about five years and his early death in 1464 was only a few years after Pollaiuolo had opened his goldsmith's shop in Florence and received his first important commissions. It is likely that Finiguerra influenced Pollaiuolo's early goldsmith work (the 1457 Florence Baptistry Cross, for example), and inspired his single-outline drawing technique, as well as stimulating his interest in intaglio printing and Northern prints. The *Battle of Nude Men* is the one major surviving print by Pollaiuolo; whereas, as has been noted, while no intaglio print can be ascribed to Finiguerra, a group of nielli prints is known to be by him, and he and his workshop certainly inspired the major copperplate engravers in Florence. The few extant drawings attributed to Pollaiuolo show that, in contrast to Finiguerra, his drawing techniques and media vary, his outlines are more searching and vital, and his inventiveness is focused on the potential of the human body for energy, drama or movement. Despite the relative rarity of these drawings, the influence of Pollaiuolo's innovative use of patterns can be seen in the work of his contemporaries who repeat his 'classic' poses and ideas. But Finiguerra's inventiveness was of a very different kind, for although his drawings are

more prosaic, he was able to take full advantage of the innovations in printing both to reuse motifs and to replicate an idea mechanically.

The range of applications of Maso Finiguerra's designs is reflected in the many functions of early prints. A print like the Fine Manner *Pattern Plate of Beast and Birds*, which can be attributed to Baldini, suggests a use within workshops similar to that of model-book drawings,[102] but there is evidence that devotional prints, such as Francesco Rosselli's series of the *Life of the Virgin and of Christ*,[103] were mounted on canvas, linen or wood and coloured so that they could be hung on walls like paintings.[104] Many of the so-called 'Otto prints' (named after Ernst Peter Otto, a former owner of many of them) depict scenes of hunting or love and were made to be pasted onto the lids of small boxes used by women.[105] These boxes were probably made of wood or leather and were cheaper substitutes for niello-decorated silver caskets. Other prints were incorporated into books, like the set of Fine Manner *Sibyls* pasted into Philippus de Barberii's *Dicta Sybillarum (Opusculu)* of 1481;[106] while prints like the series of *Planets*, *Triumphs of Petrarch* and the illustrations to Cristoforo Landino's *Dante* had a close connection with the more exclusive buying-public of the book trade.[107]

With the production of sulphurs and sulphur prints Finiguerra must have been experimenting constantly with printing processes, just as later on Rosselli developed deeper incisions for the Broad Manner technique because the fine lines of the Fine Manner and the earliest Broad Manner plates wore away too quickly in the presses.[108] Certain speculative undertakings of the period were never completed, probably because they were too ambitious in the first place. The *Florentine Picture Chronicle*, for instance, started out as a history book and developed into a compilation of historical figures and anecdotes, but was left unfinished. Only 19 of the Landino *Dante* illustrations were executed and only the first three were printed directly onto the text pages, the rest being pasted in.[109]

The period also saw innovations in narrative imagery. Nielli and prints, like cassone painting, presented a wide range of secular and mythological subjects not found in mainstream commissioned paintings, and yet the practice of workshops like that of Finiguerra was to rely on available pictorial sources. The reinvention of Masaccio's *St Peter* as the magician *Hermes Trismegistus* is but one of many examples of copying an available Florentine source and reusing it in a new context. For esoteric subjects like the Petrarch *Triumphs*,[110] the *Planets*, and the *Chronicle's* 'History of the World', artists drew from aspects of contemporary Florentine life as well as from current pictorial sources. Hence the *Planet Mercury* (Figure 4.1), a subject of universal and limitless dimensions, was represented by the prosaic – fifteenth-century goldsmiths and artists in their workshops.[111] Ideas from contemporary processions, festivals and *sacre rappresentazioni* were taken up

by cassone artists such as Apollonio di Giovanni, whose *Triumph of Scipio* is a type which influenced Baldini's print *The Triumph of Love*,[112] and these theatrical events particular to Florence are reflected in the *Chronicle*'s formulae, its ornate structures and costumes. The *Picture Chronicle*'s breadth of subject matter is matched by the richness of the drawing techniques in contemporary workshops. In the pen-and-ink drawing of the *Death of Hercules* (fol. 27r; Figure 4.7),[113] the *Chronicle* artist takes up the expressive qualities of the printmaker, the Master of the Vienna Passion,[114] including the fine hatchings arranged in one plane, the delicate, isolated contour line, and a lack of emphasis on volume, to suggest the catastrophe of Hercules' death in swirling smoke.

The fact that Pierantonio Finiguerra had to establish his claim to his father's books of drawings led Carl to suggest that the drawings were perhaps being used by other artists and goldsmiths and that a continual exchange of ideas must therefore have occurred as drawings were loaned out between small workshops.[115] This would explain the eclecticism of Finiguerra's drawings, nielli and early prints, as well as the interchange of his ideas in all these media. The discipline of the goldsmith tradition enabled Finiguerra, his associates and his followers, to experiment freely with design processes. Their mastery of the single line facilitated the transfer of images into new contexts and their collaboration with specialists in different media. From the basis of their workshop resources of books of drawings, sulphur prints and intaglio prints, these artists presented new secular and mythological subject matter to a society whose eagerness for graphic images provided an ever-increasing market.

Frequently cited literature

Vasari, G., ed., Milanesi, G., (1878–1885), *Le Vite de più eccellenti pittori scultori ed architettori*, 9 vols, Florence, (hereafter Vasari-Milanesi); Hind, A.M., (1936), *Nielli in the British Museum*, London; Hind, A.M., (1938–1948), *Early Italian Engraving*, 7 vols, London; Goldsmith Phillips, J., (1955), *Early Florentine Designers and Engravers*; Cambridge, Mass.; Degenhart, B. and Schmitt, A (1968), *Corpus der Italienischen Zeichnungen*, 1300–1450, I: *Sud- und Mittelitalien*, 4 vols, Berlin; Oberhuber, K., (1973), in Levenson, J.A., Oberhuber, K. and Sheehan, J.L., *Early Italian Engravings from the National Gallery of Art, Washington*, Washington; Kubiak, R., (1974), *Maso Finiguerra*, unpublished Ph.D thesis, University of Virginia; Haines, M., (1983), *The 'Sacrestia delle Messe' of the Florentine Cathedral*, Florence: pp. 162–5; Carl, D., (1983), 'Documenti inediti su Maso Finiguerra e la sua famiglia', *Annali della Scuola Normale Superiore di Pisa*, Serie III, **13**, 2, pp. 507–54; Holmes, M., (1983), *The influence of Northern engravings on Florentine art during the second half of the Fifteenth Century*, unpublished M.Phil thesis, University of London (Courtauld Institute of Art): pp. 42–4; Whitaker, C.L., (1986), *The Florentine Picture Chronicle – a reappraisal*, unpublished M.Phil thesis, University of London (Courtauld Institute of Art); Zucker, M.J., ed., (1993–4), *The Illustrated Bartsch*, **24**, *Early Italian Masters, Parts 1–2*, New York; Wright, A. (1994), 'Antonio Pollaiuolo, *'maestro di disegno'*, in Cropper, E., ed., *Florentine Drawing at the Time of Lorenzo the Magnificent*, (Papers of the Villa Spelman Colloquium, 1992, **4**), Bologna: pp. 131–46; Whitaker, C.L., (1994), 'Maso Finiguerra, Baccio Baldini and The Florentine Picture Chronicle', in Cropper, E., ed., *op. cit.* above, pp. 181–96; Elen, A.J., (1995), *Italian Late-Medieval and Renaissance Drawing-Books from Giovannino de' Grassi to Palma Vecchio. A codicological approach*, Leiden; Melli, L., (1995), *Maso Finiguerra: I disegni*, Florence.

Notes

1. Vasari-Milanesi, **1**, p. 209; **3**, pp. 286-8 and **5**, pp. 395–6. For the documents, early accounts and discussion of Finiguerra's life see Colvin, S., (1898; repr. New York, 1980), *A Florentine Picture-Chronicle*, London: pp. 21–26; Hind 1938–1948, **1**, pp. 3 ff. and 301 ff.; Goldsmith Phillips 1955; Degenhart and Schmitt 1968, **2**, pp. 573–621; and **4**, pls 385–439a; Oberhuber 1973, pp. xvi–xvii and 1–9; Kubiak 1974; Oberhuber, K., (1976), 'Vasari e il mito di Maso Finiguerra', in *Vasari storiografo e artista, Atti del Congresso Internazionale nel IV centenario della morte*, (Florence–Arezzo, 1974), Florence: pp. 383–93; Haines 1983, pp. 162–5; Carl 1983, pp. 507–54; Angelini, A., ed., (1986), *Disegni italiani del tempo di Donatello*, exh. cat., Florence (Gabinetto Disegni e Stampe degli Uffizi), pp. 72–113; Whitaker 1986; Petrioli Tofani, A., ed., (1992), *Il disegno fiorentino del tempo di Lorenzo il Magnifico*, exh. cat., Florence (Gabinetto Disegni e Stampe degli Uffizi), Milan; Zucker ed. 1993–4, **24**, pts-1–2; Wright 1994, pp. 131–46; Whitaker 1994, pp. 181–96; Elen 1995, pp. 229–32; Melli 1995.

2. The Fine Manner technique probably grew out of the niello technique and is closely related to the finely-detailed manner of the goldsmith. The outlines are clearly engraved, and the modelling is achieved by very fine lines of irregular cross-hatching. The Fine Manner was gradually replaced by the Broad Manner, which had regular parallel hatching, partly because the latter's broader, more deeply incised lines did not wear out as quickly as the more delicate lines of the Fine Manner. A large number of Fine Manner prints are associated with Baccio Baldini, a few with the Master of the Vienna Passion. The engraver of most of the Broad Manner prints was Francesco Rosselli. See Hind 1938–1948, **1**, pp. 2–3; Oberhuber 1973, pp. xiii–xviii; Zucker ed. 1993–4, **24**, pts. 1–2.

3. Ames-Lewis, F., (1995), 'Benozzo Gozzoli's Rotterdam Sketchbook Revisited', *Master Drawings*, **33**, pp. 388–404; Elen 1995, pp. 222–5, no. 23.

4. In the documents associating Pollaiuolo with Piero di Bartolomeo Salì, it is Bartolomeo di Piero Salì who is mentioned. Margaret Haines has suggested that this was an error on the part of the scribe. See Haines, M, (1977), 'Documenti intorno al reliquiario per San Pancrazio di Antonio del Pollaiuolo e Piero Salì', *Scritti di storia dell'arte in honore di Ugo Procacci*, Milan: **1**, pp. 264–9; Kubiak has suggested that Bartolomeo di Piero may have been the son of Piero di Bartolomeo Salì. See Kubiak 1974, pp. 3 and 167–8. See also Oberhuber 1973, p. 2; Wright 1994, p. 134; Melli 1995, pp. 10–11. Melli's book gives a full account of Finiguerra's family history and of his connections with other artists.

5. Oberhuber 1973, p. 2; Kubiak 1974, pp. 6, 169; Melli 1995, p. 12.

6. Oberhuber 1973, p. 1; Kubiak 1974, pp. 8–10 and 171–4; Melli 1995, pp. 17–18.

7. Goldsmith Phillips 1955, pp. 3–5; Oberhuber 1973, pp. 2–7; Kubiak 1974, pp. 45–67. Megan Holmes has suggested that Finiguerra's *Crucifixion* must have been influenced by Master E. S. prints and that therefore the niello has to be dated c.1450 by which time the Master E. S. had started producing prints. See Holmes 1983, pp. 42–4.

8. See Reid, G.W., (1869), *Reproduction of the Salamanca Collection of Prints from Nielli*, London; Hind 1936; Blum, A., (1950), *Les Nielles du Quattrocento, Musée du Louvre, Cabinet d'Estampes Edmond de Rothschild*, Paris; Oberhuber 1973, pp. xvi–xvii, 1–9 and 528–31.

9. A number of niello plates are in London (British Museum). Others are in New York (Metropolitan Museum of Art); Pavia (Museo Civico); and Washington (National Gallery of Art). Sulphurs and sulphur prints are predominantly in London (British Museum) and Paris (Louvre, Rothschild Collection). See Hind 1936; Blum 1950; Kubiak 1974, pp. 68–9 and 175–83.

10. Kubiak 1974, pp. 45–67; Oberhuber 1973, pp. 1–9; Goldsmith Phillips 1955, pp. 9–10; and Whitaker 1986, pp. 45–52.

11. Oberhuber 1973, p. 2; Kubiak 1974, pp. 3 and 168; Wright 1994, p. 131 ff. In Rucellai's *Zibaldone* Finiguerra is listed as both 'orafo' and 'maestro di disegno' in Rucellai's *Zibaldone Quaresimale*. See Perosa, A., ed., (1960), *Giovanni Rucellai ed il suo Zibaldone*, **1**, '*Il Zibaldone Quaresimale*', London: pp. 23–4.

12. Vasari-Milanesi, **3**, pp. 286–8.

13. Goldsmith Phillips 1955, p. 31; Kubiak 1974, pp. 8–9, 95–108 and 174.

14. For the *Justice* sulphur print, see Blum 1950, n. 34; Goldsmith Phillips 1955, pl. 11.

15. Wright 1994, pp. 131–46.

16. Goldsmith Phillips 1955, p. 25; Kubiak 1974, pp. 4, 15–44 and 166; Haines 1983, pp.140, 162–5 and 170.

17. Haines 1983, p. 207.

18. *Ibid.*, pp. 170–3, and n. 44 for the literature discussing the attribution of *Amos* and *Isaiah* intarsias to Antonio Pollaiuolo.

19. Gilli, R., (1980), 'Proposte per Maso Finiguerra: le tarsie della Sacrestia delle Messe in Santa Maria del Fiore a Firenze', *Antichita viva*, **19**, p. 36; Haines 1983, pp. 163–4; Wright 1994, p. 145.

20. Also discussed by Landau, D. and Parshall, P., (1994), *The Renaissance Print, 1470–1550*, New Haven and London: p. 9.

21. For the Arcetri *Dancing Nudes*, see Ettlinger, L.D., (1978), *Antonio and Piero Pollaiuolo*, Oxford: pl. 22. For the *Battle of Nude Men*, see Hind 1938–1948, **1**, pp. 191–2, D.I.1, **3**, pl. 264.

22. Summers, D., (1977–1978), ' "Figure come Fratelli": A transformation of symmetry in Renaissance painting', *Art Quarterly*, N.S. 1, pp. 59–88; Fusco, L., (1979), 'Antonio Pollaiuolo's use of the antique', *Journal of the Warburg and Courtauld Institutes*, **42**, pp. 257–63; and *idem*. (1982), 'The Use of Sculptural Models by Painters in Fifteenth-Century Italy', *Art Bulletin*, **64**, pp. 175–94. See also Alison Wright's essay in the present volume.

23. Carl 1983, pp. 508, 538–47 and 550–1.

24. Kubiak 1974, pp. 95–108. Illustrated in Degenhart and Schmitt 1968, **2**, pp. 608–10, figs 934, 935 and 937.

25. Vasari-Milanesi, **3**, pp. 286–8 (Lives of Antonio and Piero Pollaiuolo); Kubiak 1974, pp. 95–108.

26. Degenhart and Schmitt 1968, **2**, pp. 573–621; Melli 1995, pp. 27–42; Elen 1995, pp. 229–32.

27. Carl 1983, pp. 521–2.

28. Melli 1995, pp. 27–99. It is likely that the three Uffizi sheets inscribed by Baldinucci are Uffizi 114E, 41F and 65F. One Finiguerra drawing in the Louvre (2685) can be traced back to Baldinucci's collection.

29. The Louvre drawings were stolen from the Uffizi in the eighteenth century (Elen cites the date 1770 but Melli favours 1793) and presented to the Louvre in 1922 as part of the Léon Bonnat collection. See Elen pp. 229–32; Melli pp. 43–48.

30. Degenhart and Schmitt 1968, **2**, pp. 614 and 621, n. 61; Melli 1995, p.30.

31. Degenhart and Schmitt 1968, **2**, p. 602, fig. 903, p. 603, fig. 904; Melli 1995, p. 160, pl. 103; p. 212, pl. 180.

32. Angelini ed. 1986, *op. cit.* at n. 1, pp. 72–113; Petrioli Tofani 1992, *op. cit.* at n. 1; Melli 1995.

33. Degenhart and Schmitt 1968, **2**, p. 600, fig. 888; Melli 1995, p. 134, pl. 51.

34. Degenhart and Schmitt 1968, **2**, p. 600, fig. 887; Blum 1950, no. 18.

35. Hind 1936, pl. IV; Melli 1995, p. 57, pl. 1.

36. Blum 1950, pl. VI, no. 10. There are two other paper print versions of the same subject: one in Paris, (Louvre, Rothschild Collection); see Blum 1950, no. 167; the other is in London (British Museum); see Hind 1936, pl. XXV, no. 157; Kubiak 1974, p. 182, cats 65 and 66.

37. Degenhart and Schmitt 1968, **2**, p. 612, fig. 946; Melli 1995, p. 156, pl. 101.

38. Degenhart and Schmitt 1968, **2**, p. 596, fig. 857; Melli 1995, p. 157, pl. 97.

39. Degenhart and Schmitt 1968, **2**, p. 599, fig. 856; Melli 1995, p. 120, pl. 28.

40. Degenhart and Schmitt 1968, **2**, p. 599, fig. 881; Melli 1995, p. 126, pl. 38.

41. Elen 1995, pp. 222–6; Ames–Lewis 1995, *op. cit.* at n. 3, pp. 388–404; and pp. 26–44 of this volume.

42. Degenhart and Schmitt 1968, **2**, p. 606 fig. 927; Melli 1995, p. 133, pl. 50.

43. Degenhart and Schmitt 1968, **2**, p.594 fig. 843; Melli 1995, p. 142, pl. 66.

44. Ames–Lewis 1995, *op. cit.* at n. 3, p. 400, fig. 12.

45. Melli 1995, p. 114, pl. 15.

46. Degenhart and Schmitt 1968, **2**, p. 594, fig. 845; Melli 1995, p. 138, pl. 59.

47. Degenhart and Schmitt 1968, **2**, p. 602, figs 899 and 898; Melli 1995, p. 148, pls 79, 78.

48. Degenhart and Schmitt 1968, **2**, p. 596, fig. 855; Melli 1995, p. 141, pl. 65.

49. Degenhart and Schmitt 1968, **2**, p. 608, fig. 933; Melli 1995, p. 146, pl. 75.

50. Degenhart and Schmitt 1968, **2**, p. 599, fig. 876; Melli 1995, p. 190, pl. 143.

51. See Fusco 1982, *op.cit.* at n. 22, pp. 186–92. Holmes 1983, pp. 69–92, has also pointed out the influence of prints by Schongauer on Pollaiuolo's work. The so–called Marsyas pose and other details in Pollaiuolo's work can be found in Schongauer's *Flagellation of Christ*. See Lehrs, M., (1908–1934), *Geschichte und Kritischer Katalog Des Deutschen, Niederländischen und Französischen Kupferstichs Im XV. Jahrhundert*, 9 vols, Vienna: **5** (1925), pp. 136–7, no. 22. Finiguerra would also have seen a variant of the Marsyas pose on Ghiberti's Florence Baptistry Doors where the figure of Adam in the *Expulsion* takes up a very similar position. Ghiberti's figure has been linked with a satyr on an antique relief of the *Triumphal Procession of Bacchus and Ariadne*, then in Santa Maria Maggiore, Rome, which was well known in the Renaissance (now London, British Museum). See Krautheimer, R., (1956), *Lorenzo Ghiberti*, Princeton, p. 344, pl. 84 and fig. 127.

52. See Schlosser, J. von, ed., (1912), *Lorenzo Ghiberti's Denkwürdigkeiten (I Commentarii)*; 2 vols, Berlin, **1**, p. 35, where Giotto is described as drawing 'del naturale'. Also discussed by Anna Forlani Tempesti, 'Studiare dal Naturale nella Firenze da Fine "400", in Cropper ed. 1994, pp. 2–4. This is one of Ghiberti's many uses of the term '*naturale*' in *I Commentarii*; see Schlosser 1912, *ibid.* **2**, p. 201; and Krautheimer 1956, *op. cit.* at n. 51, pp. 147–8. For Ghiberti's use of motifs from ancient art see Krautheimer 1956, pp.337–52.

53. Degenhart and Schmitt 1968, **2**, p. 612, fig. 954; Melli 1995, p. 214, pl. 182.

54. Bober, P.P. and Rubinstein, R., (1986), *Renaissance Artists and Antique Sculpture: A Handbook of Sources*, London, pp. 120–1, pl. 87; Fusco 1979, *op. cit.* at n. 22, pp. 261–2. Another version of the same *Hercules and Cacus* drawing is by Finiguerra or an assistant (Cologny, Geneva, Martin Bodmer Library. See Degenhart and Schmitt 1968, **2**, p. 612, fig. 949; Melli 1995, p. 193, pl. 146).

55. Vasari-Milanesi, **3**, pp. 286–8.

56. Kubiak 1974, pp. 97–8; Krautheimer 1956, *op. cit.* at n. 51, pl. 102; Ruda, J., (1993), *Fra Filippo Lippi*, London, p. 211, pl. 120; Kennedy, R.W., (1938), *Alesso Baldovinetti*, New Haven, pp. 27, 50, fig. 49.

57. Petroli Tofani 1992, *op. cit.* at n. 1, pp. 262–3.

58. Illustrated in Oberhuber 1973, p. 6, and in Haines 1983, pl. 87.

59. Haines 1983, pp. 162–3; Kubiak 1974, p. 17 ff.; Wright 1994, p. 135; Gilli 1980, *op. cit.* at n. 19, p.35. Finiguerra's ability to define complex architecture accurately in space is illustrated by the

throne in the *Coronation* pax, the niello print of the *Meeting of Solomon and Sheba* (see Blum 1950, pl. XLI, no. 192) and the *Judgement Hall of Pilate* print, which was probably designed by Finiguerra; (see Hind 1938–1948, **1**, pp. 66–7, no. A.II.9; **2**, pl. 94; Oberhuber 1973, p. 19 and figs 2–9).

60. As discussed by Haines 1983, p. 163, Finiguerra's uncle was Bartolomeo di Tommaso Finiguerra, and Manno di Benincasa 'dei Cori' was the husband of his aunt Niccolosa. Giuliano da Maiano had married Maddalena di Antonio Finiguerra in 1454. See also Carl 1983, p. 509 ff.; Melli 1995, pp. 9–10.

61. Haines 1983, pp. 164–5 and 186–8; Kubiak 1974, p. 4.

62. For the various interpretations of Baldovinetti's record, see Kennedy 1938, *op. cit.* at n. 56, pp. 25–8 and 236; Goldsmith Phillips 1955, pp. 3–4; Kubiak 1974, pp. 4–5; Hind 1936, p. 9; Melli 1995, pp. 10, 15, no. 57.

63. Kennedy 1938, *op. cit.* at n. 56, pp. 26–8.

64. Vasari-Milanesi, **5**, pp. 395–6 (Life of Marcantonio Bolognese). See also Reid 1869, *op. cit.* at n. 8, p. v; Hind 1936, pp. 8–9; Oberhuber 1973, pp. 528–9; Kubiak 1974, p. 174.

65. See Goldsmith Phillips 1955, pl. 18; Blum 1950, no. 25.

66. Lanzi, L., (1834), *Storia Pittorica della Italia*, 3 vols, Florence, **1**, p. 76–7; Kubiak 1974, pp. 59–60.

67. British Museum 1845-8-25-104–110; 1845-8-25-111–118 and B.7. See Hind 1936, pp. 38–40, cats. 134–40, 142–50, pl. XIX and XX.

68. Vasari-Milanesi, **5**, pp. 396.

69. Carl 1983, p. 540.

70. For the *Crucifixion* pax, see Hind 1936, pl. IIc; Hind 1938–1948, **1**, p. 4; Goldsmith Phillips 1955, pl. 9. Regarding the similarities to the E.S. print (Lehrs 1925, *op. cit.* at n. 51, **2**, pp. 208–9, no. 146), see Holmes 1983, pp. 42–44, who cites details which are similar, like the shape of the horse's head, the nails in the hooves and the type of armour worn by the rider.

71. Blum 1950, no. 25.

72. Vasari-Milanesi, **1**, p. 209.

73. Carl 1983, p. 540.

74. Hind 1938–1948, *Deluge* (B. III 1 and 3), **1**, pp. 136–7, **3**, pls. 197, 199; *Moses on Mount Sinai*, (B. III. 5.), **1**, pp. 138–9, **3**, pl. 201a and b.

75. *Ibid.*, pp. 304–9, App. I.g. See also Oberhuber 1973, pp. 47–62; Landau and Parshall 1994, pp. 12–13.

76. Hind 1938–1948, *Conversion of St Paul*, (A II. 10) and *Judgement Hall of Pilate* (A. II. 9), **1**, pp.66–7, **2**, pl. 94, pl. 55.

77. *Ibid.*, B. III. 2; B. III. 4; B. III. 6, **1**, pp.136–8, **3**, pl. 198, 200, 202, 203; Zucker 1993–4, **24**, pt.2, pp. 74–85.

78. Kubiak 1974, pp. 116–7; Landau and Parshall 1994, pp. 73 and 83; Zucker 1993–4, **24**, pt. 2, pp. 76, 79.

79. Landau and Parshall 1994, p. 110.

80. British Museum 197 d.3. See Colvin 1898 (1980), *op. cit.* at n. 1; and Degenhart and Schmitt 1968, **4**, pls. 385–439a; Whitaker 1986; and 1994, pp. 181–96 (see p. 181 for a bibliography of the *Chronicle*).

81. Vasari–Milanesi, **5**, pp. 395–6. On the basis of statements made by Vasari, it is generally accepted that Baldini executed the 19 engravings which illustrate an edition of Dante, published in 1481 with a commentary by Cristoforo Landino. A large proportion of the Fine Manner engravings are in the same style as the Dante illustrations and have been attributed to Baldini. See Hind 1938–1948, **1**, pp. 9–10; Oberhuber 1973, pp. 13–21; Kubiak 1974, pp. 109–23; Whitaker 1986, pp. 45–80; and 1994, pp. 181–96; Zucker ed. 1993–4, **24**, pt. 1, pp. 89–93.

82. Dreyer, P., (1984), 'Botticelli's Series of Engravings of 1481', *Print Quarterly*, **2**, pp. 111–5.

83. Hind 1938–1948, **1**, A. III, 1–9, pp. 77–83; **2**, pls 114–31; Zucker ed. 1993–4, **24**, pt. 1, pp. 94–126.

84. Hind 1938–1948, **1**, p. 80, A. III. 3a, **2**, pl. 118.

85. Degenhart and Schmitt 1968, **2**, p. 610, fig. 937; Kubiak 1974, pp. 109–23.

86. Hind 1938–1948, **1**, pp. 155–8; M. Holmes 1983, pp. 49–68; Zucker ed. 1993–4, **24**, pt. 1, pp. 159–218.

87. Whitaker 1986, pp. 14–18; and 1994, pp. 183–4.

88. Degenhart and Schmitt 1968, **4**, pl. 433.

89. Ibid., **2**, p. 600, fig. 888.

90. Ibid., **2**, p. 600, fig. 887; Oberhuber 1973, p. 16; Whitaker 1986, pp. 45–52; and 1994, pp. 191–2.

91. Degenhart and Schmitt 1968, **4**, pl. 412.

92. Ibid., **4**, pl. 420.

93. Ibid., **4**, pl. 415.

94. Ibid., **4**, pl. 419.

95. Whitaker 1986, pp. 24–29; and 1994, pp. 185–7.

96. Kubiak 1974, pp. 1–14; Carl 1983, pp. 509–18; Melli 1995, pp. 7–16 and n. 50.

97. Kubiak 1974, p. 6; Carl 1983, pp. 516–7; 549–50.

98. Kubiak 1974, p. 6; pp. 169–70; Melli 1995, p. 16, n. 74.

99. Kubiak 1974, p. 13; n. 18; Carl 1983, pp. 527–9, doc. 10; p. 531, doc. 13.

100. Carl 1983, pp. 510–1.

101. Ibid., pp. 516, 547–8.

102. Hind 1938–1948, **1**, pp. 61–62, no. A. II. 2, **2**, pl. 87; Zucker ed. 1993–4, **24**, pt. 1, pp. 242–3.

103. Ibid., **1**, pp. 119–29. no. B. I. 1–17.; **3**, pls. 172–90.

104. Ibid., **1**, pp. 120–1; Landau and Parshall 1994, pp. 82–3.

105. Most of the prints of this type that survive were owned at one stage by Ernst Peter Otto (1724–1799) and are now in the British Museum. See Hind 1938–1948, **1**, pp. 85–96, A. IV. 1–42; **2**, pls 132–58; Oberhuber 1973, p. 15; Zucker ed.1993–4, **24**, pt. 1, pp. 127–57.

106. Hind 1938–1948, **1**, p. 160; Landau and Parshall 1994, p. 95; Bury, M., 'The taste for prints in Italy to c.1600', Print Quarterly, **2**, 1985, p. 13, n. 8.

107. Landau and Parshall 1994, pp.64–102; Oberhuber 1973, pp.xiii–xviii and 15; Bury 1985, op. cit. at n. 106, pp. 12–26.

108. Hind 1938–1948, **1**, pp. 2–3; Oberhuber 1973, pp. xvii–xviii, pp. 47–62; Landau and Parshall 1994, pp. 72–74; Zucker 1993–4, **24**, pt. 2, p.4.

109. Dreyer 1984, op. cit. at n. 82, pp. 111–5; Landau and Parshall 1994, p. 108.

110. Hind 1938–1948, **1**, pp. 32–36, A. I. 18–23; **2**, pls 18–23; Zucker ed. 1993–4, **24**, pt. 1, pp. 37–51.

111. Hind 1938–43, **1**, p. 82, A. III. 6,a; Zucker ed. 1993–4, **24**, pt. 1, pp. 115–8.

112. Hind 1938–1948, **1**, p. 34, no.A. I. 18; **2**, pl. 18. For Apollonio di Giovanni's Triumph of Scipio Africanus (Cambridge, Fitzwilliam Museum), see Callmann, E., (1974), Apollonio di Giovanni, Oxford, pl. 55.

113. Degenhart and Schmitt 1968, **4**, pl. 407.

114. Hind 1938–1948, **1**, pp. 32–34; Zucker ed. 1993–4, **24**, pt. 1, pp. 29–72.

115. Carl 1983, p. 519.

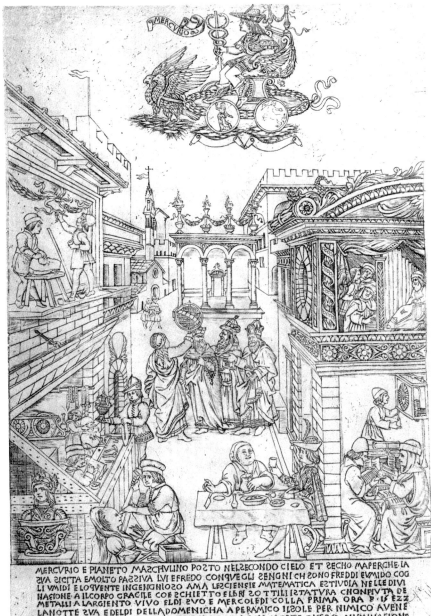

4.1 Baccio Baldini, *The Planet Mercury*, engraving.

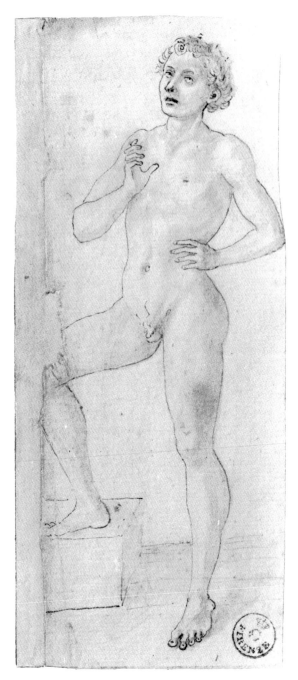

4.2 Maso Finiguerra, *Male nude with one foot resting on a plinth*,
pen and brown ink, brown wash over traces of black chalk
on paper.

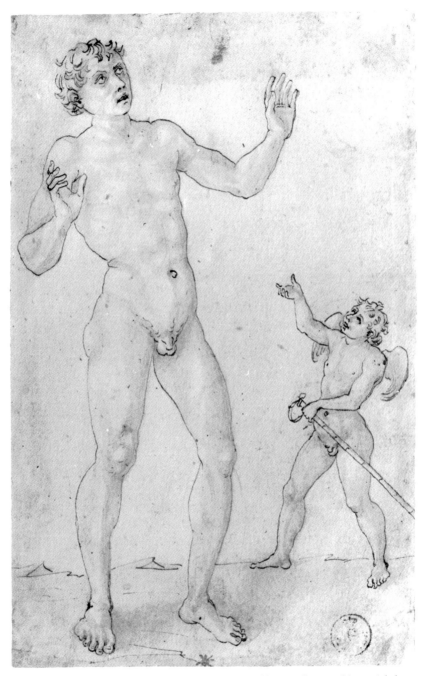

4.3 Maso Finiguerra, *Male nude with raised arms and a putto holding a staff*, pen and brown ink, brown wash over traces of black chalk on paper.

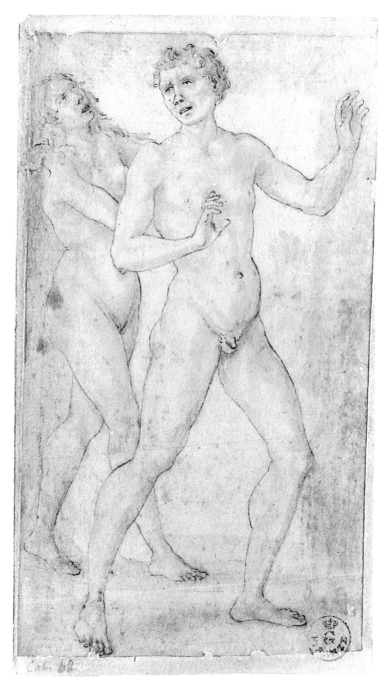

4.4 Maso Finiguerra, *Adam and Eve*, pen and brown ink, brown wash over traces of black chalk on paper.

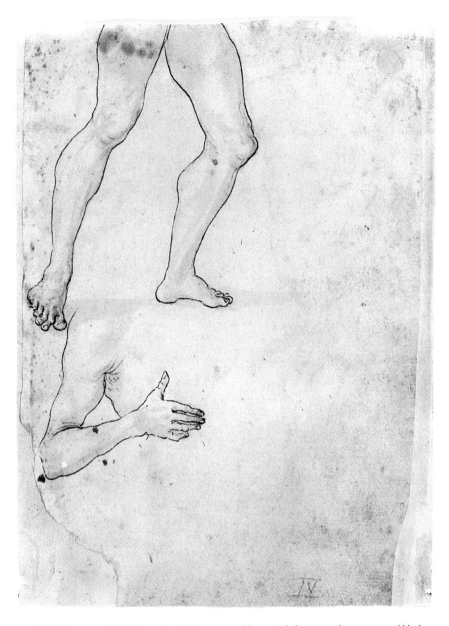

4.5 Maso Finiguerra, *Study of legs and a right arm*, pen and brown ink, brown wash over traces of black chalk on paper.

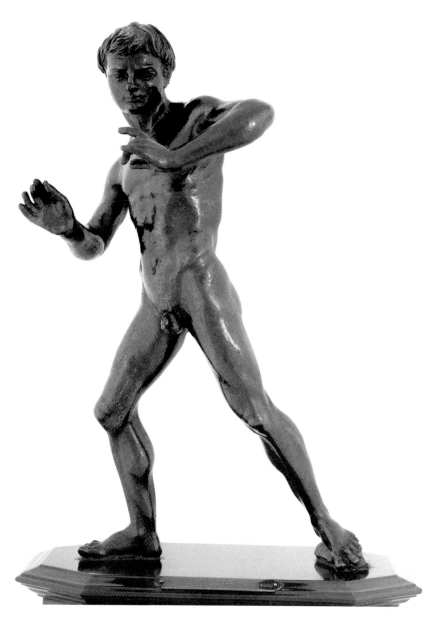

4.6 Antique statue of *Marsyas*, bronze.

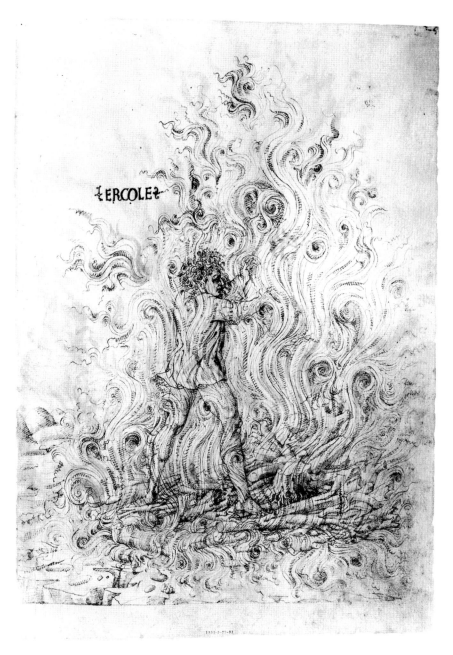

4.7 Baccio Baldini and workshop, *Death of Hercules*, pen and ink, brown wash over traces of black chalk
on paper.

Mantegna and Pollaiuolo: artistic personality and the marketing of invention

Alison Wright

The contributions of Andrea Mantegna and Antonio Pollaiuolo to the development of graphic *invenzione* have long been considered important in the study of early Italian prints. This field attracted considerable scholarly attention earlier this century,[1] and the subject has again been opened up to fresh and vigorous debate as a result of important new studies published during the 1990s.[2] This paper, although emerging from the study of Antonio Pollaiuolo, also coincides with some of the issues raised in both the old and the new literature.

To define the terms used in the paper's title, the idea of an artistic personality is understood as the projection of the various characteristics of an artist's interests, affiliations and aims through his work as a whole, taking into account both stylistic and functional preoccupations. While I am not able here to develop a very detailed picture, to speak of an artistic personality in relation to the work of Mantegna and Pollaiuolo seems especially justified since both artists appear to have had a heightened consciousness of the need for, and the increasing possibility of, control over the direction of their careers and over the type of work that they produced. This concern on the part of both artists may be read from a number of factors – their respective understandings of the different levels on which a relationship with a patron might operate, the development of new and distinctive artistic genres as outlets for their abilities, and the cultivation of a highly personal style.[3]

In the sense in which I wish to define it, artistic personality is also a phenomenon bound up with the market for art. Thus this 'personality' does not represent any kind of transparent self-expression. Although it would be fair to argue that Mantegna and Pollaiuolo attempted to fulfil their personal goals and may also have felt some restriction attached to traditional forms and subjects (Pollaiuolo's preference for new types of secular subject matter

is particularly striking), in the context of this paper I wish rather to emphasize a more pragmatic consideration which had a bearing on their stimulus to invent. The projection of an apparently original, or at least distinctive, vision was advantageous if one hoped to capture the interest of the most influential and often highly discerning patrons. This type of distinctiveness was not simply a reflection of the traditional need for an artist to develop an independent style along the lines referred to by Cennino Cennini.[4] In the competitive and expanding late quattrocento market for art, the ability to invent, to please with original ideas – both in form (new types of object) and in substance (new types of subject) – set artists like Mantegna and Pollaiuolo, as well, of course, as others such as Sandro Botticelli and Andrea del Verrocchio, on a different competitive footing from certainly successful but more conservative artists such as Neri di Bicci or Alesso Baldovinetti.

The approaches of Mantegna and Pollaiuolo to the new medium of the print, which is the main focus of this paper, present a particular problem in this respect. Very little is known about the market that the sort of complex, large-scale engravings pioneered by these two artists were designed either to stimulate or to respond to. Why were such engravings made? To whom were they really directed? How much did the two personalities owe to one another as printmakers? I hope to address some of these questions through a comparative study which, rather than attempting to be comprehensive, will highlight some of the debate's central considerations.

In an earlier paper I emphasized how important the contemporary defini-tion of Maso Finiguerra and Pollaiuolo as 'maestri di disegno' is in under-standing their role and development as artists.[5] My concerns here complement that study by bringing Pollaiuolo's work as a draughtsman, designer and printmaker into relation with that of Andrea Mantegna, his exact contemporary. In contrast to Pollaiuolo's rather unfair eclipse of Maso in the eyes of posterity, Pollaiuolo has become rather the poor cousin in relation to Mantegna. The bias towards the study of painting and preference for Mantegna's superior intellectual powers bear a large responsibility for this. The imbalance would seem to be born of a sense of two very different artistic personalities with, to a large degree, differing ambitions and pre-occupations. Mantegna was always first and foremost a painter, often seeking to imitate and surpass the achievements of sculpture and archi-tecture in his painted work. On the other hand, Pollaiuolo, principally a goldsmith, much of whose work has been lost, seems quite self-consciously to have sought mastery in a wide variety of media. He was encouraged in this partly through his exposure to a broad range of patrons, from guild *operai* to popes. But these divisions are perhaps more apparent than real. Mantegna also worked for the papacy, Pollaiuolo also appealed to princely

tastes. Mantegna had a deep interest in sculpture and was involved in all aspects of *disegno*, including architecture. He provided drawings for gold-smiths' work and perhaps even designed sculptural models, all activities more commonly associated with Pollaiuolo.[6]

So it is in their relationship to the art of *disegno* that the aims and activities of Mantegna and Pollaiuolo seem to have converged most closely. In Florence, *disegno* was the intellectual pursuit *par excellence* of the aspiring artist. Mantegna, through his training in Padua and his familiarity with the drawings of Jacopo Bellini, for example, would also have been aware of the increasing importance of drawing as an investigative procedure and source of new ideas. It is significant that Mantegna's incomparable responsiveness to Leon Battista Alberti's dicta in *De Pictura* is perhaps most obviously manifested in his *disegno*, as it is with his father-in-law, Jacopo Bellini. The *Entombment* engraving (Figure 5.1) is the most frequently cited example of Mantegna's understanding of what Alberti considered to be exemplary in an *historia*.[7] Pollaiuolo's relationship to Albertian ideas is perhaps less easy to define. His idiosyncratic approach to perspective and the comparative lack of *grazia* and emotional subtlety of his figures are apparent even when his love of *varietà* and representational ambitiousness are at their most obvious, as in the *Martyrdom of St Sebastian* altarpiece (London, National Gallery).[8]

But the preference for drawing, defined in Lorenzo Ghiberti's words as the 'fondamenta e teorica' of all artistic endeavour,[9] had been a relative com-monplace in Florence from at least the time of Cennini's *Libro dell'Arte*.[10] Pollaiuolo's training as a goldsmith – perhaps under Ghiberti himself – would constantly have affirmed this credo, and it is no coincidence, as David Landau and Peter Parshall point out, that the earliest Florentine printmakers were all goldsmiths.[11] In Padua, where Francesco Squarcione's *studium* of painting was promoting the latest artistic developments, Mantegna emerged as perhaps the first producer of independent engravings in Italy.

One enters highly contested ground in broaching the issue of Mantegna's career as a printmaker. The whole question of the degree of the artist's personal involvement in the production of prints from his designs has been energetically debated.[12] Landau and Parshall discuss some of the familiar issues but add especially useful observations concerning the market for prints.[13] My own position is aligned with that of Keith Christiansen and David Landau in considering that the registering of the master's own hand, and not that of executant assistants, in the draughtsmanship of the 'core' corpus of Mantegna's printed works (as first defined by Paul Kristeller) is critical to an understanding of their initial function.[14]

Certainly Mantegna's hypothetical exposure to print production in Flor-ence in 1466 – possible previous experience of the print trade in Padua notwithstanding – could have provided him with an early introduction to

the possibility of producing designs for others to engrave. But one of the most striking features of his prints is the careful manner in which they seek to reconstruct a highly refined drawing style. If, at least at the outset, Mantegna saw prints as a means of reproducing drawing skill to a slightly extended spectatorship, then the registering of his own hand in the engraving of the plates would be a significant factor in their appeal. The phenomenon of the printed replication of his designs, both under his direct supervision and outside his control, seems to mark a more sophisticated development, an approach to the advantages of the print that it is unlikely would have been immediately sought by an artist while he was still investigating the full formal possibilities of the medium. The delicate early states of prints such as the *Entombment* and the later *Seated Virgin and Child*[15] seem to have been produced in very few impressions and must surely have been conceived as works of art in their own right. Such objects were precious both as designs by Mantegna's hand and as outstanding examples of the new medium of engraving.

Can a comparison with Pollaiuolo's experimentation in the genre, restricted apparently to the famous *Battle of Nude Men* (Figure 5.2),[16] be instructive with regard to this issue? To begin by looking at what the physical characteristics of the print can tell us, the first question to ask is to what extent does Pollaiuolo's engraving imitate his drawing style? Landau and Parshall note that the technique of parallel hatching used in the *Battle* engraving is not common in Florentine quattrocento draughtsmanship. Pollaiuolo, like Maso Finiguerra, who probably influenced him in this respect, placed great emphasis on contour in his work, and, rather than using extensive hatching in his drawings, frequently employed an ink wash to indicate tonal contrast. The number of his surviving drawings with hatching is limited; a list would include the *Nude man seen from three angles* (Paris, Louvre, 1486) but would omit, in my view, the well-known *St John the Baptist* (Florence, Uffizi, 699E),[17] which seems to be by a less controlled hand, probably that of the artist's brother, Salvestro, who appears to have signed it. In fact, Antonio Pollaiuolo's concern with contour apparently led him, on occasion, to abandon internal modelling altogether, as with the so-called *Prisoner led before a Judge* (London, British Museum, 1893–5–29–1; Figure 5.3).[18]

When Pollaiuolo came to design the *Battle* engraving he would have had to make a deliberate decision to follow what seemed to him to be the most effective means of reproducing a broad range of tonal contrasts on the copper plate, even when it was not completely compatible with his usual pen style. The effect he sought to register in the delicate first state of the engraving, now only existing in one impression, gives, from a distance, the illusion of the figures being modelled by an internal wash. Viewed at close

range, individual lines which recall a hatched pen technique become apparent. These lines utilize a 'return stroke' effect, with one end of the line forming a small 'v', which emphasizes the extremity of the muscles.[19] This type of 'near-parallel' hatching, which becomes much more exaggerated in the cruder second state of the engraving, is only used in a very limited way in Pollaiuolo's surviving work in pen. Thus, the adoption and adaptation of a more consistent parallel-hatching technique through all elements of the *Battle* engraving strongly suggests to me that Pollaiuolo knew an engraving by Mantegna which could have provided him with a model.[20]

Curiously, Kristeller, who pointed out the relationship between pen drawing and the development of early prints, argued for the opposite, proposing that Mantegna acquired his engraving technique from Pollaiuolo.[21] But Kristeller's position seems to have been governed by his belief that Mantegna only became involved in the making of prints quite late in his career. Also, setting aside those drawings which may have been designs for engravings, Mantegna's disposition as a draughtsman towards the use of parallel hatching is certainly more apparent than that of Pollaiuolo.

The question of when Pollaiuolo became aware of Mantegna's activities as a printmaker raises the problem of the function of early engraved prints. Pollaiuolo appears to have had access at an early date, perhaps by the later 1450s, to prints produced both in Florence and in Northern Europe. Indeed, the influence of Northern engravings upon the development of Pollaiuolo's pictorial mannerisms, particularly in his treatment of drapery, is difficult to overlook.[22] Evidence from documents, from choice of subject matter and the wide geographical transfer of motifs found in prints, points to two significant forces in the market for early engraved prints. One of these was their use in artists' workshops. Another was the considerable demand from a broader public for comparatively inexpensive devotional images. The vast majority of the prints known to Pollaiuolo would have been of religious subjects with a more or less didactic function.

Regarding the use of prints in goldsmiths' and painters' workshops, it is clear that Pollaiuolo was more than keen for his designs to be seen and appreciated by other artists. The production of competitive designs was a traditional strategy for assuring quality in the Florentine commissioning system, and Pollaiuolo would have been familiar with the general scrutiny of his drawings from his involvement in numerous public decorative works.[23] Indeed the concern that his skill as a draughtsman be recognized and his designs firmly associated with his name is an aspect of his artistic personality which seems precocious even in Florence. The convention of the signature on paintings and sculpture was of course well established and increasingly exploited during the early Renaissance, but at that date it was

rare indeed for an artist to sign his own drawings, as Pollaiuolo did on at least one occasion. Elegantly romanized inscriptions with the artist's name and the date, like those on finished works of art, appear on various drawings of *Judith with the head of Holofernes* by or after Mantegna.[24] But Pollaiuolo's drawing of a thurible (Florence, Uffizi 942E) bears his handwritten signature as a testimony to his authorship of the design.

With this kind of self-consciousness as a designer, it is hardly surprising that when confronted with the possibility of stamping his authorial presence on a print (the monogram was, after all, a familiar element in Northern prints), Pollaiuolo devised the ambitious idea of transferring to the engraving the form often taken by the signature of unique works of art. In the *Battle of Nude Men*, he formulated the highly influential device of a large *all'antica* ansate tablet, shown hanging casually but prominently from a tree, within which he inscribes his name, his responsibility for the engraving and his city of origin, OPUS. ANTONII. POLLAIOLI. FLORENTINI. His name appears in Latin and as though inscribed in marble. There could be few more overt adaptations of a recognizable language of fame derived from the antique.

This does not seem to me to be a statement addressed only to other artists. Nor perhaps is the scale of the print compatible with the types of engraved patterns usually circulating in Italian *botteghe*. The design has been engraved on a very large plate, measuring 406 × 607 mm, which would occupy almost a complete *foglio reale* (445 × 615 mm). Most unusually, its subject was not intended to appeal to the pre-existing market for devotional prints. The engraving depicts an uncommonly large number of figures equipped as ancient gladiators in furious battle. Their nudity and anatomical ambitiousness, together with their exaggeratedly animated movements and facial expressions, represent a veritable manifesto of Pollaiuolo's dominant preoccupations as an artist.

How did Pollaiuolo arrive at such an ambitious treatment of the print? There seems to be very little evidence that he progressed gradually towards this master work. John Goldsmith Phillips's attempt to define a whole body of niello and other prints as by Pollaiuolo is unconvincing inasmuch as his examples are clearly not by Pollaiuolo's hand, even though some may reflect his designs.[25] Whatever their status, it is clear that they do not form part of the same agenda apparently proposed by the *Battle* print. It seems more credible that a powerful outside influence, probably effected in the late 1460s or early 1470s, stirred Pollaiuolo to experiment with engraving.[26] The fact that he apparently chose not to repeat the experiment seems only to strengthen this view. While one has to take into account stylistic anomalies created by the difficulty of the medium, the late 1460s would seem to be a likely date for the engraving, which is considerably later than the Palazzo Medici *Labours of Hercules* canvases, [27] but some time in advance of the 1475

Martyrdom of St Sebastian altarpiece with its more refined figural draughts-manship.

The question of influence brings us back to Mantegna's engravings. On stylistic and technical grounds, his *Entombment* engraving has been convincingly dated to the later 1460s and it is thus possible to conjecture that designs of the quality of the *Passion* engravings could have acted as a powerful stimulus for Pollaiuolo's desire to establish his own design skills in this broader arena.[28] A willingness to compete would explain why Pollaiuolo seems to have given himself such a difficult task in this apparently isolated venture into the new medium. While the scale of the *Battle* print surely reflects that of Mantegna's engravings, which were close in size to small paintings, the emotional pitch of the Pollaiuolo design is much less subtle and partially reflects his surprising choice of subject, which abandons the religious themes virtually standard in the market for early prints. Instead, Pollaiuolo allowed full rein to his predilection for the nude figure in action, which he had established in his classicizing treatment of the *Labours of Hercules* paintings.

In a further act of remarkable self-assertion, Pollaiuolo apparently also invented the *historia* of the *Battle of Nude Men*, partly, no doubt, in order to choose the protagonists and devise a setting to satisfy his own artistic preferences. The *Battle* engraving has stubbornly resisted any attempt to be read in relation to a particular text, although I would reject the idea, proposed by Leopold Ettlinger, that it has no real meaning beyond its form.[29] The consistently moralizing and didactic nature of images in the period, and particularly those in the *milieu* of the print, suggests rather that Pollaiuolo's design could also have been read on a didactic level. Indeed the *Battle* print makes more sense as a product of the period if it is seen as an *invenzione* in terms of both its design and its meaning, since the two were so closely linked in fifteenth-century art theory. An obvious example of the importance of this interconnection in the Renaissance is provided by the interest, both theoretical (Alberti) and artistic (Mantegna and Botticelli), in the *Calumny of Apelles* painting which was described by Lucian as an inventive subject embodied in an inventive design.

It might be argued that Pollaiuolo was not a learned artist and indeed that, in contrast to the *Calumny*, his invention has no apparent narrative centre or progression. But, although he may not have shared the same intellectual circle of poets and humanists as Mantegna, we know that he was well-acquainted with Marsilio Ficino, for example, and would have had the opportunity of receiving learned advice in Medicean Florence and later at Urbino. As Alberti himself counselled, Pollaiuolo may have sought some learned figure to help him in his invention.[30] Patricia Emison has attempted to read the *Battle* engraving as a type of *poesia* inspired by humanist thinking

which allowed for a play of meanings to create the visual equivalent of a poetic text.[31] Certainly, the idea that the *Battle* engraving, with its inventive use of associative signs – the chains, the apparently sacramental corn and vine, for example – provides a moral framework for the savage battle of irrational ferocity, seems much more comprehensible as a creation of the early Renaissance than Ettlinger's pure 'pattern-book' theory.[32] Emison's view also has implications for the question of the market, to which I shall return.

A further encouragement to the idea that the *Battle* print represents some sort of moralized conception is provided by a compositional drawing in Turin, apparently copied after a design by Pollaiuolo (Figure 5.4).[33] Here a vicious battle of nudes is linked to a scene of captivity and love. The left half of this composition exists in the form of a print known as the *Hercules and the Giants*, seemingly the work of a second-rate Paduan engraver, and was also copied virtually in its entirety by the Northern engraver Alaart Claas.[34]

The drawing of *Battling Figures* by Pollaiuolo (Cambridge, Mass., Fogg Art Museum, 1940.9; Figure 5.5), certainly represents part of this design.[35] As Lilian Armstrong has pointed out, a version of this composition was certainly known in Northern Italy by 1469 (when motifs from it were reflected in a datable Venetian miniature) and this information may also favour a 1460s dating for the *Battle* engraving which is so similar in its conception and interests.[36] Evidence that a design by Pollaiuolo was in Squarcione's Paduan workshop at an early date is provided by a document stating that the sheet (*cartonum*) had been taken and not returned by Giorgio Schiavone, together with other work belonging to Squarcione.[37] As Schiavone had definitely left the workshop by 1462, and probably earlier, it seems unlikely that the work, described as 'unum cartonum cum quibuscum nudis Poleyoli', was an engraving. It is even possible that the drawing was the one that later provided the basis for the *Hercules and the Giants* engraving. At any rate it is not clear how Squarcione had acquired the sheet in the first place, although he seems, in general, to have been assiduous in procuring artistic exemplars of various kinds from which his pupils could make their own drawings.[38]

Whether Pollaiuolo intended to make any other engravings, aside from the *Battle of Nude Men*, cannot be conclusively established. The subtle tonal range of the first state utilizes the aforementioned 'return stroke', an effect Landau claims is only possible with drypoint, and indeed the effect is quite different from the harsh contrasts of tone in the second state, which create a disturbing confusion between internal modelling and contour that seems quite alien to Pollaiuolo.[39] The likelihood that the plate was recut 'by popular demand', as Louise Richards has suggested, in order that more copies could be printed, indicates that Pollaiuolo himself had decided to allow continued exploitation of the image.[40] There seems little doubt that he would have

found a market eager for further inventions had he decided to create them. Also, given his success with the *Battle* print, had other engravings by Pollaiuolo existed it seems unlikely that none would have been preserved.

The possibility that he may have contemplated further print exploits is raised by the survival of more than one large-scale Pollaiuolo drawing in an unusual technique. The curious tonal restriction of the British Museum's *Prisoner led before a Judge* could suggest that Pollaiuolo was using this sort of drawing to fix the contour of a design, the details of which would require special attention because of the technical problems of applying the internal modelling to the copper plate. For example, the engraver of the so-called *Hercules and the Giants* print seems to have filled in the modelling within the contours, as seen in a drawing like the Fogg Art Gallery's compositional fragment, employing an anatomical rendering much cruder than that in Pollaiuolo's *bona fide* engraving, the *Battle of Nude Men*. However, I believe that the lack of internal modelling in Pollaiuolo's design is also part of the aesthetic of the drawing.[41] One can at least say that the idiosyncratically classicizing treatment of the subject, in which not only the youthful figures but even the 'judge' or king are shown nude, puts the invention into the realms of the allegorizing *historia*. Indeed the design closely recalls Mantegna's so-called *Virtus Combusta* which exists both as a drawing in its own right (a fact confirmed by the application of colour to elucidate the narrative), and as the model for an engraving.[42]

Thus far in this paper, I have emphasized the likely impact on Pollaiuolo of Mantegna's early work as a printmaker. This seems to be apparent from the scale of Pollaiuolo's *Battle* engraving, and from its technique, which adapts an effective Mantegnesque parallel-hatching stroke. The influence may also extend to details like the striated, rock-strewn ground that recalls, for example, the foreground setting of Mantegna's *Entombment with the Four Birds*.[43]

It has been convincingly argued that the subject matter, apparent technical progression, and style of Mantegna's *Passion* prints make it likely that they were the earliest engravings he made. Of this group, the horizontal *Entombment* (Figure 5.1) is the most formally advanced and most classicizing in treatment. Nonetheless, the series of paired engravings – the *Battle of the Sea Gods*, the *Bacchanals*, the *Virtus Combusta et Deserta* – representing mythological or classicizing subjects, with large-scale figures organized in a restricted foreground plane, mark a striking departure. To a large extent, the formal arrangement of figures set against a dark background in the manner of a frieze is suggested by the incorporation within the new subject matter of figures taken directly or indirectly from sources such as classical sarcophagi. But where did the stimulus to address the new secular subject matter in the print format come from? Landau has suggested verbally that one clue may

be provided by a second meaning associated with the tablet held up by the hag Invidia in the *Battle of the Sea Gods*. This echoes the tablet in Pollaiuolo's *Battle* engraving, and, at one level, Mantegna's print could be seen as a response to his own artistic *invidia* of Pollaiuolo. The idea of a veiled reference to artistic competition, though impossible to prove, would be characteristic of Mantegna's intellectual game-playing and would be particularly appropriate given the theme of the print as a whole. A possible source for its subject has been found in the description of the artistic envy of a race of sculptors referred to in both Strabo's *Geographica* and Nonnus's *Dionysiaca*. Seen in such a light, this classicizing artistic *invidia* may also support the possibility of a playful contemporary reference.[44]

Konrad Oberhuber had already argued for Pollaiuolo's influence on Mantegna's mythological prints on the basis of their technical characteristics.[45] Starting with the *Bacchanal with a Wine Vat*,[46] and finding full expression in the *Battle of the Sea Gods*, they show a tendency to a much more definite emphasis on contour, with the internal hatching strokes being placed further apart. If this is the case, such characteristics would suggest that Mantegna knew the second state of Pollaiuolo's *Battle* engraving rather than the 'Fine Manner' first state. Whatever the situation, elements of the *Battle* engraving recur in the backdrop of tall vegetation in both the *Bacchanal with Silenus* and the *Battle of the Sea Gods*, as well as in the tablet hanging from the vine-encircled tree in the *Bacchanal with a Wine Vat*.[47] This last detail seems to be particularly telling since, curiously, the signature has been left out – an unlikely omission had the idea been Mantegna's own invention.

It is not difficult to see what drew Mantegna to mythological subject matter as an appropriate focus for his skills in *disegno*. As with Pollaiuolo, mythologies provided him with the possibility of depicting the nude figure in often violent action and from a variety of difficult angles, thereby enabling him to rival the possibilities of sculpture in the round as well as the classical reliefs he so much admired. The mythological prints also permitted a much greater freedom of intellectual play than was possible with the *Passion* compositions. This is especially apparent in the *Battle of the Sea Gods* which, in its inventive relationship to the theme of Envy, seems to have a real thematic affinity with the *Calumny of Apelles*. The way Apelles' *historia* of the Calumny used personifications of virtues and vices to present a moralizing invention on the theme of ignorance and folly found an even more direct counterpart in Mantegna's designs of *Virtus Combusta et Deserta* which were engraved as pendant prints.[48] Here the enthroned figure of Ignorance/Fortune is easily recognizable as the same figure who stands on Midas' left-hand side in Mantegna's British Museum *Calumny* drawing. In conclusion, Mantegna's later mythological prints, dated by Oberhuber to the 1470s (plus the *Virtus Combusta et Deserta* – although not engraved by Mantegna

himself) seem, to a large extent, to share the formal and thematic concerns which I would argue were first posited in Pollaiuolo's *Battle of Nude Men* engraving.

One of the most obviously pertinent questions raised by these prints is who were they for? We are most clearly aware of one area of the market from the substantial evidence that other artists copied them, 'lifted' motifs from them, and possibly even stole them. Christiansen has briefly discussed some of the widely varying contexts in which motifs or whole compositions from Mantegna's prints are repeated.[49] Many of these contexts are North Italian, but the most famous example of artistic homage to Mantegna is that paid by Dürer who, on his first trip to Venice, copied the *Battle of the Sea Gods* virtually line for line. I have already outlined how Pollaiuolo and Mantegna seem to have been mutually impressed with each other's engravings, and this may have been their principal means of artistic contact prior to them both working in Rome.[50]

The case of the *Battle of the Giants* engraving indicates to some extent that the market for high-quality prints was not an easy one to control, but the question of how artists benefited from other artists' admiration of their work is a complex one. Fellow practitioners could hardly be seen as 'patrons', since little financial gain could result from this sort of spectatorship, while the potential for loss was undoubtedly great. Drawing skill was an extraordinarily valuable commodity. It could certainly help to procure much wider artistic recognition, as seems to have been the case with both Maso Finiguerra and Pollaiuolo, but it appears that no sort of copyright was attached to it. This was presumably not a problem when the circulation of well-finished drawings in artists' workshops was restricted by the limited numbers that could be produced at one time. However, these drawings may well have been 'mined' for ideas that would subsequently be completely transformed in 'new' finished works.

Inevitably, with the advent of the print it literally became possible to reproduce another artist's invention in the way that the Paduan engraver did with Pollaiuolo's design, now known through the Fogg fragment and the Turin drawing.[51] It was partly in order to answer the question of what happened next in such circumstances that many scholars, including Paul Kristeller and Arthur Hind, have wished to interpret the famous 1475 letter from the painter/engraver Simone da Reggio – in which he claims to have been physically threatened and falsely accused of sodomy by Mantegna – as evidence of Mantegna's furious response to the unauthorized use of his *invenzione*.[52] Although Simone obviously does not refer to the status of the engraved plates he was recutting for his friend Zoan Andrea, it can hardly be doubted from Mantegna's apparent reaction that he, as the inventor of the designs, perceived Simone's employment of them to represent some kind of

serious threat both to his artistic integrity, and, perhaps, to the market he had cornered.

The wide variations in quality and in the degrees of liberty taken in the large number of prints made from Mantegna's designs certainly indicate that many were not executed under his supervision. To date, and with Zoan Andrea having been eliminated, Giovanni Antonio da Brescia is the only figure who can be confirmed as working for Mantegna as an engraver of his designs, although the so-called 'Premier Engraver', who may in fact be more than one person, seems to have become another candidate.[53] These craftsmen would have worked with Mantegna's drawings either specially made for reproduction in print or, like the preparatory drawings for the *Triumphs of Caesar* canvases, designed for specific purposes.[54]

However, designs by Mantegna could also be absorbed into the oeuvres of engravers presenting themselves as independent. Giovanni Antonio da Brescia signed a number of prints closely based on Mantegna's designs, one such being the *Hercules and Antaeus with a Club*.[55] Although such images were effectively Mantegna's inventions, the perception of them by the various engravers may not have been far removed from that of Girolamo Mocetto, in whose *Calumny of Apelles* print the characters from Mantegna's British Museum drawing appear deposited rather crudely onto the new setting of Piazza San Giovanni e Paolo in Venice.[56] Similarly, at one remove from the source image, the late fifteenth-century engraver Cristofano Robetta transferred Pollaiuolo's *Hercules and Antaeus* and *Hercules and the Hydra* designs to a rocky landscape with the addition, in one case, of a delightfully implausible baby.[57]

The issue of signature in this context is fascinating, since using a signature in the early years of print production could apparently mean a number of different things. Pollaiuolo's signature on the *Battle of Nude Men* declares not only that the work is his but surely also that he was responsible for the idea. Giovanni Antonio da Brescia's signature can only claim credit for the former. On the other hand, the independent painter and designer Nicoletto da Modena relentlessly signed his prints, presumably in much the same spirit as Pollaiuolo had done – as both designer and engraver.

Although addressed by Landau and Parshall in relation to the question of the market for prints,[58] this issue undoubtedly requires further research. An examination of the ways in which signatures have been omitted from, added to, or occasionally added and then removed from early Italian prints, might enable further conclusions to be drawn as to the extent to which the early Renaissance print was seen as independent work by the engraver. It might also help answer the question of whether intellectual copyright was in fact an issue when there seems to have been nothing to stop the designs of famous artists being blatantly pirated.

Landau and Parshall also examine the necessity of positing a spectatorship beyond that of other artists, which is another fundamental aspect of the print market that has a particular bearing on the secular prints by Mantegna and Pollaiuolo. While artists may certainly have appreciated the intellectual *invenzione* of the *Battle of Nude Men* print, when Mantegna and Pollaiuolo thought of the possible audience for their designs they could not have been blind to the enjoyment to be experienced in reading an image in the same way that one might appreciate the *invenzione* of a poem. Indeed it is more than likely that the inventions themselves emerged from discussions with figures such as the humanist Felice Feliciano, who was an early collector of drawings and a great admirer of Mantegna.[59]

Prints of the quality of those by Mantegna and Pollaiuolo were initially produced in very small numbers. Pollaiuolo only made a brief excursus in the genre. Although certainly eager for wider recognition of his skills as a draughtsman and visual inventor, he cannot have foreseen, or was simply not interested in, the immense potential of the medium. Moreover, in spite of the fact that engravings may have looked like highly finished drawings, few people who owned them could have had any idea of the difficulties involved, and of the time spent, in their production. As was the case with Pollaiuolo, Mantegna's abilities were constantly sought, and, given the pressure of other commissions, his attention to engraving was inevitably intermittent. But the pattern of his involvement with the medium suggests that he was increasingly and consciously coming to terms with the possibility of satisfying the wider demand for his designs that accompanied his increasing fame. And of course, because of the circulation of his prints, his fame was itself partially nurtured by the reputation of his engravings.

Paradoxically, given the tremendous success of Mantegna and Pollaiuolo as designers, it is easy to underestimate the vision and experimental daring that characterized their artistic personalities, especially as the concept of the value of pure *disegno* was still in its infancy. At a time when few people other than artists were interested in drawings as self-sufficient entities, the experiments of Mantegna and Pollaiuolo with the possibilities offered by the print as a precious, independent work of art seem all the more impressive.

Frequently cited literature

Kristeller, P.O., (1901), *Andrea Mantegna*, London and New York; Armstrong, L., (1968), 'Copies of Pollaiuolo's Battling Nudes', *Art Quarterly*, **31**, pp. 155–67, esp. 157–8; Levenson, J.A., Oberhuber, K. and Sheehan, J.L., (1973), *Early Italian Engravings from the National Gallery of Art, Washington*, Washington; Ettlinger, L.D., (1978), *Antonio and Piero Pollaiuolo*, Oxford; Landau, D., (1992), 'Mantegna as Printmaker', and Boorsch, S, (1992), 'Mantegna and his Printmakers' both in Martineau, J., ed., *Andrea Mantegna*, exh. cat., London (Royal Academy), and New York (Metropolitan Museum of Art): pp. 44–54 and 55–66 respectively; Christiansen, K., (1993), 'The Case for Mantegna as Printmaker', *The Burlington Magazine*, **135**, pp. 604–12; Cropper, E., ed., (1994), *Florentine Drawing at the Time of Lorenzo the Magnificent*, Papers of the Villa Spelman Colloquium, 1992, **4**, Bologna; Landau, D. and Parshall, P., (1994), *The Renaissance Print 1470–1550*, New Haven and London.

Notes

1. Kristeller 1901, chap. XI for Mantegna's engravings and p. 361 ff. for monochrome paintings and 'finished' drawings; Colvin, S., (1898; repr. New York, 1980), *A Florentine Picture-Chronicle*, London; Hind, A.M., (1938–1948), *Early Italian Engraving in the British Museum*, 7 vols, London, esp. **1** (1938), pp. 1–8 and **2** (1948), pp. 3–10; Goldsmith Phillips, J., (1955), *Early Florentine Designers and Engravers*, Cambridge, Mass.; more recently, Levenson, Oberhuber, and Sheehan 1973, esp. chaps V, VIII and IX.

2. Landau in Martineau ed. 1992; and Boorsch 1992; plus cat. entries. Also important are Landau and Parshall 1994; Christiansen 1993; and Landau, D., (1994), 'Printmaking in the Age of Lorenzo', in Cropper ed. 1994, pp. 175–80.

3. It is perhaps on similar grounds that Keith Christiansen described Mantegna as the most 'self-possessed' of major early Renaissance artists. See Christiansen 1993, p. 604.

4. Cennini, C., ed., Tempesti, F., (1975), *Il libro dell'arte o trattato della pittura*, Milan: chap. XXVII.

5. Wright, A., (1994), 'Antonio Pollaiuolo, "*maestro di disegno*" ', in Cropper ed. 1994, pp. 131–46.

6. For examples of Mantegna's involvement with non-pictorial projects, see Lightbown, R., (1986), *Mantegna*, Oxford: cat. nos 85, 184 and 199.

7. Christiansen 1993, pp. 604–5; Baxandall, M., (1971), *Giotto and the Orators*, London: pp. 127–34.

8. Ettlinger 1978, cat. 6, pp. 139–40, pl. 83.

9. Schlosser, J. von, ed., (1912), *Lorenzo Ghiberti's Denkwürdigkeiten, (I Commentarii)*, 2 vols, Berlin, **1**, p. 5.

10. Cennini, *op. cit.* at n. 4.

11. Landau and Parshall 1994, p. 9.

12. Landau in Martineau ed. 1992; Boorsch 1992; Christiansen 1993.

13. Landau and Parshall 1994, pp. 12–13.

14. Kristeller 1901. For the contrary view see Boorsch 1992.

15. For the *Seated Virgin and Child* as a mature work, see Levenson, Oberhuber and Sheehan 1973, p. 194.

16. For the *Battle of Nude Men* engraving, see the entry by Fusco, L.S., in Levenson, Oberhuber and Sheehan 1973, pp. 66–80; and Ettlinger 1978, cat. 15, pp. 146–7.

17. See Ettlinger 1978, cat. 37, pp. 161–2 for the *Nude man seen from three angles*, and cat. 29, p. 160, for the *St John the Baptist*.

18. For the *Prisoner* drawing, see Ettlinger 1978, cat. 35, p. 161 and Popham, A.E. and Pouncey, P., (1950), *Italian Drawings in the Department of Prints and Drawings of the British Museum: The Fourteenth and Fifteenth Centuries*, 2 vols, London: **1**, no. 224, pp. 136–8.

19. For this term, see Landau and Parshall 1994, p. 74.

20. The same conclusion is reached by Landau in Cropper ed. 1994, *loc. cit.* at n. 2, and specifically p. 177.

21. Kristeller 1901, pp. 215 and 380.

22. Holmes, M., (1983), *The Influence of Northern engravings on Florentine art during the second half of the Fifteenth Century*, unpublished M.Phil thesis, University of London (Courtauld Institute of Art): pp. 70–85.

23. An example of what is almost certainly a kind of *modello* for a figure of *Charity* by Antonio Pollaiuolo survives on the back of his brother's painting of *Charity* for the series of *Virtues* commissioned by the Mercanzia guild, now in the Uffizi.

24. The *Judith and Holofernes* drawings are discussed in Martineau, ed. 1992, pp. 439–42.

25. Goldsmith Phillips 1955, *op. cit.* at n. 1.

26. While I believe this influence to be that of Mantegna's prints, Landau has proposed that the engraving after a design by Pollaiuolo known as the *Battle of Hercules and the Centaurs* may, by its poor quality, have stimulated Pollaiuolo to have tried the genre on his own account. See Landau in Cropper ed. 1994, *loc. cit.* at n. 2, pp. 177–8. This theory seems untenable given the dependence of the background of the *Hercules and the Giants* on the *Battle of the Nude Men* which it must therefore postdate. See pp. 79–80 of this paper for reference to the *Hercules and the Giants*.

27. For the dating of the *Labours of Hercules* canvases, see Ettlinger 1978, cat. 44, pp. 164–5. Laurie Fusco's case that Pollaiuolo's engraving may have been indebted to a Hellenistic *Satyrs* group excavated in Rome in 1488 is not strong enough to justify giving the *Battle of Nude Men* such a late dating. See Fusco, L., (1984), 'Pollaiuolo's Battle of the Nudes: a suggestion for an ancient source and a new dating', in Natale, M., ed., *Scritti di storia dell'arte in onore di Federico Zeri*, 2 vols, **1**, pp. 196–9. The so-called *Florentine Picture Chronicle*, datable no later than the 1470s, includes a nude figure that is almost certainly dependent upon Pollaiuolo's engraving; see Colvin 1989, *op. cit.* at n.1, no. 51, 'Hermes Trismegistus'.

28. For the various *Passion* engravings, their dating and attribution, see Martineau ed. 1992, cat. nos 29, 32, 36, 38 and 39.

29. Ettlinger 1978, pp. 33–5 and 146.

30. Alberti, L.B., ed. Mallè, L., (1950), *Della Pittura*, Book III, Florence: p. 104.

31. Emison, P., (1990), 'The Word made Naked in Pollaiuolo's *Battle of the Nudes*', *Art History*, **13**, pp. 261–75.

32. Earlier interpretations of the subject are discussed by Fusco in her entry on the engraving in Levenson, Oberhuber and Sheehan 1973, pp. 66–71.

33. For the Turin drawing, see Walker, J., (1933),'Ricostruzione d'un incisione Pollajesca', *Dedalo*, **13**, April, pp. 229 and 236; and Armstrong 1968, esp. pp. 157–8.

34. For the two engravings see Armstrong 1968, pp. 155–61.

35. Mongan, A. and Sachs, P.J., (1940), *Drawings in the Fogg Museum of Art*, Cambridge, Mass., pp. 30–34; and Armstrong 1968, no. 37, p. 157 and n. 17.

36. Armstrong 1968, p. 165.

37. Lazzarini, V., (1908), 'Documenti relativi alla pittura padovana del secolo XV', *Archivio Veneto*, **15**, p. 295.

38. The early date by which the *cartonum* was in Squarcione's workshop would, in my view, rule out the possibility of it being an impression of the *Battle of Nude Men* engraving.

39. Landau and Parshall 1994, p. 74.

40. Richards, L., (1968), 'Antonio Pollaiuolo's Battle of Naked Men', *Bulletin of the Cleveland Museum of Art*, **55**, pp. 62–70.

41. This hypothesis is elaborated upon in Wright, A., (1997), 'Dimensional tension in the work of Antonio Pollaiuolo' in Currie, S. and Motture, P., eds, *The Sculpted Object 1400–1700*, Aldershot, pp. 65–86.

42. For the *Virtus Combusta*, see especially Levenson, Oberhuber and Sheehan 1973, cat. 84, pp. 222–7.

43. For reference to the *Entombment with the Four Birds*, see Martineau ed. 1992, cat. 29, p. 183.

44. Jacobsen, M., (1982), 'The Meaning of Mantegna's *Battle of Sea Monsters*', *Art Bulletin*, **64**, pp. 623–9.

45. Levenson, Oberhuber and Sheehan 1973, pp. 167 and 182.

46. *Ibid.*, cat. 73, pp. 182–5.

47. *Ibid.*, cat. 74, p. 186.

48. *Ibid.*, cat. 84, pp. 222–7.

49. Christiansen 1993, pp. 611–2.

50. The subject of the broader artistic influence of Pollaiuolo's *Battle* print is a complex one which cannot be explored in further detail here. However, I would add that the Paduan engraving after Pollaiuolo's Fogg design (discussed by Armstrong 1938, p. 155 ff.) seems also to have had its admirers north of the Alps, as the theme and individual motifs in a German engraving of a *Battle of Two Men with a Centaur* indicate. See Koreny, F., and Hutchinson, J.C., eds, (1981), *The Illustrated Bartsch*, **9**, *Early German Artists, Part 1*, New York: p. 255, no. 169, attributed to Master I.A.M. von Zwolle.

51. See pp. 79–80 of this paper.

52. Kristeller 1901, pp. 380–3; Hind 1938–1948, *op. cit.* at n. 1, **5**, pp. 5–6; Landau in Martineau ed. 1992, pp. 48–52.

53. For the printmakers using Mantegna's designs, see Landau in Martineau ed. 1992, pp. 52–3; and Boorsch 1992, pp. 56–64.

54. Levenson, Oberhuber and Sheehan 1973, cat. 82, pp. 214–7; and Martineau ed. 1992, cat. nos 117–27, and esp. p. 375 for commentary.

55. Levenson, Oberhuber and Sheehan 1973, cat. 88, p. 238.

56. Hind 1938–1948, *op. cit.* at n. 1, **5**, p. 165 and pl. 727.

57. *Ibid.*, **1**, p. 207 and pl. 298.

58. Landau and Parshall 1994, pp. 101–2.

59. Fiocco, G., (1926), 'Felice Feliciano amico degli artisti', *Archivio Veneto Tridentino*, **9**, pp. 188–201.

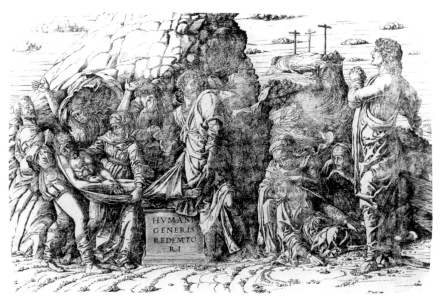

5.1 Andrea Mantegna, *Entombment*, engraving.

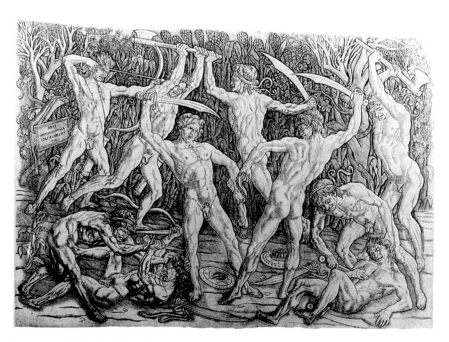

5.2 Antonio Pollaiuolo, *Battle of Nude Men*, engraving.

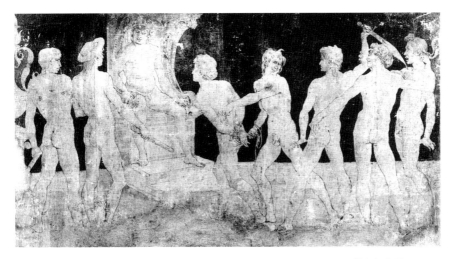

5.3 Antonio Pollaiuolo, *Prisoner led before a Judge*, pen, ink and wash with traces of black chalk.

5.4 Copy of a design by Antonio Pollaiuolo, pen and ink on paper.

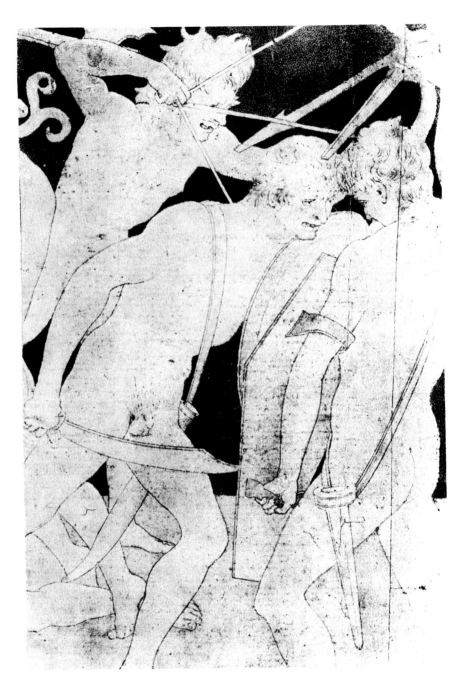

5.5 Antonio Pollaiuolo, *Fragment of a battle design*, pen and ink and wash on paper.

Luca Signorelli's studies of the human figure[1]

Claire Van Cleave

The story of a mature artist advising an aspiring artist to learn to draw is a familiar device in Giorgio Vasari's *Lives of the Artists*.[2] In his own case, Vasari credited Luca Signorelli as his motivating force, claiming that the elder artist had passed on the following advice to his father:

> Antonio, poichè Giorgino non tralinga, fa ch'egli impari a disegnare in ogni modo; perchè quando anco attendesse alle lettere, non gli può essere il disegno, siccome è a tutti i galantuomini, se non d'utile, d'onore e di giovamento.[3]

> Antonio, so that Giorgio does not fall behind, be certain that he learns to draw, for even if he were to devote himself to letters, drawing cannot but be useful, honourable, and advantageous to him, as it is to every gentleman.

Despite the fact that this topos may be a device used by Vasari to underline the importance of drawing, it is nevertheless a reflection of his esteem for Signorelli's draughtsmanship. Indeed, the artist who was able to design and paint the huge number of nudes on the walls of the *Cappella Nuova* in Orvieto Cathedral must have had a sound understanding of draughtsmanship, especially of the human form. The majority of Signorelli's forty or so surviving drawings are studies of the human figure. The subjects of these studies range from clothed to naked figures and from single figures to multiple figure groups. Throughout his career, it is evident that Signorelli was striving to depict the musculature and proportions of the human body, both in movement and at rest, in as naturalistic a manner as possible.

Before focusing on Signorelli's figure studies, it is worth diverging for a moment to discuss the materials used to create the drawings. Most were made in black chalk, but there are a few sheets in metalpoint, ink, and water colours. The only surviving example of a metalpoint drawing by Signorelli is the *San Ercolano* (London, British Museum, 1902–8–22–5).[4] Although it is a lone survivor, it must indicate that Signorelli used metalpoint in other

drawings that are now lost. There are slightly more extant ink drawings where ink was applied over black chalk underdrawing. This is the case with two sheets in Bayonne: the *Nude, seen from the Back with Right Fist clenched over Left Shoulder* (Musée Bonnat, 1749), and its companion the *Nude, seen from the Back, holding the Body of Another Nude* (Musée Bonnat, 1750), in both of which the strong ink outline virtually obscures the chalk underdrawing.[5] Signorelli also drew in watercolours, both in a combination of chalks and in colours applied with a brush. He used red, white and black chalks together for the *Study for the Money Lender in the Orvieto Antichrist* (Paris, Louvre, 1796).[6] As in most of the drawings made with more than one chalk, red chalk was used here to indicate flesh tones, while white chalk was used for highlighting. In other coloured drawings Signorelli created flesh tones with opaque colours applied with a brush. This technique, possibly a type of gouache or diluted tempera, was also used for another Paris sheet, the *Nude carrying a Cadaver on his Back* (Louvre, 1801).[7] The assumption that black chalk was Signorelli's primary drawing tool is supported by the fact that the drawings finished in other media were invariably started with black chalk underdrawing. The primacy of black chalk is also supported by the large percentage of surviving sheets drawn in black chalk alone, which, even allowing for the destruction of hundreds of drawings, must reflect his graphic output as a whole.

Black chalk is the key to Signorelli's graphic style. As I have discussed elsewhere, his use of black chalk was not unique, but he did employ it in non-traditional ways.[8] While his contemporaries tended to use chalk for cartoons and for underdrawing, Signorelli used it for figure studies. Any innovation in Signorelli's studies of the human figure is linked to the use of black chalk. Its directness, depth of tone and broad line contribute to the power of his works. Drawings such as the *Hercules and Antaeus* (Windsor Castle, Royal Library, 12805; Figure 6.1),[9] and another *Nude Seen from the Back* (London, British Museum, 1946–7–13–11),[10] are absolutely typical of Signorelli's style, which is characterized by a steady stroke, a pronounced outline, and hatched shading sometimes blended to heighten the tone. Signorelli's drawings have a very immediate quality; even the sheets obviously drawn with great care retain a swift style that is never precious or overly detailed.

Signorelli's figure studies are best approached by way of the models which inspired him to create the muscular forms for which he is famous. These include live models and three-dimensional models such as draped mannequins or free-standing sculptures. This approach will lead to a focus on the types of drawings that Signorelli made from these models, including studies of nude and clothed figures, both alone and in groups. In conclusion, it will be possible to assess Signorelli's place as an innovator in the study of the human figure.

Models for figure studies: live models

Emphasis on the form and lighting of a body's musculature, especially the thigh and calf muscles, is a defining characteristic of Signorelli's study of the live model. His sensitivity to the human body could only have been obtained from direct observation of live models, a practice which he presumably learned in the earliest stages of his training. Studies of posed live models survive from all stages of Signorelli's career. Live models were particularly useful for portraying a figure in a complicated position. This practice is well illustrated by the *Christ Being Taken Down from the Cross* (Paris, Collection Frits Lugt, Institut Néerlandais 2538; Figure 6.2),[11] which is a study for the *Deposition* altarpiece painted in 1516 for Santa Croce in Umbertide.[12] A convincing depiction of the foreshortened torso was facilitated by close study of a real slumped nude. The position of the figure's feet in the drawing strongly suggests that Signorelli was using a live model. The feet are flat, indicating that the model was standing upright, whereas in the painting the feet have been adapted to hang more freely as if the body was suspended from above. Placing a nude model in the slumped pose while he was actually standing upright enabled Signorelli to concentrate on the fore-shortening of the torso over the period of time necessary to execute the drawing with minimal discomfort to the model.

A drawing of a *Flagellator* (Paris, Louvre, 1797; Figure 6.3) represents another example of study from a nude model.[13] It appears that Signorelli began this drawing by making a quick sketch of the figure in the upper right-hand corner of the sheet. The economy of line in this sketch may reflect the short amount of time that the model was able to stand on his toes with his arms above his head. Despite its rapid execution, the sketch was sufficient to serve as a guide for the fully developed drawing below. In the main drawing, the play of light over the muscles is so carefully recorded that it suggests Signorelli continued to observe a live model. Once the overall body position was established in the small sketch, in order to aid further study of the muscles and bone structure of the figure's back, the model could have reassumed the position of the arms without standing on his toes. The slight line of a rope in the figure's hands may be an indication of a studio prop used to help keep the arms in position for an extended period. The result is a convincing depiction of the musculature of a figure with both arms held above his head.

Signorelli also used clothed models to pose for his drawings, as in the *Study of a Young Man in Contemporary Dress* (Liverpool, Walker Art Gallery, 9833).[14] Details such as the folds of the sleeves, the tight hose and the bows tied just below the knees suggest that this drawing was made from direct observation of life. Despite attention to these details, the objectives of this

drawing, as with the nude studies, are to examine the figure's anatomy and the play of light over its contours.

Not surprisingly for the time, Signorelli's life studies are of male models. There is no evidence to suggest that he used naked female models, especially since his images of naked women are not as realistic as his nude men. In drawings such as the *Four Nudes* (Paris, Louvre, 1794), the female figures are awkwardly drawn.[15] This is also true of the paintings of naked women. For example, the idealized body of the woman on the left of the lost painting of *Pan* does not appear to have been observed from life.[16] In each of these cases, the oddly formed breasts confirm that these women were not drawn directly from female models. Furthermore, Signorelli does not seem to have drawn clothed female models. In the privately owned drawing of a *Draped figure seen from the back*, for the Volterra *Circumcision*,[17] he studied a male model for what was to be a female figure in the painting (formerly Volterra, San Francesco; now London, National Gallery).[18] In the drawing, the long, curly locks of hair are worn by a man, while in the painting the hair, bound in a bun at the nape of the neck, is obviously that of a woman. In general, it is most likely that Signorelli's models were members of his workshop who would pose for either male or female figures.

Models for figure studies: sculptural models

In addition to live models, sculptural or three-dimensional models were a common feature of the Renaissance artist's workshop.[19] A piece of sculpture or a mannequin freed the artist from the drawback that a live model could only hold a difficult pose for a limited time. It has been suggested that Signorelli used sculptural models, especially for the fresco of the *Conversion of St Paul* in the sacristy of the basilica of the Santa Casa in Loreto where a single figure has been painted from four different viewpoints.[20] No drawing by Signorelli of the sculptural figure portrayed here has come to light. In fact there is no irrefutable evidence among the extant drawings to confirm that Signorelli ever made a drawing of a sculptural model. Nevertheless, there are some drawings which merit discussion in connection with three-dimensional models because they exhibit characteristics associated with studies of sculpture. Three types of sculptural model, namely draped mannequins, anatomical models and contemporary or antique sculpture, should be examined individually while considering whether or not Signorelli depended on any of these sources.

On at least one occasion Signorelli used a draped mannequin. The drawing of a *Kneeling Bishop* (London, British Museum, 1895–9–15–602v) concentrates on the elaborate mantle and the folds formed as the drapery touches the ground, while the head and hands, the only exposed parts of the

body, are awkwardly drawn.[21] Normally, the focus in a drapery study was on the folds, while the mannequin underneath was often only schematically drawn or even completely ignored.[22] In this case, the stiff, wooden qualities of the hands and face are not due to a lack of interest or any inability on the part of the artist. Rather, they probably indicate that Signorelli was studying a sculptural model which in this case would have been in the form of an ecclesiastical mantle draped over a mannequin.

There is no conclusive evidence in either his drawings or his paintings to suggest that Signorelli studied anatomical models or cadavers. It has been plausibly proposed that the *Study of an Écorché* (Bayonne, Musée Bonnat, 1751) was drawn after an anatomical model,[23] but in my opinion this drawing does not correspond closely enough to Signorelli's style and I do not believe that it is autograph. The popular misconception that Signorelli studied anatomy from a cadaver has its origins in Vasari's *Life* of the artist, where the moving story of Luca drawing the dead body of his beloved son is related:

Dicesi, che essendogli stato occiso in Cortona un figliuolo che egli amava molto, bellissimo di volto e di persona, che Luca così addolorato lo fece spogliare ignudo, e con grandissima constanza d'animo, senza piangere o gettar lacrima, lo ritrasse, per vedere sempre che volesse, mediante l'opera delle sue mani, quello che la natura gli aveva dato e tolto la nimica fortuna.[24]

It is said that a son he loved dearly, who was beautiful in countenance and in person, was killed in Cortona; and that Luca, heart-broken as he was, had him stripped naked, and with the greatest firmness of soul, without lamenting or shedding a tear, drew his portrait, so that whenever he wished, he could, by means of the work of his own hands, see what nature had given him and adverse fortune had snatched away.

Signorelli always depicts the superficial anatomy of a body in a correct if somewhat exaggerated form, but his understanding of bone structure and body parts is confined to what may be observed from life. The awkward skeletons of the Orvieto *Resurrection of the Flesh* fresco, particularly the flawed renderings of rib structures and pelvic bones, demonstrate that Signorelli did not have a sound understanding of the human skeleton. It is therefore unlikely that he studied either cadavers or skeletons in the process of creating these figures.[25]

Despite the evidence in the Loreto *Conversion of St Paul*, there are no drawings by Signorelli that are unquestionably made after reliefs or free-standing sculptures. It is interesting, however, to consider the Windsor *Hercules and Antaeus* (Figure 6.1) in this context, because it may have been drawn from a sculpture. There are no explicit indications within the drawing

to suggest this, but implicit qualities of the drawing hint at such a source. The inherent problem in determining whether a drawing was made after a sculpture is that the sculptural model itself was intended to emulate life, so drawings made after sculptures invariably resemble drawings made after life. Therefore, it is necessary to be cautious when classifying any drawing as being made after a three-dimensional model. The contorted positions in the *Hercules and Antaeus* would have been extremely difficult for two men to hold long enough for the artist to consider and describe the muscles as carefully as he has on this sheet. It is thus possible that Signorelli was studying a sculpture when he made this drawing. None of Antonio Pollaiuolo's images of *Hercules and Antaeus* was the source for the drawing because in each of them the position and the musculature is very different from Signorelli's study.[26] Both artists present the same subject, but that is where the similarity ends. Rather than finding inspiration from a contemporary artist, it is possible that Signorelli was influenced by one of the various antique sculptures of Hercules and Antaeus that were known during his lifetime.[27]

Figures drawn from memory

While it is important to recognize that Renaissance draughtsmen often studied models, the ability of these artists to draw a figure from memory should never be discounted. It is evident from Signorelli's drawings and paintings that he had a keen understanding of the human body, and he certainly was able to draw a realistic figure without any model. The hastily-drawn nudes scratched into the wet plaster at the top of the Orvieto *Resurrection of the Flesh* or the equally hastily-drawn nude on the ladder in the *Descent from the Cross* (Besançon, Musée des Beaux-Arts et d'Archéologie, D3100) attest to Signorelli's ability to draw a figure from memory.[28] The quick execution of these figures implies that they were drawn without a model, but despite their sketchy nature, they were drawn with Signorelli's normal attention to proportion and musculature. Furthermore, he must have been able to draw certain poses from memory because he used them on a regular basis. One example is the previously mentioned British Museum *Nude seen from the Back* which appears in several paintings of the 1490s, such as the fresco of *St Benedict Receiving Totila* in the large cloister of the Benedictine monastery at Monte Oliveto Maggiore. Although the drawing could have been taken from a live model, Signorelli undoubtedly knew this position so well that he could draw it without any visual aid. Needless to say, the ability to draw realistic nudes from memory could only come from solid training and practice in drawing the human body.

Types of figure studies

To sum up Signorelli's use of models, he certainly made life studies of both clothed and nude models on a regular basis. He also drew draped mannequins and perhaps sculptural models, but never anatomical models. Years of practice also enabled him to draw a figure from memory. Although he may have drawn for pleasure, it is safe to assume that the majority of his graphic works were made to learn how to draw or to design a painting. The different types of figure studies made by Signorelli show how he approached the human form as he prepared to paint. These drawings, which represent both clothed and naked bodies, usually focus on an individual or a pair rather than on a large number of figures.

Signorelli drew nudes as models for both nude and clothed figures in paintings. The *Christ at the Column* (Florence, Uffizi, 224S)[29] and the Louvre *Flagellator* (Figure 6.3) show nudes drawn for the fresco of the *Flagellation* in the chapel of San Crescentino at Morra in Umbria. In the painting, both figures remain partially nude, although each is given a loincloth. In other drawings, Signorelli made studies of a nude which would become a clothed figure in the painted form. The *Nude seen from the Back* is an example of this, since it probably served as a model for a soldier in the Monte Oliveto fresco of *St Benedict Receiving Totila*,[30] in which the figure is clothed, yet his back muscles are particularly pronounced, so a study of a nude in this position would have helped Signorelli to depict the form of these muscles.

The drawings of clothed figures can be divided into two categories: men in the contemporary fashion of leggings and both men and women wearing heavy mantles or long robes. The leggings of the figures in contemporary dress are often so tight that they do not obstruct the artist's observation of the musculature. This is true of drawings such as the *Soldier Poised for Action* (Florence, Uffizi, 50E; Figure 6.4),[31] and the Liverpool *Study of a Young Man in Contemporary Dress*, both of which feature calf muscles that are as pronounced as those in the *Nude seen from the Back*. Signorelli's understanding of anatomy beneath clothing is also conveyed in his drawings of heavily-draped figures. However, such figures are often so heavily draped that they give little indication of the body underneath. This is illustrated by drawings such as the *St Francis and St Peter* (Paris, Louvre, 1795), or the privately owned *St Lucy*, where only the head, hands and feet of the figures protrude from the drapery.[32] Yet even though so little of the body is depicted, what is presented remains as realistically proportioned as the bodies in the nude studies.

Signorelli was able to render a body covered by heavy drapery as successfully as a nude because of his understanding of the body beneath the drapery. A common Renaissance drawing practice was to study a figure in the nude prior to drawing it draped in order to understand the proportions

of the body before it was obscured by fabric. Leon Battista Alberti's advice encapsulates this manner of working:

> Just as for a clothed figure we first have to draw the naked body beneath and then cover it with clothes, so in painting a nude the bones and muscles must be arranged first, and then covered with the appropriate flesh and skin in such a way that it is not difficult to perceive the positions of the muscles.[33]

While no drawings survive to indicate that Signorelli's studies progressed in this way, one sheet does attest to his sympathy for this practice. In the drawing of *Four Apostles* for the Cortona *Assumption of the Virgin* (London, British Museum, 1885–5–9–40; Figure 6.5),[34] the Apostle on the left of the sheet is fully draped, whereas the second figure is only dressed above the waist and the furthest two are completely nude. The reason for this progression from clothed to nude is unclear. There is no indication in the fully-draped Apostle on the left to suggest that Signorelli first sketched a nude before adding the drapery.[35] Therefore, it should not be presumed that the nudes on this sheet are merely unfinished clothed figures. It seems more likely that Signorelli began by drawing the draped figures in detail, then, perhaps because he wanted to finish the drawing quickly, he drew the last two figures as nudes to indicate their positions without elaborating upon the drapery. The same mixture of fully developed and sketchy figures within a single drawing is also seen in the *Three Soldiers on Horseback* (London, British Museum, 1860–6–16–93), where only one of the horsemen has been carried to a finished state.[36]

Up to this point, I have examined the models which Signorelli used for his figure studies and discussed the types of figures detailed in these drawings. I now turn to the disposition of the figures on the page, the number of figures normally included and the emphasis put on certain parts of the body, since these issues are also crucial to understanding Signorelli's approach to the human figure.

Whether he was drawing a study of an individual or of a group, Signorelli tended to isolate figures on the paper with little or no indication of setting or of any relationship to other figures. The *Nude Man and Naked Woman Embracing* (Stuttgart, Staatsgalerie, C 90/3969) was made in preparation for the Orvieto frescoes and later adapted for the couple on the far left of the *Resurrection of the Flesh*.[37] In this drawing, Signorelli considered the effects of light and the interaction of the couple but gave no indication of the setting or of their relationship to other figures in the composition. The isolation in a drawing of a small group of figures is also seen in the *Study for the Massacre of the Innocents* (London, British Museum, 1946–7–13–10; Figure 6.6),[38] which shows a soldier and the mother of a young child, two representatives of a small portion of a heavily populated scene. In this case, it is also interesting

to note that Signorelli drew both figures in the nude even though they would have been clothed in the painting. Although the practice of isolating a small group of figures within a drawing was by no means unique for the time, it certainly stresses Signorelli's emphasis on the thorough examination of individual bodies.

Signorelli's figure studies often focus on a portion of a composition even if in the finished work that particular section was not to be visible in its entirety. Such is the case with the Louvre *Nude carrying a Cadaver,* in which the artist has carefully studied the whole bodies of two nudes in the Orvieto image of the *Damned.* In the fresco, however, only the top of the man's body and part of the limp corpse are visible. In addition to this example, evidence of incising from cartoons in the plaster of the Orvieto chapel walls shows that Signorelli often made cartoons of full figures when only a portion of those particular figures would be visible in the finished painting. The result of this practice is that once the composition was assembled, the figures were never excessively crowded together.

Just as he focused on the figures within a composition but ignored the surroundings, he also emphasized certain elements of the figures while neglecting others. In the Windsor *Hercules and Antaeus,* for example, the tops of the heads are barely sketched in when compared to the detail lavished on the muscles elsewhere on the bodies. The same approach is evident in the Uffizi *Soldier Poised for Action* (Figure 6.4) in which the greatest emphasis is placed on the figure's body and stance, with particular concentration on the legs and their muscles. The hands and the head are less detailed: an angry facial expression is legible, but the eyes, nose, mouth and curly locks of hair are schematically drawn. The contrast between these resolved and incomplete areas of concentration reveals that Signorelli was not always interested in defining every aspect of the figure. Rather, his studies often established the position of the figure and the muscles, while other details were left for a future stage of design. This seems to have been a common feature of his drawings.

The focus on a small number of figures, the practice of drawing an entire figure even if only part was going to be visible in the painting, the emphasis on the musculature and position of the body, plus the use of black chalk, all contribute to Signorelli's constant attempts to portray the human body in a realistic manner. This search for naturalism resulted in powerful depictions of the nude which are often closer in style to Michelangelo and Raphael than to many of Signorelli's fifteenth-century contemporaries. In fact, his bold studies for the Orvieto cathedral frescoes immediately preceded Michelangelo's black chalk studies for the *Battle of Cascina,* which were drawn around 1504. It is nothing new to say that Signorelli is remembered for his powerful depiction of the human body. Moreover, it is precisely his facility in

rendering the nude that caused Vasari to conclude the second part of the *Lives* with Signorelli, thereby placing him in a position on the cusp of the third part of his progressive view of the history of art. Explaining his reasons for this, Vasari wrote:

Cosi col fine della vita di costui, che fu nel 1521, porremo fine alla Seconda parte di queste Vite, terminando in Luca come in quella persona che col fondamento del disegno e delli ignudi particolarmente, e con la grazia della invenzione e disposizione delle istorie, aperse alla maggior parte delli artefici la via all'ultima perfezione dell'arte; alla quale poi poterono dar cima quelli che seguirono, de'quali noi ragioneremo per inanzi.[39]

We now come to the end of the second part of the *Lives*, ending with Luca as the person who with the fundamentals of drawing, particularly with nudes, and with grace of invention and disposition of topics, laid open to the majority of artists the path to ultimate perfection in art, thereby empowering those who followed, about whom we shall soon speak, to reach the highest summit.

Even if Vasari's motives in giving Signorelli this position may be disputed, Signorelli's powerful depictions of the human form remain what the spectator instinctively responds to today.

Frequently cited literature

Vasari, G., ed., Milanesi, G., (1878–1885); *Le Vite de più eccellenti pittori scultori ed architettori*, 9 vols, Florence (hereafter Vasari-Milanesi); Popham, A.E. and Pouncey, P., (1950), *Italian Drawings in the Department of Prints and Drawings of the British Museum. The Fourteenth and Fifteenth Centuries*, London; Berenson, B., (1938), *The Drawings of the Florentine Painters*, 3 vols, Chicago.

Notes

1. Drawings by Signorelli and his school are fully catalogued in Van Cleave, C., (1995), *Luca Signorelli as a Draughtsman*, unpublished Ph.D thesis, University of Oxford.

2. Vasari-Milanesi.

3. *Ibid.*, **3**, p. 693.

4. Metalpoint with light brown wash and white lead highlighting on light brown prepared paper, 17.5 × 17.0 cm. Illustrated in Popham and Pouncey 1950, pl. CCII.

5. The *Nude, seen from the Back with Right Fist clenched over Left Shoulder*, pen and ink over black chalk on paper which has turned grey, 27.2 × 12.3 cm, is illustrated in Berenson 1938, **3**, fig. 98. The *Nude, seen from the Back, holding the Body of Another Nude*, is in pen and ink over black chalk on paper which has turned grey, 27.1 × 17.3 cm. These drawings were once part of a single sheet.

6. Black, red and white chalks on cream coloured paper, 46.6 × 25.8 cm. Illustrated in Berenson 1938, **3**, fig. 103.

7. Red, brown, green, dark grey and white pigments over black chalk on cream coloured paper, 36.7 × 22.4 cm. Illustrated in Berenson 1938, **3**, fig. 102.

8. Van Cleave, C., 'Tradition and Innovation in the Early History of Black Chalk Drawing', in Cropper, E., ed., (1994), *Florentine Drawing at the Time of Lorenzo the Magnificent*, Papers of the Villa Spelman Colloquium, 1992, **4**, Bologna: pp. 231–43.

9. Black chalk on cream coloured paper, 28.0 × 16.0 cm.

10. Black chalk on cream coloured paper, 26.8 × 13.7 cm. Illustrated in Popham and Pouncey 1950, pl. CCII.

11. Black chalk on coarse buff-grey coloured paper, 27.9 × 18.0 cm.

12. Luca Signorelli, *Deposition*, oil on panel, 1.98 × 1.47 m; formerly in Santa Croce, Umbertide, now in restoration in Rome. Illustrated in Dussler, L., (1927), *Signorelli*, Stuttgart: p. 141

13. Black chalk on fine, cream coloured paper, 41.0 × 25.2 cm.

14. Black chalk with white lead highlighting and traces of white chalk on fine, cream coloured paper, 40.9 × 21.3 cm; illustrated in Ames–Lewis, F. and Wright, J., (1983), *Drawing in the Italian Renaissance Workshop*, exh.' cat., London (Victoria and Albert Museum): p. 91.

15. Black chalk on coarse, buff coloured paper which has turned brown with age, 36.9 × 24.9 cm; illustrated in Berenson 1938, **3**, fig. 111.

16. Luca Signorelli, *Pan*, oil on panel, 1.94 × 2.57 m; destroyed (formerly, Berlin, Kaiser Friedrich Museum). Illustrated in Dussler 1927, *op. cit.* at n. 12, p. 59.

17. *Draped Figure, seen from the Back, and Bust of a Sleeping Woman*, black chalk on cream coloured paper, 29.4 × 21.4 cm; private collection. Illustrated in Berenson 1938, **3**, fig. 118.

18. See Davies, M., (1961), *National Gallery Catalogues. The Early Italian Schools*, London: cat. 1128, pp. 479–81.

19. For a full bibliography on the use of sculptural models see Fusco, L., (1982), 'The Use of Sculptural Models in Fifteenth Century Italy', *Art Bulletin*, **69**, p. 194; and Van Cleave, C., (1988), *The Practice of the Paragone*, unpublished MA report, University of London (Courtauld Institute of Art).

20. The use of sculptural models for this fresco is suggested in Fusco 1982, *op. cit.* at n. 19, p. 191 ff. and Appendix II.

21. Black chalk on cream coloured paper, 38.5 × 24.9 cm. Illustrated in Popham and Pouncey 1950, pl. CCI.

22. For more examples see Département des Arts Graphiques, Musée du Louvre, (1990), *Léonard de Vinci: Les Études de Draperie*, exh. cat., Paris (Musée du Louvre, Département des Arts Graphiques).

23. Red chalk on cream coloured paper, 40.0 × 27.0 cm. See Van Cleave 1995, *op. cit.* at n. 1, cat. D1.

24. Vasari-Milanesi, **3**, p. 691.

25. For further information on artists and anatomy, see Kornell, M., (1992), *The Study of Anatomy by Artists in Sixteenth Century Italy*, unpublished Ph.D thesis, University of London (Warburg Institute). See chap. 3 on the development of accuracy in the depiction of skeletons, which includes Signorelli's somewhat 'awkward' skeletons in the *Resurrection of the Flesh* at Orvieto.

26. For a comparison of Pollaiuolo and Signorelli which concludes that the two artists had completely different conceptions of the human body, see Clegg, E., (1984) *The Treatment of the Male Nude in the Drawings of Antonio Pollaiuolo and Luca Signorelli*, unpublished Ph.D thesis, University of Oxford.

27. For an example of an antique *Hercules and Antaeus* known in the fifteenth century see Bober, P.P. and Rubinstein, R., (1986), *Renaissance Artists and Antique Sculpture: A Handbook of Sources*, Oxford: cat. 137.

28. The drawings in the *intonaco* at Orvieto were first published in Bertini Calosso, A., (1941), 'Disegni tracciati ad affresco da Luca Signorelli nel Duomo di Orvieto', *Rivista d'Arte*, **23**, pp. 194–202. The Besançon drawing, black chalk on cream coloured paper, 26.5 × 14.3 cm, is cited in Van Cleave 1995, *op. cit.* at n. 1, cat. 4.

29. Black chalk on cream coloured paper, 34.5 × 15.2 cm; illustrated in Berenson 1938, **3**, fig. 112.

30. See n. 10 for reference.

31. Black chalk on cream coloured paper, 24.7 × 17.4 cm.

32. *SS Francis and Peter*, black, red and white chalks on cream coloured paper, 38.7 × 35.1 cm. *St Lucy*, black chalk on cream coloured paper, 13.5 × 23.3 cm, private collection; illustrated in Baroni, J–L., (1990), *Master Drawings*, exh. cat., New York, (Colnaghi), cat. 5.

33. Alberti, L.B., ed. and trans., Grayson, C., (1991), *On Painting*, London, Book II, p. 72, para. 36.

34. Black chalk on cream coloured paper, squared in black and red chalks, white highlighting on the left figure only, pricked for transfer, 33.4 × 25.4 cm.

35. Laurence Kanter has suggested that all these figures were started with nude drawings, but there is no evidence of lines describing a nude in the drawing of the clothed figure to substantiate his assertion. See Kanter, L.B., (1992), 'Some Documents, a Drawing, and an Altarpiece by Luca Signorelli', *Master Drawings*, **30**, p. 417.

36. Black chalk on buff coloured paper, pricked for transfer, 34.3 × 27.2 cm. Illustrated in Popham and Pouncey 1950, pl. CCIII.

37. Black, red and white chalks on coarse, cream coloured paper, 26.6 × 16.3 cm. Illustrated in Höper, C., (1992), *Italienische Zeichnungen, 1500–1800*, 2 vols, Stuttgart: **2**, cat. E 190.

38. Black chalk with white lead highlighting on cream coloured paper, 28.8 × 20.0 cm.

39. The correct date of Signorelli's death is 1523; see Vasari-Milanesi, **3**, p. 696.

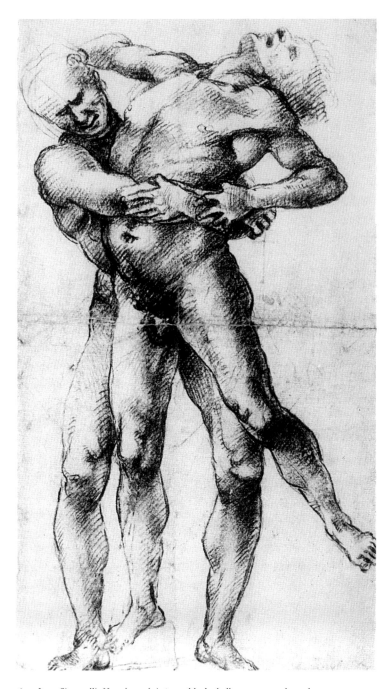

6.1 Luca Signorelli, *Hercules and Antaeus*, black chalk on cream coloured paper.

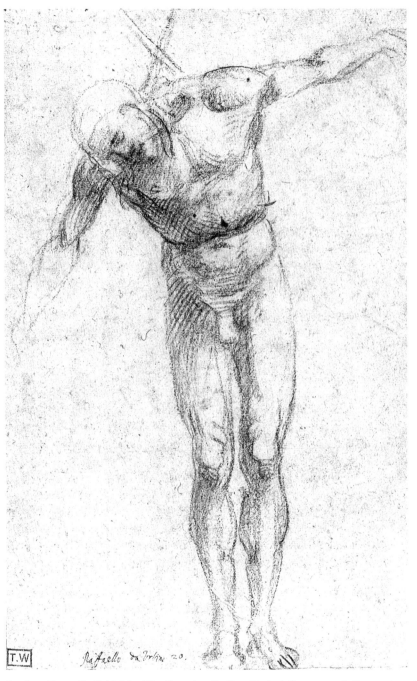

6.2 Luca Signorelli, *Christ Being Taken Down from the Cross*, black chalk on coarse buff-grey coloured paper, laid down.

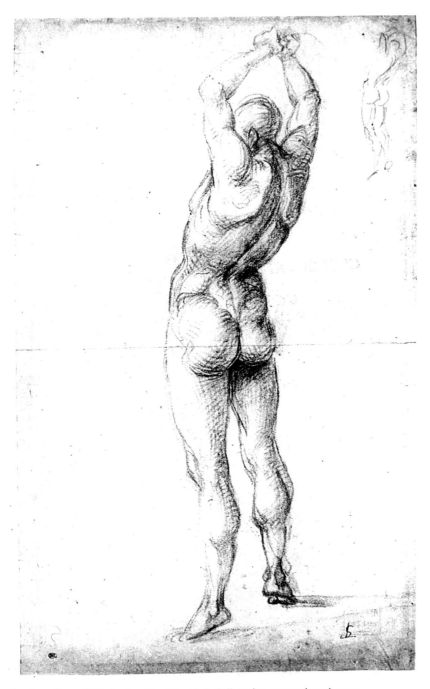

6.3 Luca Signorelli, *Studies for a Flagellator*, black chalk on fine cream coloured paper.

6.4 Luca Signorelli, *Soldier Poised for Action, Sword in Hand*, black chalk on cream coloured paper.

6.5 Luca Signorelli, *Four Apostles* black chalk on cream coloured paper, squared in black and red chalks, white chalk highlighting on the left figure only, pricked for transfer.

6.6 Luca Signorelli, *Study for the Massacre of the Innocents*, black chalk with white lead highlighting on cream coloured paper.

The *'Deutsch'* and the *'Welsch'*: Jörg Breu the Elder's sketch for the *Story of Lucretia* and the uses of classicism in sixteenth-century Germany

Andrew Morrall

Jörg Breu the Elder's *Story of Lucretia* (Munich, Alte Pinakothek, 7969; Figure 7.1),[1] was painted in 1528 as the first of a cycle of paintings of *Heroines* commissioned from prominent Bavarian and Swabian artists by Wilhelm IV, the Wittelsbach Duke of Bavaria, and his wife Jacobaea von Baden. At the same time, the duke commissioned a further series of *Antique Heroes*, to which Breu contributed a panel of the *Battle of Zama* (Munich, Alte Pinakothek, 8).[2] These cycles hung in the Residenz in Munich, though their precise location there is unknown.[3] The prestige attached to such commissions may be judged from the fact that Albrecht Altdorfer declined a term as mayor of Regensburg in order to paint the *Battle of Issus*, depicting the defeat of Darius by Alexander the Great in 333 B.C., which today is the cycle's best known image.[4]

Breu's *Lucretia* is painted in a self-consciously classicizing style. The story of Lucretia's rape, her suicide, the avowal of revenge by her family and the subsequent revolt against the Tarquins, is told in continuous narrative form within an elaborate classical architectural setting. The painting represents an important stage of a stylistic development which Breu had begun in the first decade of the century with an original and expressive manner, closely related to the evolving Danube School of painting. To the generation of German art historians writing in the 1920s and 1930s, the 'mannerism' of this work was seen as a decline from the artist's participation in the great flourishing of an indigenous style, brought about by the corrupting influence of Italy. Ernst Buchner, writing in 1928 what is still the main account of Breu's career, explained this change of style in personal, psychological terms, as the product of the artist losing interest due to a 'failing of spirit' in later life.[5] Buchner was writing from an art–historical perspective governed by the late-Romantic aesthetic notions of his day: the celebration of individual genius, a belief in the expression of strong emotion and in the display of

personal temperament and feeling. For Buchner, Breu's 'mannerist' period became 'dry' and 'bloodless' because the style no longer sprang from within, as it notionally had done in his more 'expressive' earlier phase. Despite a descriptive truth in Buchner's account, he does not adequately explain what is perhaps the most historically significant aspect of Breu's career – his response to Italian art. He ignores the fact that in 1528 Breu was at the height of his maturity, at the head of a thriving workshop and held in high regard by contemporaries. The intention of this essay is to examine Breu's classicism from a more strictly historical point of view, to look at the wider cultural context of classicism in which Breu was operating, and to define how the italianate and the classical were regarded and used.

A drawn study for the *Lucretia* painting (Budapest, Nationalgalerie, 62; Figure 7.2) [6] provides insights into the planning of the composition as well as into Breu's approach to the classicism of the definitive image. The difference in character between the two is immediately apparent. While in the painting the costumes and physiques of the figures are exotically classical in style, in the drawing the protagonists are dressed in a kind of generically 'noble' costume, based loosely upon contemporary fashions. In this initial conception no attempt at historical or 'archaeological' reconstruction is apparent. The figures are drawn in a fluent and elegant idiom that is entirely unforced, the product of the artist's native, German training. Breu's familiarity with the drapery style and with the cut and fall of such garments is clear in the easy and practised manner with which he was able to abbreviate their details. In marked contrast, the figures of the finished painting are dressed in fanciful Roman attire, and the natural and graceful gestures of the drawing are transformed into stiff, mannequin-like poses. Their artificiality is exacerbated by the bulging 'antique' musculature of chests, calves and knees. The natural twist of the figure on the extreme right has been rendered painfully wooden by the painter's compulsion to endow him with a martial torso and a particularly heroic pair of knees.

The comparison between painting and drawing shows the artist consciously employing two manners of style at will, one individual and indigenous, the other italianate. Michael Baxandall has shown that contemporary artists were aware of and had terms for such stylistic distinctions: the '*Welsch*' for the latter and the '*Deutsch*' for the former. He cited a woodcut by Peter Flötner in Vienna, datable to some time in the 1530s, which featured 'Veit the sculptor', forced by lack of work to join the ranks of mercenaries. In the accompanying verses the sculptor claims: 'Many fine figures have I carved / With skill, in *Deutsch* and *Welsch* manners'.[7] The term '*Welsch*' was generally used to denote the foreign or the exotic. When applied to art, it usually referred to the italianate. The use of the term '*Deutsch*' in relation to artistic style is interesting, for it suggests a contemporary recognition of

certain generic or shared qualities amongst essentially individual styles. It also implicitly acknowledges cultural distinctions made along national lines. Between Breu's drawing and the finished painting one sees the abandonment of his own normative '*Deutsch*' style, used in the more informal preparatory stages of the composition, and its transformation in the final image into a self-consciously '*Welsch*' idiom.

The drawing allows one to reconstruct the wilful process of rationalization from sketch to fully realized composition. In the architecture (the first element of the work to be drawn in, since the columns run through the figures placed before them) one may see the degree to which Italian perspective construction governed Breu's usual compositional habits. The columns and arcade have been established by ruled verticals and horizontals. The orthogonals conform generally to the vanishing point on the right hand side. Yet it had evidently not been the artist's intention to create either a credible building or a logical architectural space. The figures do not relate with strict accuracy to the ground, nor does their scale recede proportionately. Their grouping has been arrived at additively in a linear manner, rather than in terms of volumes in space, and disparities of scale are everywhere apparent. The foreground protagonists are linked together by an entirely ad hoc patterning of lights and darks that runs through them but which displays no concern for a single light source. This approach corresponds to a graphic convention entirely characteristic of Breu and indeed of widespread German practice. Its employment reveals Breu to be oblivious of the system of working out the respective scale and distance of figures and objects in space, of which, largely through Dürer, German artists in the later 1520s and 1530s had become increasingly aware.[8] Instead, Breu composed his sketch in an informal and accomplished manner within the idiom of his training and mature development.

The most perplexing element of Breu's drawing is the system of orthogonal lines which radiate from the vanishing point. They do not relate to the architecture and, together with the horizontal grid that maps out the tiled floor in the painting, have been drawn over the design after the initial compositional drawing had been completed. These elements reveal a process of rationalization. The horizontal lines that run from points along the right-hand edge show the artist using the Albertian method of establishing degrees of recession relative to a viewing distance from a point on the horizon line.[9] Secondly, the orthogonals are arranged so that four of them proceed to the corners of the sheet, while the others neatly divide the areas above and below the horizon line. It is as if, having established the design, Breu was attempting to rationalize the composition with a grid-system which would unify architecture and floor surface within the 'aperture' of the picture frame.

This process has been carried into the finished painting where architecture and floor conform to the same vanishing point. Nonetheless, compared with the fluency of the drawing, the painting creaks with the effort of acquired theory. Although the orthogonals of the tiled floor are more or less correct, the foreshortening of the circle and lozenge patterns within it are not, and the floor appears to be tilted too steeply to carry the figures. Moreover, although there is an indication of a single light source in the cast shadows and in the shadowing of the capitals, its spatial effect is subsumed by a greater interest in decorative colour, pattern and detail. The insistent detail of the roundel reliefs on the pillars, for instance, pulls the eye constantly away from an easy passage into depth dictated by the perspective lines. It might be said that all the constructive elements of italianate composition, logical pictorial space, naturalistic lighting effects, the classical treatment of the figure and of decorative form and detail, exist in Breu's work as discrete elements that nudge and jostle uncomfortably against each other.

How does one explain so complete and dramatic a change in Breu's style? What prompted such a concentrated effort to paint in a manner foreign to his training and artistic instincts? One might begin by tracing the sources of Breu's forms to establish the kind of Italian art that helped determine this strange hybrid style and his own notion of 'Welsch' art. Despite a probable visit to Italy by the artist at some point in the second decade of the sixteenth century, his classicism was based principally upon printed sources. The decorative roundels of the pillars in the *Lucretia* painting depend upon fifteenth-century Florentine nielli, which Breu had employed since at least 1515,[10] while the exotic capitals and frieze decorations are similar to those in decorative architectural prints from northern Italy. Underlying the structure of Breu's composition, and particularly discernible in the drawing, is the example of Girolamo Mocetto's *Calumny of Apelles* print after Andrea Mantegna, of which Breu made a copy (British Museum, H.V.165.12).[11] The townscape background with Venetian chimneys, and the figure pointing upwards on the extreme right, recall the Italian model. The drapery style, the details of armour and the classical physique also derive chiefly from prints by Mantegna and his school. Comparison with the right-hand figure in the Mantegnesque *Flagellation of Christ with a Pavement*, reveals striking similarities in the cuirass musculature and skirt, in the lion ornament on the leg armour, and in the sandalled feet. One can be sure that Breu knew this print at first hand because some years earlier he had adapted the left-hand scourger for a design of his own (Warsaw, Muzeum Narodowe, 146606/6).[12] In this case the artist used a highly classicizing Italian print as a source for a pose, rather than for the italianate sense of style contained within it. Another striking example of this kind of borrowing can be seen in Breu's design for a glass roundel, datable to the mid-1520s, depicting a classical subject: the

Murder of Agamemnon by Clytemnestra and Aegisthus (New York, Pierpont Morgan Library, 1966.1; Figure 7.3).[13] The pose of the king pulling off his robe has been cleverly, if inexpressively, adapted from the figure of Minerva in Marcantonio Raimondi's print after Raphael's *Judgement of Paris*.[14] Although in the bulging calves, thighs and muscled torso, one sees the clear influence of Italian form, the 'classicism' of this drawing – the desire of the artist to recreate an antique atmosphere and setting – is entirely home-grown. The difference between this borrowing and the ostentatious neo-classicism of the *Lucretia* suggests that Breu attached specific meaning to the latter style, that he had a precise intention in fashioning his painting thus. The 'classical' conception into which he fitted his borrowed details is not obviously modelled upon Italian example; it is personal and idiosyncratic, a vision of the antique formed under the pressure of its own meanings and compulsions and not those of mere mimesis.

Some light is cast upon the method of assimilating and applying 'classical' motifs, and upon the qualities artists attached to them, in the *Kunstbüchlein*, a treatise on art by the Strassburg painter Heinrich Vogtherr the Elder.[15] Although the treatise was first published in 1538 – a year after Breu's death, and a full ten years after the *Lucretia* – Vogtherr was active in Augsburg during the early 1520s. His teacher is not known, but, as John Rowlands has pointed out, the most prevalent influence upon him seems to have been Jörg Breu.[16] Vogtherr's style of decorative classicism during the 1530s is very close to that of Breu's late manner and to that of Breu's son and successor, Jörg Breu the Younger (c.1510–1547). It is likely that the *Kunstbüchlein* reflects the methods of Vogtherr's Augsburg training. It contains none of the theory, condensed or otherwise, of the Albertian tradition that characterized the writings of Dürer or his followers.[17] Instead, it conforms to an essentially medieval pattern-book format, consisting of a large number of designs, of italianate/classical character, for exotic head-dresses, armour, weapons, escutcheons, capitals and pilasters, all fantastically elaborated in shape and decoration. Together with these are pages of character types, hands, arms and feet, drawn in different poses and gestures and from different angles (see Figure 7.4). The work was practical in outlook and purpose, and was intended, as Vogtherr wrote in the preface, to be of use to all artists, whether painters, goldsmiths, embroiderers, sculptors or cabinet-makers, and in particular to those German artists, burdened with wife and children, who were unable to broaden their outlook and knowledge through travel.[18] What is striking about the treatise is the closeness of conception of these 'classical' details to those exhibited by Breu in the *Lucretia*, as well as in the *Battle of Zama*, his other commission for Wilhelm IV's *History Cycle*, painted in the same year. Though they share a common source in Italian nielli and prints, the similarity between individual capitals or helmets, even between sections

of anatomy, is so close that one might almost infer that Vogtherr drew in part upon Breu's own works for such motifs. Vogtherr's collection of individual details of italianate designs and anatomy surely reflects, in codified form, the method by which artists such as Breu acquired a 'classical' manner, a studio practice of assiduously building up a store of isolated motifs and elements plundered, magpie-like, from Italian prints. The awkwardnesses of a figure such as the man on the extreme right of the *Lucretia* may be explained if one sees his body as a composite of discrete borrowings, such as those compiled by Vogtherr. This would explain the concentration upon details at the expense of the whole, the unnatural emphasis placed upon the knees, the stiffness of the torso, and the awkward relationship between the upper and lower body.

Vogtherr asserted in his preface that he had written the *Kunstbüchlein* because, as a result of the new religious atmosphere (of Protestantism), the arts in Germany were in a calamitous state.[19] He feared that artists would give up their profession in great numbers. His book, therefore, was to serve as a means of maintaining the standards of German art in this difficult period, in order that the German Nation might uphold its position amongst other nations, not as rough barbarians but with great achievements in all the arts.[20] He therefore brought together everything that was foreign, difficult, exotic and imaginative in order to stimulate artists that they might bring to light even higher and finer achievements, enabling art to rise again to its proper position of honour and prestige, so that Germans might rival other nations.[21]

In these words one sees Vogtherr's prescription for a new art. Robbed of its traditional religious purpose as a consequence of the Reformation, art had become a secular activity. Its purpose was now one of general cultural prestige – to show other nations that Germans were not barbarians, but a 'Teutsch Nation', a German Nation, with a culture and tradition of their own. One recognizes in these notions the cultural chauvinism of Jacob Wimpheling and the Strassburg humanist circle, whose efforts in literary creation had been made in a spirit of strident competition with Italian humanism.[22] In his preface, Vogtherr enumerated the essential qualities invested in the classical elements that he was presenting: the foreign, the exotic, virtuosity in execution, imagination and invention. These factors guided his choice of materials in the pages that followed – in the heads, costumes, weapons, architectural and anatomical parts. Such notions colour his idea of the Italian and correspond with the connotations implied by the term *Welsch*.

Breu's *Lucretia* is infused with the same qualities: the variety and invention in the decorative elements, the exoticism of the costumes, the straining after Italian effect in the spatial organization and in the details of anatomy. The *decorative* nature of the *Kunstbüchlein*'s examples is of great significance, since

Vogtherr was concerned neither with the subject matter nor with the expressive elements of art. That he addressed his book not only to painters and sculptors but also to goldsmiths, embroiderers and cabinet-makers, reveals a belief in the status of pure decoration, in and of itself. For Vogtherr, German artistic prestige was to be maintained by a notion of elevated and exotic style. His model of decorative classicism found its most fertile expression in the applied arts, particularly metalwork, and within an aesthetic and theoretical framework increasingly governed by notions of display.[23] The *Kunstbüchlein* was reprinted twice by Vogtherr himself in 1539 and again in 1540. Further editions were printed in Strassburg after his death – in 1545, 1559 and 1572. In 1540 and the following years, versions with Spanish and French texts appeared in Antwerp. It was thus an important precursor to the kinds of pattern-books popularized by Jacques Androuet Ducerceau and Hans Vredeman de Vries later in the century.[24] Breu was one of the first to pioneer the visual expression of the classical style that Vogtherr's book codified and helped spread. The *Kunstbüchlein* therefore links Breu to the broader Northern 'classical' movement of the sixteenth century.

Given Breu's stylistic influence upon Vogtherr's brand of classicism, can one attribute the same motivations in the use of this style to the older artist? Was Breu's attitude to classicism also primarily decorative? If so, what meanings did such decoration convey? It might be reasonable to suppose that the change in style from the drawing to the finished panel in the *Lucretia* was determined by the demands of the patron, Wilhelm IV. Yet the Duke does not seem to have imposed particular stylistic requirements upon his painters. The later works in the cycle of *Virtuous Women* lack the same degree of classicism. In Hans Schöpfer's *Story of Virginia* of 1535, for instance, apart from a solitary Roman soldier in the right foreground, the figures are dressed in contemporary sixteenth-century costume. Only in the fictive frescoes on the left-hand background buildings in Schöpfer's painting does one find a perfectly-developed italianate style. Yet these *Welsch* elements are restricted to the broader details of an exotic imaginary architecture. From such evidence in this and other subsequent paintings, it appears that the choice of decorative classical setting and style in the *Lucretia* rested with Breu.

One might look instead to the function of the painting as a determining factor of style and composition. For the *Lucretia* was not merely an historical narrative: it was intended to be an exemplum of matronly chastity and virtue, one of a series that included Cloelia, Susanna, Virginia, Esther, and the Empress Helen. In a manner comparable to the decoration of fourteenth-century palaces and public buildings with *Viri Illustres*, or the 'Nine Heroes and Heroines', Wilhelm's series showed exemplary deeds and events which were supposed to mirror the virtues of the ideal ruler. This is expressed in

formal terms by Lucretia's pose, facing the spectator frontally in the posture of a Man of Sorrows: one might compare her attitude of martyrdom with that of Christ in Dürer's Small Passion woodcut of *Doubting Thomas*.[25] Rather than following the older medieval Christian usage of Lucretia as a victim of tyranny and a motif of despair, Breu was adopting the humanist tradition of Petrarch and Boccaccio in portraying Lucretia as a symbol of virtue and her fate as a kind of martyrdom.[26]

In an article of 1935, Hermann Beenken criticized what he saw as the coldness and stylistic decline of this painting and accused the artist of 'reducing the drama of Roman female virtue to a conversation-piece, where the stage is of greater importance than the action'.[27] Yet a review of early sixteenth-century Augsburg art reveals the same kind of classicizing form and decoration belonging to the province of allegorical and exemplary representation. One finds it in the allegorical woodcuts of Hans Burgkmair: thus *Wrath*, from a series of *Virtues and Vices*, is depicted in the classical armour of Mars, standing in a niche formed by a classical arch and socle. In this figure, as in another woodcut of *Mars*, one finds the same elaborately decorative costume that was to mark the later classicism of Breu's fighting Romans in the *Battle of Zama*, and indeed of Vogtherr's fragments.[28] Closer in narrative format to Breu's *Lucretia* is a small limewood panel of c.1520, possibly by Sebastian Loscher, depicting an *Allegory of Power and Wealth* in which a seated, emperor-like figure (who has been identified as Jacob Fugger) receives the personification of Wealth, introduced by a classically-dressed herald.[29] The architecture in the *Allegory* is generically close to Breu's and has a similar monumental effect.

The link between classical architecture and exemplary types, the visual expression of nobility and virtue through architectural form, is made explicit in another commission for Duke Wilhelm of c.1534: the relief of the *Temple of Friendship* attributed to Doman Hering.[30] Its imagery is founded on the exemplary tradition mentioned above, for it is based on Burgkmair's wood-cut of the *Three Good Christians*.[31] The artist has imposed the portrait features of Duke Wilhelm onto the figure of Burgkmair's Charlemagne, those of Pfalzgraf Ottheinrich onto King Arthur, and those of Pfalzgraf Philipp der Kriegerische onto Godfrey of Bouillon. The reliefs in the coffering above them show, amongst others: Lucretia, the Judgement of Paris, Susanna and the Elders, Pyramus and Thisbe, Cimon and Pera, Marcus Curtius, Judith, and Cleopatra – in other words, those exempla of particular virtues embodied by the three figures below. In the relationship between the coffering relief-panels and the portrait figures beneath, one sees in miniature, so to speak, the intention of the painted series vis-à-vis the living Duke.

In the *Lucretia*, Breu uses a similar classicizing form and decoration to express the same notion of the exemplary. The grandeur of the forms and of

the architecture was intended to convey not merely time and place, but something of the moral authority and antiquity of ancient Rome and of Roman example. The architecture frames the narrative elements and, through its rich ornamentation, adds rhetorical force to the two central episodes, the suicide itself and the avowal of revenge.

Breu thus found in the Augsburg/Burgkmair allegorical tradition a fruitful starting point for his own expression of the exemplary. In this context, the decorative classicism recommended by Vogtherr in his treatise for use by German artists had a semantic function beyond the merely decorative. But can further corroborative evidence be found to confirm that this style was endowed with particular moral or ethical qualities? And what of the second notion raised by Vogtherr's treatise, that classical ornament be used to create a self-conscious Germanic classical style, in competition with that of Italy?

Overt competition with Italian style was explicitly and consciously registered in other areas of production, notably printing. The Augsburg printer Günther Zainer produced a calendar in traditional gothic type in 1472. However, in the same year and in that following, he had it reprinted in Italian 'antiqua' type. Signing his name at the end, he specifically stated that he had produced it in a happier medium: 'ne italo cedere videamur' – 'lest we be seen to cede to Italy'.[32] This seems to be the only known case of a fifteenth-century printer commenting upon his typographical practice, but it gives a clear expression of his confidence to compete typographically with Italian printers on his own terms and in a borrowed idiom.

A further, more complicated manifestation of a spirit of competition with Italy is to be seen in an album of script types, the *Proba centum scripturarum*, produced in 1517 by Leonard Wagner, one of the last and greatest professional scribes in Augsburg. At the beginning – as his most favoured script for all books that did not serve the liturgy – Wagner placed a script known as 'gothico-antiqua', or 'Rotonda' (as he himself called it). He described it thus:

Of all the scripts it is the most noble. It is called the mother and queen of the others, and excels over all other scripts in its style (*racione*), its authority and its excellence. Style, because it is more legible, authority because it is more noble, excellence, because it is more distinguished (*praestancior*) and more ancient (*antiquior*).[33]

Here, in the field of script design, are to be found ethical qualities attached to style: authority through nobility of style, excellence through historical precedent and antiquity. Without the example of the script itself, one might assume from Wagner's description that he was referring to 'antiqua' script. Both Dürer and Erasmus had praised this latter script for similar qualities of legibility and a dignity afforded by its antique origins; and from Basel to

Antwerp, it became the favoured type for humanist and classical texts. Yet in Augsburg, between 1470 and 1520, the *gothico-antiqua* was employed alongside the imported *antiqua* of Italy as a suitable modern substitute for the old-fashioned gothic.

As its name implies, the *gothico-antiqua* conjoins elements of gothic with the simpler, clearer 'antique' elements of romanesque minuscule. In this conscious historicism, drawn from an indigenous classical tradition, a taste is evident for native forms that were suitably authoritative in their antiquity, as alternatives to those of Italy.

In the pictorial arts, a cognate of Wagner's *gothico-antiqua* is found in Hans Burgkmair's sketch for a proposed equestrian monument of Maximilian I. It is an image of the Emperor as knightly hero of the Teutonic medieval tradition, yet constructed in the unmistakeable forms of the Italian Renaissance equestrian monument – a kind of northern Colleoni. On the monument's plain, rectangular classical plinth – as if matching these dual elements of pictorial style – the Latin inscription is written in *gothico-antiqua* script and signed by Leonard Wagner.[34]

Breu's familiarity with the meanings inherent in different script styles may be inferred from his involvement in various humanist printing projects for the publishers Grimm and Wirsung. His *Doubting Thomas* woodcut (Freiburg im Breisgau, Universitätsbibliothek; Figure 7.5), forms the central image of a 'Lehrgedicht', or sermonizing poem, by the Strassburg humanist Thomas Vogler, and lies at the heart of a complex typographical arrangement.[35] The sheet is centred by the image, above a distich set into a scroll that separates it from the surrounding verses, and is bounded above and below by borders of musical notation with corresponding words. The image and inscription form the beginning of the poem, a plea to God from Didymus (that is, St Thomas – a pseudonym for Thomas Vogler) for protection and mercy. This forms a proemium to a poem carefully structured into sections – a 'narratio', 'propositio', 'argumentatio' and 'peroratio' – that consciously follows Quintilian's method of rhetorical composition.[36] In the ode, the poet/orator's voice leads an implied congregation, shows them the current ills, and with the full use of oratorical forms and ornament brings them to a return to God's protection. The use of music at emotionally loaded points in the work strengthens the force of the poet's appeal. The types chosen – a *gothico-textura* at the emotionally loaded parts, a modern italic for the expository sections – are meant to mirror the content and to aid oral exposition.

The equation between gothic form and religious feeling that this typographical arrangement registers was also made by Leonard Wagner and other script users in their retention of a gothic type or script for liturgical purposes. This practice might have implications in the wider usages of the *Welsch* and the *Deutsch* styles in the fine arts. Breu, I believe, was sensitive to

the type of meaning inherent in different orders of decoration. In his *Sketch for a family epitaph* (Stockholm, Nationalmuseum, 1712/1875; Figure 7.6), executed some time in the 1520s,[37] he drew the fourteen Auxiliary Saints in an entirely *Deutsch* manner, comparable to that of the *Lucretia* sketch. The classicizing architecture that surrounds them is softened by gothic decorative elements that are in keeping with a traditional tone of religious devotion. It too forms a pictorial equivalent of the *gothico-antiqua*.

Hans Fugger, in a letter of 1568 to David Ott in Venice, expressed vividly the difference in tone between the two styles when he wrote to reject an Italian painting of the *Resurrection*. He criticized the italianate manner of using gratuitous artistic effects at the expense of a proper and accurate treatment of the theme, desiring in its place the simpler and more decorous style of the German tradition. He wrote of the painting:

> it has certainly been artfully painted, but the Resurrection hasn't been made as it should, for our Lord should stand up out of the tomb and not fly around as he does here . . . The panel is therefore not appropriate, it is too much *a la italiana*, flashy *(frech)* and in such a manner that standing in front of the altar, one can't tell what is going on.

In its place, he continued: 'I would like something devout and beautiful and not this kind of thing, where the painter is showing off his skill and nothing else . . . Your *Welsch* painters are far too wanton *(vagi)*'.[38]

Hans Fugger might have felt much the same way about Jörg Breu's *Meitinger Epitaph* of 1534 (Augsburg, Evang-Luth. Kirchenstiftung, St Anna; Figure 7.7),[39] which, like the *Lucretia*, is painted in a wilfully classical style. This is explicable in terms of a well-to-do and worldly merchant family wishing to have its memorial in the fashionable Italian style, rather in the manner of the Fugger funerary chapel in St Anna.[40] The patron, Conrad Meiting, was married to Barbara Fugger and their epitaph was intended for the same church. Even so, it is worth considering the painting within the context of the relationship between classical style and the Reformation. For here the style is applied to a religious work painted at the height of the iconoclastic outbursts in Augsburg, three years before the official implementation of a Protestant reform of the city's churches. Since the mid-1520s, Breu's religious views had undergone considerable change, crystallizing from a rather amorphous, non-denominational evangelism into a distinct brand of Zwinglianism. By 1531 he approved the removal of 'idols' from churches.[41] In the light of the strong Zwinglian sympathies he expressed in his chronicle during these latter years, it is difficult to explain the fact that Breu painted this work at all, other than that he had to continue to make a living.[42] Given the apparent contradiction, one might ask whether the style he so conspicuously adopted was in any way a response to the increasingly

problematic status of religious images within the city. Might the style, in some way, have been both acceptable to the Catholic sensibilities of the commissioning family, conscious of the need to address reformers' questions of pictorial decorum, as well as allowing the Protestant artist a form of religious expression that squared with his antipathy to devotional imagery?

It is true that there existed a Protestant tradition which equated the classical style with paganism, Rome and, by extension, popish superstition. Thus when the subject of *Solomon's Idolatry* was depicted by Hans Burgkmair, Albrecht Altdorfer or Lucas van Leyden, the pagan deity before which Solomon knelt was dressed in a classical exotic manner comparable to that used by Breu and Vogtherr.[43] This tradition finds its apogee in Milton's vision of classical magnificence in Satan's palace of Pandaemonium, half noble, half corrupt: 'Built like a Temple, where Pilasters round / Were set, and Doric pillars overlaid / With golden Architrave; nor did there want / Cornice or Frieze, with bossy Sculptures grav'n'.[44]

Yet despite this persistent undercurrent of hostility, another tradition within Protestantism saw positive values in the classical manner as a substitute for the older gothic style, tainted with associations of superstitious usage. This attitude was particularly strong in Augsburg, a city proud of its Roman origins and traditions and where, with its close geographical and commercial links with Italy, the *Welsch* style took root easily. On the one hand, Italian fashions in art and architecture were identified with the wealthy merchant classes. The Renaissance style of the Fugger funerary chapel in St Anna was regarded by certain members of the German aristocracy as a nouveau-riche parading of wealth.[45] On the other hand, within the context of the power struggle between the secular authorities and the Church during these years, the classical style was also used to assert the pedigree of the city's secular civic community by reference to its Roman imperial heritage. On 26 February 1537, the year of the Protestant Reformation in the city, the Bishop of Augsburg, Christoph von Stadion, wrote a letter to the Emperor and Reichstände bitterly complaining about the removal of a statue of St Ulrich, the patron saint of the city, from its position above a fountain in the main square, and its replacement by a full-size naked 'idol', an emphatically *Welsch* Neptune.[46] While the St Ulrich was a traditional symbol of the community, in style and subject it clearly also contained an assertion of the authority of the Church within the secular life of the city. Its removal by the council marked a desire to banish all such traces from the town. St Ulrich was traditionally associated with water and the choice of a Neptune to replace him might be seen as a deliberate secular alternative. It is significant that while the Bishop could refer to it as an 'idol', the Neptune's

secular symbolic properties presumably prevented such a brazen display of the *Welsch* style from offending Protestant sensibilities.

In the *Meitinger Epitaph* Breu's Christ figure is based upon Dürer's visual essay in ideal proportions: the figure of Adam in his 1504 *Fall of Man* engraving. The comparison illustrates the wide divergence between Dürer's intellectual humanism and Breu's notion of decorative style in their respective approaches to the classical. Dürer had written: 'Just as they (Greek and Roman artists) attributed the most beautiful human shapes to their false God Apollo, so we will use the same proportions for Christ our Lord, who was the most beautiful man in the universe'.[47] Dürer captured the expressive beauty of Italian classicism: the supple athleticism of the human body at its most beautiful is used to express an inner perfection of spirit. By contrast, Breu's application of style is purely external: the effect is cold, artificial, impersonal, and calculated to distance. Reformers from Martin Luther to Huldrych Zwingli condemned as 'idolatrous' all images that, by their mimetic exactness to the life, inspired reverence towards themselves and not the personage represented. However, for Luther, the most tolerant of all the reformers towards images, cheap woodcut prints continued to serve as legitimate mnemonic aids and stimuli to devotion. As he said, 'One does not pray to penny images, nor does one trust them. They are *Merckbilder* (mnemonic images – to help 'mark' in the memory), and we do not reject them'.[48] Luther praised the very crudity of their execution, for it limited the image to the function of a sign that referred directly to its substance without external reference or aesthetic distraction. The expressive poverty of such images ensured that they could not be taken at face value.[49]

A classical style, something perceived as foreign, decorative and inherently unnaturalistic, could perform a similar distancing function. By representing the divine in so stylized a manner, there was no danger of idolatry, for the image could not be taken at face value as a representation of reality. The classical form of the *Meitinger Epitaph* could thus present a credible and acceptable alternative to the gothic. Unlike the cheap woodcut, it possessed a rich aesthetic character, the semantic meanings of which were borrowed from the tradition of exemplary form in classical allegory. In this way Breu's use of the *Welsch* evolved from its beginnings in classical subject matter into a general rhetorical convention, denoting an 'elevated' or grand manner, that did honour to its subject through style rather than expressive means. When applied to religious subjects, it provided a new stylistic model which, tied more to allegory than to realism, might successfully bypass the issue of idolatry and win the acceptance of Catholics and moderate reformers alike.

To conclude: Breu's idea of the 'classical' was very different from the monolithic tradition of ideal form with which, since Heinrich Wölfflin, it has tended to be regarded. Together with a degree of interest in Italian formal

construction, the *Welsch* was primarily a form of the exotic, valued for its strangeness, its richness and its grandeur of forms – an attitude governed by an historically naïve idea of Ancient Rome and its artefacts.

As the Reformation took hold, the tradition of a personal, individual style tied to the expression of religious sentiment gave way, as Vogtherr registers, to a decorative, secular style governed by notions of prestige and outward display. The stylistic jump between the sketch and the painting in the formation of Breu's *Lucretia* registers a particular moment in that progress from the individual to the generic. Drawing on a tradition of decorative classicism in the representation of the allegorical and the exemplary, and created in a city with strong Roman roots and imperial traditions, Breu's classicism also displays the desire to emulate, if not surpass, the Italians in the use of a consciously home-grown classical style. In this sense, from the 1530s onwards, the *Welsch* paradoxically becomes a new and assertive form of the *Deutsch*.

Frequently cited literature

Vogtherr, H., (1538), *Ein Frembdes und wunderbarliches Kunstbüchlin / allen Molern Bildtschnitzern / Goldschmiden / Steynmetzen/ waffen / und Messerschmiden hochnützlich zugebrauchen / Dergleichen vor nie keines gesehen / oder in der Trück kommen ist*, Strassburg (hereafter Vogtherr 1538).

Notes

1. Oil on panel, 103.5 × 148.5 cm.

2. Oil on panel, 162 × 120.8 cm. Illustrated in Hale, J.R., (1990), *Artists and Warfare in the Renaissance*, New Haven and London: p. 93.

3. On the circumstances of the commission, see Goldberg, G., (1983), *Die Alexanderschlacht und die Historienbilder des Bayerischen Herzogs Wilhelm IV. und seiner Gemahlin Jacobaea für die Münchener Residenz*, Munich.

4. Munich, Alte Pinakothek, 688. See Wood, C.S., (1993), *Albrecht Altdorfer and the Origins of Landscape*, London: p. 19.

5. Buchner, E., (1928), 'Die Ältere Breu als Maler', in Buchner E. and Feuchtmayer, K., eds, *Beiträge zur Geschichte der Deutschen Kunst*, pp. 366–80, esp. p. 383.

6. Pen, ink and wash on blue-grey paper.

7. Baxandall, M., (1980), *The Limewood Sculptors of Renaissance Germany*, London and New Haven: pp. 135–43.

8. See, for instance, Schön, E., (Nürnberg, 1542), ed. Baer, L., (1920), *Unterweisung der Proportion und Stelling der Possen*, Frankfurt am Main, which includes a reduction of Dürer's instruction to a practical formula, and which, although not published until 1542, is indicative of earlier studio practice.

9. See Alberti, L.B., ed., Spencer, J., (1977), *Della Pittura*, New Haven and London: Book I, pp. 56–58.

10. Giehlow, K., (1899), 'Beiträge zur Entstehungsgeschichte des Gebetbuches Kaiser Maximilian I', *Jahrbuch der kunsthistorischen Sammlungen des Allerhöchsten Kaiserhauses*, **20**, pp. 30–112.

11. See Buchner 1928, *op. cit.* at n. 5, p. 370; Dodgson, C., (1916), 'The Calumny of Apelles by Breu', *Burlington Magazine*, **19**, pp. 183–9.

12. Chalk on paper, 272 × 267 mm. Illustrated in Pfeiffer, W., (1965), 'Der Entwurf zu einem Augsburger Renaissancerelief', *Anzeiger des Germanischen Nationalmuseums*, pp. 120–6, pl. 1.

13. Pen and ink on paper, 24.6 cm diam.

14. See Oberheide, A., (1933), *Der Einfluss Marcanton Raimondis auf die nordische Kunst des 16. Jahrhunderts*, unpublished Ph.D thesis, Hamburg.

15. Vogtherr 1538.

16. See Rowlands, J., (1988), *The Age of Dürer and Holbein. German Drawings 1400–1500*, London: p. 148.

17. As for example, Schön 1542, *op. cit.* at n. 8.

18. Vogtherr 1538, Aii, v: '. . . habe ich Heynrich Vogteherr/ Moler und Burger zu Strassburg/ auss Bruderlicher liebe/ meniglichen zu nutz/ und sollichen künsten zur fürderniß/ auch den jhenigen/ so inn gemelten künsten/ mit wieb und kinden beladen/ auch etlichen/ so von natur weit umbreysens ungewohnt . . . '.

19. *Ibid.*, Aii: 'Nach dem der barmherzig Gott auss sonderer Schickung seines Heyligen worts/ jetz zu unsern zeiten in ganzer Teutscherr nation/ allen subtilen und freien Künsten/ ein merckliche verkleynerung unnd abruch mitgebracht hat . . . '.

20. *Ibid.*, Aii: 'und solche Künstler . . . volfürter handlung in kunstlichen Übungen nit matt oder müd werden und sich in gemeyner Christenheyt nit alss die groben Barbari/ sondern wie man (Gott hat lob) Teutsch Nation inn allen künsten hohelichen auffgestigen syhet.'

21. *Ibid.*, Aii: 'aller frembden und schweresten stücken/ so gemeinlich vil fantasierens/ nachdenkens haben wollen/ . . . zusamen in ein büchelin gebracht . . . die hochverstendigen visierlichen

Künstler dardurch ermundert unnd ermanet werden/ noch vil hoher und subtiler kunsten aus bruderlicher liebe an tag zubringen/ damit die Kunst widerumb in ein auffgang/ und seinen rechten wirden und ehren komme/ und wir uns anderen Nationen befleissen fürzuschreiten.'

22. See Knepper, J., (1898), *Nationaler Gedanke und Kaiseridee bei den elsässischen Humanisten*, Freiburg; Joachimsen, P., (1910), *Geschichtsauffassung und Geschichtsschreibung in Deutschland unter dem Einfuss des Humanismus*, Leipzig and Berlin; Borchardt, F., (1971), *German Antiquity in Renaissance Myth*, Baltimore.

23. See, for instance, Dacosta Kaufmann, T., (1985), *The School of Prague. Painting at the Court of Rudolph II*, Chicago and London: p. 11 ff., and *ibid.*, (1982),'The Eloquent Artist: Towards an Understanding of the Stylistics at the Court of Rudolph II', *Leids Kunsthistorisch Jaarboek*, **1**, pp. 119–48.

24. See Jessen, P., (1920), *Der Ornamentstich*, Berlin; Jervis, S., (1974), *Printed Furniture Designs before 1650*, London.

25. See Strauss, W.L., ed., (1980), *The Illustrated Bartsch*, **10**, *Albrecht Dürer*, 2 parts, pt. 1, p. 144, no. 49. See Blankenhorn, H., (1979), *Die Renaissancephase Jörg Breu den Älteren*, unpublished Ph.D thesis, University of Vienna, p. 89.

26. See de Chapeaurouge, D., (1960), 'Selfstmorddarstellungen im Mittelalter, *Zeitschrift für Kunstwissenschaft*, **14**, pp. 145–6; for a useful discussion of Lucretia imagery, see Garrard, M.D., (1989), *Artemisia Gentileschi*, Princeton, pp. 216–39.

27. Beenken, H., (1935), 'Beiträge zur Jörg Breu und Hans Dürer', *Jahrbuch des Preussischen Kunstsammlungen*, **56**, p. 60: 'Überall ein verbindliches Kommen und Gehen, man verschwört sich unter Konventionellen Beteuerungsgesten. Das Drama römischer Frauentugend ist hier zum Konversationsstück geworden, bei dem die Bühne mehr als die Handlung gilt.'

28. See Burkhard, A., (1932), *Hans Burgkmair der Ältere. Meister der Graphik*, Berlin: cats. 21 and 23, pls 29 and 21.

29. Berlin, Staatliche Museen Preussischer Kulturbesitz, Skulpturengalerie, M98. Limewood, 8.9 × 5.4 cm, illustrated in Bushart, B., et al. eds, (1980), *Welt im Umbruch, Augsburg zwischen Renaissance und Barock*, exh. cat., 3 vols, Augsburg Rathaus und Zeughaus: **2**, p. 198, no. 568.

30. Schloss Neuenstein, Hohenlohe-Museum, NL69; relief of Solnhofen stone and scagliola (the scagliola probably being a seventeenth–century addition), 36.2 × 29.3 cm. See Goldberg 1983, *op. cit.* at n. 3, pp. 62–63, fig. 50. For the attribution to Doman Hering, see Eser, T., (1996), *Hans Daucher, Augsburger Kleinplastik der Renaissance*, Munich: pp. 287–90.

31. Falk, T, ed, (1980), *The Illustrated Bartsch*, **11**, *Sixteenth Century German Artists. Burgkmair, Schäufelein, Cranach*, p. 67, no. 64.

32. Wehmer, C., (1955), 'Ne Italo Cedere Videamur', in *Augusta 955–1955*, Augsburg: pp. 145–72.

33. *Ibid.*, p. 148, 'Omnium scripturarum est nobilissima. Vocatur eciam mater et regina aliarum, quia racione, auctoritate et excellentia omnes scripturas excellit. Racione, quia legibilior, auctoritate, quia nobilior, excellencia, quia prestancior et antiquior'.

34. *Ibid.*, p. 158.

35. The woodcut measures 363 × 265 mm. For the literary analysis of the poem, see Sack, V., (1988), *Glauben im Zeitalter des Glaubenkampfes. Schriften der Universitätsbibliothek Freiburg im Breisgau*, **13**, Freiburg im Breisgau.

36. *Ibid.*, esp. pp. 35–8.

37. Pen and dark brown ink on paper, 41 × 31 cm.

38. See Baxandall, M., (1966), 'Hubert Gerhard and the Altar of Christoph Fugger: the Sculpture and its Making', *Münchener Jahrbuch der Bildenden Kunst*, **17**, pp. 127–44.

39. Oil on panel, 208.5 × 128 cm.

40. See Bushart, B., (1994), *Die Fuggerkappelle bei St. Anna in Augsburg*, Augsburg.

41. See Roth, F., ed., (1906), *Die Chronik des Augsburger Malers Georg Breu des Älteren 1512–1537. Die Chroniken der Deutschen Städte vom 14. bis ins 16.Jahrhundert*, **29**, Leipzig: p. 50.

42. *Ibid.*, p. 77. In an entry for 1537, Breu recognizes the economic implications for those threatened by the Reformation, yet remains unsympathetic: 'Also dem gemainen mann, schneidern,

schuestern u[nd anderen], den was etwas daran gelegen und umb ir narung zu thun; sie bedachten nit die grossen gotlesterung und unfreuntschaft . . . [und die gefar] in der Spaltung aufruerig zu werden'.

43. See Falk ed. 1980, *op. cit.* at n. 31, p. 13, no. 4; Marrow, T., Strauss, W.L., Jacobowitz, E.S. and Stepanek, S.L., eds, (1981), *The Illustrated Bartsch*, **12**, *Baldung, Springinklee, Van Leyden*, p.162, no. 30 and Koch, A., ed., (1980), *The Illustrated Bartsch*, **14**, *Early German Masters. Altdorfer, Monogrammists*, p. 12, no. 4.

44. Milton, J., *Paradise Lost*, Book 1, lines 713–22, in Campbell, G. ed., (1980), *John Milton. The Complete English Poems*, London: p. 170. See Thomas, K.V., (1995), 'English Protestantism and Classical Art', in Gent, L., ed., *Albion's Classicism. The Visual Arts in Britian 1550–1660*, New Haven and London: p. 225.

45. See von Hutten, U., ed., Böcking, E., (1860), *Schriften*, Leipzig: **4**, pp. 391–2; quoted in Baxandall 1980, *op. cit.* at n. 7, pp. 137–8.

46. '. . . daß die von Augsburg, als widersinnige Leute, S. Ulrichs, deß heiligen Bischofs Bildnuss, so lange Zeit auff den Berlach gestanden ist, verachter weiß hinweg gethan/ vnd an derselben statt deß Abgotts Neptun Bildnuß auff den Brunnen gestellt haben'. Quoted in (1980), exh. cat., Augsburg, *op. cit.* at n. 29, **2**, p. 502, cat. 502. The statue is attributed to Adolf Daucher.

47. Quoted in Panofsky, E., (1969), 'Erasmus and the Visual Arts', *Journal of the Warburg and Courtauld Institutes*, **32**, pp. 213–4, n. 36.

48. 'Die Groschen Bilder betet man . . . nicht an, man setzet kein vertrawen drauff, sondern es sind Merckbilde . . . [D]ie verwerffen wir nicht'; Seventh Sermon on Deuteronomy, October 21st, 1529, in *D. Martin Luthers Werke: Kritische Gesamtausgabe*, 1883–[1990], 66 vols, Weimar: **28**, (1903) p. 677; quoted by Koerner, J.L., (1993), *The Moment of Self Portraiture in German Renaissance Art*, Chicago: p. 381.

49. *Ibid.*, p. 382.

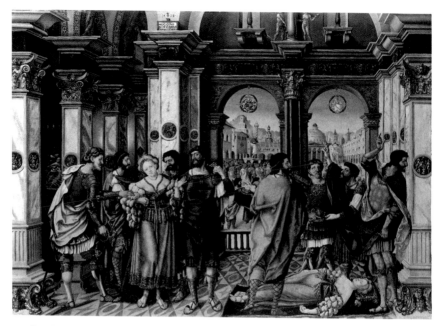

7.1 Jörg Breu the Elder, *Story of Lucretia* oil on panel.

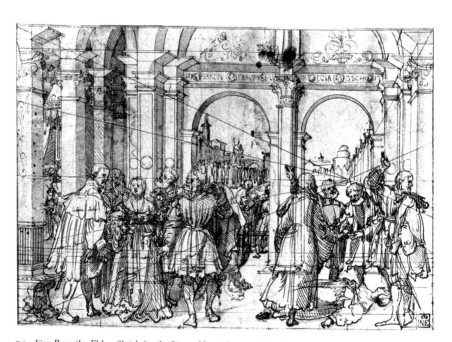

7.2 Jörg Breu the Elder, *Sketch for the Story of Lucretia*, pen, ink and wash on blue-grey paper.

7.3 Jörg Breu the Elder, *The Murder of Agamemnon by Clytemnestra and Aegishus*, pen and ink on paper.

7.4 Heinrich Vogtherr the Elder, pages from the *Kunstbüchlein*, woodcuts.

7.5 Jörg Breu the Elder, *Lehrgedicht of Thomas Volger*: woodcut.

7.6 Jörg Breu the Elder, *Sketch for a family Epitaph*, pen and dark brown ink on paper.

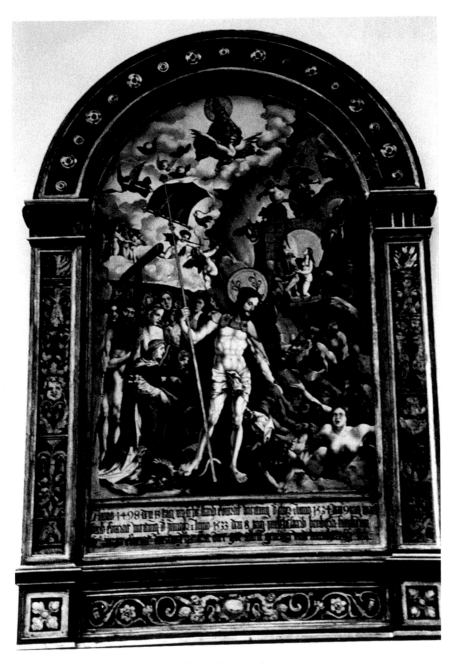

7.7　Jörg Breu the Elder, *The Meitinger Epitaph*, oil on panel.

Vasari, prints and imitation

Sharon Gregory

'I know that our art consists primarily in the imitation of nature but then, since it cannot by itself reach so high, in the imitation of those judged to be more accomplished artists.' Thus wrote Giorgio Vasari in the Preface to his *Lives of the Artists*.[1] What then is this imitation? In seeking to respond to this question, the focus in this paper will be on the imitation by artists of other more accomplished masters, rather than on the problem of the imitation of nature, which is not within the essay's scope.

During the fifteenth and sixteenth centuries in Italy, the concept of imitation permeated many fields of endeavour. As an issue of debate it originated with the humanist scholars of the fourteenth century, who made attempts to reconstruct the Latin language as it had been used in antiquity prior to what they viewed as the changes and 'degeneration' that had occurred in the intervening years. One of the surest ways to recover that language was to read the ancient authors and, when writing Latin, to imitate them.[2] However, the problem of whether one should imitate many different authors or only one, which had been discussed in the ancient Roman texts themselves, became the central issue in cinquecento debates between rhetoricians.[3] This issue will be returned to, but, as Vasari remarked, 'theories . . . when separated from practice are generally of very little use'.[4] So at first it will be helpful to see what imitation looks like in the work of a single artist. For this I have chosen Vasari himself, and, in relation to his imitation of other masters, I have limited myself, more or less, to his use of images from copperplate engravings and woodcuts, the models most easily accessible to all artists in the sixteenth century, even those who did not travel.

Imitation in an artist's work can be undertaken for varying purposes and can therefore take on a number of forms.[5] The simplest form is the type of quotation in which an artist refers to the work of another artist in order to aid the expression of an idea in visual terms. In Vasari's 1544 painting, the

Presentation in the Temple (Naples, Capodimonte),[6] the composition was influenced by Albrecht Dürer's woodcut of the same subject.[7] In both works, one group of figures stands in front of columns to the left, while another group surges inwards from the right. Similarly, in both images, the columns and the cornice above recede towards the centre, where they meet a wall containing an open archway with sculptural decoration above. But, in his painting, Vasari added Solomonic columns and altered other elements of Dürer's architecture the better to reflect classical usage. He also eliminated the area of sky at the top of Dürer's print. More concrete evidence for Vasari's reliance on Dürer's woodcut can be seen in his preparatory drawing for the Naples painting (Dijon, Musée des Beaux-Arts, T42),[8] in which Mary approaches the temple and stoops to kneel upon two rounded steps. In Dürer's woodcut, a column stands upon two similarly rounded steps, and behind it the young Virgin climbs the stairs to the temple. In Vasari's painting, however, the two steps have been squared off. The drawing also shows less elaborate embellishment of architectural features such as the arched doorway, but it reveals more space above the arch and a window through to the sky. Similar in effect to the woodcut is the sculptural motif above the door, which replaces the soldier in Dürer's image. In the history of printmaking inserted into the second edition of the *Lives*, Vasari was lavish in his praise of Dürer's prints. He specifically favoured the *Life of the Virgin* series for its inventiveness and for its composition of perspective views and buildings, and it is evident that he made use of Dürer's print for what it offered him in these respects.[9]

Though Vasari also praised Dürer's *disegno*, he denied the German's mastery in that field on account of what he saw as an inability to draw the nude. Describing the subject of one engraving, now thought to represent *Hercules at the Crossroads* (Figure 8.1), as 'Diana beating a nymph', Vasari wrote:

In this sheet, Alberto wanted to show that he knew how to make nudes. But though these masters were praised at the time in their countries, in ours their works are commended only for the skill of the engraving. I am willing to believe that Alberto was not able to do better because, not having other models, he drew, when he had to make nudes, from one of his assistants, who must like most Germans have had ugly bodies, though one sees many men from those lands who are attractive when well clothed.[10]

Vasari insisted in the *Lives* that '*disegno* cannot have a good beginning unless it comes from continual practice in copying natural objects . . . but above all, the best thing is to draw men and women from the nude.'[11] Profound knowledge of the human figure was essential in *disegno*.

In taking elements from Dürer's prints, Vasari often corrected them in such a way as to show his greater mastery in drawing the human figure.

From the above-mentioned engraving he borrowed the figure that he identi-
fied as Diana for a man descending the stairs in his small painting, the c.1565
Forge of Vulcan (Florence, Uffizi). I reproduce here the *modello* (Paris, Louvre,
2161; Figure 8.2), which the painting closely follows.[12] In rendering the figure
nude, and changing its sex to male, Vasari gave himself greater opportunity
to reveal musculature and also, by increasing the *contrapposto* twist of the
torso, to show greater animation and more forceful movement, more appro-
priate to masculine action. Here, Vasari can be seen to compete with Dürer,
confident of his own victory in the difficult matter of rendering the figure in
motion.

A similar situation arises in a drawing of *Doubting Thomas* (Steiner
Collection, USA), thought to date from the 1550s.[13] Vasari's only known
painting of this subject (Florence, Santa Croce, Guidacci Chapel), generally
dated c.1569–72, is thus at least a decade later, and bears little resemblance to
the drawing. Charles Saumarez-Smith pointed out the drawing's unusual
juxtaposition of St Peter and St Thomas,[14] but not its source in Dürer's *Small
Passion* woodcut of the same subject.[15] Other similarities occur in the cluster
of subsidiary figures around the central trio, even to such specific details as
the tilted head of the apostle at the upper left, who strains to see what is
happening. But again Dürer's figures of Peter and Thomas are too static for
Vasari, who therefore gives them greater animation through increased *contra-
pposto*. The same thing occurs with the figure of Christ, but here Vasari had
yet another model in mind – an engraving of *Empedocles* by René Boyvin,
after a design by Rosso Fiorentino.[16] Vasari's use of this print is made clear
by similarities such as the knot in the loincloth and the treatment of the
figure's hair and beard. Apart from rendering the figure of Christ nearly
nude, and changing the position of the hands so that the wounds are
emphasized, Vasari made few changes to the actual pose. For, in contrast to
his opinion of Dürer, he credited Rosso with mastery of *contrapposto*. He also
accorded extravagant praise to Rosso for his figures, which for him were
simultaneously poetic and fiery, showing both grace and *terribilità*.[17] In this
single drawing, then, there is evidence of Vasari having used imitation as a
means of both competing with and paying homage to other artists.

In another, more complex type of imitation, an artist could show the extent
of his erudition by referring to his primary source in a work by another
artist, while also making reference to that artist's sources. Vasari did this in
two paintings of the *Way to Calvary*, a subject which must have brought to
most Italian artists' minds Raphael's c.1520 version, known as *Lo Spasimo di
Sicilia* (Madrid, Prado). Vasari praised this composition in the *Lives* – and I
say 'this composition' because he could only have known the engraving after
it, probably by Agostino Veneziano.[18] Raphael's own quotations from depic-
tions of the subject by Northern artists have been discussed by others.[19]

Briefly, he owed debts to Lucas van Leyden – in the position of Christ, evidently derived from an engraving of *Christ and Veronica*[20] – and also, of course, to Dürer, with whom he had even been in contact around 1515.[21] Though many correspondences between Dürer's Large Passion *Way to Calvary* and Raphael's image have been pointed out, I would like to add my own observation that Simon of Cyrene, who, in taking up the cross in Raphael's painting, almost appears to be the heroic protagonist of the composition, bears a more than passing resemblance, in his facial features and in the angle of his right arm and upper body, to Dürer's Christ.[22]

The first of the Vasarian painted versions of the subject (Lawrence, KS, University of Kansas, Spencer Museum of Art; see Figure 9.6) is probably by a member of the workshop.[23] The presence of soldiers on horseback suggests Raphael more than any other source. As in Raphael's depiction, one soldier carries a Roman banner; in both images a soldier points a baton; and the foot of Christ in Vasari's painting appears to be derived from that of the woman who supports the Virgin in Raphael's panel. Knowing that Raphael had looked at Lucas's prints may have led Vasari to examine the Northern artist's engraved *Way to Calvary* as a potential source for his own design.[24] The proportion of architecture to open space is similar in the two images. Also similar is the manner in which Christ holds the cross with both hands. In the painting, and in Lucas's print, a man positioned above Christ's head whips him with a rope.

In Vasari's Kansas *Way to Calvary*, though not in Raphael's, Christ looks up at Veronica: this motif is derived from Dürer's woodcut. Veronica's hands and the position of her veil are similarly treated. In both images, the Virgin stands directly behind Veronica, with another woman's head squeezed in between the Virgin and the left edge. The soldier in the left foreground with his arm extended towards Christ performs the same compositional role in both images.

On the basis of Vasari's *Ricordanze*, which reveal that he and the workshop produced a number of paintings of this subject in 1553, the Kansas painting has tentatively been dated to that year.[25] However, I feel it must be closer in date to the second version of 1568–72 (Florence, Santa Croce, Cappella Buonarroti) because of a drawing sold at Christie's in 1982, which clearly represents a transitional stage between the two paintings, or rather a fluid continuation of the same thought.[26] Vasari seems to have intended that the new composition be slightly more complex, with the procession to Calvary shown winding its way back into the distance on the right. The Northern emphasis on cruelty – the man whipping Christ – is eliminated.

In the *modello* for the Santa Croce altarpiece (Florence, Uffizi, 1190E),[27] Vasari's figural grouping is even more varied, including on the left a depiction of the swooning Virgin, apparently derived from an engraving by

Giulio Bonasone after a Raphael preparatory drawing for the Baglioni *Entombment* (Rome, Galleria Borghese).[28] In the painting itself, the resemblance is even closer, with St John, who replaces the standing female figure in the engraving, embracing the Virgin rather than simply clinging to her arm as he does in Vasari's *modello*. The soldier on the right now walks towards the right, but his torso twists back towards Christ, thus adding a *figura serpentinata* to the composition. Once again, this most elegant figure derives from an engraving after Rosso – *Saturn and Philyra* by Gian Jacopo Caraglio.[29] Vasari has reversed the figure and changed its sex, but the derivation is, I feel, unmistakable.

This figure had begun to assume importance for Vasari in about 1556, when he designed a small painting depicting *Jupiter and Io* for the Palazzo Vecchio. In the painting he used Rosso's Philyra for his own Io, although the rest of the composition was in fact based on a print designed by Perino del Vaga from the same series.[30] Once Vasari had made it his own in the *Way to Calvary,* by simply changing the figure's sex, he was able to use it again in his 1572–3 fresco of *Coligny Wounded* for the Sala Regia in the Vatican.[31]

There are many examples of such figures derived from prints after Rosso, but here one will suffice: Rosso's *Hercules and Cacus,* also engraved by Caraglio (Figure 8.3). Vasari was clearly attracted to the figure of Hercules, whose *contrapposto* is so extreme as to show both the front and back of the figure at the same time. David Summers has written about the importance of such figures to many of Vasari's compatriots, including Rosso, Jacopo Pontormo and Francesco Salviati.[32] On at least seven different occasions between 1539 and 1573, Vasari employed Rosso's figure with no essential change. In his *Apocalypse* scene of the *Four Avenging Angels,* painted for the Bolognese church of San Michele in Bosco (1539–40), he used the Hercules figure for one of the foreground angels.[33] The posture of this figure, as he grasps an adversary with his extended left arm while holding a weapon above the head with his right arm bent at the elbow, is identical to Rosso's. A figure in the same stance appears twice in the Vasari ceiling panels of the Sala di Leo X in the Palazzo Vecchio (1556–62). In both the corner panel of *Cardinal Giovanni de' Medici Escaping from Prison,* and the *modello* (Vienna, Albertina, 2534; Figure 8.4), the foreground soldier is based on Rosso's Hercules, although his posture has been slightly altered. However, in Vasari's earlier preparatory drawing for the entire ceiling (Paris, Louvre, 2175), the soldier's stance precisely echoes Rosso's figure.[34] The Louvre drawing's central scene, which shows the *Taking of Milan,* has no figure corresponding to Rosso's Hercules. But in a drawing which develops the composition (Florence, Uffizi, 626F), Vasari inserted the figure into a group of soldiers defending the city walls. These soldiers, and the figure in question, appear in the final painting.[35] The Hercules makes a further appearance at

the Palazzo Vecchio in the Stanza di Penelope's *Blinding of Cyclops*, probably executed by Vasari's assistants, Giovanni Stradano and Francesco Morandini (Il Poppi).[36]

Among the many personal emblems adopted by Florence's Duke Cosimo de' Medici was the image of Hercules triumphant over Cacus (represented also in Baccio Bandinelli's monumental sculpted group). Thus the prevalence in the Palazzo Vecchio images of figures by Vasari derived from a print of this subject may owe something to Cosimo's wishes. But this does not explain Vasari's continued use of the Hercules figure from Rosso's engraving in works designed for other patrons. In 1569, Vasari and Poppi painted a *Martyrdom of St Peter Martyr* for the church of Santa Croce at Boscomarengo, in which Rosso's Hercules appears as the soldier in the foreground killing the saint.[37] The same figure returns in the extreme forefront of Vasari's 1572–3 *St Bartholomew's Day Massacre* fresco in the Vatican's Sala Regia.[38] The Hercules figure's final appearance in Vasari's designs is in a series of drawings for the Florence Cathedral vault. In two early sketches (Paris, Louvre, 2113 and 2140), the figure becomes a demon pushing souls into the reptilian mouth of Hell, and is still present in a more fully developed study, (Louvre, 2146).[39] Presumably, it was intended that the figure would feature in the frescoes themselves but, following Vasari's death in 1574, the decoration was largely completed by Federico Zuccaro, who made many alterations to the design. Nevertheless, we have seen that the Hercules figure in Rosso's print acted as a continual inspiration for Vasari from an early stage in his career until its very end.

A distinction between *imitare* (imitating) and *ritrarre* (copying) was made by Vincenzo Danti in the First Book of his *Treatise on Perfect Proportion* (1567). According to Danti, Nature intends forms that are beautiful and perfect, but matter cannot always receive the forms perfectly. The difference between imitation and copying is that:

the latter fashions perfect things as they are, and the former makes things perfect as they should be seen . . . But, as we turn to the works of art that can be imitated and copied, we see that those which have both perfection of art and matter must be copied; and those which are deficient in some way must be imitated, giving them all the perfection that they require.[40]

This points to the reason behind the close resemblances between Vasari's figures and those of Rosso. The latter are perfect, or nearly so, and thus can be copied. On the other hand, Dürer's figures are good to use but must be perfected.

The major point in Renaissance debates about rhetorical imitation centred around whether it was better to imitate one master alone, or to cull elements from several masters and combine them into something new. In the second

decade of the sixteenth century, Gianfrancesco Pico della Mirandola and Pietro Bembo locked horns over this precise issue.[41] Pico was in favour of studying the work of many masters, and from this eclectic reading forming a style congenial to one's own make-up, in accordance with the particularized Idea of eloquence that resides in the individual. Bembo denied the existence of an Idea of perfect eloquence, unless it was formed only after long study and much practice. He also thought that the confluence of various styles in a single work was an absurdity. The writer should form his taste by studying as intimately as possible the works of the best master and seek to emulate him alone, cultivating even his very temperament. Among the notables who entered into the debate was Vasari's friend and adviser Vincenzo Borghini. In 1542, Borghini proposed a compromise which permitted the writer to take his vocabulary from a wide range of authors but his syntax or form from only one – the best master available.[42]

How did this debate affect Vasari? and what was his solution as an artist? In the definition of *disegno* added to the 1568 edition of the *Lives*, Vasari suggested that the Idea of perfect form comes to the individual artist from experience and long practice; the ability to discern the Idea and then the skill to represent it accurately are both essential for *disegno*:

Because *disegno*, the father of our three arts of architecture, sculpture, and painting, proceeding from the intellect, derives from many things a universal judgement, like a form or idea of all things in nature – which is most consistent in her measures – it happens that not only in human bodies and those of animals, but in plants as well and buildings and sculpture and paintings, *disegno* understands the proportion that the whole has to the parts and the parts to one another and to the whole. And because from this understanding there arises a certain notion and judgement which forms in the mind that which, when expressed with the hands, is called *disegno*, one may conclude that *disegno* is nothing other than a visible expression and declaration of that notion of the mind, or of that which others have imagined in their minds or given shape to in their idea . . . What *disegno* needs, when it has derived from the judgement the mental image of any thing, is that the hand, through the study and practice of many years, may be free and apt to draw and to express correctly, with the pen, the stylus, charcoal, chalk, or other instrument, whatever nature has created.[43]

The great master of *disegno* in Vasari's time was Michelangelo, because of his proficiency in that most difficult area of representing the human figure and because he had mastered all three of the arts born from *disegno*: painting, sculpture and architecture.[44] But Michelangelo's perfection was such that it was difficult to imitate him without actually copying him, and Vasari censured artists who by doing so had created 'a style that is very dry and full of difficulty, without charm, without colour, and weak in invention'.[45] Despite Michelangelo's perfection and his 'having shown us the way to facility in this art',[46] an artist must 'be content with doing those things to

which he feels inclined by natural instinct and should never, merely to emulate others, desire to try his hand at something for which he has no natural gift'.[47]

In the second version of his *Life* of Raphael, Vasari said that Raphael had formed his own style by assiduously studying the work of many masters and assimilating the parts that suited his needs and inclinations.[48] Thus it would seem that, at least by 1568, Vasari, in essence, advocated the method of an artist learning from many masters what best suits his own Idea, which of itself must be formed by long study and much practice. Like Borghini, he proposed a sort of compromise position.[49]

In the discussion thus far, we have seen that in his own paintings and drawings, Vasari was prepared to make use of the work of a variety of masters. I would like to discuss one final image, Vasari's 1540 *Deposition* for the monastery at Camaldoli (Figure 8.7), which I believe to be something in the nature of an early manifesto on imitation by the artist. The *modello* for the altarpiece (Paris, Louvre, 2094) may have been completed in 1539, before Vasari was called to work in Bologna for a time.[50] The basic compositional structure of the Camaldoli *Deposition* owes a considerable debt to Rosso's Volterra altarpiece of the same subject, a painting to which Vasari had already made reference in his own 1536/37 *Deposition* altarpiece for the Church of San Domenico in Arezzo.[51] In the Louvre *modello*, the presence of the figure of Nicodemus behind the cross also makes evident Vasari's interest in Dürer. In Italian art, Nicodemus is normally shown as a younger, dark-bearded man, but Vasari has represented him as an old man with a long white beard, as he appears in Dürer's *Lamentation* woodcut from the *Small Passion*.[52] In Vasari's *modello*, Nicodemus even holds his cylindrical lidded vessel in much the same way as his counterpart in Dürer's print: with his right arm bent at the elbow so that his bare right hand rests on top of the jar, while his left hand, covered with drapery, supports it from below. The Nicodemus figure was, however, eliminated in Vasari's actual painting. There are a few other changes that suggest the work of other masters who interested him. For instance, the figure on the ladder at the right has lost his hat and some of his clothing, and is given instead a rather spiky mass of hair and beard that may allude to similar workers in Filippino Lippi's *Crucifixion of St Philip* fresco (Florence, Santa Maria Novella, Cappella Strozzi);[53] or, perhaps, to one of the men lowering Christ's body in Rosso's *Deposition*. The body of Christ, arms outstretched, as in the drawing, resembles that in Fra Angelico's *Descent from the Cross* (Florence, Museo di San Marco)[54] although the hands have been changed to look very much like the extended hands of God and Adam from the *Creation of Adam* scene on the Sistine Chapel ceiling. The figure on the left of the painting, gazing back over his shoulder in a melancholy fashion, is entirely new. This single figure, which features in a

Vasari drawing (Florence, Uffizi, 6494F; Figure 8.5), was to be reused by Vasari in two other paintings during the 1540s: the 1546 fresco of *Paul III Receiving the Homage of Nations* (Rome, Palazzo della Cancelleria) and the 1548 *Wedding Banquet of Esther and Ahasuerus* (Arezzo, Museo Statale di Arte Medievale e Moderna).[55] Janet Cox-Rearick has noted that this figure's facial features appear to age in each successive painting, and, on the basis of known portraits of Vasari, she has suggested that these images are self-portraits.[56]

The figure itself is based upon that of St Paul in Raphael's *St Cecilia Altarpiece* (Bologna, Pinacoteca; Figure 8.6), a painting with which Vasari became acquainted during his 1539–40 stay in Bologna.[57] Raphael's paintings had had a profound impact upon Vasari while he was in Rome in 1538, and indeed, as Sydney Freedberg among others has pointed out, a sense of Raphaelesque grace pervades Vasari's *Deposition*.[58] If the facial features of this figure are Vasari's own, then it is surely significant that the figure who bears them is derived from Raphael. One has the sense from Vasari's later career that he had determined to pattern his life on that of Raphael. Like Raphael, Vasari was sociable, friendly with learned men, created large decorative schemes for influential patrons, and ran a large shop with many able assistants to whom he was quite willing to allocate important tasks. We have also seen that Vasari studied Raphael's works so intently that he could even recognize the master's own sources.

The Camaldoli *Deposition* shows Vasari associating himself with a specific artistic lineage. It represents his intention to follow a particular tradition in painting, based on the creations of earlier great masters who had worked in Florence and Rome. This is why, in spite of the fact that Dürer's prints had already been of interest and use to Vasari – and indeed would continue to be so throughout his career – the Düreresque figure of Nicodemus was eliminated from the altarpiece's final design.[59]

I have noted that by 1568 Vasari's position on imitation, as revealed in the second edition of the *Lives*, was in some respects similar to that of Vincenzo Borghini, who, in the 1550s, had become his adviser and close friend. But given the carefully constructed artistic genealogy that Vasari had associated himself with in the Camaldoli *Deposition*, it seems likely that he had already pondered the matter to some extent by 1540. The conclusions he reached show why he was later to find in Borghini a friend with whom he was so intellectually compatible. Vasari himself was ready to take individual figures and other inventions from the work of many artists as they suited him, but his syntax – his sense of form – came from a more select group of masters whose styles he found congenial. It has been one of the purposes of this paper to make this distinction, and to point to two masters from whom Vasari derived his personal syntax: Rosso and Raphael.

Frequently cited literature

Barocchi, P., (1964),*Vasari Pittore*, Milan; Vasari, G., eds, Bettarini R. and Barocchi, P., (1966–1987), *Le vite de' più eccelenti pittori, scultori e architettori*, 6 vols (text), Florence: all quotations from Vasari come from this edition (hereafter Vasari–B/B 1966–1987) which allows comparison between the texts of 1550 and 1568. Unless otherwise indicated, all quotations appear in both sixteenth-century editions; Strauss, W.L., ed., (1980) *The Illustrated Bartsch*, **10**, *Albrecht Dürer*, 2 parts, New York, (hereafter Strauss ed. 1980, **10**; Corti, L., (1989), *Vasari: Catalogo completo dei dipinti*, Florence.

Notes

1. Vasari–B/B 1966–1987, (from the Preface to the *Lives*), **2**, p. 12. This paper has evolved from my Ph.D research, which has been generously funded by the Commonwealth Scholarship Commission in the United Kingdom and by the Social Sciences and Humanities Research Council of Canada. I am grateful for the advice offered by Dr Patricia Rubin, and for suggestions made by Murray Gibson.

2. See Baxandall, M., (1971), *Giotto and the Orators*, Oxford, and also Greene, T.M., (1982), *The Light in Troy: Imitation and Discovery in Renaissance Poetry*, New Haven and London.

3. For an introduction to the ancient texts and their impact on Renaissance rhetoricians, see Greene 1982, *op. cit.* at n. 2, pp. 54–103, and Pigman, G.W., (1980), 'Versions of Imitation in the Renaissance', *Renaissance Quarterly*, **30**, pp. 1–32.

4. Vasari–B/B 1966–1987, (*Life* of Alberti), **3**, p. 283.

5. My analysis of types of imitation in the visual arts is partially based upon the discussion by Shearman, J., (1992), *Only Connect . . . Art and the Spectator in the Italian Renaissance*, Princeton: pp. 227–61.

6. Reproduced in Corti 1989, p. 53.

7. Reproduced in Strauss ed. 1980, **10**, p. 176, no. 81.

8. Reproduced in Monbeig–Goguel, C., and Vitzthum, W., (1968), 'Dessins inédits de Giorgio Vasari', *Revue de l'Art*, **1/2**, pp. 89–93, pl. 5.

9. The history of printmaking appears in the *Life* of Marcantonio Raimondi and Other Engravers of Prints, Vasari–B/B 1966–1987, **5**, pp. 2–25. Several pages are devoted to Dürer; the *Life of the Virgin* series is discussed on p. 5.

10. Vasari–B/B 1966–1987, **5**, p. 4. For the *Hercules at the Crossroads* engraving, see Strauss ed. 1980, **10**, p. 64, no. 73. For the iconography of the engraving, see the companion volume, **10**, *Commentary*, p. 160.

11. Vasari–B/B 1966–1987, (Introduction to the *Lives*), **1**, p. 114.

12. For the painting, see Corti 1989, p. 111.

13. Reproduced in Oberhuber, K., ed., (1977), *Renaissance and Baroque Drawings from the Collections of John and Alice Steiner*, Cambridge, Mass.: cat. 35.

14. *Ibid.*, p. 95.

15. Reproduced in Strauss ed.1980, **10**, p. 144, no. 49.

16. Reproduced in Carroll, E.A., (1987), *Rosso Fiorentino: Drawings, Prints, and Decorative Arts*, exh. cat., Washington, (National Gallery of Art): cat. 110.

17. Vasari–B/B 1966–1987, (*Life* of Rosso), **4**, p. 474.

18. As far as we know, Vasari never travelled to Palermo, where the painting was located. The engraving, reproduced in Oberhuber, K., ed., (1978), *The Illustrated Bartsch*, **26**, *The Works of Marcantonio Raimondi and his School*, p. 44, no. 28, was attributed by Vasari to Marcantonio in the 1568 edition of the *Lives*: Vasari–B/B, 1966–1987, **5**, p. 11.

19. Polzer, J., (1974), 'Dürer et Raphaël', *Nouvelles de l'estampe* **17**, pp. 15–22; also Quednau, R., (1983),'Raphael und "alcune stampe di maniera tedesca" ', *Zeitschrift für Kunstgeschichte*, **46**, pp. 167–70.

20. Reproduced in Marrow, J., Strauss, W.L., Jacobowitz, E.S. and Stepanek, S.L., eds, (1981), *The Illustrated Bartsch*, **12**, *Baldung, Springinklee, Van Leyden*, p. 204, no. 72.

21. Vasari described an exchange of artworks between Raphael and Dürer in the *Life* of Raphael, Vasari–B/B 1966–1987, **4**, pp. 189–90. Concerning a drawing sent in 1515 by Raphael to Dürer (Vienna, Albertina, Bd.V 17575), see Nesselrath, A., (1993), 'Raphael's Gift to Dürer', *Master Drawings*, **31**, pp. 376–89.

22. Dürer's print is reproduced in Strauss ed. 1980, **10**, p. 105, no. 10.

23. Reproduced in Corti 1989, p. 84.

24. Reproduced in Marrow, Strauss, Jacobowitz, and Stepanek, eds, 1981, *op. cit.* at n. 20, p. 183, no. 51.

25. Corti 1989, p. 84. For Vasari's *Ricordanze*, see Frey, K., (1930), *Der literarische Nachlass Giorgio Vasaris*, 3 vols, Munich: **2**, pp. 870–1.

26. See the sale catalogue for Christie's London, 6 July 1982, no. 26. Corti 1989, p. 143, would like to attribute the drawing to Naldini, but I think this unlikely. A number of its features share more with Vasari's drawing style: see for example the treatment of the heads and the ankle bones, in comparison with a drawing such as Louvre 2121r, for the vault of the Florentine Duomo (reproduced in Monbeig-Goguel, C., (1972), *Musée du Louvre. Inventaire général des dessins italiens, I. Vasari et son temps*, Paris: cat. 265).

27. Uffizi 1190E; reproduced in Barocchi, P., Bianchini, A., Forlani, A., and Fossi, M., (1963), *Gabinetto disegni e stampe degli Uffizi, XV. Mostra dei disegni dei Fondatori dell'Accademia delle Arti del Disegno*, Florence: pl. 24.

28. Reproduced in Boorsch, S. and Spike, J., (1985), *The Illustrated Bartsch*, **28**, *Italian Masters of the Sixteenth Century*, p. 254, no. 50. The composition of the engraving is related to the swooning Virgin group in Raphael's Baglione *Entombment* (1507), though the poses differ significantly in the painting. The source for the print was probably a drawing (now lost) recording an early idea for the figures. See Pouncey, P. and Gere, J., (1962), *Italian Drawings in the Department of Prints and Drawings of the British Museum: Raphael and His Circle*, (2 vols), London, **1**, p. 35, cat. 39. The Baglione *Entombment* is reproduced in Dussler, L., (1971), *Raphael: A Critical Catalogue of His Pictures, Wall Paintings and Tapestries*, trans. Croft, S., London: pl. 67.

29. From the *Loves of the Gods*; reproduced in Boorsch and Spike 1985, *op. cit.* at n. 28, p. 100, no. 23.

30. The painting was executed by Vasari's assistant Cristofano Gherardi. The drawing (Louvre 2156) has been attributed to Gherardi by Barocchi 1964, p. 135 (reproduced as pl. 56a). Monbeig-Goguel (1972, *op. cit.* at n. 26, cat. 206) reattributed the drawing to Vasari, and noted that the composition was based on Perino del Vaga's design *Jupiter and Io* reproduced in Boorsch and Spike eds, 1985, *op. cit.* at n. 28, p. 86, no. 9. Ronen, A., (1977), 'Il Vasari e gli incisore del suo tempo', *Commentari*, **28**, pp. 100–1, discovered that Vasari's Io was based upon Rosso's Philyra.

31. Reproduced in Corti 1989, p. 145. The *modello* (see Barocchi 1964, pl. 98b) is in Vienna (Albertina, 518). For Vasari's reuse of designs made by him for other purposes, see Nova, A., (1992), 'Salviati, Vasari, and the Reuse of Drawings in their Working Practice', *Master Drawings*, **30**, pp. 83–108.

32. Summers, D., (1977), 'Contrapposto: Style and Meaning in Renaissance Art', *Art Bulletin*, **59**, pp. 336–61. For the *Hercules and Cacus* engraving, see Boorsch and Spike eds 1985, *op. cit.* at n. 28, p. 188, no. 49.

33. Reproduced in Barocchi 1964, pl. 9.

34. Reproduced in Allegri, E. and Cecchi, A., (1980), *Palazzo Vecchio e i Medici: guida storica*, Florence: pls. 27 (the Louvre drawing for the ceiling), and 27.8 (the ceiling panel).

35. For the drawing, see *ibid.*, pl. 27.1a; for the painting, Barocchi 1964, pl. 65.

36. Reproduced in Barocchi, P., (1963–4), 'Complementi al Vasari Pittore', *Accademia toscana di scienze e lettere 'La Colombaria', Atti e memorie*, **28**, pl. 101.

37. Reproduced in Barocchi 1964, pl. U.

38. Reproduced in Corti 1989, p. 145.

39. The drawings are reproduced in Acidini Luchinat, C., (1989), 'Federico Zuccari e la cultura fiorentina. Quattro singolari immagini nella cupola di Santa Maria del Fiore', *Paragone*, **467**, pls 20a,b (Louvre 2146, 2140r) and 21a (Louvre 2113).

40. In Barocchi, P., ed., (1973), *Scritti d'Arte del Cinquecento*, 3 vols, Milan and Naples: **2**, pp. 1573–4.

41. For discussions of these debates, see: Battisti, E., (1956), 'Il concetto d'imitazione nel Cinquecento: da Raffaello a Michelangelo', *Commentari*, **7**, pp. 86–104; Greene 1982, *op. cit.* at n. 2, pp. 171–81.

42. *De imitatione commentariolum*, in Barocchi 1973, *op. cit.* at n. 40, **2**, pp. 1537–50.

43. Vasari–B/B 1966–1987, (Introduction to the *Lives*), **2**, p. 111.

44. Concerning Michelangelo as master of *disegno*, see Vasari's discussion of the *Last Judgement* inserted into the *Life* of Michelangelo in the 1568 version of the Lives, Vasari–B/B 1966–1987, **6**, pp. 56–57.

45. Vasari–B/B 1966–1987, (1568 *Life* of Raphael), **4**, p. 206.

46. Vasari–B/B 1966–1987, (1568 *Life* of Michelangelo), **6**, p. 56.

47. Vasari–B/B 1966–1987, (1568 *Life* of Raphael), **4**, p. 207. Vasari's own instincts evidently did not lead him often to imitate Michelangelo; in some cases, he deliberately avoided doing so. For example, when in the early 1570s he began to design a *Last Judgement* for the cupola of the Florentine Duomo, he at first avoided reference to Michelangelo's great fresco. Instead, his point of departure seems to have been Dürer's depiction of the scene (Bartsch, no. 52) from the *Small Passion*, to which there are many parallels in one of Vasari's sketches at the Louvre, (2140r), reproduced in Monbeig-Goguel 1972, *op. cit.* at n. 26, cat. 276.

48. *Ibid.*, pp. 204–8, for Vasari's analysis of the process of successive emulation through which Raphael acquired his personal Roman style.

49. For the formulation of Vasari's thought on imitation as a route to an individual's own style, and for the influence upon him of Borghini, see Williams, R.J., (1988), 'Vincenzo Borghini and Vasari's *Lives*', Ph.D thesis, Princeton: pp. 177–85.

50. Reproduced in Barocchi 1964, pl. 7.

51. Rosso's painting (1521; Volterra, Pinacoteca) is reproduced in Ciardi, R.P. and Mugnaini, A., (1991), *Rosso Fiorentino: Catalogo completo dei dipinti*, Florence: p. 65; for Vasari's Arezzo *Deposition* (1536–7; SS. Annunziata), see Corti 1989, p. 16.

52. Reproduced in Strauss ed. 1980, **10**, p. 138, no. 43.

53. Reproduced in Scharf, A., (1950), *Filippino Lippi*, Vienna: pl. 125.

54. Reproduced in Hood, W., (1993), *Fra Angelico at San Marco*, New Haven and London: pl. 76.

55. Nova 1992, *op. cit.* at n. 31, figs. 7 and 8 respectively.

56. Cox–Rearick, J., (1984), *Dynasty and Destiny in Medici Art*, Princeton: p. 110, n. 118.

57. Noted by McTavish, D., (1985), 'Vasari and Parmigianino', in *Giorgio Vasari: tra decorazione ambientale e storiografia artistica, convegno di studi Arezzo 1981*, Florence: p. 138, n. 11.

58. Freedberg, S.J., (1975), *Painting in Italy 1500–1600*, Harmondsworth: p. 446.

59. For Vasari's continuing interest in Dürer, see Herrmann-Fiore, K., (1976), 'Sui rapporti fra l'opera artistica del Vasari e del Dürer', in *Il Vasari storiografo e artista, Atti del Congresso internazionale, Arezzo–Florence 1974*, Florence: pp. 701–15; also Gregory, S., (1992), *Vasari and Northern Prints: An Examination of Giorgio Vasari's Comments on, and Use of, Woodcuts and Engravings by Martin Schongauer, Albrecht Dürer and Lucas van Leyden*, unpublished MA thesis, Queen's University, Canada: pp. 103–60.

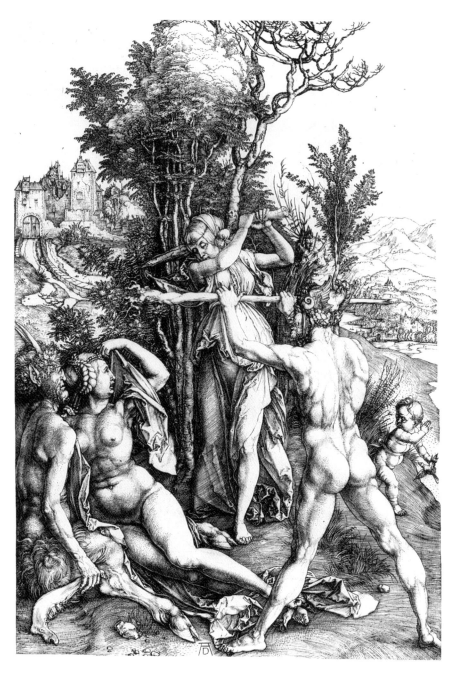

8.1 Albrecht Dürer, *Hercules at the Crossroads*, engraving.

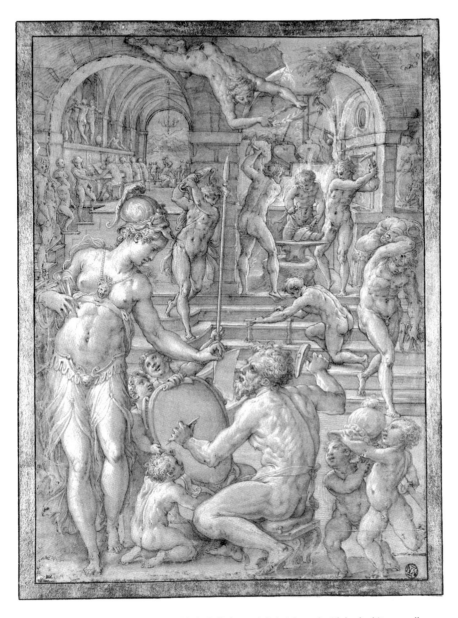

8.2 Giorgio Vasari, *The Forge of Vulcan*, black chalk, brown ink, heightened with lead white, on yellow-ochre coloured paper.

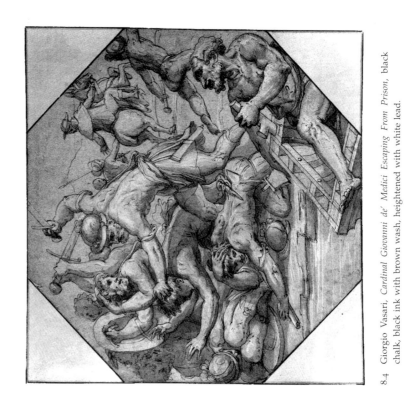

8.4 Giorgio Vasari, *Cardinal Giovanni de' Medici Escaping From Prison*, black chalk, black ink with brown wash, heightened with white lead.

8.3 Gian Jacopo Caraglio, after Rosso Fiorentino, *Hercules and Cacus*, engraving.

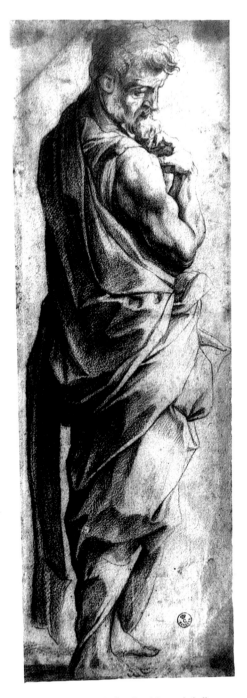

8.5 Giorgio Vasari, *Standing Man*, red chalk.

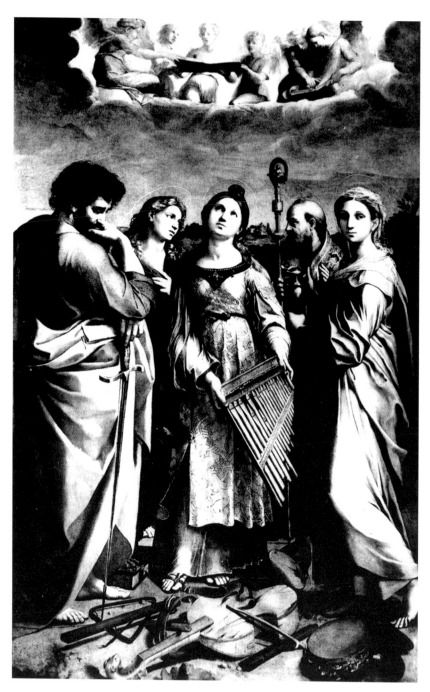

8.6 Raphael, *St Cecila altarpiece*, oil on panel (transferred to canvas).

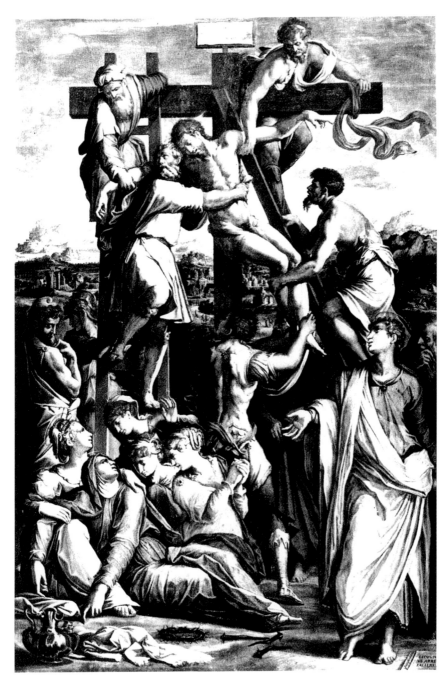

8.7 Giorgio Vasari, *Deposition*, oil on panel.

Invenzione, disegno e fatica: two drawings by Giovambattista Naldini for an altarpiece in post-Tridentine Florence[1]

Stuart Currie

This paper seeks to elucidate some of the features of the drawing practice of the Florentine painter Giovambattista Naldini (1537–1591), through discussion of two studies for the first altarpiece produced by the artist in his native city. Executed some three years after the final meetings of the Council of Trent,[2] the painting (Figure 9.1), which features the gospel subject, the *Way to Calvary* or *Christ Carrying the Cross*,[3] is still *in situ* in the chapel to the left of the chancel in the Badia Fiorentina.[4] It is generally dated 1566 due to mention of a related *bozzetto* in a letter of that year from Vincenzo Borghini to Giorgio Vasari,[5] and reference to the panel in the 1568 edition of the latter's *Lives of the Artists*.[6] Both Vasari and Borghini were intimately associated with Naldini's early artistic development.[7]

The two drawings which form the main focus of this discussion are now in London (British Museum, 1856-7-12-9 and 1856-7-12-10; Figures 9.2 and 9.3).[8] Universally accepted as exploratory compositional sketches for the imagery of the Badia altarpiece,[9] both are in pen, ink, wash and white heightening.[10] The strikingly vigorous quality of these graphic essays has been recognized in the literature but barely elaborated upon. The same is true of the substantial differences in mood and style between the two studies and the painting, which eschews the bustling technical bravura of both drawings in favour of a calmer, more refined rendering.

Contemplation of the three compositions and of their connections with associated contemporary circumstances helps to clarify why the directions Naldini seemed to have been pursuing in the drawings came to be so drastically subdued in the painting. It is my contention that in the drawn statements he sought to fuse innovative *disegno* effects with imaginative and precisely focused interpretations of the gospel incident, and that these aims were closely tied to a continually evolving, quasi-traditional manner of representing the subject. Ultimately, however, such ambitions seem to have

been constrained in the altarpiece by concerns that the final image should comply more thoroughly with current ecumenical prescriptions for religious art than the vigorously-executed but unresolved preliminary conceptions may have appeared to do.

The relatively unexpansive discussion of the two drawings in the literature suggests that their raw energy has tended to mask the inventive compositional elements in them. On the other hand, elegant stylistic features in the solution adopted for the altarpiece seem to have prevented detection of iconographical nuances specifically appropriate to the essence of post-Tridentine thinking. Thus, substantial reconsideration of both drawings and the painting, and of the relationships between them, is warranted in order that their unheralded qualities may be brought to light.

The primary sources contribute little to this task. Vasari simply recorded the subject, siting and technique of the altarpiece, adding only the conventionally approbatory remark that it contained many fine figures ('molte buone figure').[11] Such a condensed summary is typical of the *Lives* and wholly understandable in the context of one of the final sections of Vasari's massive undertaking.[12] The thin description in the *Lives* is slightly augmented in Raffaello Borghini's 1584 publication, *Il Riposo*, where the rhetorical 'molte buone figure' was replaced by the more prosaic but pertinent observation that Christ was accompanied by the crowd ('accompagnato dalla turba').[13] And, although there is no reason to expect mention of drawing in either text, Borghini related that after the death of Jacopo Pontormo,[14] alongside whom Naldini had been working,[15] the maturing painter had left for Rome to study 'le cose del disegno'.[16] Vasari had indicated the same scenario but spoke of Naldini studiously attending 'all'arte'.[17]

What is to be understood by 'le cose del disegno'? Are they simply 'the things of drawing'? or was Borghini referring to the more elaborate formal interrelationships associated with the word *disegno*? and therefore to the more complex compositional intricacies it implies? Vasari's apparently more general wording suggests the latter is more likely, and one would have expected Naldini to have acquired the fundamentals of drawing from close contact with such an accomplished practitioner as Pontormo.[18]

A precisely contemporary text, Vincenzo Borghini's *Selva di notizie*, helps to throw light on the situation.[19] Particularly appropriate are the pages published by Paola Barocchi under the subtitles *Testimonianze sulla Pittura e sulla Scultura. Pittoria, Poesia e Musica* and *La "Somma della Disputa"*, which incorporate a detailed discussion of the intricacies of pictorial composition and an informed interpretation of the relationship between religious imagery and artistic aims.[20]

Vincenzo Borghini had taken up the religious life at the Badia Fiorentina from 1531.[21] He was ordained in 1541,[22] became prior of the Ospedale degli

Innocenti in 1552,[23] and, in this latter role, seems also to have been mentor to Naldini who was resident at the Ospedale for an extensive period.[24] In 1563 Borghini was elected *Luogotenente* of the newly-formed Florentine *Accademia del Disegno*.[25] Thus, from the early 1560s and at the time of the creation of Naldini's altarpiece, Borghini held a position of major influence on artistic life in the Tuscan capital.[26] He would also have been acutely aware that the immediate post-Tridentine period had brought heavy criticism of Italian artists working in a manner widely deemed to have breached accepted codes of decorum in religious painting.[27] Principal dissatisfactions focused on what were felt to be the excessive employment of nude figures in religious images and on the apparently overriding preoccupation with stylistic effects at the expense of spiritual content. To many twentieth-century observers, the most dedicated codifier of such criticisms was Gilio da Fabriano, whose opinions were voiced in his 1564 *Dialogo degli errori de' pittori circa l'istorie*.[28]

Vincenzo Borghini's text can be seen to counter such attitudes by alluding to the early Christian validation of religious images as vehicles for the transmission of scriptural and moral teachings.[29] In a period when traditional Christian doctrine was being emphatically restated by the Catholic Church, this firmly endorsed the morality of contemporary artists' creative procedures. Borghini also asserted the inherent good in religious images, citing the Church's embracing of artistic visualizations of scenes from the lives of saintly figures which revealed how their exemplary virtue, faith, and love of God had sustained and inspired them. He then drew parallels with the endeavours of artists as the authors of works through which such concepts were conveyed, thereby elevating the actual task of creating religious images.

These verbal distillations of the fundamental interdependence between art and the Church were accompanied by an appraisal of the subtleties of painting, which Borghini aligned with those of music.[30] Stating that his specific reference was to 'musica vocale ch'acompagn i versi' in relation to painted 'istorie',[31] he emphasized the common concern for compositional harmony, the ordered placement of parts relative to each other, and the avoidance of confusing entanglements. He also compared the manner of uniting high and low voices in musical harmony with the arrangement of diversely-scaled elements in paintings which guaranteed similarly concordant visual effects.[32] The resultant gentle and discrete distribution of forms ensured that no principal character would be impeded by any extended parts of a subsidiary protagonist, an eventuality to be avoided since artists would be deemed to have failed if the main figures in an *istoria* were not accorded appropriate deference.[33] Successful figural disposition was therefore seen to be dependent on adherence to ideals of formal grace which led to compositions of harmonious visual music, termed 'pittoresca' by

Borghini.[34] He thus conjured a literal image of paintings as complex, precisely-organized orchestrations of formal elements in which minute nuances of pictorial syntax corresponded to the intricacies of choral structure.

Borghini also championed the intellectual aspects of artistic creativity by drawing attention to the rigorous mental discipline involved in the development and visual articulation of 'concetti', and by asserting that the renown won by those successful in any artistic field corresponded to their imaginative capacity. Artists were exhorted to develop their creative powers in seeking personal visual conceptions and expansions upon accepted iconographic solutions;[35] the subject being seen as merely the starting point from which they were free to evolve individual interpretations. Thus the independent nature of artistic decisions was underlined, but so was the fact that the accompanying liberty meant painters had to contend with the 'fatica' of expressing their 'invenzioni': art being not simply the result of them doing whatever they wished, but of their striving for an appropriate response to every subject.[36] The process of invention, accommodation and expression of the *'concetto'* was thus deemed mentally taxing but highly meritorious. It required awareness and observance of contemporary standards of decorum, as well as the imaginative facility to visualize subjects accordingly. Borghini maintained that in evolving appropriate images, artists followed conventions similar to those governing poetry and rhetoric. This aligned artistic practice with liberal arts of established pedigree, thereby further elevating the principles guiding painters' creative activity.

It is possible to view Borghini's whole approach in this section of his writings as counteracting the sort of criticisms voiced by Gilio.[37] His positive presentation of the complexities of pictorial composition provides an extensive résumé of Florentine artistic aims during the immediate post-Tridentine period. Consequently, as Naldini was both a personal acquaintance and a member of the *Accademia del disegno*, it is likely that his creative procedures would have corresponded closely to the fundamental ideals of Borghini's analysis of pictorial composition.[38]

Some 340 years later, the first enthusiastic appreciation of Naldini's drawings came from Bernard Berenson in *The Drawings of the Florentine Painters*, initially published in 1903.[39] Berenson praised Naldini's drawings for being 'so full of spirit, so pictorial, so lively in execution'. And, relating how Naldini based his manner on Pontormo's earlier style, he further characterized them as instances of 'successive copying at the second remove', while also observing that they retained much of the quality of the original.[40] Berenson's remarks, although applicable to a broader range of drawing types, seem entirely appropriate to Naldini's methods in the two British Museum sheets, and his assertion that Naldini's drawings were 'so

pictorial' accords with Vincenzo Borghini's appellation 'pittoresca' for compositions of a harmonious visual music.[41]

Brief observations on the three *Way to Calvary* images are incorporated into Paola Barocchi's lengthy 1965 summary of Naldini's output.[42] Artistic precedents are uppermost as note is made of Pontormesque compositional and figural origins, stylistic elements stemming from Giovanni Stradano and Vasari, and the influence of the latter on the final pictorial arrangement.[43] The drawings under review here are also dealt with specifically in two 1980s exhibition catalogue notes which are equally thrifty in their analyses. In 1980, Anna Maria Petrioli Tofani observed the high quality of the drawings and their constancy of compositional theme but judged the consequent painted solution to be of a lower standard.[44] Six years later, Nicholas Turner likewise noted the drawings' compositional similarities, reasoned which was the earlier, and identified the main changes between them to be in the soldier on the right. He also remarked upon their compositional resemblances to the painting but suggested they differed from it only in detail.[45] Fuller analysis permits expansion of these basic insights and reveals that the drawings provide evidence of the artist's attempts to fuse contemporary stylistic concerns with a rendering of the gospel narrative that accords effectively with both Tridentine religious thinking and the evolving image-tradition.

Art historians have tended to restrict acknowledgement of the effect of the Tridentine decrees on art to that from the twenty-fifth and final session of December 1563 which, amongst other things, dealt with the lawful use of sacred images.[46] Commentators have mainly laid stress on this decree's justification of religious images as the vehicles through which reflection upon the essences of faith, veneration of exemplary figures and the inspiration to emulate their piety, were encouraged.[47] However, instances of the decree being related convincingly to specific visual imagery are rare. And, if particular elements from the general points it presents are concentrated upon with regard to the developing *istoria* of Naldini's three images, several apposite connections emerge. Fundamentally, there can be little doubt that the dominant focus in each is the relationship between Christ and St Veronica. And, if this is viewed in terms of the justification of images as the media through which religious mysteries are made visible to the faithful, then the coming together of the two major figures in the three compositions must be the prime exemplary element intended to inspire piety and emulation of the essential aspects of Christian behaviour.

Such a concern appears to have been particularly relevant to Naldini's thinking in the two drawn images which emphasize Veronica's sympathetic confrontation with Christ. Firstly, all the supporting figures either turn towards this central incident or are part of a coherent group revolving around it. Secondly, the two leading protagonists are given visual

prominence through their scale and relative isolation; and thirdly, the white-highlighting effects are concentrated on them and on the compositionally-significant parts of the surrounding group.[48]

The first of these points is pertinent to the general mood of Tridentine reformatory thinking in which the concept of turning towards God is of singular importance, being reiterated on several occasions in, for instance, the Decree on Justification, where two Old Testament sources are cited as fundamental instructive exemplars: 'Turn ye unto me, saith the Lord of Hosts, and I will turn unto you', from *Zechariah* 1:3; and, perhaps most appropriately: 'Turn thou us, O Lord, unto thee, and we shall be turned', from *Lamentations* 5:21.[49]

Such indicators appear to be particularly apt in relation to Naldini's developing conception of the subject, since even the aggressively pulling or dragging soldier of the drawings is turned gracefully and with greater forbearance towards Christ and Veronica in the painting. However, the relationship between the two main figures also provokes consideration of the apocryphal incident traditionally associated with the *Way to Calvary* narrative – the miraculous fixing of Christ's image on Veronica's veil after she had mopped his brow with it. Since the concept of the imprinted veil represented the first recorded portrait of Christ, not from the hand of man, but from a mysterious transferral bestowed upon a compassionate follower, this could have been seen to symbolize the very essence of the Church's approval of images set before the eyes of the faithful. It could thus be regarded as an exemplary Christian image, reflecting divine acknowledgement of Veronica's charitable act.[50] Furthermore, in relation to cinquecento disputes over the use of religious imagery, the subject could be seen to present an additional dimension by the fact that Veronica's name stems from the words *vera icona* or 'true image'. The sudarium may also have been viewed as bearing witness to the concept of God turning towards and conferring grace upon an individual who had moved towards Him.

In Naldini's drawn interpretations, it is clear from the almost iconic precedence given to Veronica's advance towards Christ that attention is focused on exemplary Christian behaviour in the face of brutal aggression rather than on the apocryphal image. Ultimately, however, as if tempered by Borghini's emphasis on the desirability of gentle and discrete presentation, excessively violent imagery was anomalous to contemporary Florentine conceptions of visual decorum.[51] So, in highlighting the compassion at the heart of the dramatic confrontation between the two central figures, Naldini's drawings add considerably to the religious implications of the subject. They also create a novel focus in the evolution of two-dimensional images of a theme which, for the most part, had underplayed Christ's burden and

accentuated the brutality of his separation from those close to him,[52] ele-
ments which appear to relate to the graphic descriptions of the subject in the
fourteenth-century Franciscan manuscript, *Meditations on the Life of Christ*.[53]

Naldini's drawn conceptions also succinctly accommodate the implica-
tions of the sudarium without actually showing the mysterious imprint,
which, if included at all in pre-cinquecento depictions of the event, was often
presented as an adjunct to the main narrative image.[54] That all three Naldini
versions avoid precise visualization of the mysterious image underlines the
shift of emphasis towards the sympathetic essence of the encounter. The
playing-down of the apocryphal element without completely denying it
echoed many earlier sixteenth-century renderings of the subject which were
perhaps responding to hardening reformatory attitudes.

Underpinning the condemnation of apocryphal and indecorous elements,
a further fundamental precept of Tridentine reformatory stipulations was the
re-emphasizing of authentic scriptural sources.[55] It is therefore revealing to
consider Naldini's images in relation to the gospel accounts of the *Way to
Calvary* episode, of which Luke's is by far the most detailed.[56] *Luke* 23:26 tells
of Christ being led away and Simon the Cyrenian bearing the Cross for Jesus.
Then verses 27–32 relate how:

there followed him a great company of people, and of women, which also bewailed
and lamented him. But Jesus turning unto them said, daughters of Jerusalem, weep
not for me, but weep for yourselves, and for your children. For, behold, the days
are coming, in which they shall say, blessed are the barren, and the wombs that
never bear, and the paps which never give suck. Then shall they begin to say to the
mountains, fall on us; and to the hills, cover us. For if they do these things in a
green tree, what shall be done in a dry?

These words are Christ's last verbal contact with those who followed Him to
the end. It seems that consideration of their parabolic content, directed to the
women to whom He turns, may have transformed Naldini's thinking as he
moved towards the final visualization of the subject for the Badia altar-
piece.[57] The relationship between Veronica and Christ is changed from one of
convergence to one of separation, distinguishing the painted solution from
the two drawn versions but, conversely, also linking it more fundamentally
to interpretations from the preceding centuries. Complementing this, the
facial expressions and gestures of the accompanying women imply bewilder-
ment at Christ's words. Moreover, that these women are now positioned
immediately behind Veronica rather than further into the distance, and now
also include the Virgin, are additional departures from the compositional
solutions presented in the drawings but which also correspond more closely
to earlier renderings of the subject.

The visual roots of Naldini's reworkings of the imagery inevitably lie in
the elaboration of *Way to Calvary* iconography stimulated by the influx of

Northern prints into Italy from the latter half of the cinquecento onwards.[58] This led to the demise of depictions of the walking and relatively unburdened Christ being decisively separated from His followers. The revised focus on Christ falling under the burden of the Cross and being violently maltreated by His captors probably originated in Martin Schongauer's horizontal 1470s engraving.[59] However, it appears that the vertical compactness of Albrecht Dürer's 1498–9 woodcut (Figure 9.4) proved more compelling for emulation in the altarpiece format.[60] It seems to have been particularly significant in relation to many of the essential features in Naldini's versions.

Nonetheless, the major stimulus for the Badia altarpiece drawings was undoubtedly Pontormo's 1520s fresco at the Certosa del Galluzzo (Figure 9.5).[61] Long association with the Florentine master, the closeness of Galluzzo, and the possible survival at the time of more Pontormo drawings for the mural than those now extant, make Naldini's knowledge of this version difficult to dismiss.[62] It is also universally accepted in the literature that Pontormo's Certosa images had been substantially affected by his knowledge of Dürer's prints.[63] But the intimate interaction between Christ and Veronica in the Galluzzo *Way to Calvary* engenders a far more positive mood than any of Dürer's interpretations. Isolation of the two main characters beneath the diagonal of the Cross in the lower central portion of the image significantly emphasizes their convergence. As Barocchi has intimated, this focus is more broadly articulated by the circumscribing sequence of limbs, heads and bodies of the immediately surrounding group.[64] These radiating forms, and particularly the gazes of the figures, transmit a series of directional impulses that converge on Christ's acceptance of Veronica's proffered veil, which – uniquely in Pontormo's image – He Himself also holds before His face with His left hand.

The essence of Pontormo's depiction seems to be in the visual potency of this shared act, the viewing of it, and the awareness – implied by the frozen movements of all the protagonists – that something of major consequence is occurring.[65] Amongst the central group, the figure most pertinently involved in this is Simon of Cyrenia, whose gaze, as he stoops to take up the Cross, echoes that of Christ. Also incorporated are the two horsemen beyond who swivel round to observe the incident, each with a correspondingly turning, foreground equivalent directly below.[66]

As one would expect from an artist aware of Vincenzo Borghini's ideas about painterly creativity, Naldini's graphic variations on Pontormo's interpretation of the theme are infused with a number of imaginative revisions, each testifying to his desire to address elements related to the contemporary religious situation. Firstly, Christ's pose – basically similar in the two drawings – appears to be a unique Naldini invention. Facing left as in

Pontormo's fresco, this figure's compositional force is intensified by its centrality, its monumental verticality, and by the wilfulness of its rhetorical torsion. But Christ's twisting posture is so contrived that the plausibility of Him having turned from moving in the opposite direction while also supporting the Cross is severely compromised. Nonetheless, in devising compositional thrusts to stabilize the weighty inclination of this monumental Christ-figure and balance the visually-demanding diagonal of the Cross, Naldini intuited alternative linear concordances in the two drawings. His incorporation in both of a *contrapposto* arm movement not unlike that employed by Michelangelo in his similarly iconicized, Cross-bearing *Risen Christ*,[67] created an imaginative reversal of Pontormo's Veronica–Christ grouping.

However, in the first drawing, the prominent horizontal of Christ's right forearm is paralleled by the left arm of the soldier pulling the Cross. These striking *disegno* effects extend into the foreshortened, grabbing action of the arm of the soldier above. They create a sequential variation of the threatening triple thrust of arms encircling Christ's head in the mid-1550s Vasarian version, now in Lawrence, KS, (University of Kansas, Spencer Museum of Art; Figure 9.6), and indicate the older artist's influence on Naldini's thinking.[68] The alternative arrangement in the second drawing, which accommodates the left arm and spear of the soldier above in a more relaxed manner, seems to indicate the desire to mitigate the frenzied Vasarian effects, but this effort is partially denied by retention of the aggressive action of the foremost soldier. It is strengthened, however, by the repositioning of the Cross – formally imposing, but somewhat sketchily considered in both studies – which becomes perspectively more convincing in the second drawing as its horizontal arm forms a less acute angle. This creates a framing device which significantly clarifies the interaction between Veronica and Christ, with whom Simon of Cyrenia also becomes more effectively linked. The elevated Cross further separates this trio from the soldiers, lessening the physical restrictions upon them and thereby instigating a calmer, more dignified presentation of the main figures.

In the second drawing, the two main figures are infused with an imposing monumentality which replaces the exaggerated pathos of Veronica's movement and the dramatic, twisting response of Christ in the first image. Similarly, the narrow space between the principal protagonists in the first drawing is transformed from the compressed zigzag shape which virtually defines Christ's front profile into an expressive element of greater visual potency. This is augmented by the repositioning of Simon of Cyrenia which effects a more succinct unification as his right arm and left shoulder align respectively with Veronica's shoulder and Christ's head. The discrete separation of the major figures is retained but made more meaningful by the now-

raised veil with the implied imminent contact and miraculous consequence. The juxtaposition of Veronica's tentatively-raised hands and the lower tip of the sudarium with the three projecting convex forms of Christ's forehead, shoulder and knee produces a more elegant and intimate interrelationship between the figures. The restraint evident in Veronica's upright posture, the gently emphatic verticality of the veil and the more perpendicular arm of the Cross maintain a narrow zone of isolation around Christ's head. This, however, is brutally breached by the aggressively outstretched arm of the soldier to the right which intrudes upon Christ's body and impedes the visual integrity of the Cross, as do the arms of the soldier above.

Nonetheless, both drawings embrace these affronts to decorum in an unbroken circle of concentration similar to that initiated by Pontormo, with Veronica, Simon of Cyrenia and the other soldiers to the right all turned towards Christ. The two images represent consecutive attempts at balancing psychologically-conflicting pictorial elements, as in the aforementioned par-alleling of forearms which pull in directional opposition to each other. But, although contrasting with the muscular back-view of his tenaciously outward-tugging predecessor in the earlier image, the inward- and forward-lunging soldier of the second drawing creates an even more brusque link in the chain of heads focused on Christ. This contradictory connection is enforced by the rope tying Christ's right arm to the soldier's left hand, which did not feature in the first image. Thus, linear concordances are increased in the more evolved second drawing but, in spite of Naldini's imaginative redeployment of pictorial components, both versions retain a sense of impatient, rupturing separation as the physical and visual violence of the soldier's movements ultimately compromise compositional harmony and spiritual intensity.[69]

Naldini's attempts to preserve these tensions by subduing and balancing them in the two-part drawn evolution of the subject appear to provide evidence of the kind of rigorous creative meditation recommended by Vincenzo Borghini. And, in view of the calmer, more rhetorically-refined visual text of the altarpiece, alongside the implications of Borghini's letter to Vasari, it is possible that between drawings and painting Naldini may have received advice from Borghini.[70] The definitive changes in the altarpiece depart so dramatically from the graphic interpretations that it seems that a decisive intervention or a drastic rethinking must have caused Naldini to align his final solution more precisely with contemporary religious and artistic ideals. Corroborating evidence of this is provided by the subduing of Veronica's scripturally unauthenticated movement towards Christ. From advancing towards Him in the two drawings, first in a tentative, crouching manner, and then with more upright conviction, her demeanour in the painting suggests a sense of bemusement as she looks questioningly beyond

Christ towards the now calm soldier. Turned to meet Veronica's gaze with a posture of extreme elegance, the soldier's bearing is totally at variance with the aggressive poses rehearsed in the drawings, implying that he too is dumbfounded by what has occurred. If Luke's gospel is taken as the guiding text, Naldini has depicted both figures as if they are responding to Christ's startling words to the women. Alternatively, if the apocryphal story was also in his mind – even if it is played down – their reaction could be to the miraculous transferral. Ultimately, in the painted statement, it could be either or both – the multiplicity of visual allusiveness permitting the sort of individual interpretation which H. Outram Evennett considered to be characteristic of Counter-Reformation spirituality.[71]

However, that the apocryphal elements were consciously minimized in the final image is given further substance by the lowered position of the previously proffered veil. Now suppressed by Christ's right hand as He turns with a parting gesture of blessing, the veil's earlier prominence is quelled by the purposefully highlighted, downward thrust of Simon of Cyrenia's arm as he takes up the Cross. This powerful action affirms Christ's separation from the kneeling woman and acts as a compositional response to the left arm of the soldier. Furthermore, it reasserts Simon's gospel-endorsed role in the narrative,[72] although his pictorial prominence is also decorously subdued in relation to Christ through the placement and shadowing of his head behind the highlighted Cross.

Such contrasts of illumination draw attention to the restored inviolability of the Cross in the painting, with only Christ and Simon permitted direct contact with its form. It is also significant that Christ's left hand, barely visible in the drawings, is now crucially involved in the compositional articulation, directing attention back to His head with the index finger pointing to His mouth, and thereby provoking thoughts of his parting words to the women. The suggestiveness of these visual indicators is supported by the transformed figure of Christ who, from the stoically submissive focal point of the drawings, becomes the less monumental but more gracefully active, dominant force in the painting. Visually isolated under the arch formed by the Cross and Simon's arm, He assumes the principal sympathetic role from Veronica, who becomes the foremost reactive recipient of His parting words and gesture.

The commanding centrality of Christ in the three images was inevitably crucial to the altarpiece's role as the visual focus of a chapel, but ultimately, the directional reversal of His body in the painting, away from, but still turning towards the women, suggests a more appropriate unfolding of events in relation to Luke's text. In the fundamental implication of Christ's briefly arrested symbolic movement towards the high altar in the Badia, it is

also appropriate to the image's situation in a chapel on the left side of the church.

The two British Museum drawings seem to have been the means by which Naldini contemplated and explored the visually-expressive possibilities of the gospel incident. They provide substantial evidence of rapid reconsiderations of alternative solutions which eventually progressed to a topically relevant and aesthetically compelling rendering of the subject. They also indicate the earnest manner in which the maturing painter selected, adapted and combined germane elements from renowned pictorial precedents as he sought a visual statement capable of transcending the effects of earlier, often infinitely more detailed and aggressively dramatic images in order to stimulate the attendant devotee to deeper spiritual contemplation in line with prevailing religious attitudes.

That the imagery of Naldini's two drawings evolves towards the more scripturally authentic dénouement in the altarpiece is confirmation of the gradual crystallization of his perception of the subject. The strategy of progressively sharpening the focus through thoughtful modification suggests an increasing compliance with ecumenical recommendations, at the heart of which was the concept of reaffirming harmony within the Catholic Church. This purpose achieves specific significance in the painted solution with the restrained pose of the soldier to the right. In formal terms, this figure's conversion from the compositionally-contentious, harmony-breaking aggressor of the drawings into an acquiescent, sympathetic observer also suggests a dramatic psychological transformation.

To sum up, it is instructive to turn to further details of the Council of Trent's decree from the twenty-fifth session which stressed the total abolition of any abuses that had crept into religious imagery, and the elimination of anything associable with false doctrine or superstition. The decree also asserted that no imagery should appear unbecoming or confusedly arranged, that nothing profane or indecorous should be allowed, and that no unusual images or new miracles should be admitted. To these ends, it recommended that the advice of theologians and other pious men should be sought to confirm that only images consistent with truth and piety be permitted.[73] In the light of these points, it seems reasonable to consider the radical changes in Naldini's altarpiece as evidence of his attention to such instructions, possibly through consultation with Vincenzo Borghini.

Frequently cited literature

Vasari, G., ed., Milanesi, G., (1878–1885), *Le Vite de' più eccellenti pittori, scultori e architettori*, 9 vols, Florence (hereafter Vasari-Milanesi); Buckley, A., (1851), *Canons & Decrees of the Council of Trent*, London; Barocchi, P., (1965), 'Itinerario di Giovambattista Naldini', *Arte Antica e Moderna*, **31–32**, pp. 244–88.

Notes

1. I am grateful to Francis Ames-Lewis for his advice during the editing of this essay.

2. The final session of the Council of Trent took place on 3 and 4 December 1563. For a brief summary see Jedin, H., (1960), *Ecumenical Councils of the Catholic Church. An Historical Outline*, London, etc.: pp. 181–2; and for a full translation, Buckley 1851; p. 212 ff.

3. The episode is mentioned in all four Gospels: Matthew 27:32; Mark 15:21; and John 19:17; but the most extensive coverage is in Luke 23: 26–32.

4. See Vasari-Milanesi, **7**, p. 611; Borghini, R., (1584), *Il Riposo*, Florence: pp. 613–4. For other outline descriptions of the altarpiece see Richa, G., (1754), *Notizie istoriche della chiese fiorentine divise ne' suoi Quartieri*, 10 vols, Florence: **1**, p. 199; Paatz, W., (1955), *Die Kirchen von Florenz*, 8 vols, Frankfurt: **1**, p. 286. For the Badia, see Guidotti, A., (1982), *The Badia Fiorentina*, Biblioteca de 'Lo Studiolo', Florence: esp. pp. 9, 17, 27 and, for the altarpiece and its situation, p. 29; and also (1982), 'Vicende storico-artistiche della Badia Fiorentina', in *La Badia Fiorentina*, Casa di Risparmio, Florence: p. 123.

5. Frey, K. and Frey, H.W., (1930), *Der Literarische Nachlass Giorgio Vasaris*, 3 vols, Munich: **2**, p. 272.

6. Vasari-Milanesi, **7**, p. 611. To date, no documentary evidence has emerged to permit greater precision on the dating. A patronal family name was suggested in Bocchi, F., ed., Cinelli, G., (1677), *Le Bellezze della città di Firenze*, Florence, p. 384; the painting being mentioned as being in 'la Cappella de' Lenzoni', but this has been discounted by Barocchi 1965, p. 273, n. 92.

7. See Vasari-Milanesi, **7**, p. 611; Cecchi, A., (1977), 'Borghini, Vasari, Naldini e la "Giuditta" del 1564', *Paragone*, **28**, no. 323, pp. 100–7; Wazbinski, Z., (1985), 'Giorgio Vasari e Vincenzo Borghini come maestri accademici: il caso di G. B. Naldini', in Garfagnini, G.C., ed., *Giorgio Vasari tra decorazione ambientale e storiografia artistica*, Convengo di Studi, Arezzo, Florence: pp. 285–99.

8. Respectively, the drawings measure 316 × 226 mm and 322 × 225 mm.

9. See Voss, H., (1920), *Die Malerei der Spätrenaissance in Rom und Florenz*, 2 vols, Berlin: **2**, p. 306, n. 1; Barocchi 1965, pp. 244–88, esp. p. 252; Petrioli Tofani, A.M., (1980), in *Firenze e la Toscana dei Medici nell' Europa del' 500. Il primato del disegno*, exh. cat., Florence (Palazzo Strozzi): p. 151; Turner, N., (1986) *Florentine Drawings of the Sixteenth century*, exh. cat., London (British Museum): p. 210.

10. The materials are more expansively described by Petrioli Tofani 1980, *op. cit.* at n. 9, p. 151, nos. 325 and 326 (*penna, aquarellature marroni e grige, biacca, tracce di matita nera, carta nocciola*), than by Turner 1986, *op. cit.* at n. 9, p. 210 (pen and brown ink and brown wash, heightened with white, on a ground washed light brown).

11. Vasari–Milanesi, 7, p. 611.

12. Naldini's life and work are discussed in the section *Degli Accademici Del Disegno*, *ibid.*, **7**, pp. 593–641.

13. Borghini, R. 1584, *op. cit.* at n. 4, p. 614.

14. Pontormo died in 1556.

15. See also Baldinucci, F., ed., Ranell, F., (1846–7), *Notizie dei professori del disegno da Cimabue in quà*, Florence: **3**, pp. 511–2.

16. Borghini, R. 1584, *op. cit.* at n. 4, p. 613.

17. Vasari-Milanesi, 7, p. 611.

18. For Pontormo's drawings see: Clapp, F., (1914), *Les Dessins de Pontormo*, Paris; Becherucci, L., (1943), *Disegni del Pontormo*, Bergamo; Cox-Rearick, J., (1964, Cambridge, Mass.; rev., 1981), *The Drawings of Pontormo*, 2 vols, New York; Berti, L., (1965, repr. 1975), *Pontormo, I Disegni*, Florence;

Forlani-Tempesti, A., (1970), *Disegni del Pontormo nel Gabinetto di Disegni e Stampe degli Uffizi*, Florence; Nigro, S., (1991, Munich; English edition, 1992) *Pontormo Drawings*, New York.

19. The manuscript K783 (16) is in the Kunsthistorisches Institut, Florence, 60765. Selected sections of it are presented in Barocchi, P., ed., (1971), *Scritti d'Arte del Cinquecento*, Milan and Naples: **1**, pp. 611–73; see also Barocchi, P., (1970), 'Una "Selva di notizie" di Vincenzo Borghini' in *Un Augurio a Raffaele Mattioli*, Florence: pp. 87–172.

20. See Barocchi 1971, *op. cit.* at n. 19, pp. 644–55 and p. 659 ff. See also Scorza, R., (1981), *Vincenzo Borghini (1515–1580) and Medici Artistic Patronage*, M.Phil diss., University of London (Warburg Institute), pp. 22–3, who states that another part of the text, *Sulla disputa circa il primato delle arti* (Barocchi 1971, *op. cit.* at n. 19, pp. 611–29), was 'probably intended as a circular or address at the Accademia del Disegno'. The same would seem to apply to all parts of the *Selva* published by Barocchi.

21. Folena, G., (1970),'Borghini Vincenzo Maria' *Dizionario Biografico Degli Italiani*, **12**, Rome: pp. 680–9, esp. p. 681; Scorza, R., (1988), *Vincenzo Borghini (1515–1580) as Iconographic Adviser*, unpublished Ph.D thesis, University of London, (Warburg Institute), p. 16.

22. Scorza 1988, *op. cit.* at n. 21, p. 16.

23. Folena 1970, *op. cit.* at n. 21, p. 682; Scorza 1981, *op. cit.* at n. 20, p. 19.

24. Baldinucci–Ranell, *op. cit.* at n. 15, p. 511; Wazbinski 1985, *op. cit.* at n. 7, p. 294.

25. Folena 1970, *op. cit.* at n. 21, p. 683; Scorza 1981, *op. cit.* at n. 20, p. 22.

26. Folena 1970, *op. cit.* at n. 21, pp. 682–3; Scorza 1988, *op. cit.* at n. 21, p. 16.

27. The breadth of Borghini's interest in religious matters is apparent from the contents of his library; see Folena 1970, *op. cit.* at n. 21, p. 681; Testaverde Matteini, A.M., (1983), 'La biblioteca erudita di don Vincenzo Borghini', in Garfagnini, G., ed., *Firenze e la Toscana dei Medici nell' Europa del' 500*, **2**, *Musica e spettacolo scienze dell'uomo e della natura*, Florence: pp. 611–43.

28. The second of his two dialogues in Gilio da Fabriano, (1564), *Due Dialoghi*, Camerino, reprinted in Barocchi, P., ed., (1960–1962), *Trattati d'arte del Cinquecento*, 3 vols, Bari: **2**, pp. 1–115.

29. Barocchi 1971, *op. cit.* at n. 19, p. 647.

30. *Ibid.*, pp. 647–8.

31. *Ibid.*, p. 648.

32. *Ibid.*, p. 648.

33. *Ibid.*, pp. 649–50.

34. *Ibid.*, pp. 649–50; Borghini here emulates Vasari's employment of the term in the 1550 edition of the *Vite*, (Vasari, (1550), Florence, p. 75); see Barocchi 1971, *op. cit.* at n. 19, **1**, p. 650, n. 1.

35. *Ibid.*, pp. 663–4.

36. *Ibid.*, p. 664.

37. Barocchi 1970, *op. cit.* at n. 19, p. 87.

38. Naldini became an academician in 1564. See Colnaghi, (1928), D., *A Dictionary of Florentine Painters*, London: pp. 187–8.

39. Berenson, B., (1903, 2 vols, London; 1938, amplified edition, 3 vols, Chicago; repr. 1969); *The Drawings of the Florentine Painters*, New York.

40. *Ibid.*, 1903, **1**, p. 327; also, 1938 and 1969, **1**, p. 321.

41. See n. 33 above.

42. Barocchi 1965, pp. 244–88.

43. *Ibid.*, p. 252.

44. Petrioli Tofani 1980, *op. cit.* at n. 9, p. 151.

45. Turner 1986, *op. cit.* at n. 9, p. 210.

46. See Jedin 1960, *op. cit.* at n. 2, pp. 181–2, 'It promulgated additional decrees on Purgatory, Indulgences, the veneration of Saints, their relics and images'; and Buckley 1851, pp. 212–5.

47. For the various approaches see Déjob, C., (1884), *De l'influence du Concile de Trent sur la littérature et les beaux-arts chez les peuples Catholiques*, Paris and Toulouse; Mâle, E., (1932), *L'Art religieux*

après le Concile de Trente; repub. (1951), as *L'Art religieux de la fin du XVIe siècle*, Paris; Blunt, A., (1940, 1962), *Artistic Theory in Italy 1450–1660*, Oxford; Jedin 1960, *op. cit.* at n. 2, pp. 181–2; Janelle, P., *The Catholic Reformation*, Milwaukee, (1963), London, (1971), p. 159 ff.; Hautecoeur, L., (1965), 'Le Concile de Trente et l'art', in *Il Concilio di Trento e la Riforma Tridentina, Atte del convegno storico internazionale Trento 2–6 Settembre 1963*, 2 vols, Rome: **1**, pp. 345–62; Hall, M., (1979), *Renovation and Counter-Reformation*, Oxford.

48. Further discussion of the technical aspects of the three images is impractical here; it will be dealt with in a future publication.

49. The Council's sixth session on Justification began on 13 January 1547. See Buckley 1851, pp. 29–46, esp. p. 32, 'On the necessity of Preparation for Justification and whence it proceeds'. These quotations are from the Authorized Version of the Bible.

50. For discussion of images of Veronica see Chastel, A., (1978), 'La Veronique', *Revue de l'Art*, **40/41**, pp. 71–82.

51. Barocchi 1971, *op. cit.* at n. 19, pp. 649–50.

52. This seems to have been the case with most Tuscan trecento Passion-cycle versions of the subject; e.g. by Duccio, Ugolino di Nerio, Giotto, Barna da Siena, Simone Martini, etc. This trend is also apparent in the fourteenth–century frescoed version of the subject in the Badia Fiorentina by the so-called Orcagnesque Master; see Guidotti (Casa di Risparmio) 1982, *op. cit.* at n. 4, p. 65.

53. See Ragusa, I. and Green, R., eds, 1961, *Meditations on the Life of Christ: An Illustrated Manuscript of the Fourteenth Century*, Princeton: pp. 330–2.

54. Inclusion of the *sudarium* image seems not to have occurred until the late quattrocento as, for instance, in Tuscan images attributed to Tuccio di Antonio (Paris, Louvre) and Ridolfo Ghirlandaio (London, National Gallery). For reference to a similar situation in France, see Mâle, E., (1931), *L'Art Religieux de la fin du Moyen Age en France*, 4th ed., Paris: p. 64.

55. See Buckley 1851, 'Decree concerning the Canonical Scriptures', pp. 17–19, and 'Decree concerning the edition and the use of sacred books', pp. 19–21.

56. See n. 3 above.

57. For interpretations of these verses see Nicoll, W. R. and Stoddart, J. T., eds, (1978), *The Expositor's Dictionary of Texts*, Grand Rapids, Michigan: **2**, pt 1, p. 165 ff.; Kittel, G., ed., (1966, 1967), *Theological Dictionary of the New Testament*, Grand Rapids, Michigan: **3**, pp. 152–3.

58. For Italian acknowledgement of the quality of Northern prints, see Vasari–Milanesi, **5**, pp. 396–411.

59. 163 × 115 mm.; see Musée du Petit Palais (1991), *Martin Schongauer, Maître de la gravure rhenane, vers 1450–1491*, exh. cat., Paris (Musée du Petit Palais): pp. 180–1.

60. 387 × 275 mm, from the *Large Passion* series; see Strauss, W., ed., (1980), *The Woodcuts and Woodblocks of Albrecht Dürer*, New York: pp. 212–3. Dürer produced two compositional variants of the subject: the 1509 woodcut from the *Small Passion* series (127 × 97 mm) – see Strauss ed. 1980, *op. cit.* above, pp. 374–5 – and the smaller, 1512 version from the *Small Engraved Passion* (117 × 74 mm) – see *idem.*, ed., (1976, 1981), *The Intaglio Prints of Albrecht Dürer*, New York: pp. 180–1; but neither seems as relevant to Naldini's image as the earlier woodcut.

61. Barocchi 1965, p. 252.

62. For the surviving drawings see Cox-Rearick 1981, *op. cit.* at n. 18, **1**, pp. 213–26; **2**, figs 187–207.

63. See Vasari-Milanesi, **6**, pp. 266–9; Clapp 1914, *op. cit.* at n. 18, pp. 39–40; Forster, K., (1966), *Pontormo*, Munich: pp. 48–56; Cox-Rearick 1981, *op. cit.* at n. 18, **1**, pp. 52-54 and p. 213 ff.; Berti, L., (1993), *Pontormo e il suo tempo*, Florence: p. 225 ff.; Costamanga, P., (1994), *Pontormo*, Milan: pp. 61–65; Beckers, P., (1985), *Die Passionfresken Pontormos Für Die Certosa del Galluzzo*, 2 vols., Salzburg.

64. Barocchi 1965, p. 252.

65. *Ibid.*, p. 252, Barocchi speaks conventionally but to my mind erroneously of the *instabilità* of these figures' poses.

66. *Ibid.*, p. 252, Barocchi makes reference to the compositional significance of the horsemen, while the rhythms of repeated forms are significantly echoed in Vincenzo Borghini's ideas of musical consonance.

67. For an illustration see Pope-Hennessy, J., (1986), *Italian High Renaissance and Baroque Sculpture*, Oxford: pp. 325–7.

68. Oil on panel, 610 × 432 mm, see Corti, L., (1989), *Vasari. Catalogo completo dei dipinti*, Florence: p. 84, cat. 63.

69. These elements echo the emphasis on the soldiers' impatience to see Christ crucified as described in Ragusa and Green eds 1961, *op. cit.* at n. 53, pp. 330–2.

70. For Borghini as an advisor, see Cecchi 1977, *op. cit*, at n. 7 and (1982), ' "Invenzioni per quadri" di don Vincenzo Borghini', *Paragone*, **33**, nos 303–5, pp. 89–96; Scorza 1988, *op. cit.* at n. 21.

71. Evennett, H.O., ed. Bossy, J., (1968, 1975), *The Spirit of the Counter Reformation*, Cambridge: p. 36.

72. See n. 3 above.

73. See Buckley 1851, pp. 214–5.

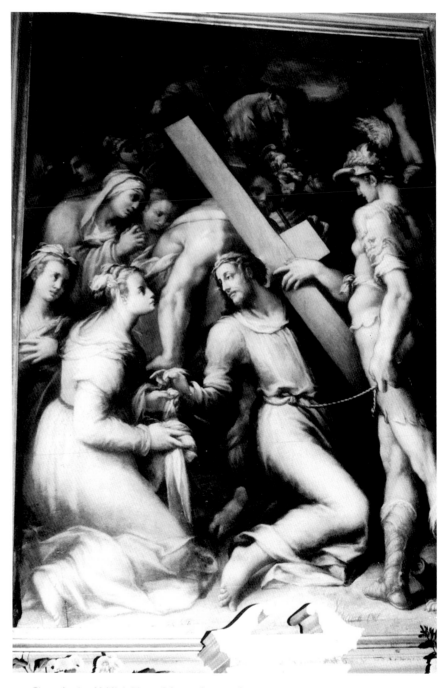

9.1 Giovambattista Naldini, *Way to Calvary,* oil on panel.

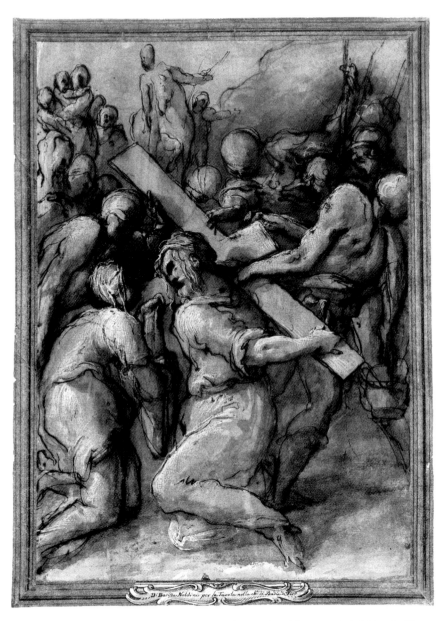

9.2 Giovambattista Naldini, *Way to Calvary*, pen and brown ink and brown wash, heightened with
white, on a ground washed light brown.

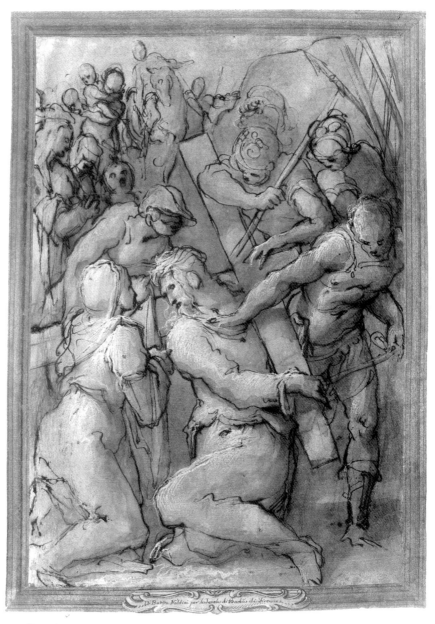

9.3 Giovambattista Naldini, *Way to Calvary*, pen and brown ink and brown wash, heightened with white, on a ground washed light brown.

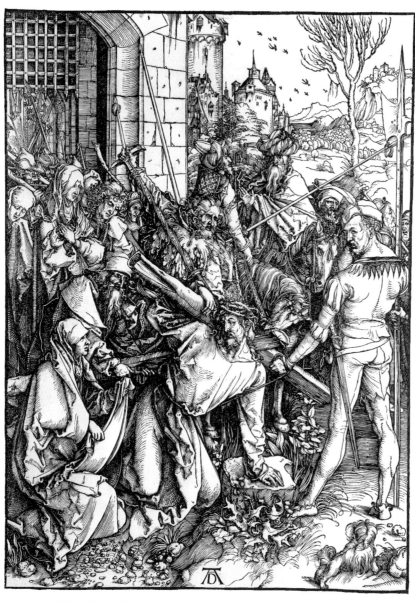

9.4 Albrecht Dürer, *Way to Calvary*, woodcut.

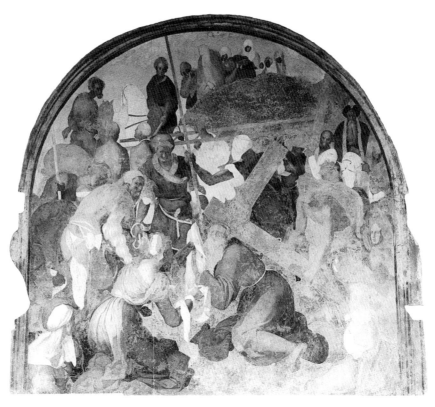

9.5 Jacopo Pontormo, *Way to Calvary*, fresco.

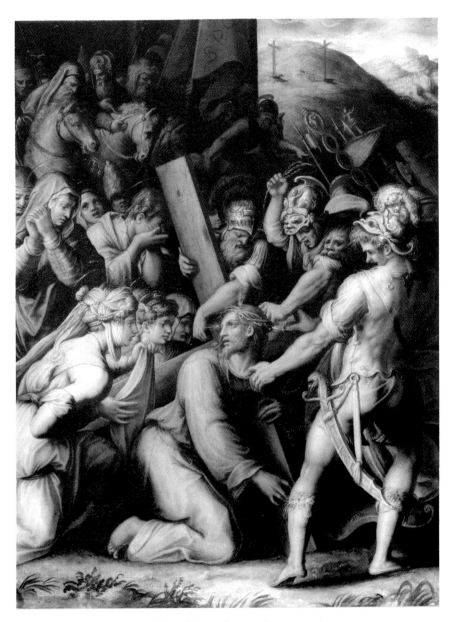

9.6 Attributed to Giorgio Vasari, *Way to Calvary*, oil on panel.

Drawings for Bartolomeo Passarotti's Book of Anatomy

Monique Kornell

Although several drawings from the collection of Sir Hans Sloane (1660–1753) are to be found in the Print Room of the British Museum, many others remain in the Department of Manuscripts in the British Library.[1] Among these are drawings by the sixteenth-century Bolognese artist, Bartolomeo Passarotti (1529–92), bound in a Sloane album of anatomical drawings (MS Add. 5259, fols 18–19).[2] The scientific nature of these drawings and of those of three skeletons by Battista Franco (c.1510–1561) in the same volume have perhaps discouraged their transfer to the Print Room and their appreciation by a wider audience.[3]

The four Passarotti drawings (Figures 10.1 and 10.2) are of a half-nude/half-skeleton figure seen from the front and the back, with profile views of a male nude and a walking skeleton.[4] Executed in pen and dark brown ink, they display Passarotti's characteristic bold, cross-hatched style and bring to mind Carlo Cesare Malvasia's remark, 'His pen . . . was the best ever seen'.[5] These figures offer highly effective comparisons between the nude and its underlying skeleton and may be connected with Passarotti's book of anatomy, on which he was engaged when Raffaello Borghini described it in *Il Riposo* of 1584:

He is at work on a book of anatomies, of skeletons, and of flesh, in which he wishes to show how one must learn the art of design to put it into practice, and one would hope that it will be a fine thing, because he draws so well.[6]

Passarotti's anatomy book does not survive but, according to Borghini, it was to deal with the muscles, the bones and the flesh, and was intended to instruct in the arts of design. Later reports of the book all derive from Borghini, and for any further indication of Passarotti's ideas, one must turn to his drawings. There is no shortage of anatomical drawings ascribed to Passarotti who, along with Michelangelo, Rosso Fiorentino, Baccio Bandinelli

and Lodovico Cigoli, is a popular candidate in the attribution of early Italian drawings of this type.[7] However, only a selection of these may be confidently accepted as by his hand. Fewer still go beyond mere studies to carry a clear sense of didactic purpose or are of sufficient finish to be convincingly associated with book illustration. Such qualities are however present in the Sloane drawings, as they are in Passarotti's *Self-portrait with anatomical figures* (Warsaw, University Library, Zb. Kr. 1113, fol. 24; Figure 10.3), which is usually linked with his book of anatomy.[8] In these images, one finds the comparison of different anatomical layers of the body that was the key feature in Borghini's description.

The original, inscribed attribution of the Sloane drawings is to 'Baccio Bandinelli', an artist whose drawing style has often been confused with that of Passarotti.[9] The letter 'B' appears at the lower right of MS Add. 5259, fol. 18, with the rest of the inscription, 'accio Bandinelli' seen at the lower left of fol. 19, signalling that the heavy card on which the four trimmed studies by Passarotti are pasted was originally one sheet. The drawings of the *Nude in profile* on the right of fol. 18 and the *Skeleton in profile* at the left of fol. 19 are of matching length and were probably once joined. Several repairs have been made to the drawings. These may have occurred when the drawings were trimmed, and some may have been carried out by the artist himself.[10] On the left of fol. 18 is a figure seen from the front, which offers a direct comparison between the male nude on its right side and the revealed skeletal structure on its left side (Figure 10.1). Next to this figure is a male nude in profile which can easily be imagined as the bisected figure turned to the right. This illusion, however, is not sustained in the next folio which has a skeleton in right profile (Figure 10.2). To the right is another bisected figure, seen from the back, which is a counterpart to the figure on fol. 18. There is, however, some variation in this figure's pose, discernible in the action of the left, or skeletal, side. The arm has been slightly raised, and the leg rotated outwards with the heel lifted from the ground, giving the impression that the figure is walking forward. The most remarkable change is seen in the head. Passarotti has accentuated the division of the body in an oddly believable way by having the head of the right half of the body look forward, while the skull, Janus-like, is seen in profile looking towards the left. Equally striking is the way in which the handsome but solemn face of the *Half-nude/half-skeleton* of fol. 18 blends into the perpetual grin of the skull. Taken together, the profile drawings of the nude and the skeleton complement the two bisected figures so that all the main views of these two anatomical layers are presented in just four figures.

Given the nature of these drawings, Giovanni Antonio Bumaldi's observation, in his *Minervalia Bononiae* of 1641, that Passarotti had made a great study of the structure and symmetry of the human body, is particularly apt.[11]

The bisected figure that Passarotti employs in the MS Add. 5259 drawings utilizes the symmetrical nature of the human body to arrive at a succinct and didactic presentation of the nude and of the skeleton that underlies and supports it. This treatment of the body was not unique to Passarotti. In 1543, it was adopted for the illustrations of the *Epitome* of Andreas Vesalius to condense the stately decomposition of the 14 muscle figures published in the *De humani corporis fabrica* of the same year, into just five plates. A half-nude/half-skeleton figure (Figure 10.4) features as the final plate of a series of 14 anatomical prints by Giulio Bonasone (active 1531–1574), and in the late seventeenth century José García Hidalgo (c.1650–1717) applied this method of display to the female body in his drawing book, *Principios para estudiar el nobilísimo y real arte de la pintura*. A drawing of a bisected figure, with the right side as skeleton, is found in an album of anonymous sixteenth-century Italian anatomical drawings in the British Museum.[12] The drawing of a half-nude/half-skeleton, attributed to Passarotti, that passed through the sale rooms in Amsterdam in the late 1920s, is, to judge from the photograph in the Witt Library (Courtauld Institute of Art, London) at best a poor copy of a lost Passarotti.[13]

Passarotti's student Francesco Cavazzoni (b. 1559), included an illustration of a half-nude/half-skeleton figure in his 1612 manuscript treatise, *Esemplare della nobil arte del disegnare per quelli che si dilettano della virtù, mostrando parte per parte, con simetria, anatomia e geometria ed altri modi*.[14] This drawing, along with illustrations of limbs in different anatomical states which graduate from skeleton through to muscle and flesh, demonstrates that Cavazzoni shared the concerns of his master and that perhaps some reflection of Passarotti's lost book of anatomy and *disegno* may be seen in his student's treatise. Coincidentally, it is through Passarotti's deposition at the 1574 trial of Cavazzoni, concerning the amorous attentions of the 15-year-old youth to the sister of the painter Sammachino, that Passarotti's study of anatomy through dissection is documented. In it Passarotti accounts for his own presence at the house of a physician because of his desire to witness a dissection.[15]

An important element of the physical description of the Sloane drawings cannot be easily discerned in reproduction. The figures bear horizontal stylus marks indicating the length of the head, the neck, the hip, the groin and the knee, with the exception of the *Half-nude/half-skeleton* of fol. 18, where demarcations can be discerned only on the neck and at the knee. These markings demonstrate that Passarotti sought to define the proportions of the body on the basis of its anatomical structure. Similar measurements are found in anatomical drawings by Passarotti in Cambridge, Florence, Stockholm, and a sheet that recently passed through the New York sale rooms. These share interrelated proportional measurements and markings based on

the length of the bones and their joints, with particular attention paid to the measurement of the hip and the arm, suggesting that in addition to dealing with the bones, the muscles and the nude body – the three anatomical states specified by Borghini – Passarotti's book of anatomy would also have dealt with the proportions of the body based on the skeleton.

In the Cambridge *Male nude with proportional measures* (Fitzwilliam Museum, PD. 122–1961; Figure 10.5), once traditionally attributed to Michelangelo but now given to Passarotti, a basic unit of a third of the length of the face is employed, a division often used by Passarotti.[16] Along the lower left side of the sheet is a proportional scale of a skeleton. Only the skull and collarbone have been drawn, with the rest of the skeleton indicated by names written along the left border and along the arm, in which each joint is identified with the word 'congiunta'. Compass marks link the joints of the arm, in which the proportions of the upper and lower sections and the hand are expressed as 5, 4 and 3, with the rest of the body. This is paralleled in the nude on the right, where the arm has been measured and horizontal lines connect its divisions with the body. In this sheet and in other drawings by Passarotti, one may note the special consideration that has been given to the measurement of the hip and the groin, which is established as the centre point of the body. In the Fitzwilliam nude Passarotti has assigned a unit of one third to the wrist, to the groin and to a similar width of the hip, marked with an asterisk, while in the skeletal scale on the left the joint of the wrist has been linked to the groin, or 'natura'. In the profile skeleton of Add. 5259, fol. 19 (Figure 10.2), Passarotti also used an asterisk, connected by a line, to mark the point on the skeleton corresponding to that indicated by the asterisk in the Fitzwilliam nude. This is the position of the greater trochanter, a protuberance at the head of the femur, and the widest point of the hip joint. Passarotti also marked the same area with parallel stylus marks on the profile nude of Add. 5259, fol. 18 (Figure 10.1). Finally, the measurement of the hip is repeated in a sheet of studies featuring the muscles of the right leg in profile, and those of the upper right back with the arm raised compared to the bones of the same area with the arm lowered, sold in New York at Christie's, 30 January 1997, lot 15 (Figure 10.6).[17] Here it is demarcated by lines labelled 'A' and 'B' and its length is compared to that of the heel. According to the partially-legible inscription by the artist along the left border of the sheet, this comparison was based on a series of measurements: 'et è misurata più volta da me' (and I measured it many times). This is corroborated by the Fitzwilliam sheet where the area of the hip on the nude is given the same unit of length as the heel, 'una tertia' or one-third of the length of the face.

Correspondences found in other anatomical drawings by Passarotti further consolidate the attribution of the Fitzwilliam sheet to the artist. A

drawing similar in style and subject, once in the collection of Pierre Crozat (1661–1740) where it was attributed to Michelangelo, is now in Stockholm (Nationalmuseum, NMH 121/1863; Figure 10.7).[18] In the Fitzwilliam and the Stockholm drawings Passarotti used a more fluid line, rather than his distinctive cross-hatched pen work seen in the Sloane drawings. Both methods of handling are present in a sheet of Passarotti studies in Oxford (Christ Church, 1393) for his *Adoration of the Magi* in the Palazzo Arcivesco-vile, Bologna.[19] On the right of the Stockholm sheet is an armless nude in left profile with the face divided into three units like that of the Fitzwilliam nude, and in the study of an arm and torso at the upper left of the sheet the proportional division of five units for the upper arm, four units for the lower arm and three for the hand has again been applied. On the verso (NMH 122/1863) are studies of the upper half of the skeleton, drawn in right profile and from the front, where measurements have been made of both its length and width. The inscription along the hand reads 'parte 3 misura della testa', or 'three one-third units of the length of the face'. The lower arm is assigned 'parte 4' and the upper 'parte 5', with the differing lengths of the radius and the ulna, the bones of the lower arm, observed in arriving at these measure-ments. The 5:4:3 ratio for the arm is found once more on the verso of a sheet in Florence (Uffizi, 12375F). Only the pen and ink drawing of a left thigh and an écorché right leg on the recto has been connected with the artist's study of anatomy but, to my knowledge, the anatomical and proportional studies on the verso have not been discussed.[20] Uffizi 12375Fv, which has suffered losses, is a study of the bones of the pelvis and of the legs, crossed over as if in mid-step. Along the left side of the sheet is a male nude seen in right profile view with proportional markings that largely correspond to the Fitzwilliam nude, although the groin area is given a measurement of one quarter. Extending horizontally from the nude at the height of the shoulder are the bones of the shoulder joint and of the arm. Once again, the arm bones have been given the numbered divisions '5', '4', '3', with the length of the clavicle (collarbone) assigned a measurement of '3'. The length of the left heel has been measured with two compass points – noteworthy when one recalls Passarotti's comment on the sheet sold at Christie's in New York that he had personally measured the lengths of the heel and of the hip many times – and a line extends from these points along the back of the leg to the knee joint and then along the femur.

The New York drawing, the Stockholm sheet (Figures 10.6 and 10.7), and Uffizi 12375Fv, are all in the nature of working studies, whereas the drawings in the British Library, Warsaw, and Cambridge (Figures 10.1, 10.2, 10.3 and 10.5) have a greater finish and would have been more suitable for inclusion in Passarotti's 'libro di notomie, d'ossature, e di carne'. It is likely that Passarotti's book, in addition to dealing with the bones, the muscles and

the nude – the three main anatomical states of the body of relevance to the artist – would have included a study of the proportions of the body based on human anatomy, with particular attention paid to the skeleton and its joints.

The type of measured anatomical drawing by Passarotti discussed here was also produced by other artists. Domenichino (1581–1641) owned three drawings of 'skeletons with measures' by one of the Carracci.[21] Amongst the copies by Giulio Clovio (1498–1578) after Michelangelo listed in an inventory of Clovio's belongings was 'an anatomy with all the measures by Michelangelo'.[22] Michelangelo's red chalk study of a standing nude (Windsor, 12765), which has been suggested as the original after which Clovio's copy was made,[23] has also been compared with the Passarotti Fitzwilliam drawing. The Windsor Michelangelo drawing has proportional measurements with subsidiary studies of the hand, thigh, knee and foot, and, as in the Fitzwilliam drawing, the same unit of measurement – a third of the length of the face – is used. At the top right, there is a rough sketch of a face in profile alongside the length of a hand. One face length, or three units, is the measurement that Passarotti consistently assigned to the hand, as is seen in the Fitzwilliam, Stockholm and Uffizi drawings. There is also the measured juxtaposition of the wrist with the hip area in the Windsor and Fitzwilliam drawings.[24] A study of the bones and muscles of the leg with proportional markings along the top border of a further Michelangelo sheet (Uffizi, 18719F), a drawing related to both the Sistine Ceiling *Eve* and the Medici Chapel *Night*, demonstrates that Michelangelo also investigated the proportions of the body based on its anatomy. Perhaps Passarotti knew and was influenced by Michelangelo drawings like Windsor 12765 and Uffizi 18719F.

In his own lifetime, Michelangelo was renowned for his knowledge of anatomy, and Passarotti honoured him in a drawing (Paris, Louvre, 8472) by making him the central figure dissecting the muscles of the leg in an anatomy session attended by other famous masters of the day.[25] The example of Michelangelo's own projected but never completed book of artistic anatomy, which was to have dealt with 'the appearance of the body in motion and its bones',[26] served as a stimulus for the Bolognese artist, as it did for his contemporaries Alessandro Allori (1535–1607) and Vincenzo Danti (1530–1576), working in Florence. While none of these works on anatomy saw publication, there is, however, a possibility that Vincenzo Danti's unfinished treatise might have had a direct influence on Passarotti's anatomy book, through the artist's friendship with Vincenzo's brother, the mathematician and cartographer Ignazio Danti (1536–1586). Much of the introduction to the second part of Ignazio Danti's 1583 commentary on Giacomo Vignola is spent praising Passarotti, whom he considered to be 'one

of the most shining lights that the art of drawing has had till this day'.[27] Ignazio's collection of drawings contained two Passarotti sheets, and he also sat for his portrait by the artist, which is now in the Musée Municipal, Brest.[28] Vincenzo Danti intended that eight of the 15 books which were to follow his *Il primo libro del trattato delle perfette proporzioni* (Florence, 1567) would deal with anatomy.[29] Upon Vincenzo's death in 1576 these unpublished books were consigned to Ignazio's care, and it is likely that when, in the same year, he left Florence for Bologna, where he was to live until 1580, he took Vincenzo's manuscripts with him, since a summary of their content is included in his *Le scienze matematiche ridotte in tavole* published in that city in 1577.[30] Ignazio Danti, aware of Passarotti's interest in anatomy, could have shown the artist his late brother's writings on the subject.

When Raffaello Borghini described Passarotti's book on anatomy as a work in progress, he had every expectation of its excellence because of the artist's great skill in draughtsmanship.[31] Regrettably, Passarotti's project, along with similar plans for books on anatomy by various other sixteenth-century artists, was never carried through to publication. Nonetheless, the drawings discussed here, and particularly those bound in the Sloane album, which exhibit such vibrancy in their execution and innovation in their conception, provide an indication of the concerns Passarotti would have addressed in his lost book: the structure of the human body, its measurement and proportions based on anatomy.

Frequently cited literature

Borghini, R., (1584), *Il Riposo*, Florence: reprint (1967), Milan; Höper, C., (1987), *Bartolomeo Passarotti (1529–1592), Manuskripte zur Kunstwissenschaft in der Wernerschen Verlagsgesellschaft*, **12**, 2 vols, Worms; Ghirardi, A., (1990), *Bartolomeo Passerotti pittore (1529–1592). Catalogo generale*, trans., Vichi, I., Rimini (references here are to the Italian text).

Notes

1. See Griffiths, A. and Williams, R., (1987), *The Department of Prints and Drawings in the British Museum, User's Guide*, London: pp. 165–7.

2. The spelling of Passarotti's name varies, as it did in his own time when he was known, for example, as Passerotto, Passerotti, or Pasarotti. For the artist and his works, see Ghirardi 1990; also Bodmer, H., (1938–1939), 'Die Kunst des Bartolomeo Passarotti', *Belvedere*, **13**, pp. 66–73; and *idem*, (1932), in Thieme, V. and Becker, F., eds, *Allgemeines Lexikon der bildenden Künstler*, 37 vols, (1915–1950), Leipzig: **26**, pp. 278–9. For Passarotti's drawings, see Höper 1987. For Passarotti's prints, see Bohn, B., (1988), 'Bartolomeo Passarotti and Reproductive Etching in Sixteenth-Century Italy', *Print Quarterly*, **5**, no. 2, pp. 114–27.

3. For the Franco drawings, see Kornell, M., (1989), 'Anatomical Drawings by Battista Franco', *The Bulletin of The Cleveland Museum of Art*, **76**, no. 9, pp. 302–25, esp. p. 321, n. 20, where the attribution of the Passarotti drawings was first suggested.

4. British Library, MS. Add. 5259, fol. 18: *Half-nude/half-skeleton, seen from the front*, 415 × 105 mm; right: *Nude in right profile*, 403 × 61 mm; MS. Add. 5259, fol. 19: *Skeleton in right profile*, 403 × 112 mm (max); right: *Half-nude/half-skeleton, seen from the back*, 410 × 133 mm. The drawings have been laid down on heavy card that measures 485 × 305 mm for fol. 18 and 470 × 330 mm for fol. 19. All are in pen and dark brown ink on darkened and mottled cream paper and bear horizontal stylus marks.

5. Malvasia, C.C., (1678), *Felsina Pittrice*, 2 vols, Bologna: **1**, p. 241: 'La sua penna . . . fu delle più brave, che mai si vedesse . . . '.

6. Borghini 1584, p. 566: 'Fa un libro di notomie, d'ossature, e di carne, in cui vuol mostrare come si dee apprendere l'arte del disegno per metterlo in opera, e si può sperare, che habbia ad essere cosa bella; perche egli disegna benissimo.'

7. With regard to anatomical drawings, C. Höper's catalogue serves primarily as a checklist of attributions to Passarotti. For a list of drawings linked to Passarotti's anatomy book, see Höper 1987, p. 123, n. 82. Since the submission of this article, Dr Höper has published a drawing in the Staatsgalerie in Stuttgart, connecting it to other studies by Passarotti of cadaverous figures: Höper, C., (1997), 'Zu den Anatomiebüchern von Bartolomeo Passarotti und Peter Paul Rubens', in *L'Arte del Disegno. Christel Thiem zum 3. Januar 1997*, Berlin: pp. 73–82.

8. Ameisenowa, Z., (1963), *The Problem of the Écorché and the Three Anatomical Models in the Jagiellonian Library*, trans. Potocki, A., *Monografie z Dziejów Nauki i Techniki*, **20**, Wrocaw: pp. 34–35; Amerson Jr, L.P., (1969),'Marco d'Agrate's San Bartolomeo: an introduction to some problems' in Gatti Perer, M.L., ed., *Il duomo di Milano*, 2 vols, Milan: **1**, p. 196; Höper 1987, cat. Z.328; Ghirardi 1990, pp. 22–23 and 41; Cazort, M., Kornell, M. and Roberts, K.B., (1996), *The Ingenious Machine of Nature. Four Centuries of Art and Anatomy*, exh. cat., Ottawa (National Gallery of Canada): no. 46.

9. See Ward, R., (1988), *Baccio Bandinelli (1493–1560). Drawings from British Collections*, exh. cat., Cambridge (Fitzwilliam Museum): no. 47.

10. The right edge of the *Nude in profile* on fol. 18 and the left edge and lower right edge of the *Skeleton in profile* on fol. 19 have been repaired, as has the wrist of the *Half-nude/half-skeleton, seen from the back* on fol. 19. There are patches in the area on the left rib cage of the same figure and at the hip of the skeleton on fol. 19. In the Warsaw sheet (see n. 8 above), Passarotti's self-portrait is on a separate patch attached to the sheet.

11. Bumaldi, G.A., (1641), *Minervalia Bononiae*, Bologna: pp. 259–60, quoted in Malvasia 1678, *op. cit.* at n. 5, p. 245. 'Bumaldi' was a pseudonym for O. Montalbani.

12. London, British Museum, album 197.c.3, fol. 12r (1866–12–8–660). Another version of this drawing is in Siena, Biblioteca Comunale degli Intronati, MS. S. II.5, fol. 12r. The so-called 'Bandinelli album' is discussed in Kornell, M., (1993), *Artists and the Study of Anatomy in*

Sixteenth–Century Italy, unpublished Ph.D thesis, University of London (Warburg Institute): pp. 138–46. For the Bonasone print (which is not in listed by Bartsch, A. von, (2nd edition, 1818–1876), *Le Peintre–Graveure*, Leipzig), see Massari, S., (1983), *Giulio Bonasone*, 2 vols, exh. cat., Rome (Istituto Nazionale per la grafica-calcografica): 1, no. 184, The Hidalgo etching is reproduced in the facsimile of the 1693 edition, (1965), Madrid: p. 128. For Vesalius, see Saunders, J.B. de C.M. and O'Malley, C.D., (1950), *The Illustrations from the Works of Andreas Vesalius of Brussels*, Cleveland. For early examples of this type of anatomical figure see Kornell 1993, *op. cit.* above, pp. 126–28. In the eighteenth century, half-skeleton/half-clothed figures appeared in English allegorical prints (London, Wellcome Institute Library, London, BRN 26236; BRN 26238). In the nineteenth century, Jean-Galbert Salvage and Paul Richer both produced models demonstrating different anatomical levels (Meige, H., (1926), 'Les Écorchés', *Aesculape*, 16, January 1926, pp. 1–4).

13. A half-nude/half-skeleton figure, seen from the front with the right arm and leg in écorché. Amsterdam, de Vries, 20 December 1927, lot 288: 'Étude anatomique du corps humain', pen and ink, 340 × 200 mm, inscribed at the lower left in a late hand: 'Passarotti' and at the upper left, 'disegno anatomico fato ad istanza dei signori Medici'. Accepted as autograph in Höper 1987, cat. Z.7

14. Bologna, Biblioteca Comunale dell'Archiginnasio, MS. B.330. fol. 16r. See Varese, R., (1969), *Francesco Cavazzoni critico e pittore*, Florence: p. 197, fig. 10. Cavazzoni is also the author of *Pitture & sculture & altre cose notabili che sono a Bologna e dove si trovano*, a manuscript of 1603 in the same library.

15. Passarotti says that he had been '. . . a casa di un medico che stava nella Mascarella che io voleva vedere una notomia.' Quoted in Ghirardi 1990, p. 40, citing Mazzoni Toselli, O., (1837), 'Sopra un antico processo fatto a Francesco Cavazoni pittore del secolo XVI. Lettera a Gaetano Giordani, 3 novembre 1836', *Almanacco Statistico Bolognese*, 8, p. 108. On this case, see also Varese 1969, *op. cit.* at n. 14, p. 24, and Cammarota, G., (1988), in Emiliani, A., ed., *Dall'Avanguardia dei Carracci al secolo Barocco. Bologna 1580–1600*, exh. cat., Bologna (Museo Civico Archeologia): p. 67, n. 30.

16. Originally part of the collection of anatomical drawings given to the King of Poland in 1776 and bequeathed in 1960 to the Fitzwilliam Museum by Dr Louis C.G. Clarke. For the complete provenance, see Scrase, D., (1981), *Drawings from the Collection of Louis C.G. Clarke, LL.D., (1881–1960)*, exh. cat., Cambridge (Fitzwilliam Museum): p. 46. The attribution to Michelangelo was rejected by Popham, A.E. and Wilde, J., (1949), *The Italian Drawings of the XV and XVI centuries . . . at Windsor Castle*, London: no. 421, p. 245, who described it as an anonymous drawing of the sixteenth century. The drawing was exhibited as by Passarotti in 1974, following the attribution suggested by M. Cormack, in (1974), *Sixteenth Century Italian Drawings from the Museum's Collections*, exh. cat., Cambridge (Fitzwilliam Museum): typescript facs., p. 5. It was catalogued as 'attributed to' Passarotti by Scrase 1981, *op. cit.* above, pp. 46–51, and accepted in Höper 1987, cat. Z.39. Other versions exist: two in Turin (see Bertini, A., (1958), *I disegni italiani della Biblioteca Reale di Torino*, Rome: nos 245 and 246) and one in Brno (see Parronchi, A., (1975), *Opere giovanili di Michelangelo*, 2, Florence: p. 220, pl. 124). The drawing was engraved by Giovanni Fabbri (d.1777) and was illustrated in several books on artistic anatomy. Another print was produced by Carlo Paroli (active 1755–1807), an example of which is in London (Wellcome Institute Library, Iconographic Collections, Anat. 342). For further analysis of the proportions, see Scrase 1981, *op. cit.* above; and Summers, D., (1981), *Michelangelo and the Language of Art*, Princeton, pp. 384, 388–9 and 405. Summers's observations, however, are of the Fabbri engraving which he considered to be after a lost drawing by Michelangelo.

17. Pen and brown ink over black chalk, 435 × 282 mm. Now in a New York private collection. Previously sold at Sotheby's, London, 4 December 1969, lot 86. The drawing is accepted as being by Passarotti and connected to his book of anatomy by both Höper and Ghirardi. See Höper 1987, cat. Z.189; Ghirardi 1990, pp. 41–2.

18. For this drawing, which is not in Höper 1987, see Sirén, O., (1917), *Italienska handtechningar från 1400–och 1500–talen i Nationalmuseum. Catalogue Raisonné*, Stockholm: no. 426. I am grateful to Isobel Askeloff for translating this entry for me.

19. Byam Shaw, J., (1976), *Drawings by Old Masters at Christ Church, Oxford*, 2 vols, Oxford: no. 894; Ghirardi 1990, cat. 2.

20. Once attributed to Agostino Carracci, Uffizi 12375 Fr was associated by Bodmer with Passarotti in connection with the artist's anatomical studies (Bodmer 1938–1939, *op. cit.* at n. 2, p. 72). See

also Johnston, C., (1973), in *Mostra di disegni Bolognese dal XVI al XVIII secolo*, exh. cat., Florence (Uffizi, Gabinetto Disegni e Stampe): **40**, no. 25; Béguin, S. and di Giampaolo, M., (1979), in *Maestri Emiliani del secondo Cinquecento, Biblioteca dei disegni*, **12**, Florence: p. 32, where it is incorrectly stated that Passarotti's book was published in the seventeenth century; Höper 1987, cat. Z.95

21. Listed in the inventory of Francesco Raspantino, Domenichino's assistant and heir to his studio effects, dated 4 April 1664: 'Schel[e]tri d'ossatura con sue misure di Caracci no.3'. Archivio di Stato Roma, Notaio Olimpiade Petrucci, Ufficio 6, 1664, 2a parte, vol. 5943, fol. 33v. Transcribed in Spear, R.E., (1982), *Domenichino*, 2 vols, New Haven and London: **1**, p. 343.

22. Inventory dated 31 December 1577: 'Una notomia con tutti le misure di Michelangelo fatta da Don Giulio' (Bertolotti, A., (1882), 'Don Giulio Clovio principe dei miniatori. Notizie e documenti inediti', extract from *Atti e Memorie delle Deputazioni di storia patria dell'Emilia*, nuova serie, **7**, parte II. Modena: p. 14). The inventory also lists two other anatomical drawings after Michelangelo, 'Una figura di Notomia' and 'Un contorno di notomia con due figure'.

23. Popham and Wilde 1949, *op. cit.* at n. 16, no. 421, inv. 12765r, p. 245; Summers 1981, *op. cit.* at n. 16, pp. 385–9.

24. Noted by Summers 1981, *op. cit.* at n. 16, p. 388.

25. Steinmann, E., (1913), *Die Porträtdarstellungen des Michelangelo*, Leipzig: pp. 80–81; Pinault, M. with Jaoul, M. and Cordellier, D., (1984), *Dessins et Sciences XVIIe–XVIIIe siècles*, exh. cat., Paris (Louvre, Cabinet des Dessins): no. 60; Ghirardi 1990, pp. 42 and 46. Höper assigns both the drawing and the related painting in the Borghese Palace, Rome, to a follower of Passarotti; see Höper 1987, cat. A.70 and A.286.

26. Condivi, A., (1553), *Vita di Michelagnolo Buonarroti*, Rome: recto of second of two unpaginated folios inserted between fols 42 and 43: 'che tratti di tutte le maniere de' moti umani e apparenze, e dell'ossa, con una ingegnosa teorica, per lungo uso da lui ritrovata'. On Michelangelo's treatise, see also Vasari, G., *Vite*, (1878–1885), ed. Milanesi, G., Florence: **7**, p. 274. For Allori's dialogue, *Le regole del disegno*, see Barocchi, P., ed., (1971–1977), *Scritti d'arte del Cinquecento*, 3 vols, Milan–Naples: **2** (1973), pp. xvii–xix and 1941–81; Ciardi, R.P., (1971), 'Le regole del disegno di Alessandro Allori e la nascita del dilettantismo pittorico', *Storia dell'Arte*, **12**, pp. 267–84. For Danti's treatise see Barocchi, P., ed., (1960–1962), *Trattati d'arte del Cinquecento*, 3 vols, Bari: **1**, pp. 209–69; Daly Davis, M., (1982), 'Beyond the primo libro of Vincenzo Danti's *Trattato delle perfette proporzioni*', *Mitteilungen des Kunsthistorischen Institutes in Florenz*, **26**, pp. 63–84. On anatomy books for artists, Kornell, M., 'The Study of the Human Machine', in Cazort, Kornell, and Roberts 1996, *op.cit.* at n. 8, pp. 43–70.

27. Danti, I., ed., (1583), *Le due regole della prospettiva pratica di M. Iacomo Barozzi da Vignola*, Rome: p. 97: 'uno de' più risplendenti lumi, che l'arte del Disegno habbia fin'hoggi havuto'.

28. Borghini 1584, p. 566. On the portrait, see Ghirardi 1990, cat. 55.

29. Danti in Barocchi ed. 1960, *op. cit.* at n. 26, pp. 268–9.

30. Borghini 1584, p. 522; Daly Davis 1982, *op. cit.* at n. 26, p. 64 ff.

31. Borghini 1584, p. 566.

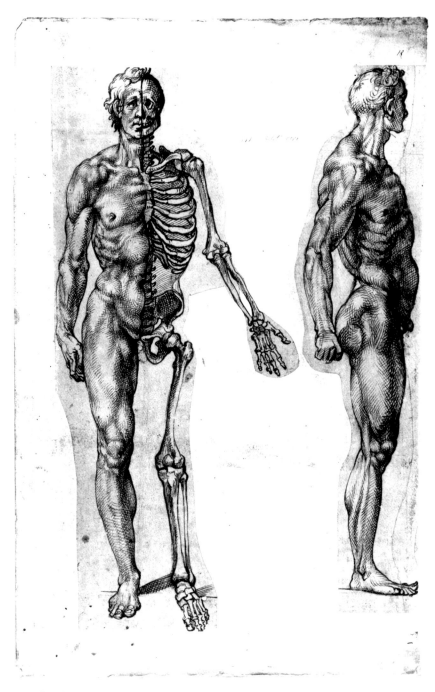

10.1 Bartolomeo Passarotti, left: *Half-nude/half-skeleton, seen from the front*, right: *Nude in right profile*, both in pen and dark brown ink, right drawing only with stylus marks.

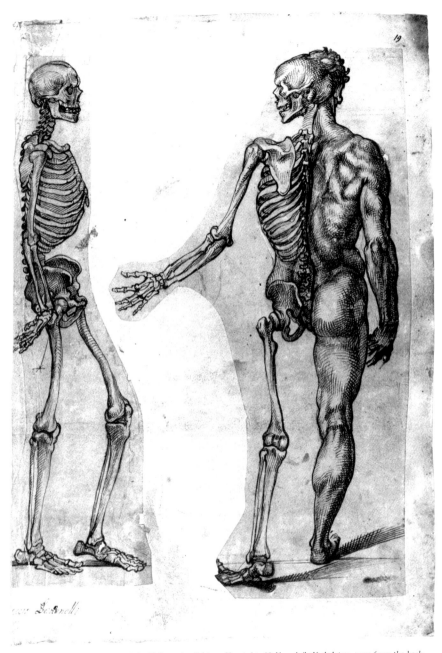

10.2 Bartolomeo Passarotti, left: *Skeleton in right profile*, right: *Half-nude/half-skeleton, seen from the back*, both in pen and dark brown ink, with stylus marks.

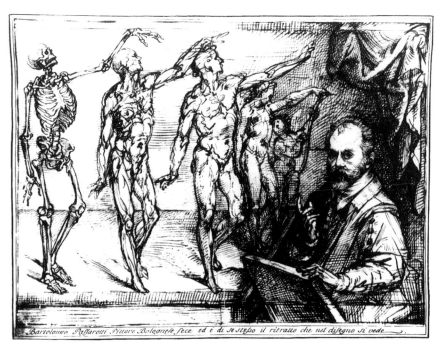

10.3 Bartolomeo Passarotti, *Self-portrait with anatomical figures*, pen and ink.

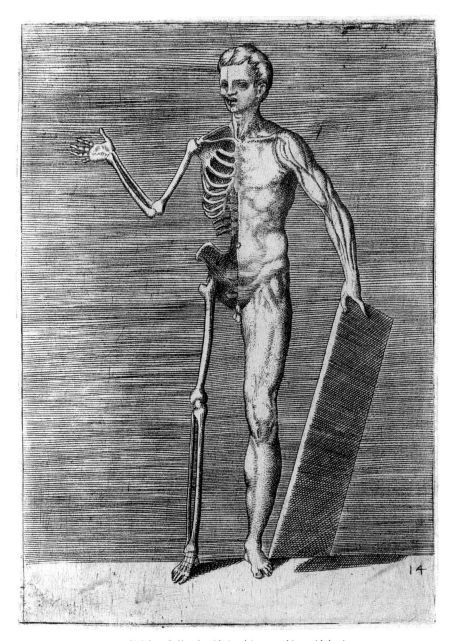

10.4 Giulio Bonasone, *Half-skeleton/half-nude with écorché arm*, etching with burin.

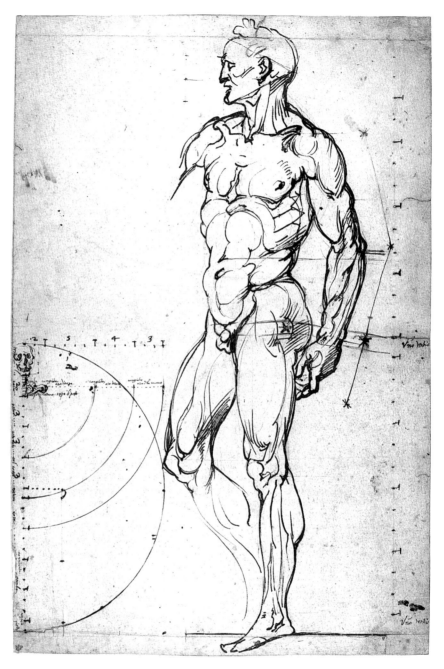

10.5 Bartolomeo Passarotti, *A male nude with proportional measures and, on the left, a proportional scale based on the skeleton*, pen, brown ink and black chalk.

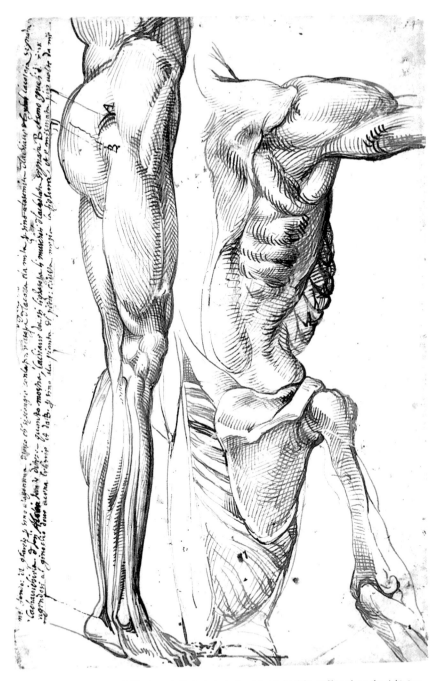

10.6 Bartolomeo Passarotti, *The lower half of a body in écorché seen in right profile and, on the right, two studies of the muscles of the right side of the back and of the upper arm, the lower one being a deeper dissection*, pen and brown ink over black chalk.

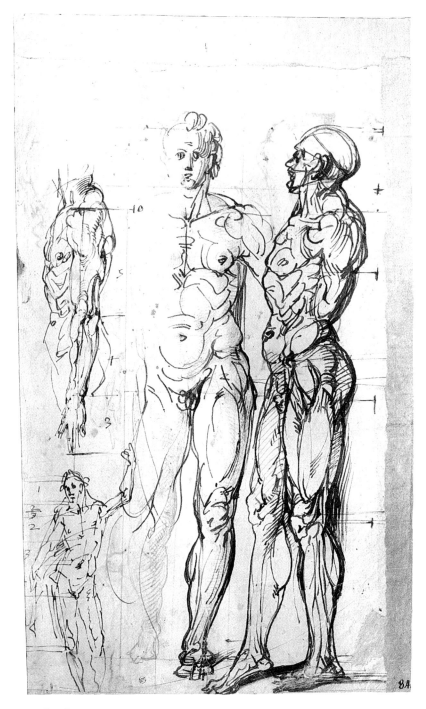

10.7 Bartolomeo Passarotti, *Four proportional studies of the nude*, pen and ink with red chalk underdrawing.

Antonio Tempesta as printmaker: invention, drawing and technique

Michael Bury

Antonio Tempesta (1555?–1630) is an almost forgotten figure in the history of later sixteenth- and early seventeenth-century printmaking. Yet his output was astonishing in both its quantity and its range of subject matter. Although active as a painter and draughtsman, Tempesta produced an immense number of etchings – Adam von Bartsch listed some fifteen hundred and more have come to light since.[1] His etchings were apparently very successful and were well known in the seventeenth and eighteenth centuries. They were produced using strong, deeply-bitten lines, but the plates became worn through overuse, and many of them were later recut.

Through his employment of firm line and bold tonal contrasts, Tempesta was able to create original compositions that are clear and striking, whatever their subject matter. He himself was responsible for the 'invention' in a large proportion of the prints he produced, and it was his mastery of invention and design that was especially praised during his lifetime. His success was not just on a popular level: he received a great deal of attention from the best seventeenth-century critics. To one of those critics, Filippo Baldinucci, it was the fertility of Tempesta's imagination that had led him to take up graphic media in the first place.[2] The purpose of this paper is to explore certain aspects of this imaginative power and the techniques that Tempesta employed to express it.

Tempesta was a Florentine whose initial training had been as a pupil of Giovanni Stradano at the time when the Flemish artist was assisting Giorgio Vasari in the decoration of the Sala del Cinquecento in the Palazzo Vecchio.[3] He subsequently became a pupil of Santi di Tito, who, because of his rejection of the figural and compositional complexities of his predecessors, was credited with introducing a new clarity to Florentine painting.[4] By 1580 Tempesta was working as a painter in the Vatican, alongside Matthaeus Bril.[5]

Around this time, he also contributed to decorative schemes at the Villa Farnese at Caprarola and the Villa Lante at Bagnaia.[6]

Tempesta's first dated prints are of 1589. In considering the implications of this beginning, two points need to be made. The first is that when he started printmaking, he did not stop painting but continued to undertake both public and private commissions, often on a large scale.[7] The second point is that an examination of his earliest printed output reveals an extraordinary variety of types. The first dated prints were the *Emblemata Sacra*, a publication of the emblems from Santo Stefano Rotondo, the church of the Jesuit-run, German-Hungarian College in Rome, where Tempesta had worked as a painter in the early 1580s.[8] His early printed output included further important series of religious subjects: the *Life of S. Filippo Benizzi* in 1590, and then two works for Antonio Gallonio: the *Martyred Virgins* and the *Treatise on Instruments of Martyrdom*, both of 1591.[9] In the 1580s and 1590s there was considerable demand for devotional works in which illustrations were accompanied by only a minimal text. Evidence of this is the publication of the narrative fresco cycles in the Roman churches of San Tommaso di Canterbury and Santo Stefano Rotondo, and of the books illustrated by Bernardino Passari, as well as many saints' lives.[10] It seems that even before he took up printmaking, Tempesta had been responsible for the designs for one such work, the *Life of St Bernard of Clairvaux*, which had been engraved by other artists and published in 1587.[11] Free from the imposition of artistic idiosyncrasy, these lives of the saints have a clarity of manner ideally suited to their didactic purpose. Tempesta's *St Antony Abbot* series, of 1597/98 (see Figure 11.1), testifies to a continuing interest in this kind of subject, but by that time devotional imagery had come to take a minor place in his output.[12]

Tempesta's interest in non-religious subject matter began at an early stage in his career as a printmaker. A single hunting scene, dated 1590, anticipates the first great *Hunts* series, published in 1595.[13] A series of *Horses* appeared in 1590,[14] to be followed in 1592 by a series of *Landscapes*.[15] In a different vein, Tempesta published the great *Map of Rome* in 1593.[16] The map, printed on 12 sheets, is so elaborate that it would have required an enormous amount of preparation, and was thus, presumably, begun rather earlier. If Tempesta first entered the field of printmaking by illustrating devotional texts, it appears that he quickly began to explore the wider possibilities offered by the Roman print market.

From the middle of the sixteenth century, the printmaking and print-selling business in Rome was a complex entrepreneurial structure dominated by print publishers. Within it there was a strong tendency towards specialization, with the functions of designer, cutter and printer–publisher often being separated and placed in the hands of different people. Tempesta

worked for many Roman publishers and there is at least one instance of him creating an etching after another artist's design.[17] For the most part, however, he invented his own compositions as well as actually etching the plates, and, in his early printmaking years, he also published many of them himself. What support he was given and how he was able to finance these ventures would be very interesting to know.[18]

One observation about his enterprise which is especially intriguing is that the earliest examples of a particular genre of print within Tempesta's oeuvre often appear to have been self-published, while later examples carry publishers' names. The 1590 illustrated *Life of S. Filippo Benizzi* was self-published, whereas the 1597/98 *Life of St Antony Abbot* was published by Orlandi. Equally, the first of the great *Hunts* series (1595) carried only Tempesta's name, while subsequent series, from 1598 onwards, were handled by professional publishers.[19] A similar situation is apparent with the *Battles* series. The first of these, dated 1599, has no publisher's address, but only Tempesta's dedication to Teofilo Torri.[20] It was followed in 1601 by a series published by Nicholas van Aelst.[21]

With both the *Hunts* and the *Battles*, Tempesta was instrumental in introducing new categories of subject matter to Roman print production. There were precedents for the *Hunts* series – engravings after designs by Stradano – but they had been published in Antwerp rather than in Rome. There were also isolated earlier examples of *Battles*, but Tempesta's series effectively created a new genre. On the whole, print publishers were rather conservative, wanting to exploit the proven viability of existing genres rather than take a risk with new ones. By taking the first risk himself, Tempesta appears to have found a way around this commercial caution.[22]

According to Baldinucci, Tempesta's motive for taking up etching had been his impatience with the slow, methodical procedures essential to engraving with a burin.[23] Nonetheless, the artist's numerous surviving drawings reveal that a careful process of preparation lay behind his etched images. Although the compositional ideas tend to be confidently presented from the start, they are diligently developed to create a more refined final result. This is apparent in the group of three surviving drawings for the *Bear Hunt*, one of the images from the 1595 *Hunts* series. The initial composition was laid out in a pen-and-wash drawing (Paris, Louvre, 434): the precise format of the plate was indicated and the wash used to work out the overall balance of light and shade.[24] This was followed by a pen drawing (Florence, Uffizi, 1174E), in which the figural elements were more carefully drawn;[25] and finally by another pen-and-wash drawing (Paris, Louvre, 435), in which the landscape setting was elaborated.[26] There may also have been a further drawing (now lost) used to transfer the design on to the prepared plate. In Tempesta's later work, his preparatory procedure may not have been so

elaborate, but the care evident in the evolution of the *Bear Hunt* indicates that the need for speed, so emphasised by Baldinucci, did not preclude the thoughtful development of ideas.

Tempesta's etching technique attracted a certain amount of criticism. Giovanni Baglione remarked that the artist was prepared to send out into the world designs that were 'terminati e crudi'.[27] To some degree, the context of this apparently critical observation renders it ambiguous, since it is unclear whether Baglione was referring to drawings alone or to prints as well. It is possible that he was only expressing regret that Tempesta had not carried his ideas into finished paintings. However, Baldinucci understood the remark to refer to the etchings, since, as we shall see, he defended them against the charge.

But what could have been the basis of Baglione's criticism? There is visual evidence of one way in which contemporaries perceived the inadequacy of Tempesta's prints. Matthaeus Merian of Basle produced etched copies of many of Tempesta's images from 1615. Merian was one of those etchers of whose work Abraham Bosse approved; the precision and variation of his line, and the systematic method he employed for laying out the graphic web, gave his etchings the appearance of engravings.[28] Merian ruthlessly imposed this technique in what should perhaps be described as his 'translations' of Tempesta's work. The way that Merian approached Tempesta was, as L.H. Wüthrich noted, quite different from the way he responded to the works of Jacques Bellange, some of whose prints he also copied.[29] In the latter case, he was scrupulously attentive to the graphic character of the originals. Thus, although Merian's copies of Tempesta's works are an acknowledgement of his admiration for the Italian artist's powers of invention, they can also be seen to contain an implicit criticism of Tempesta's loose and comparatively unsystematic technique.

It seems unlikely that Baglione would have shared this way of thinking. He had set out his ideas of excellence among printmakers in a brief passage in the life of the German engraver Mattheus Greuter.[30] For etching, which he admittedly regarded as an art less noble than engraving, he mentioned Federigo Barocci from Urbino and the Roman Orazio Borgianni, as the finest practitioners. It is in this context that his negative remarks regarding Tempesta should be seen. Compared with those of Barocci and Borgianni, Tempesta's prints reveal a significant lack of tonal subtlety in their *sfumato* effects.

Baldinucci defended Tempesta against the specific charge that his etchings were 'terminati e crudi', arguing that the Florentine had not been interested in simply producing works that were pleasing to look at because of fine and delicate cutting, but had wanted his images to have a quality that he termed 'pittoresco'.[31] He drew an analogy with the difference between finished

drawings, that were almost like paintings, and more sketchy ones which nevertheless expressed the artist's *concetti* in such a way as to provide visual models and instruction for others.[32] For Baldinucci, the value of Tempesta's prints, with what for him were their outstanding invention and good contours, lay in their being a fertile resource for other artists. This certainly reflects a way that they were in fact used.

Baldinucci's characterization of Tempesta's style as one directed not to the perfection of the medium but to the effective communication of *concetti*, stressed the sense of speed in the act of creation. And this was entirely appropriate to the subject matter that he thought Tempesta handled best. In a judgement that was entirely in tune with what earlier writers such as Giulio Mancini, Vincenzo Giustiniani, Karel Van Mander and Giovanni Baglione had said, Baldinucci identified scenes of battles, hunts and all kinds of animals as the subject areas in which Tempesta had achieved his finest results.[33]

To Giustiniani, such subjects were 'istorie dato dalla natura', and represented areas where the artist had a freedom to invent, constrained only by the need for verisimilitude.[34] In 1584, Raffaello Borghini had drawn attention to the opportunities artists had to show their powers of independent invention and named the following types of subject: the four seasons, hunts, battles, dances, marriages, baths with lascivious women and amorous young men, children's games.[35] With such subjects there were no texts to inhibit the artist, and when figures were incorporated there was no need for him to have to deal with the character, or with the dignity of individual protagonists, independently of the general action of the scene.

Hunts as a subject for engraving had become established in the second half of the sixteenth century, above all through the work of Tempesta's first master, Stradano, who, around 1566, had been commissioned to make designs for a series of tapestries for the Medici villa at Poggio a Caiano. In 1570, six of these designs were engraved by Herman Muller and published by Hieronymus Cock in Antwerp.[36] Subsequently, a series of *Hunting Parties* after Stradano was engraved by Philips Galle in 1578.[37] Tempesta obviously owed a great deal to Stradano, but where the master was didactic and encyclopaedic, the pupil exploited and developed the dramatic possibilities of such compositions. This is evident in his earliest *Hunts* series of 1595, where the increase in the size of the foreground figures, a clear separation of foreground from middleground, and the attempt to maximize a sense of vitality and movement, are already noticeable.[38] In the subsequent series, culminating in 1609, these features were intensified, while richer and more varied landscapes created increasingly impressive spatial environments (see Figures 11.2 and 11.3).[39]

As regards the *Battles* subjects, there had been a long tradition of their representation in prints, *all'antica* scenes based upon the compositions of Raphael and his circle being a case in point. Again, Stradano's work provided many ideas for Tempesta to develop. The isolation of small groups of figures in the foreground and the build-up of the composition in depth, which permitted an extensive overview of an entire military operation, were devices employed by Tempesta that Stradano had previously made his own.[40]

In 1599 Tempesta issued a series of nine *Military Scenes*.[41] They are freely-imagined events rather than illustrations of specific historical or mytho-logical incidents. Variety is achieved through the depiction of different episodes that might occur in any campaign: the call to attack, the advance, the siege of a fortress, the crossing of a river, the joining of the fray, the stripping of the dead. There are also differentiations of period and place; one of the scenes is of ancient Romans, another involves Turks, and so on. Drawing upon many different sources, Tempesta developed these ideas in two subsequent series. He continued to borrow from Stradano, and, for the antique battle scenes, from the manner of sarcophagus reliefs. His treatment of those relief subjects suggests that he learned much from the methods that Polidoro da Caravaggio had employed for his painted reliefs decorating the façades of so many houses and palaces in Rome. Through a clear separation of planes and a heightened sense of drama, Tempesta gave an extraordinary dynamic intensity to his prints (see Figures 11.4 and 11.5).[42]

He evolved an epic technique in which the great sweep of an event was described and counterpointed with the action of individuals. Tempesta redeployed these procedures in his illustrations of texts, with subjects such as *Alexander the Great* and *Old Testament Battles*.[43] By building on genres which encouraged artistic freedom, where the emphasis was on action separate from individual ethos or the dignity of person, Tempesta developed new compositional methods and new ways of articulating dramatic subject matter.

Particularly striking examples of his inventive methods are apparent in the confident swagger of Pharaoh's army descending to its unexpected fate on the bed of the Red Sea, from the *Old Testament Battles* series (Figure 11.6);[44] and, in a different mode, the dedicated concentration of the Macedonian troops and their allies, overcoming all obstacles in the relentless pursuit of their enemies into the mountains, from the *Alexander the Great* series (Figure 11.7).[45] Both these complex and contrasting compositions involve the crea-tion of a dramatic link between foreground and background. They are also charged with precise emotional force, the dynamism of which is conveyed through movements and gestures much more than by facial expressions. It is noticeable that in many of these scenes the actions of the ordinary soldiers

rather than of the commanders or of those of the highest social status carry the dramatic burden.[46]

The etched line that Tempesta employed was merely a practical element for building the compositional structures of his inventions. It was rarely used to elicit local beauties of light or texture. As we have seen, urgency and drama are very effectively conveyed in the scenes of *Hunts* and *Battles*, and it is interesting to compare these with Tempesta's treatment of completely different kinds of subject matter. In the 1590s, when he was developing his freely inventive and dramatically expansive manner, his illustrations of devotional subjects show no sign at all of a similar approach. The plates he made for the *Lives of the Saints* drew upon the restrained figure-types and subdued compositional arrangements that he must have learned from Santi di Tito. The stylistically unrefined and somewhat generalized technique employed for this kind of imagery served to achieve a restrained didactic clarity that Tempesta evidently felt was the prime objective of such works.

In his graphic works, Tempesta ultimately emerges as an artist who observed what might be called 'the decorum of invention'. His technique in itself offered little intrinsic attraction, so that when his subject matter called for didactic clarity the images he produced were dignified, but dull. On the other hand, when his subjects required drama, he was able to give them the furious energy that remains an impressive achievement even today.

Frequently cited literature

Baglione, G., (2nd edition, 1649). *Le Vite de' Pittori, Scultori et Architetti dal Pontificato di Gregorio XIII fino a tutto quello d'Urbano VIII*, Rome; Baldinucci, F., ed., Manni, D.M., (1808), *Cominciamento e Progresso dell'Arte dell'Intagliare in Rame*, in *Opere*, Milan: 1; Bartsch, A. von, (2nd edition, 1818–1876), *Le Peintre–Graveur*, Leipzig: 17, (1870), (hereafter Bartsch 17).

Notes

1. Bartsch 17, pp. 123–88. For the relevant illustrations, see Buffa, S., ed., (1984), *The Illustrated Bartsch*, 35, 36 and 37, *Antonio Tempesta*, New York. To use those volumes, it is also necessary to consult Birke, V., (1985), 'Towards a Tempesta Catalogue', *Print Quarterly*, 2, pp. 205–18.

2. Baldinucci 1808, p. 83.

3. Baglione 1649, p. 314.

4. Baldinucci 1808, p. 80.

5. Cecchi, A., (1986), 'La Pêche des Perles aux Indes. Une peinture d'Antonio Tempesta', *Revue du Louvre*, 36, pp. 45–57, esp. p. 48.

6. Brugnoli, M.V., (1961), in Cantoni, A. et al., eds, *La Villa Lante di Bagnaia*, Milan: p. 111; Faldi, I. et al., eds, (1981), *Il Palazzo Farnese di Caprarola*, Turin: p. 37.

7. Cecchi 1986, *op. cit.* at n. 5, *passim*.

8. Vannugli, A., (1983), 'Gli Affreschi di Antonio Tempesta a S. Stefano Rotondo e l'Emblematica nella Cultura del Martirio presso la Compagnia di Gesù', *Storia dell'Arte*, 48, p. 103.

9. *Vita B. Philippi Benicii*, Rome, (1590), Bartsch 17, p. 137, nos 375–89; the *Martyred Virgins*, for Antonio Gallonio's *Historia delle Sante Vergini Romane*, Rome, (1591), Bartsch 17, p. 138, nos 390–462; and the *Instruments of Martyrdom* for the same author's *Trattato de gli Instrumenti di Martirio*, Rome, (1591), Bartsch 17, p. 142, nos 498–544.

10. Vannugli 1983, *op. cit.* at n. 8, p. 101 ff.

11. Grelle, A., (1992), 'Mercato e produzione delle stampe a Roma all'inizio del secolo XVII e alcuni problemi sugli inizi romani di Callot', in *Le Incisioni di Jacques Callot nelle Collezioni Italiane*, exh. cat., Rome (Istituto Nazionale per la Grafica-Calcografia), Pisa (Museo Nazionale di San Matteo), Naples (Istituto Italiano per gli Studi Filosofici), Milan: pp. 29–50, esp. p. 45, n. 28. The *Life of St Bernard of Clairvaux* was published by Marcello Clodio.

12. *Life of St Antony*; Bartsch 17, p. 139, nos 463–89.

13. The *Hunt* dated 1590 is Bartsch 17, p. 172, no. 1170. The series of 1595 is Bartsch 17, p. 164, nos 1015–26

14. The *Horses* are Bartsch 17, p. 161, nos 941–68.

15. The *Landscapes* are Bartsch 17, p. 173, nos 1172–81.

16. Ehrle, F., ed., (1932), *Roma al tempo di Clemente VIII, La Pianta di Roma di Antonio Tempesta del 1593*, Vatican.

17. Publishers who handled Tempesta's work from early in his career included Battista Panzera da Parma (from 1590, see Bartsch 17, p. 141, no. 495) and Nicholas van Aelst (from 1590/91, see Bartsch 17, p. 136, nos 344–57). Cristoforo Stazio published his *Death of Camillus*, after a design by Cesare Nebbia, in 1591 (Bartsch 17, p. 144, no. 559).

18. The figure of Giulio Rossi (Julius Roscius) emerges as possibly significant in supporting Tempesta in his career; see Vannugli 1983, *op. cit.* at n. 8, p. 112, n. 51.

19. From 1598 Tempesta produced a number of series of *Hunts*. They carry the names of many different publishers: Giovanni Antonio de Paoli, Andrea Vaccaro, Giovanni Orlandi, Cesare Capranica and others.

20. Bartsch 17, p. 156, nos 838–47.

21. Bartsch 17, p. 156, nos 848–55. There is a third series of *Battles*, dedicated to Piero Strozzi (Bartsch 17, p. 156, nos 828–37), which bears Tempesta's name alone. Subsequent *Battles* series

emerged as part of historical subject groups, such as the *Old Testament Battles* of 1613, published by Nicholas van Aelst (*Imagines Acierum ac Proeliorum Veteris Testamenti*), Bartsch **17**, p. 128, nos 235–59), or within the *Alexander the Great* cycle of 1608 (*Alexandri Magni Praecipuae Res Gestae*), Bartsch **17**, p. 143, nos 545–56.

22. A contemporary printmaker who tried to maintain a distance from print publishers was Cherubini Alberti; see Ewart Witcombe, C.L.C., (1989), 'Cherubino Alberti and the Ownership of Engraved Plates', *Print Quarterly*, **6**, pp. 160–9.

23. Baldinucci 1808, p. 83.

24. See Viatte, F., (1988), *Dessins Toscans XVIe–XVIIIe Siècles I: 1560–1640. Musée du Louvre Inventaire Général des Dessins Italiens*, **3**, Paris: p. 216, no. 434; pen, brown ink, grey wash over traces of black chalk.

25. See Petrioli Tofani, A., (1987), *Disegni Esposti 2, Inventario del Gabinetto Disegni e Stampe degli Uffizi*, Florence: p. 486, no. 1174E; pen.

26. Viatte 1988, *op. cit.* at n. 24, p. 217, no. 435; pen, brown ink, brown wash over traces of black chalk.

27. Baglione 1649, p. 316.

28. Bosse, A., (1645), *Traité des manières de Graver en Taille Douce sur Lairain par le moyen des Eaues Fortes et des Vernix Durs et Mols*, Paris.

29. Wüthrich, L.H., (1966), *Das druckgraphische Werk von Matthaeus Merian d. Ae.*, 2 vols, Basle: **1**, pp. xv–xvi.

30. Baglione 1649, p. 399.

31. Baldinucci's antithesis echoes Bosse's. Bosse contrasts the 'manière finie' and the 'manière croquée'; he preferred the former, but allowed that others might not share his view. Admiration for the latter manner rested upon: 'l'invention, les beaux contours et les touches de ceux qui les ont faites'. Baldinucci's 'pittoresco' will have derived in part from Bosse's formulation of the 'manière croquée'.

32. Baldinucci 1808, p. 88. See also Held, J., (1963), 'The early appreciation of drawings', in *Studies in Western Art*, **3**: *Latin American Art and the Baroque Period in Europe*, Acts of the XXth International Congress in the History of Art, Princeton: pp. 72–95; and Sohm, P., (1991), *Pittoresco*, Cambridge: p. 164, n. 26.

33. Baldinucci 1808, *Proemio* to the *Cominciamento*, p. 9; Mancini, G., ed., Marucchi, A., (1956), *Considerazioni sulla Pittura*, Rome: **1**, p. 111; Giustiniani, V., ed., Banti, A., (1981), *Discorso sopra la pittura*, in *Discorsi sulle Arti e sui Mestieri*, Florence: p. 43; Van Mander, see Vaes, M., (1931), 'Appunti di Carel van Mander su vari pittori italiani suoi contemporanei', *Roma* **9**, pp. 341–56, esp. 347, and Baglione 1649, p. 315.

34. Giustiniani, *ibid.*

35. Borghini, R., (1584), *Il Riposo*, Florence: p. 76. This point is noted by Borroni, F., (1950), 'Antonio Tempesta incisore', *La Bibliofilia*, **52**, p. 242.

36. de Pauw–de Veen, L., (1970), *Hieronymus Cock, Prentenuitgever en Graveur 1507?–1570*, Brussels: no. 130, p. 52.

37. Dolders, A., ed., (1987), *The Illustrated Bartsch*, **56**; *Netherlandish Artists. Philips Galle*, New York.

38. Sricchia Santoro F., (1980), 'Antonio Tempesta fra Stradano e Matteo Bril', in L'Institut Historique Belge de Rome, *Relations Artistiques entre Les Pays–Bas et l'Italie à la Renaissance, Etudes Dediées à Suzanne Sulzberger*, Brussels and Rome: p. 231.

39. The 1609 series, dedicated to Giovanni Leoncini, is Bartsch **17**, p. 167, nos, 1140–47.

40. Stradano's compositions were published in the *Mediceae Familiae Rerum Feliciter Gestarum Victoriae et Triumphi*, engraved by P. Galle and H. Goltzius, and published in Antwerp in 1583. See Dolders ed. 1987, *op. cit.* at n. 37, p. 102; and Strauss, W.L., ed., (1977), *Hendrik Goltzius, Complete Engravings, Etchings, Woodcuts*, 2 vols, New York: **1**, pp. 44–53.

41. Buffa, S., ed., *The Illustrated Bartsch*, **36**, *op. cit.* at n. 1, reproduces only eight of the nine scenes; for the ninth, see Birke 1985, *op. cit.* at n. 1, pp. 208–10 and fig. 117.

42. For battles as a subject, see Lomazzo, G.P., (1584), *Trattato dell'arte*, in Ciardi, R.P., ed., (1974), *Scritti sulle Arti*, 2 vols, Florence: **2**, p. 306, where he writes of the artist who paints 'il suo

capriccio'. See also Hale, J., (1990), *Artists and Warfare in the Renaissance*, New Haven and London: p. 164.

43. For the *Alexander* series, and the *Imagines Acierum ac Proeliorum Veteris Testamenti*, see n. 21.

44. Bartsch **17**, p. 129, no. 242.

45. Bartsch **17**, p. 143, no. 552.

46. But he can equally well emphasize the principal figure, as in the *Flight of Darius*, Bartsch **17**, p. 143, no. 550

Sanct' querens homines solitarios a quib, mo-
nastica uita disciere posset, senē reperies
illuā imitari cupiens, sportas facere ince-
pit, illasq uendens, pauperibus precium
largiebatur

Il S.to cercando persone solitarie da chi po-
tesi imparare uita monastica trouò un
uecchio e uolendolo imitare cominciò ha
fare cesti di sua mano o uendēdoli daua
il prezzo alli poueri

VI

1.1 Antonio Tempesta, *The young St Antony encounters a hermit*, etching.

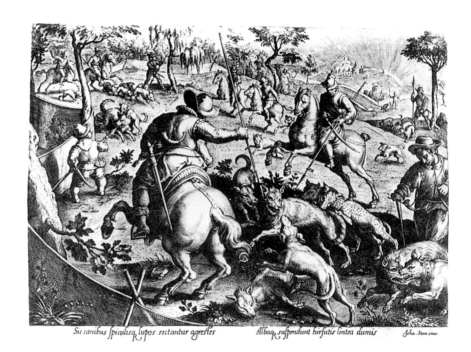

Sic canibus spiculisq. lupos sectantur agrestes Albaq. suspendunt hirsutis lintea dumis Joha. Stra. inve.

11.2 Philips Galle, *Wolf Hunt*, engraving, after Giovanni Stradano.

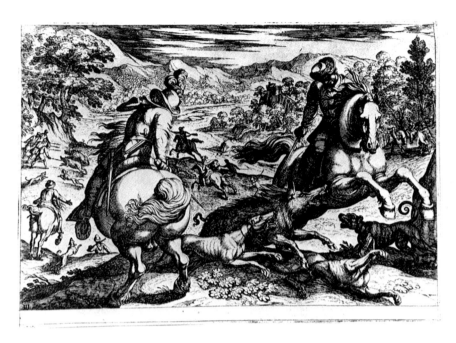

11.3 Antonio Tempesta, *Boar Hunt*, etching.

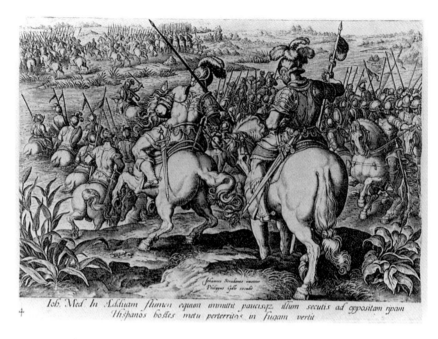

11.4 Philips Galle, *Giovanni delle Bande Nere crossing the Adda*, engraving, after Giovanni Stradano.

11.5 Antonio Tempesta, 4 plates from a series of *Battles*, etchings.

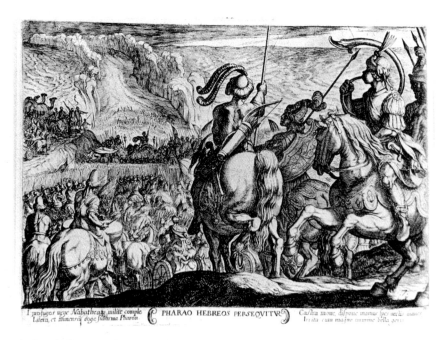

11.6 Antonio Tempesta, *The Egyptians follow the Israelites to the Red Sea*, etching.

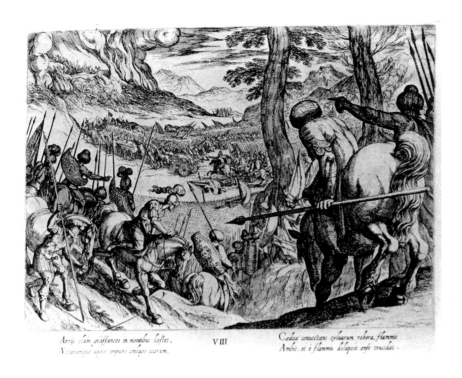

11.7 Antonio Tempesta, *Alexander the Great campaigning in the mountains*, etching.

Early modern collecting in Northern Europe: copied drawings and printed prototypes

Tarnya Cooper

Drawings deemed by the modern eye to be of slight quality rarely receive attention from art historians or from museum curators – the present guardians of taste. This neglected category of drawings often includes copied drawings by unknown artists. In attempting to answer the various questions that such drawings provoke, it is necessary to consider both the individual sources of the drawings and the often functional intentions behind their original creation. Aside from royal collecting, the acquisition of drawings in the late sixteenth century and early seventeenth century was undoubtedly an activity limited to artists, dealers and a tiny proportion of the culturally-sophisticated, city-dwelling elite – sometimes known as 'amateurs'. The central focus of this paper is a now-dismantled, seventeenth-century album of sixteenth- and seventeenth-century drawings by German, Dutch, Flemish and Italian artists. The album into which the drawings had initially been pasted belonged to George Grote (1794–1871), a prominent banker, classical scholar and a member of the original council of University College London. Now known as the 'Grote Collection', the detached drawings are housed in the College Art Collections at University College, the album having been donated to the University in 1872 by Grote's widow.[1]

In order to evaluate the status of copies in this and other contemporary collections, this paper will draw comparisons between the Grote Collection and three other partly-dismantled, British-owned drawings albums. These are: a late seventeenth-century Dutch album from the Ashmolean Museum in Oxford; the 'Cartwright Album' from Dulwich College, London; and two volumes of the '1637 Collection' from the Department of Prints and Drawings at the British Museum, London.[2]

The relatively modest collection of Grote drawings was originally made up of 189 works by renowned European artists, including Georg Pencz, Hans Burgkmair, Sigmund Holbein and Wenceslaus Hollar. These works were

combined in one album with drawings by unknown artists, many of which are copies after printed images. The varied range and quality of the drawings within this album suggests that distinctions regarding media, quality and originality – in other words, connoisseurial distinctions – were either less clearly defined than they seem to be today, or else they existed within a different range of expectation during the period of the album's compilation.

For comparative purposes, questions arising from attempts to reconstruct the order of the Grote album and thus to detect any discernible classification therein, need to be viewed in relation to contemporary or preferably earlier examples. However, amateurs (or non-artists) had begun collecting drawings at a later date than they had paintings and antiquities, and, unfortunately, there is little existing evidence of early drawing collections in Northern Europe. Julius Held, who has undertaken a survey of written sources for the early appreciation of drawings, cites figures such as Joachim van Sandrart (1606–1638) and Giovanni Pietro Bellori (1615–1696) to illustrate the high level of connoisseurship that sixteenth- and seventeenth-century collectors applied to the selection of drawings. It is nonetheless clear that the greater degree of freedom enjoyed by artists operating outside the workshop tradition from the late sixteenth century meant that after an artist's death, his records and studies were as likely to pass into the hands of a collector as into those of other artists. Thus, although there were collectors who were able to make distinctions concerning originality and quality, there were undoubt-edly others, particularly those who were less wealthy or who lived in the provinces, who were content to acquire whatever material they could directly from artists' studios. This material would have included all types of drawings – finished studies, initial sketches, preparatory drawings and copies – indeed a broad variety of the sort that would have stimulated the development of a market in drawings.[3]

A study of the seventeenth-century Dutch artist Jan de Bisschop by Jan Gerrit van der Gelder and Ingrid Jost includes a discussion of late sixteenth-century Dutch collectors.[4] It outlines the three known collectors of drawings in the Northern Netherlands before 1600 who were not principally artists: Joris Edmheston (d. post 1604) in Den Breil, Arnold van Beresteyn in Haarlem (1556–1612), and Jacob Rauwaert (d.1597) in Amsterdam.[5] All three collected studies by two of the most copied of Northern European artists: Albrecht Dürer and Hendrick Goltzius. Beresteyn had bought an album of drawings directly from the artist Lucas de Heere (1534–1584).[6] Thus an artist's album that had probably been used by its original owner as a source book, or as a practical record of designs by other artists, became the object of a connoisseur's gaze.[7] Such information on the provenance of drawings albums is rare, but the practice itself must have been quite common, since

inventories of artists' studios often list books or volumes which were to be disposed of by sale.[8]

In the seventeenth century, a period of intense duplication of designs, individual motifs and complete compositions, it would have been difficult for artists and collectors to identify most drawings as belonging to specific masters or even to particular schools. Such difficulties would have been compounded by the lack of easy reference to bodies of comparable identified material such as are accessible today in museums and in illustrated catalogues. Reproductive prints after paintings had the capacity to make artists famous outside their immediate localities, and thus collectors of drawings were almost always collectors of printed imagery as well. Thus the specific difficulties that confronted sixteenth- and seventeenth-century collectors must have increased their resolve to accumulate all sorts of images, irrespective of whether they were original designs or copies.

The search for other collections of drawings within albums has revealed more about the collecting tendencies of dealers since the eighteenth century, and about recent curatorial practices, than about classification by sixteenth- and seventeenth-century provincial collectors. It is not surprising that three of the albums from different collections studied here have been dismantled, either totally or partially, although each had been reasonably intact when first acquired by the institutions that are their present guardians. Moreover, many have been dismantled without any record having been made of their original order, and often even knowledge of the original contents has remained vague.[9] Yet where the existing albums are only partially intact, with single drawings having been removed intermittently over a 300-year period, the museums responsible for them have simply been completing a cycle of selective preservation.[10] Nonetheless, in all but one case, the dismantling of the albums has taken place within the past 15 years. This means of selecting a collection differs little from that of the elite seventeenth-century connoisseur, Thomas Howard, Earl of Arundel (1586–1646). Howard employed the painter Hendrik van der Borcht to work on his own collection and 'to have a good guess at originals from copies'.[11] Most amateur collectors of drawings appear to have knowingly amassed copies, occasionally noting the source in their own hand on the sheet or within the album. However, a major collector such as Arundel, with the financial resources to collect and travel, would certainly have had less need of the *aide-mémoire* function of copies, as, in general, he would have been able to find 'original' examples of the artists or subjects he wanted represented within his collection.

It is an indubitable fact that a high proportion of drawings within such albums are copies after other works of art, and most commonly after printed images. This should not surprise us, as all types of prints were used by artists as informal exemplars from the second half of the sixteenth century. In

particular, printed artists' drawing books, such as those engraved by Crispin van de Passe, Abraham Bloemaert and Jan de Bisschop, were designed specifically to be copied.[12] Certain subjects then became motifs that could be lifted wholesale and reused. However, prints were generally sold as single sheets or as a series, and, as the drawings within the album discussed here illustrate, both original and reproductive prints were used by artists for drawing practice, and to familiarize themselves with other drawing styles. Thus, such images had a practical function for artists as well as for amateur collectors.

In looking at the Grote album, consideration has been given to the question of what sort of information the artists who had produced the drawings were recording by copying, or what they were acquiring in the process of recording. In relation to the context of general practice, and not necessarily to that of training, the artists' intentions appear plainer than might have been expected. Nonetheless, assigning a definite function to individual drawings may suggest a logic which does not apply, so attempting to understand the intention of the artist rather than the function of the drawing may provide a clearer basis from which to attempt a hypothesis. The studies collected in the Grote album reveal a range of artistic intentions, amongst which three of the most common are: the desire to record compositional details and classical forms; the aim of assimilating various stylistic vocabularies; and the interest in noting unusual subjects for curiosity value. Most enlightening is the fact that these intentions are virtually standard, being a constant feature in the other drawings albums referred to in this study, although this is not to say that other motivations are not also evident.

The recording of compositional details from other art works was one of the key tools used by artist and amateur alike in the development of drawing skills. In England, Samuel Pepys had bought prints from William Faithorne in 1666 with the intention of presenting them to his wife to 'draw this winter'.[13] This practical function of making and collecting copies from accepted exemplars was not dissimilar from the precedent of the late-gothic artists' model-book, which had the specific purpose of preserving a stock of chosen motifs as a resource, and from which the drawings album's use as a compendium of copied imagery or of images to be copied had evolved. These highly-valued volumes were made up of exemplary studies by the master, which served as prototypes for the education of generations of pupils. Indeed, within the Grote album, the incorporation of several drawings on the relatively expensive and highly durable support of vellum recalls the didactic nature of drawings on vellum in studio model-books. Two Grote album studies of male heads in black and red chalk on vellum by the German artist Hans Troschel (1585–1628) are dated 1618. In both of these drawings, which look back to early sixteenth-century Northern European

draughtsmen like Hans Baldung and Hans Holbein, the chalk has been delicately applied to this smooth surface to depict two heads, verging on caricature, which Troschel may have wished to preserve for use in a future composition.

Several other Grote Collection drawings may have been made in similar circumstances, simply to record compositional details. A copy of Lucas van Leyden's *Crucifixion at Mount Calvary* engraving (UCL 4645; Figure 12.1) illustrates a studied approach to pictorial construction above all else. Here the copyist has reduced the complex composition of the original to a simple map of the figures, picking out the actions of the characters in grey wash. The value of this drawing for the Grote album collector must have been in relation to its printed prototype and the link with the famous name of Lucas. Engravings by Lucas van Leyden were still highly prized in the seventeenth century, but this print does not appear in the Grote collection of prints.[14] Thus, for the original artist and collector, the drawing records a composition of exemplary inventiveness by a great master of Northern European print-making in response to a familiar religious subject.

Another common training exercise that artists set for themselves involved the assimilation of forms from classical sculpture. Outside Italy, artists' studios without an adequate stock of plaster casts of Greek and Roman statues could only undertake this task through copying two-dimensional imagery. So it was common practice for Northern draughtsmen to study classical exemplars from printed sources. A drawing of the *Death of Seneca* (UCL 4724; Figure 12.2), by an anonymous Flemish artist after an engraving (UCL 1130: Figure 12.3) by Cornelis Galle (1615–78),[15] is one of nine drawings by anonymous artists in the Grote Collection which record classical or Renaissance sculpture through seventeenth-century Dutch and Flemish prints.[16] Advice on copying from sculpture came from as eminent a source as Pieter Paul Rubens in his essay on the imitation of Roman statues, where he considered that study of antique sculptures was essential for all artists, but also warned that it could be detrimental to their art if not practised with care: 'I am convinced that in order to achieve the highest perfection one needs a full understanding of the statues, nay a complete absorption in them; but one must have judicious use of them and before all avoid the effects of stone'.[17]

In Galle's image, deeply-engraved dark lines are used to emphasize the prominent veins across Seneca's body. In contrast, the drawn copy, executed in the soft tonal medium of red chalk, has the effect of reviving a plastic formal solidity in the study, so that the artist appears to be following Rubens's advice in reproducing not so much a marble statue as the quivering body of a live model.

The desire to obtain technical proficiency in draughtsmanship must have been only part of the exercise in undertaking copies from prints. Through this practice of careful observation of engravings after paintings or drawn designs, an artist also became aware that copying was one of the most efficient means of acquiring another stylistic vocabulary, or *maniera*. In the *Het Schilderboek* of 1606, Karel van Mander mentions the practice of copying over 16 times. In the 'Life' of Cornelis Ketel (1548–1616), he describes how Ketel tutored a student, Isaac Oserijn:

> When he came to Ketel, Ketel had him copy a print in his own way, one of the deeds or labours of Hercules which [Cornelis] Cort had engraved after [Frans] Floris. And when he had done that he had him do it again with his guidance and let him scratch out his own botched job. Then it was astonishing to see the great difference from the former, and the similarity to the print, so that he was straight away put to painting.[18]

Van Mander's testimony of how prints were used as prototypes for artists learning to draw is common enough. Yet it is interesting that he names the artists that Ketel had set Oserijn to copy, thereby implying that both skills in composition and specific artists' *manière* were being assimilated.

Several Grote album drawings appear to be exercises in the acquisition of another artist's vocabulary. One such is the *Study of a Rearing Horse with a Nude Male Rider* (UCL 1349; Figure 12.4), a drawing attributed to Cornelis Ketel, after a chiaroscuro woodcut of c.1565, *Le Cavalier Romain* (Figure 12.5), by the Italian artist Niccolo Boldrini (1530–1570), which was itself copied from a drawing by Pordenone (1484–1539). The image has been scaled up to almost double the size of the original print, with the chiaroscuro gradations, carefully built by patches of tone in the woodblock print, having been brought out in the drawing by Ketel through the use of brush and wash, the likely medium of the first design by Pordenone. This cyclical process of invention and reinvention may be part of the pleasure an artist would take in copying prints, as the copyist is in a position to remake the drawing by the original artist. Thus, in essence, the artist would be attempting to emulate the 'spirit' of the study rather than the 'letter' of the line. The Ketel drawing is the result of the Northern artist's desire to test and exercise his own ability in imitating Italian mannerist style, and, at the same time, to modify several compositional details to his own taste.

Another ex-Grote-album drawing, possibly with a similar intention, is a large-scale study of the *Entombment of Christ* (UCL 4600; Figure 12.6), by a seventeenth-century Northern draughtsman, after a chiaroscuro woodcut by Joseph Scolari (active in Venice 1592–1607). The copy is almost exactly the same size as the woodcut, yet the design has not been traced through but transposed visually as an exercise in compositional exactitude.[19] Curiously,

the drawing has been left incomplete, with the limp body of the dead Christ, the main focus of Scolari's composition, being left untouched, while all the supporting figures have been fully worked in. This half-finished study may indicate a sense of fulfilment on the part of the draughtsman at his attempt to assimilate the working practice of an Italian mannerist artist with his own. Both the scale and the often unfinished nature of such drawings provide evidence of how copies were used by both trained and student artists in the understanding of work by other schools and in the pursuit of new approaches.

One of the most common motivations in undertaking a drawn copy was an interest in recording unusual subject matter. *Il Contento*, an oil painting on copper by Adam Elsheimer (1574/78–1620) (Edinburgh, National Gallery of Scotland),[20] is one of the first known representations of a subject derived from the Spanish picaresque novel, *Guzmán de Alfarache*, by Mateo Alemán, published in 1599. An anonymous Grote Collection drawing records this rare subject (UCL 4745; Figure 12.7), although it bears the slightly different title *Dio Contento*. This drawing may have been copied from the painting or from one of the several surviving drawn copies.[21] Alemán's text, which can be traced to classical sources, includes a scene in which Mercury, who has been sent to deceive the people, seizes a personification of Contentment and leaves Discontent in its place.[22] Such a unique image may have compelled draughtsmen to make a visual record of this narrative, perhaps as one of a body of visual references to be collected within an album alongside other allegorical subjects.[23]

As is evident from several other papers in this book, it was standard practice across Europe to borrow motifs and figure-types from the work of other artists for assimilation into 'original' designs. However, any wholesale copying from prints for finished works became problematical as the distribution of printed imagery on a wide scale made plagiarism a tempting possibility for all artists, but also plain for everyone to see. Karel van Mander underlined this point in the 'Life' of Michael Cocxie, who, he said:

was not copious in his composition and therefore made use of Italian designs now and then; for this reason he rather took offence with Jeroon Cock [Hieronymous Cock] when he published in print-form, the *School [of Athens]* of Raphael, after which he had worked and from which he had used a great deal for the altarpiece with the *Death of Mary* in St Goelen in Brussels, which then became clear to everyone.[24]

Thus the work of others could be studied for solutions to compositional problems and even for the purloining of devices or single figures, but, aside from being artistically unchallenging, the copying of entire images had distinct dangers. An early seventeenth-century drawing from the Grote

Collection by an unknown Netherlandish artist (UCL 4680) borrows a single figure from a Netherlandish print, but alters the context of the image to produce an allegorical personification of Vanity that bears an almost exact resemblance to the bride in the engraving *A Marriage founded solely on pleasure* by Jan Saenredam (1563–1607). An impression of this print (London, Victoria and Albert Museum, E490–1887) provides telling evidence of the widespread practice of copying through from the back of the sheet with a pin. This would be done so that an accurate copy could be made, in much the same manner as the pouncing technique was used in the transfer of cartoon drawings onto a wall in fresco painting.[25] The particular tracing technique evident in this print suggests that the composition was recorded for reuse by other artists.[26]

From the remaining 88 drawings by different hands in a modest album of Dutch and Flemish mid to late seventeenth-century drawings (Oxford, Ashmolean Museum), it appears likely that the collection was compiled by an amateur artist/collector.[27] It is also likely to have been much larger in the original state, as many pages have been removed from the centre binding. An etching by Nicholas Bercham (1620–1683) of a man riding a donkey has been pasted inside the front cover. Being the first image of the album, the print provides a clue to the contents, and most of the drawings within are copies after sixteenth-century and early seventeenth-century Italian, German, Dutch and Flemish prints, including some after Bercham. The subject-matter of these drawings ranges from details of pastoral scenes, architecture, classical sculpture and figure studies after David Teniers, Adrian van Ostade and Rembrandt, to simple linear representations of animals and plants.

Another late seventeenth-century album containing drawings of a similar nature is housed at Dulwich College, London. Likely to have been owned by William Cartwright (1606–1696), an actor and bookseller by profession,[28] the album dates from the 1660s and, in surviving almost intact, is unique amongst those considered here.[29] Like the Grote and Ashmolean albums, the Cartwright album contains both original drawings and copies after paintings, sculpture, and particularly after sixteenth-century and early seventeenth-century prints. The choice of imagery varies from designs taken from medieval manuscripts to studies after Lucas van Leyden, Michelangelo, Giambologna, Rubens, Van Dyck and Rembrandt. The ordering of the material is loosely iconographic: heads and figures after ancient sculpture are placed in close proximity. Two studies after engravings by Bloemaert are meticulously copied, the draughtsmen having taken pains to imitate even the swelling and pointed lines of the engraved compositions. However, many of the drawings are roughly worked with little care, which implies that they were made by amateurs or by artists in training. Lindsay Stainton suggests that this album may originally have belonged to John Greenhill

(1642–1676), a painter associated with Cartwright's circle, because studies by Greenhill appear in the album.[30] If this is so, as studies in an artist's album the works may have had a clear didactic function within a source-book of models and styles. As with the Grote and Ashmolean albums, the range of subjects is vast, including drawings of classical sculpture, religious and allegorical figure studies, nudes, portraits, animals and heraldry. Two life drawings by different artists, which feature a female model in the same pose but seen from different positions in a room, appear to confirm that the album had been compiled within an artist's studio.[31] Some of the sources of the copied drawings in the Cartwright album are common to both the Grote and Ashmolean albums. This would seem to suggest that certain prints were in wide circulation and that a specific body of work, deemed worthy of appreciation and duplication, had been singled out by seventeenth-century draughtsmen.[32]

A larger and more prestigious collection of drawings albums, known as the '1637 Collection', probably originated in Holland and was placed into albums around 1637; hence its name.[33] Some of these albums are now housed in five separate collections across Europe and America.[34] The Department of Prints and Drawings at the British Museum owns eight '1637' albums from the collection of Hans Sloane, which were thought by Sloane's curator to have been purchased in Holland.[35] Jan van der Gelder has speculated that this large collection of drawings was owned by Pieter Spiering Silfvercrona (died 1652), a wealthy and highly successful merchant who ran the largest tapestry-weaving factory in the Northern Netherlands.[36] The collection included prints and drawings classified both by artist and by subject, and it is possible that as many as 158 volumes may have existed. The albums of drawings included a huge range of works by early masters such as Lucas van Leyden, Albrecht Dürer and Heinrich Aldegrever (1502–1555/61), as well as contemporary artists such as Arent van Bolten (1573–1633).

One of the British Museum '1637' albums, known as the 'Dürer volume',[37] remains reasonably intact, presumably due to the fact that most of the contents are copies or drawings undertaken as exercises by artists in training. It still contains 179 drawings of animals, birds and plants by anonymous artists, and is arranged in something like the original order. Material in the 'Dürer volume' provides an interesting parallel to that of the Grote album. Its original drawings by Dürer, as well as others attributed to Hans Burgkmair (1473–1531), Lucas Cranach (1472–1553), Hans Sebald Beham (1500–1550), and Bartholomeus Spranger (1546–1611), were mostly removed in 1985. This left anonymous copies after paintings and prints, and several other curious original drawings. Therefore, even with a collection as impressive as the '1637' material, anonymous copies after known works of art were considered to be of sufficient value and significance to merit being

bound by the original collector with drawings by unknown 'masters'. That this was not always so is evident from a note on the final page of the 'Dürer' volume, which provides an insight into nineteenth-century attitudes to copying. Written by William Young Otley (1771–1836), keeper of the British Museum's Department of Prints and Drawings (1833–1836), it reads: 'This is the last drawing in the volume and has no business here, being a copy after Paolo Veronese. The five drawings that follow were found loose in the book, May 15th 1833 (WYO)'. This example of the Victorian perception of copies as wholly unfit to share page-space with so-called 'original' drawings has something in common with our own attitudes today, taste still being a slave to the genius of originality. A treatise by Roger de Piles published in 1699 on the relative merits of drawings asserted that copies by masters such as Rubens turn themselves into 'second originals'.[38] This kind of logic views the perceived, connoisseurial concept of genius as the epitome of originality. It implies that only the so-called 'great artist' was enough of a creative hero to turn an earlier design into a new invention, with 'masterly' strokes of pen or brush – a perception maintained to this day by many museum curators of drawings.

In the late sixteenth century and early seventeenth century, however, a drawn copy was clearly more highly valued by artists and collectors than appears to be the case with late-twentieth-century connoisseurs. That this was true for those collectors who had no didactic interest in drawing is perhaps the most telling aspect of all, because copied drawings must have represented whole bodies of work otherwise unknown or unavailable to them in the original form. The Grote album and other less complete provincial drawing collections confirm that artists continued to work from sixteenth- and early seventeenth-century models into the late seventeenth and early eighteenth century. It is evident, too, that Northern European provincial collectors may also have valued finished drawings more highly than sketches, while the modest collections examined here affirm our understanding of prints as visual exemplars that could be assimilated by a vast artistic community and used on a wide scale as prototypes for drawings by both trained and student artists.[39]

Frequently cited literature

Van der Gelder, J.G. and Jost, I., (1985), *Jan Bisschop and his Icones and Paradigmata, classical antiquities and Italian drawings for artistic instruction in seventeenth century Holland*, Doornspijk.

Notes

1. Drawings from the Grote Collection at UCL formed the basis of the exhibition held at the Strang Print Room, University College London, 1 February – 26 March 1994. See Cooper, T., (1994) *Origin and Originality; Copied Drawings from the Grote Collection*, exh. cat., London (University College). It is unlikely that George Grote added to the album as there are no British drawings in the collection. Grote's Dutch grandfather had emigrated to London in 1731 from Bremen in Germany. The drawings were removed from the album sometime in the 1970s, and the album itself was lost at this time. A.M. Hind described the album as an 'old volume from the Grote Collection, from which the drawings described above were taken, containing 138 drawings of small importance, (Grote Bequest 51–188)'. See Hind, A.M., (1930), *Select list and outline inventory of the prints and drawings in the possession of University College, London*, London: p. 22. The album was perhaps compiled in the late seventeenth century as there are few drawings later than 1680. Like other seventeenth-century collections, the material comprised bodies of earlier collections; consecutive numbering in the bottom corners of the drawings indicates a sequence prior to the compilation of the album.

2. Held, J., (1963), 'The Early Appreciation of Drawings', in Meiss, M., ed., *Studies in Western Art: Acts of the Twentieth International Congress of the History of Art*, 4 vols, Princeton: **3**, pp. 72–95.

3. Drawings were not generally sold as finished objects by artists or dealers and were usually purchased from the artist's estate following his death. However, some drawings were undoubtedly sold at art markets and at book and print fairs. The painter-dealer, Jan van Kessel, maintained a shop in the painters' Pand (art market) in Antwerp. On his death in 1581, the inventory of his shop included 'six hundred paintings, more than eighty prints, maps, copper plates and several bundles of drawings and prints'. See Ewing, D., (1990), 'Marketing Art in Antwerp, 1460–1560: Our Lady's Pand', *Art Bulletin*, **72**, p. 579.

4. Van der Gelder and Jost 1985.

5. *Ibid.*, p. 198. For a survey of collectors of paintings in the Netherlands mentioned by Karel van Mander in 1604, see van Bok, M., (1994), 'Art lovers and their Paintings, Van Mander's Schilderboeck as a Source for the History of the Art Market in the Northern Netherlands', in Luijten, G., et al., eds, *Dawn of the Golden Age*, exh. cat., Amsterdam (Rijksmuseum): pp. 136–67.

6. 'Many drawings are also to be found in the possession of various art-lovers: with the art-loving gentleman Joris Edmheston in Den Briel, in a book which belonged formerly to Lucas d'Heere are some portraits by Albert, among others one that is highlighted and shadowed with the brush, representing a cardinal or some other ecclesiastic and a figure of Mary, most subtly executed with pen, things worth seeing. Next to the figure of Mary is the date: 1526. In the same book are also some proportion-figures like those in his own book. At the house of Mr Arnoudt van Berensteyn in Haarlem, who is also a great art lover, the same kind of proportion-figures are to be found – only quite large and partly shaded – together with some arms, hands and other parts which were made by Albert to assist him while making the aforementioned Adam and Eve, these things are beautifully treated.' From the 'Life' of Albrecht Dürer in Van Mander, K., *Het Schilderboek*, (1604), Haarlem: v. 209r. See also Van Mander, K., ed. and trans., Miedema, H., (1993), *Lives of the illustrious Netherlandish and German Painters*, Doornspijk (hereafter Van Mander-Miedema 1993).

7. Berensteyn was a wealthy city councillor and is described in an inscription on a copy of a portrait by Goltzius as a promoter of the art of painting. See van Bok 1994, *op. cit.* at n. 5, p. 153.

8. The most famous of such inventories is that of Rembrandt; see 'Inventory of Rembrandt's possessions 1656', in Strauss, W.L. and van der Meulen, M., (1979), *The Rembrandt Documents*, New York: pp. 349–87.

9. An exception to this are the 1637 *Albums* at the British Museum which generally have register numbers in the place of missing drawings. It appears that no photographs were taken of the layout of any of the albums prior to drawings being removed.

10. It should be noted that the practical demands of managing a collection such as the loan, display and conservation of objects often forces museums to remove drawings from their original context.

11. Sutton, D., (1947), 'Thomas Howard, Earl of Arundel and Surrey as a Collector of Drawings', *Burlington Magazine*, **89**, pp. 3–9.

12. Van de Passe, C., (1643), *t'Light der teken en schilder konst*, etc., Amsterdam; Bloemaert, F., (no date), *Artis Apellae liber* etc., Utrecht; Bisschop, J. de, (no date), *Signorum veterum Icones*, no place, and (1671), *Paradigmata graphices variorum artificum*, The Hague. See also, Bolton, J., (1985), *Method and Practice, Dutch and Flemish Drawing Books, 1600–1750*, Landau.

13. Robinson, W.W., ed., (1991), ' "This Passion for Prints": Collecting and connoisseurship in Northern Europe during the Seventeenth Century', in Ackley, C.S., *Printmaking in the Age of Rembrandt*, exh. cat. Boston (Museum of Fine Arts): p. xliv, n. 19.

14. Stock-lists of print publishers in Amsterdam indicate that exhausted impressions of engravings by Lucas van Leyden were still on sale in the early seventeenth century, and could command relatively high prices. See Orenstein, N., Leeflang, H., Luijten, G. and Schuckman, C., (1994), 'Print Publishers in the Netherlands 1580–1620', in Luijten et al. 1994, *op. cit.* at n. 5, pp. 167–201.

15. For the *Death of Seneca* engraving, see Hollstein, F.W.H. et al., (1949–93), *Dutch and Flemish Etchings, Engravings and Woodcuts ca. 1450–1700*, 46 vols, Amsterdam: **7**, p. 59, no. 279.

16. The eight others are: UCL 4686, *Study of an antique bust*; UCL 4720, *Study of the Laocoön*; UCL 4723, *Study of the Apollo Belvedere*; UCL 4725, *Study of the Belvedere Antinous*; UCL 4726, *Study of the Borghese Gladiator*; UCL 4775, *Study of a draped Roman statue*; UCL 4773, *Study of a Sculpture Head – Gio Andrea Calderini*; UCL 4738, *Study of the Pietà after Michelangelo*.

17. See Stechow, W., (1968), *Rubens and the Classical Tradition*, Harvard: p. 29.

18. Van Mander-Miedema 1993, *op. cit.* at n. 6, v. 280r.

19. The UCL drawing measures 670 × 450 mm. The British Museum's impression of the woodcut, (W.5–62) measures 670 × 432 mm.

20. For an illustration, see Andrews, K., (1977), *Adam Elsheimer, Paintings, Drawings, Prints*, Oxford: pl. 71.

21. Written at the bottom of the Grote Collection drawing is the title: *Dio Contento*, which is a variation on the title of the National Gallery of Scotland's painting. Andrews 1977, *op. cit.* at n. 19, pp. 149–161, cite further copies of this drawing in Leningrad (Hermitage) and Vienna (Albertina).

22. *Ibid.*, p. 28, where the source is cited as Lucian via Leon Battista Alberti.

23. Early collections of curiosities and art objects were divided by subject to illustrate an encyclopaedic history of the world. One of the earliest ordering plans for collectors of all types of material was Quicchelberg, S., (1565), *Inscriptiones vel tutuli theatri amplissimi . . .*, Munich. This small quarto set out various classes within which to order a collection of curiosities in works of art. See Hajós, E.M., (1958), 'The concept of an engravings collection in the year 1565', *Art Bulletin*, **40**, pp. 151–6. This iconographic ordering system was taken up by some collectors of art objects, most notably Cassiano dal Pozzo; see Haskell, F., (intr.), (1993), *The Paper Museum of Cassiano Dal Pozzo*, exh. cat., London (British Museum, Department of Prints and Drawings).

24. Van Mander-Miedema 1993, *op. cit.* at n. 6, v. 259r.

25. A technique used to transfer a design from a sheet onto another surface. Tiny holes are made in the back of the original to denote the lines of the composition. The original is then placed onto a surface and charcoal dust is rubbed through the holes; the original is then removed so that a dotted pattern of the lines is produced on the new surface and the design can be sketched in.

26. It is possible that many other prints were used in this way and have been discarded in the process of transfer, as has occurred with the vast majority of cartoons.

27. The Ashmolean designates the donor as 'Anon'. Before the album was bequeathed to the museum, drawings had been removed, presumably for the British Museum, by Teddy Croft Murray (Keeper of the Department of Prints and Drawings at the British Museum, 1954–1973). Nine pages have had all the drawings removed, with the word 'Yes' written in a modern hand, presumably to indicate their removal, several others are also marked 'Yes' but have not been removed. Page 11 may have contained a drawing by Scibaldo Scorza (Genoa, seventeenth century) as his name appears in pencil on the empty page.

28. Stainton, L., (1988), 'A Seventeenth-Century Album', in Waterfield, G. and Kalinsky, N., (intr.), *Mr Cartwright's Pictures. A Seventeenth-Century Collection*, exh. cat., London (Dulwich Picture Gallery): pp. 14–15.

29. Eighty-eight drawings remain in the album and only a few appear to have been removed. The pages are decoratively numbered on all four corners although those pages after fol. 33 are blank.

30. Stainton 1988, *op. cit.* at n. 27, pp. 14–15.

31. Drawing no. 18, *Reclining Female Nude* (black chalk) and drawing no. 24, *Reclining Female Nude* (pen and brown ink).

32. The Cartwright album includes a red chalk drawing of the artist Lucas Vorsterman. It has been copied from Anthony Van Dyck's *Iconographia*, a series of portraits of artists, collectors, princes and statesmen, first published in Antwerp in 1641. Eleven other drawn copies by anonymous draughtsmen from Van Dyck's *Iconographia* also appeared in the Grote album. These are UCL 4649, *Portrait of Jacob Jordans*; UCL 4650, *Portrait of Gaspar de Crayer*; UCL 4651, *Portrait of Wenceslaus Coeberger*; UCL 4653, *Portrait of Constantius Hugens*; UCL 4654, *Portrait of Petrius Stevens*; UCL 4655, *Portrait of Johan Wildens*; UCL 4656, *Portrait of Cornelius Schut*.

33. See van der Gelder and Jost 1985, pp. 201–3.

34. *Ibid.*, pp. 201–2.

35. See Hind 1931, *op. cit.* at n. 1, **5**, p. xiii.

36. See van der Gelder and Jost 1985, p. 205.

37. British Museum: Sloane 5219.

38. De Piles, R., *Abrégé de la vie des peintres avec des réflexions sur leurs ouvrages et un Traité du peintre parfait, de la connaissance des dessins, & de l'utilité des estampes*, Paris, 1699.

39. Subsequent to the writing of this essay, papers by David Landau and Matteo Lafranconi, given at the conference, *The Collecting of Prints and Drawings in Europe c.1550–1800*, held at the National Gallery, London on 20–21 June 1997 (publication forthcoming), have cast new light on the subject. Landau discussed an early sixteenth-century Spanish collection of prints once belonging to Hernando Colon, son a Christopher Columbus; Lanfranconi spoke on a late sixteenth-century collection of drawings assembled in Rome by Antonio Tronsarelli. It has emerged that many collectors of prints also collected drawings, and it may well be that extensive drawing collections were being assembled in the early sixteenth century.

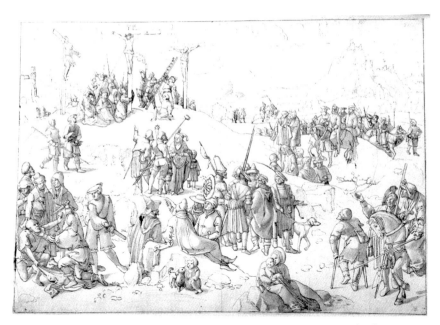

12.1 Anonymous, *Crucifixion at Mount Calvary,* pen and black ink with grey wash, after Lucas van
Leyden.

12.2 Anonymous, *Death of Seneca*, red chalk, after an engraving by Cornelis Galle.

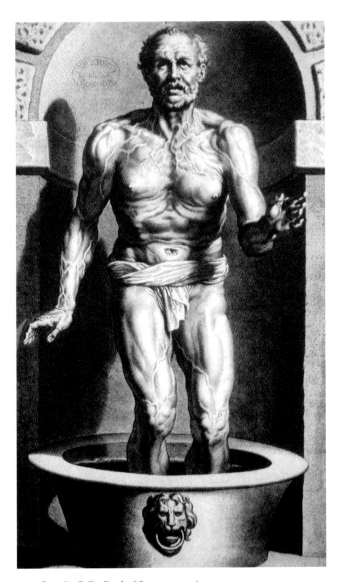

12.3 Cornelis Galle, *Death of Seneca*, engraving.

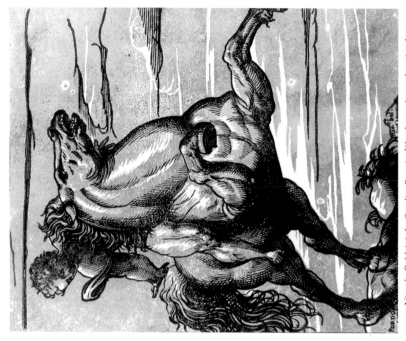

12.5 Niccolo Boldrini, *Le Cavalier Romain*, Woodcut, after a drawing by Pordenone.

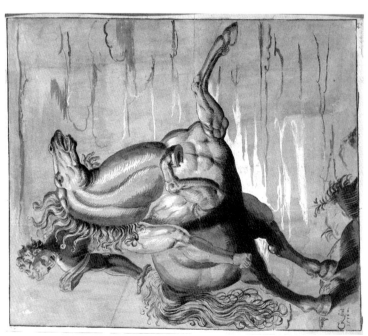

12.4 Cornelis Ketel, *Rearing Horse with a Nude Male Rider*, after Niccolo Boldrini, pen and brown ink with white and grey wash.

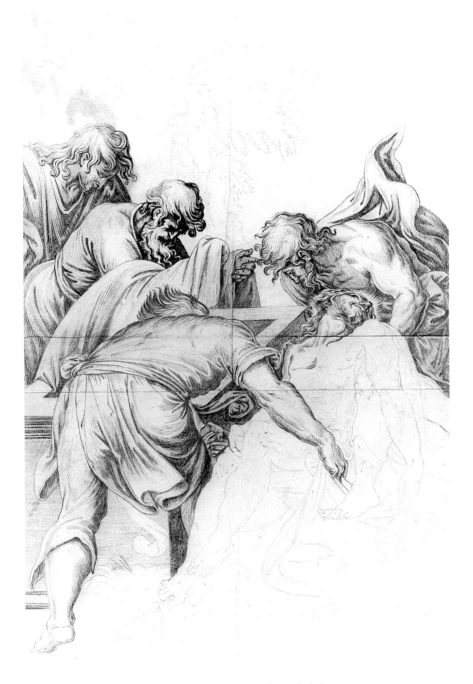

12.6 Anonymous, *Entombment of Christ*, black chalk, after Joseph Scolari.

12.7 Anonymous, *Dio Contento*, pen and brown ink with coloured wash, after Adam Elsheimer.

Index